Art and Pornography

Art and Pornography

Philosophical Essays

Edited by
Hans Maes and Jerrold Levinson

OXFORD
UNIVERSITY PRESS

OXFORD
UNIVERSITY PRESS

Great Clarendon Street, Oxford, OX2 6DP,
United Kingdom

Oxford University Press is a department of the University of Oxford.
It furthers the University's objective of excellence in research, scholarship,
and education by publishing worldwide. Oxford is a registered trade mark of
Oxford University Press in the UK and in certain other countries

British Library Cataloguing in Publication Data

Data available

Library of Congress Cataloging in Publication Data

Data available

ISBN 978–0–19–960958–1

Printed in Great Britain by
MPG Books Group, Bodmin and King's Lynn

Contents

Introduction

HANS MAES AND JERROLD LEVINSON

Whatever else it is, pornography is big business. With around 420 million webpages devoted to X-rated content, 700 million dvd rentals, and more than 13,000 hardcore films released every year, the worldwide annual revenue of the porn industry has been estimated at 97 billion dollars. People spend more money on pornography every year than they do on movie tickets, and more than they do on all the performing arts combined. So, in terms of output and economic impact, at least, pornography appears to be more mainstream than, say, the $600 million Broadway theatre industry or the 400 films a year Hollywood industry.[1]

Of course, size is not the only thing that matters. Pornography's cultural impact and visibility has been comparatively small in the past. For the greatest part of the twentieth century the stars of Hollywood and the entertainment industry have commanded the public eye and shaped popular culture, while pornography remained very much a private affair. (The first adult entertainment company to be traded on the NASDAQ stock market was aptly named 'The Private Media Group'.) However, in recent years this has gradually but significantly changed. The distribution of and access to pornography has been facilitated immensely by the internet, and pornography has acquired a growing presence in and influence on contemporary culture—a process that is usually described as 'the pornification of society'. Many music videos and advertising campaigns now eagerly copy the groaning and grinding aesthetics of pornography. What was cheap and sleazy has become funky and fashionable, with the PornStar logo or Playboy bunny printed on T-Shirts and other

[1] These figures are borrowed from Rich (2001), Williams (2004), and Ropelato (2006).

fashion accessories. The best-paid actors and actresses in the business have achieved genuine stardom, complete with fan clubs and signing sessions, and TV shows and magazines now frequently contain playful references to sexual entertainment

Given that pornography is such a popular genre, boasting an unparalleled output and cutting across different demographics, cultural boundaries, and artistic media, one may wonder why philosophers of art and aesthetics have remained silent on this topic for such a long time. Moral philosophers, sociologists, legal scholars, feminist and queer theorists, film scholars, economists, and cultural theorists have written volumes on pornography, but meanwhile not a single monograph or essay collection has been published by an analytic philosopher of art.

This neglect will probably come as less of a surprise if one considers the bad aesthetic reputation that much pornography traditionally enjoyed and still enjoys. According to a widely held belief, pornographic representations cannot be art or, at best, can only be bad art. This view seems to be confirmed by a cursory look at these two domains of representation. Of the thousands of hardcore films released every year, there are very few, if any, that are artistically or aesthetically rewarding. Conversely, there are very few, if any, artistic masterpieces that would seem to qualify in any straightforward way as pornography. To be sure, there are plenty of works, especially within contemporary art, that one could loosely describe as 'pornographic art'. The paintings of John Currin, the neon sculptures of Bruce Nauman, the stitching of Ghada Amer, the collages of Paul McCarthy, the photographs of Thomas Ruff, the statuettes of Jeff Koons, the installations of Judy Chicago come to mind. But these are works of art that mimic, criticize, or reference pornography. They are *like* pornography or *about* pornography, but arguably they are not themselves pornography.

The fact that, at least at first sight, there appears to be no substantial intersection between art and pornography helps to explain why philosophers of art have ignored this topic for so long, but it also raises an interesting and pressing question: Why is there no significant overlap between these two vast domains of representation? Is this merely because of external and contingent factors or are art and pornography inherently incompatible? That is the central research question which this book focuses on. It is a question that philosophers of art are particularly well suited to answer. One cannot hope to critically examine the middle ground between art and pornography,

it seems, without seriously engaging with current research on the role of imagination and emotion in our engagement with fiction, the nature of aesthetic experience and aesthetic value, the notion of transgression and its artistic and erotic potential, the relation between ethical and aesthetic judgements, and the analysis of depiction and picture perception. So, in this volume we have assembled philosophers of art with different areas of specialization to bring their knowledge and expertise to bear on the main topic of this volume. Thinking about these fundamental issues in aesthetics in relation to pornography will not only bring a fresh perspective and new arguments to certain long-standing discussions in the field, but it will also help to clarify the artistic status and aesthetic dimension of pornographic pictures, films, and literature, and to answer what Roger Scruton has termed 'one of the most important questions confronting art and the criticism of art in our time: that of the difference, if there is one, between erotic art and pornography' (2009: 158–9).

The chapters in this collection are ranged under four broad themes. Part I tackles the central issue of whether or not art and pornography are mutually exclusive in the most direct way. Part II explores the topic of imagination and fictionality in relation to pornography. Issues surrounding medium and genre provide the central focus of Part III, while Part IV addresses ethical and feminist concerns about pornography.

The opening chapter, by Hans Maes, provides the contours of the debate about whether art and pornography are mutually exclusive and is meant as an introduction to the main themes of this book. It begins by looking at some of the classic ways of explaining the difference between art and pornography. Pornography, some have said, is sexually explicit and focuses exclusively on certain body parts, while art possesses emotional and psychological depth and is essentially suggestive. Others have stressed that pornography, unlike art, is inherently formulaic, or that pornography is exploitative in a way that art is not, or that pornography aims for a particular response, sexual arousal, that is anathema to artistic contemplation or aesthetic experience. Such dichotomies, Maes argues, are illuminating insofar as they help us to clarify how typical examples of art differ from typical examples of pornography, yet it would be wrong to see them as absolute distinctions. Whenever one attempts to draw a strict line between the two domains, whether it is on the basis of representational content, moral status, artistic quality, or prescribed response, one can always find examples of art or

pornography that would fall on the 'wrong side' of the divide. Many works of pornography possess features that some have exclusively ascribed to art. Likewise, there are numerous works of art that possess precisely those features which supposedly disqualify pornography from the realm of art (being explicit, exploitative, formulaic, arousing). Of course, one could argue that pornographic works, *by definition*, lack any significant artistic or aesthetic aspect. But Maes argues against such a normative characterization of pornography and proposes instead a value-neutral definition. Finally, after providing a critical assessment of one of the most recent and original arguments in the debate, one that contrasts the 'manner specificity' of art with the 'manner inspecificity' of pornography, Maes highlights some of the practical implications of this philosophical discussion. Many of the issues raised in Maes's introductory chapter are dealt with in greater detail in later articles.

Alex Neill's chapter explores a largely unremarked corner of Schopenhauer's aesthetic theory, his treatment of what he labels the 'charming', which might also be rendered as the 'attractive' or the 'seductive'. Schopenhauer regards this as the opposite of the sublime: whereas the sublime presents the will with something that fascinates at the same time as it terrifies, threatening the will's very existence, the charming presents the will with something that fascinates more directly, in promising the will's most immediate and complete satisfaction. The differences between the sublime and the charming, which Neill carefully details, account for why for Schopenhauer the former is a possible object of aesthetic experience while the latter is not. Neill draws illuminating connections between Schopenhauer's discussion of the charming and contemporary discussion of the pornographic, and in so doing provides partial support for Levinson's position on the inherent tension, perhaps amounting to incompatibility, between the artistic regard and the pornographic regard. But Neill also argues, *pace* Schopenhauer, that in the guise of the erotic the charming does admit of aesthetic appreciation, much as does the terrifying in the guise of the sublime, thus restoring a parallel between the charming and the terrifying which Schopenhauer might well have acknowledged.

According to David Davies, both the nature of art and the nature of pornography can be usefully elucidated in terms of the kind of regard or response intended by the maker of an artefact. In this sense, both art and pornography are 'in the intended response' of the receiver. But, he main-

tains, although the kinds of response demanded by art and pornography differ, this is no obstacle to something's being both art and pornography in a sense that justifies the label 'pornographic art'. It is, Davies argues, no more difficult to see how there can be pornographic art than it is to see how there can be religious art, or political art, or indeed art that has any non-artistic primary intended function. In all such cases what makes something art is both the kind of response solicited and the manner in which that response bears upon the content of the work. Given this way of determining when we are dealing with art, we can further classify artworks in terms of those non-artistic purposes that they are intended to serve in virtue of those qualities that make them artworks in the first place.

The heart of Levinson's brief reply to David Davies's chapter is that the analogy Davies offers between, on the one hand, putative pornographic art and, on the other hand, religious or other art possessing a primary non-aesthetic function, is simply overdrawn, and that the ease of fulfilling an aesthetic and a non-aesthetic function at the same time is significantly over-estimated in the former case as compared to the latter case. Levinson also outlines some differences with Davies as to how the concept of regarding something as an artwork is to be understood, emphasizing a divergence between how the concept might function in a definition of art and how it functions in modern criticism and evaluation. Levinson's reply to Davies concludes with a few reasons why we may yet be justified in maintaining a fairly sharp division between art and pornography, despite strong briefs offered to the contrary by Davies, Maes, Kania, and others.

The chapters in Part II all examine the relation between pornography, fiction, and imagination. The starting point for Cain Todd is the idea that the appreciation of pornographic representations is heterogeneous. In particular, he makes a distinction between two different appreciative attitudes or states: regarding pornography as fiction, and regarding it as non-fiction. The latter, he holds, does not involve the imagination, but involves instead the voyeuristic-like 'transparency' that precludes aesthetic interest, and in virtue of doing so, involves real sexual desire. In contrast, the appreciation of pornography as fictional, Todd argues, essentially involves the imagination and aesthetic attention to and appreciation of the 'formal features' of the work. The awareness of fictionality ensures that one's imaginative engage-ment implies merely imagined 'desire-like' states involving some aspects of the self as a character in the fictional world. Significantly, this imaginative

engagement is enough to cause certain physiological and emotional sexual responses, but ones that people are sufficiently detached from, allowing them to serve as objects of reflection and permitting meta-responses of approval and disapproval.

While Todd argues that the engagement with pornography can possess certain cognitive values, insofar as it involves the self in *de se* imaginative projects, Kathleen Stock explores, and ultimately rejects, the thought that enjoying erotica or pornography must *always* involve imagining something about oneself. After making some distinctions between different kinds of imagining *de se*, and clarifying the general claim that there is a connection between emotional engagement with fiction and implicitly imagining *de se*, she turns to the case of pornography, examining and rejecting three possible arguments for a necessary connection between imagining, from the inside, being aware of represented events (that is, implicitly imagining *de se*), and being aroused by them. Since versions of these arguments might equally be applied to affective response to fiction more generally, Stock's chapter goes at least part way to undermining the 'argument from affective response', that is, the claim that one can provide a good explanation of our emotional responses to fictional events by construing imagining in relation to these events as imagining being aware of those events.

Christy Mag Uidhir and Henry John Pratt focus on the particular puzzle that the more imaginative forms of pornography pose. If the primary purpose of pornography is sexual arousal through sexually explicit representations, and if 'prototypical pornography' is best able to fulfil that purpose through the adoption of a maximally realistic depictive style, then why, they ask, do not all works of pornography aspire to prototypical status? There are quite a few non-standard pornographic genres, including Tijuana Bibles, hentai manga, and slash-fiction, that possess certain depictively or fictively oriented properties that appear at least prima facie incompatible with prototypical pornography. These give rise to two issues that any viable analysis of pornography must address. On the one hand, there is the Depictive Question: How might issues in depictive realism bear, if at all, upon such works being pornographic? More specifically, does the lack of realism in Tijuana Bibles or hentai affect their status as pornographic? On the other hand, there is the Fiction Question: How might the conditions for being a work of fiction, whether slash-fiction or otherwise, fit, if at all, with the conditions for being a work of pornography? Put differently, are the primary aims of

fiction and pornography compatible, and can a work be an excellent example of both? By addressing these questions, Mag Uidhir and Pratt hope to offer a clearer picture of the aims of pornography and the reasons for which significant sub-genres of pornography might diverge from the prototypical ideal. In the process, they also provide a better understanding of what lies at pornography's edge, and the ways in which pornography might relate to what lies beyond.

The chapters in Part III also throw light on specific subgenres of pornography such as Japanese Pink film or the predominantly French tradition of transgressive pornographic literature. However, it is pornography's relation to different artistic media that provides the main organizing principle of this part. Each chapter addresses one of the three dominant artistic media for pornographers: film, photography, and literature.

Petra Van Brabandt and Jesse Prinz, who focus on pornographic cinema, set out to investigate and explain what they call the paradox of porn: the fact that so few pornographic films qualify as art despite instantiating so many characteristic features of art. The average pornographic film, they point out, arouses very strong emotions, is a product of the imagination, and belongs to a well-established art medium and genre; in addition, its performers display both striking aesthetic properties and considerable skill. Furthermore, porn flicks seem to have so much in common with art films in particular. Think of the amateurish production values, the episodic rather than narrative character, the Brechtian acting, or the grittiness characteristic of cinema verité. Given all these commonalities, one may wonder why almost no pornographic films have attained art status.

One explanation could be that, notwithstanding certain superficial similarities, pornography and art are for some reason fundamentally incompatible. Van Brabandt and Prinz look at several such incompatibility and oppositional theories before firmly rejecting them and proposing a different explanation. The main reason why pornographic films rarely attain art status is that they do not permit the taking of an aesthetic stance, and that is because they lack any aspiration to excellence in their effort to instantiate characteristic features of art. There is almost never any noticeable pursuit of unique style, painstaking execution, or exceptional beauty. Market forces are likely to be blamed for this because pornographers, in order to make money, have to cater to the wishes and expectations of their target audience. Hence, they avoid creative risk-taking and opt instead for reliable tricks and

formats that trigger without delay, surprise, or ambiguity the strong, simple emotional response of sexual arousal. According to Van Brabandt and Prinz, market forces also help to explain what one could label the second paradox of porn: the fact that very few art films have strong pornographic content, while one would expect this sort of content to fit perfectly with the common ambition of these films to evoke and explore human emotions and moral dilemmas in all their intensity and extremity. An art film with sexually explicit content, they point out, runs the risk of receiving an X-rating and hence being banned from ordinary retail stores and cinemas, which would amount to financial disaster. The authors conclude by describing how the creativity associated with art could make sexual content more exciting and affective, and how the transgressive carnality of pornography could amplify artistic intensity and impact, in both cases by examining films that come closest to those ideals.

In Bence Nanay's chapter the medium of photography takes centre stage. Typical of pornographic photographs, he suggests, is that the spectator's attention is drawn to what is being depicted and not to the way the subject matter is being depicted. To borrow Richard Wollheim's terminology, the 'recognitional' aspect of pictorial representation is emphasized at the cost of the 'configurational' aspect. In order to achieve a better understanding of the specific perceptual experience that is solicited by pornographic pictures, Nanay analyses what could be thought of as the counterpoint to pornography: André Kertész's series of photographs from 1933, entitled *Distortions*. Instead of underplaying the configurational aspects of the picture, making the picture transparent and fully in the service of showing naked bodies and triggering arousal, Kertész aims to achieve the exact opposite. His photographs, made with the aid of two distorting mirrors, effectively strip the female body of its sexual connotations and draw our attention to the formal features of the pictures. A close examination of these modernist photographs, Nanay shows, helps to illuminate issues regarding the antithetical experience of photography-based pornography, as well as to answer some general questions about the configurational aspect of pictorial representation. The chapter ends by contrasting Kertész's *Distortions* with the work of another famous modernist photographer, Man Ray. In his *Mr and Mrs Woodman* series (1927–47), Man Ray photographed two wooden figures in various sexual poses and positions. According to Nanay, Man Ray succeeds in making pornography with simple pieces of wood, while Kertész

achieves the contrary, creating anti-pornography out of flesh-and-blood female nudity.

Michael Newall's contribution targets works of literary pornography that achieve their primary effect, sexual arousal, in part by representing a particular kind of norm-breaking, namely the violation of social or moral norms about sexual behaviour. Key examples include the Marquis de Sade's *The One Hundred and Twenty Days of Sodom* and Raymond Queneau's *We Always Treat Women Too Well*. Stories like this include scenarios featuring couplings deemed by society inappropriate to various degrees: sex between strangers, sex in public places, sex between members of different social classes, sex between members of different age groups, incest, sexual violence, bestiality, and so on. While some of these scenarios, especially the milder ones, sometimes function as little more than an 'interesting' way of framing otherwise standard sex scenes, they can also add to sexual arousal, as well as provide a basis for other affective states, such as disgust, humour, and awe. Such affects, which are typically adventitious and unsolicited in popular pornography, are exploited for artistic purposes in literary pornography. Newall not only shows how each of these affects has a basis in the norm-breaking of transgressive pornography, but also investigates the artistic value that can accrue to these affects by examining Georges Bataille's *Story of the Eye* and the roles that disgust, humour and awe play in it. He concludes by suggesting that this constellation of affects goes some way to mapping a distinctive aesthetic of literary examples of transgressive pornography.

Ordinary usage suggests that the term 'pornographic' is pejorative, while the term 'erotic' is neutral or approving. However, the assumption that there is a categorical ethical distinction between pornography and erotic art is one that is fundamentally challenged in Part IV. It does not follow from the fact that something is pornography that it is ethically flawed, nor does it follow directly from the fact that something is a work of art that the work is immune to ethical criticism. This insight is pivotal in each of the chapters of this final part.

Brandon Cooke's chapter offers a detailed critical examination of some of the most powerful moral objections against pornography. One such objection is built on the idea that one can acquire true beliefs from fiction, but also false beliefs, and that the latter invariably happens to consumers of pornography. Pornographers, so the argument goes, are liars because they present fiction as fact; or at least, they are 'background liars' who lie about

certain background propositions which are purported to be true both in the fiction and in reality; or at the very least, pornographers are 'background blurrers' when they present background propositions as fiction, but, innocently or otherwise, blur the authorial moves that enable an audience to distinguish fact from fiction. A different moral objection states that women as a group are exploited by heterosexual pornography. As Cooke explains, this claim can be unpacked in a number of ways. If to exploit a person means to benefit unfairly by taking advantage of that person's characteristics or circumstances, then one may argue that the circumstances or traits of women themselves are turned to unfair advantage in pornography, or that pornography gains by endorsing exploitation, or that pornography causes exploitation. After discussing each of these objections Cooke moves on a critical assessment of a variety of causal arguments put forward by anti-porn critics who believe that pornography causes harm or induces unethical behaviour. Against the latter Cooke argues that there still is no adequate evidence for any such causal link and that the relevant causal mechanism has yet to be discovered. He also remains sceptical about the other moral objections against pornography. In his view, these typically fail to square with the fact that most pornography is offered as material for non-alethic imagining and that imaginings of this sort are not morally equivalent to actions or to genuine attitudes. It is this connection with imagining, Cooke argues, that makes pornography on a par, ethically, with art. To be sure, works of art are sometimes an appropriate object of ethical criticism. But establishing that an artwork is ethically flawed requires much more than showing that it has a certain content. According to Cooke, the same is true of much pornography.

It is important to keep in mind, Andrew Kania observes, that theorists who attempt something like an analysis or definition of pornography often engage in different kinds of projects. Some engage in a conceptual project aimed at elucidating a shared concept of pornography, attempting to achieve reflective equilibrium through a priori reflection on our intuitions about general claims and particular cases. Others pursue a descriptive projection which they seek to bring our concept of pornography in line with the world and discover the objective phenomena that the concept seems to be attempting to track.

A third kind of project is what Kania, following Sally Haslanger, calls an analytical project. Such a project has two parts. In the first part, one steps

back from the concept in question and asks what work one really wants the concept to do. In the second part, one generates the best concept for the job identified in the first part. Feminists who hold that the point of a concept of pornography is to combat the oppression of women and who consequently propose a stipulative definition of pornography, typically engage in this kind of project. By contrast, Jerrold Levinson's attempt to articulate the distinction between erotic art and pornography qualifies as a descriptive project. According to Kania, there are serious problems with both Levinson's project and the feminist project. Levinson's analysis of pornography can be faulted on descriptive grounds, but it might also be challenged from an analytical point of view, since it cannot account for the distinction between egalitarian pornography (deemed morally unproblematic) and inegalitarian pornography (deemed morally defective), and hence cannot be used for feminist purposes. However, many feminist discussions of pornography can also be criticized from an analytical point of view, Kania points out, because they focus exclusively on mass-market pornography and in the process overlook erotic and pornographic art as a significant source of subordinating material.

Anne Eaton's chapter picks up where Kania's chapter leaves off. Insofar as erotic art and in particular the female nude makes male dominance and female subordination and objectification sexy, Eaton argues, it eroticizes the traditional gender hierarchy and in this way is a significant part of the complex mechanism that sustains sex inequality. To substantiate this claim, she offers a close analysis, supported by a long list of examples, of the different ways in which artworks belonging to the genre of the female nude can be sexually objectifying. She also lends some much-needed precision to the concept of the male gaze, and addresses two serious objections to her particular feminist approach. Firstly, if visual representations typically trade in tokens, not types, then the question arises how a picture can objectify women *in general*. Eaton argues that the latter is possible because the female nude in the European tradition is almost always both generic and idealized. Secondly, since many consider objectification to be a normal and even healthy part of human sexuality, one might wonder what is wrong with sexual objectification in the first place? While Eaton grants that isolated instances of sexual objectification are not necessarily any more problematic for women than for men and that, at certain appropriate times, a woman may indeed want to be a sexual object for her lover rather than, say, a

challenging intellectual sparring partner, there remains the problem that women really have very little choice in this regard because they constantly live under the umbrella of sexual objectification; and it is the systematic and pre-eminent sexual objectification of the female body, and only the female body, that persists throughout the European artistic tradition, that helps to sustain this situation. Furthermore, Eaton notes a significant difference between pornographic works and the traditional female nude: the latter not only eroticizes but also aestheticizes the sexual objectification of women, and does so 'from on high', art's venerated status investing the traditional nude's message of female inferiority with special authority, making it an especially effective way of promoting sexual inequality.

Besides being objectifying and exploitative, pornographic pictures are also often said to be inherently voyeuristic. But what exactly does it mean for a representation to be voyeuristic and what, if anything, is the difference between voyeurism in artistic and non-artistic representations? These are the central questions that Elisabeth Schellekens addresses in the final chapter of this volume. According to Schellekens, a representation will count as voyeuristic if a number of interrelated conditions are fulfilled, the most crucial of which refers to the delight we take in such a representation. That delight must at least partly be grounded in the fact that we are witnessing something that, in some sense, we shouldn't be witnessing. In other words, the particular *frisson* that voyeuristic works give us relies fundamentally on breaking a moral taboo or crossing the line of what is traditionally regarded as morally acceptable. As such, Schellekens believes that there is an inescapable moral tension at the heart of all voyeuristic works, including voyeuristic works of art. What in the end distinguishes voyeurism in art from voyeurism in non-artistic contexts is that in art we are invited to simultaneously occupy the point of view of the voyeur *and* observe ourselves qua spectator from an external point of view so as to reflect on our morally problematic indulgences. Ordinary voyeuristic repre-sentations, much like ordinary pornographic pictures and films, do not tend to invite the viewer to reflect on their broader context, or on their under-lying meaning but rather offer something more instrumental and one-dimensional. The chapter ends with the question whether, given the gradual erosion of moral taboos and inhibitions that we are currently experiencing in the West, there still is a place for innovative voyeuristic art.

This book will surely not constitute the last word on the debate in philosophy about the relationship between art and pornography. We fervently hope, though, that it will contribute to clarifying, enriching, and invigorating that debate.

References

Rich, F. (2001) 'Naked Capitalists'. *New York Times*.

Ropelato, J. (2006) Internet Pornography Statistics, <www.TopTenReviews. com>.

Scruton, Roger (2009) *Beauty*. Oxford: Oxford University Press.

Williams, Linda (ed.) (2004) *Porn Studies*. Durham, NC: Duke University Press.

I
Pornography, Erotica, and Art

1

Who Says Pornography Can't Be Art?

HANS MAES

Many art historians, art critics, and philosophers of art have argued, or sometimes just assumed, that art and pornography are mutually exclusive. I aim to show that this popular view is without adequate support.[1] I start by listing the different ways in which the distinction between art and pornography has been drawn in the past. While strong dichotomies of the sort I will discuss may help to illuminate the differences between certain prototypical instances of each, I argue that they do not serve to justify the claim that pornography and art are fundamentally incompatible. Next, I consider those definitions of pornography that make an a priori distinction between pornographic and artistic representations and I explain why such definitions should ultimately be rejected. Finally, after providing a critical assessment of one of the most recent and original arguments in the debate, I conclude by highlighting some of the practical implications of this philosophical discussion.

1. A Black and White Distinction?

In the existing literature one finds roughly four ways of marking the difference between artistic and pornographic representations. The line is

[1] This is a thoroughly revised and significantly extended version of a paper that appeared earlier in *Philosophy Compass* under the title: 'Drawing the Line: Art versus Pornography'.

drawn either on the basis of (1) representational content, (2) moral status, (3) artistic qualities, or (4) prescribed response.

(1) *Representational content.* Pornographic representations are sexually explicit and rich in anatomical detail. Art, by contrast, relies on suggestion and, instead of focusing on certain body parts, tries to capture the individuality, personality, and subjectivity of the represented person. This is one of the most common ways of distinguishing between the two—one that figures prominently in accounts offered by Luc Bovens and Roger Scruton. The latter's standard example is Titian's *Venus of Urbino*. In this painting, as in all erotic art, Scruton points out, it is not the sexual organs but the face, as 'window to the soul', that provides the focus of attention (1986: 154; 2005: 11; 2009: 149). Luc Bovens takes this a step further and argues that it is precisely *because* artists refrain from overly graphic detail that they succeed in drawing the viewer into the first-person perspective of the depicted subject (1998: 215). Graphic representations, he thinks, only engage the spectator into a shameful gaze which will prevent her from developing such a phenomenal connection. Art, on the other hand, by retaining a suggestive character, exerts a great pull on the imagination and invites the viewer to explore the mindset of the depicted person. Thus, art reveals in concealing, whereas pornography conceals in revealing (1998: 215).

A related and no less popular way of drawing the distinction is to say that pornography focuses on sex that is aggressive, emotionless, or alienated, whereas in art, and particularly in erotic art, love, passion, and equality between partners are of crucial importance (Webb 1975: 2; Steinem 1995: 31; Mahon 2005: 15; Ellis 2006: 30). In support of this view, authors often appeal to etymology. For while 'erotic art' ultimately derives from 'eros', the Greek word for love or passion, indicating an integrated sexuality based on mutual affection, the term 'pornography', whose etymological root is 'porne', meaning prostitute, reflects a dehumanized, emotionless sexuality (see, for example, Webb 1975: 2, Steinem 1995: 31). In line with this, the novelists Kingsley Amis and E. J. Howard even went so far as to formally recommend, in their essay for the 1972 Longford Committee on Pornography, that the word 'love' be forbidden in the title of any work of hard-core pornography so as to avoid any misconceptions regarding its content (1972: 158).[2]

[2] Another famous novelist, D. H. Lawrence, once claimed that pornography is recognizable 'by the insult it offers, invariably, to sex and to the human spirit' (1929: 13). And he continues: 'Pornography is

(2) *Moral status*. Delineating the distinctiveness of pornography, as opposed to (erotic) art, in terms of a particular content will not in and of itself establish that pornography is immoral. To begin with, even if one thinks that pornography always focuses on emotionless and impoverished forms of sexuality, one may insist that this makes pornography 'charientically flawed', i.e. coarse and vulgar, but not morally flawed (just like someone with vulgar manners or a coarseness of mind is not necessarily a morally corrupt person).[3] Joel Feinberg (1979, 1985) makes this argument with regard to obscenity, but one could easily extend it to pornography. Furthermore, Theodore Gracyk (1987) has convincingly argued that the morally objectionable character of a representation can never be just a matter of represented subject matter. For an artist can decide to depict rape or other aggressive forms of abuse in an attempt to precisely warn and protest against such degradation of women or men. That is why Helen Longino is careful to define pornography as 'verbal or pictorial material which represents or describes sexual behavior that is degrading or abusive to one or more of the participants *in such a way as to endorse the degradation*' (1980: 43, my emphasis).

Longino is of course only one of the many authors who have tried to capture what is morally problematic about pornography. Since the aim of this chapter is to investigate the artistic status of pornography I intend to put the intricacies of that debate aside here. However, I will introduce some of the more basic distinctions, because they can be, and have been, put to use in discussions on the distinction between art and pornography.

The most straightforward way to argue that pornography is morally objectionable (in a way that art is not) is to argue that it is harmful. The harm that pornography does may occur in the production phase, and take the form of coercion, brutality, violence, or rape. But even if no harm takes place in the making of pornography, and models are treated fairly and with respect, there can still be post-production harms. Some have argued that the pornographic materials themselves *constitute* harm because, as a form of hate speech, they silence and subordinate women (MacKinnon 1987; Langton

the attempt to insult sex, to do dirt on it.... Ugly and cheap they make the human nudity, ugly and degraded they make the sexual act, trivial and cheap and nasty' (1929: 13).

[3] The term 'charientic' is derived from Peter Glassen's article '"Charientic" Judgements' (*Philosophy*, 1958). A charientic judgement is an evaluative judgement, but one that concerns the non-moral qualities of an action, character, or representation. For instance, to judge someone as boorish and uncivilized (or, conversely, as refined and civilized) is to make a charientic judgement (see also Kieran 2002: 34).

1993). Others have emphasized that exposure to pornographic material may *cause* harm (Eaton 2007). The latter claim is further refined by specifying the frequency of exposure (isolated/cumulative), the nature of the material (egalitarian/inegalitarian), the kind of harm inflicted (physical/attitudinal), and whom it is mainly inflicted on.

Pornography can be said to cause harm to a third party, in particular women, through the pernicious effect it has on the consumer, but some philosophers have also drawn attention to the harm that is supposedly caused to consumers themselves. Susan Dwyer (2008), for instance, argues that frequently watching pornography, much of which involves the humiliating and abusive treatment of others in a highly sexualized context, is like persistently engaging in bad thoughts about others. It is toxic and can erode one's moral character. Roger Scruton takes a slightly different line. Sexual desire in its fullest and most fulfilling form, he argues, 'is a desire for a person, someone who confronts me eye to eye and I to I' (2003). It is not a desire for sensations. Insofar as the consumption of pornography facilitates and promotes the brute pursuit of mere sensations, it does not contribute to an individual person's flourishing and rather diminishes that person's sense of self and moral integrity. In somewhat similar vein, it has been argued that devoting oneself sexually entirely or even primarily to pornography-aided masturbation, if a matter of choice, must be considered perverse, as it precludes the fully interpersonal sexual relations at the heart of an optimal experience of human sexuality (Levinson 2003).

'Exploitation' and 'objectification' are probably the terms that are used most often to describe what is wrong with pornography. Martha Nussbaum (1995), for instance, has written a seminal essay on different forms of objectification and how they apply to pornography, whereas artists like Nancy Spero have defined pornography as 'stuff that exploits women's bodies, and particularly in a harmful way' (Cembalest 1989: 142). It might be thought, and indeed Spero and others have argued, that these ethical terms may serve to demarcate art from pornography—pornography being exploitative or objectifying in a way that art is not.

(3) *Artistic quality.* Those who are sceptical of the artistic potential of pornography will often put forward one or more of the following five reasons why pornography, by its very nature, will lack the kind of artistic quality that works of art are meant to possess. First, while art is necessarily complex and multi-layered, pornography is one dimensional.

That is because it has only one job to do. As a consequence, one will look in vain for the purposive and interpretive openness of art. Especially among art historians this appears a popular rational for separating art and pornography (see, for example, Webb 1975: 6; Mahon 2005: 14; Wallace, Kemp, and Bernstein 2007: 15). Second, works of art possess originality, whereas in pornography, as Nabokov once put it, 'action has to be limited to the copulation of clichés' (1995: 313). One is presented with the same kind of stock roles, sexual acts, flimsy narratives over and over again. This is not just a contingent feature of pornography. Pornographic films, novels, magazines are *inherently* formulaic. Because the pornographer's sole intent is sexual arousal, he has to insert as many sexually explicit scenes as possible, leaving no room for plot or character development. Moreover, the actual sum of possible sexual postures, gestures, and consummations seems drastically limited. In the words of George Steiner: 'the mathematics of sex stop somewhere around the region of *soixante-neuf*' (1975: 203)—which explains the inescapable monotony of pornographic representations (see also Amis and Howard 1972: 153).

A third and related complaint is that pornographic films, photographs, and stories are mass-produced commodities—products of what is aptly termed 'the porn industry'. A work of art, by contrast, is not an industrial product but a unique creation, carefully crafted and skilfully made. Fourth, art is concerned with beauty, while pornography is non-aesthetic and 'smutty.' In *Civilization and its Discontents*, Freud famously observed that 'the genitals themselves, the sight of which is always exciting, are hardly ever regarded as beautiful' (1961: 83). From this, it seems to follow that 'we only get beauty if we do not depict the site of sexual pleasure directly' (Danto 2003: 82). Another reason why pornography cannot be beautiful is offered by Roger Scruton: 'The pornographic image is like a magic wand that turns subjects into objects, people into things—and thereby disenchants them, destroying the source of their beauty' (2009: 163). To further illuminate this, Scruton appeals to the distinction between 'the nude' and 'the naked' made famous by Kenneth Clark (1956). The artistic nude constitutes, as the subtitle of Clark's book indicates, a 'Study in Ideal Form': the body is beautifully shaped and framed by the conventions of art. The people in pornographic images are not nude, but naked. They are deprived of clothes, and as such exposed or exposing themselves in an embarrassing way.

Fifth, art is imaginative, porn is pure fantasy. Both artists and pornographers deal in fictional worlds, but the imaginative creations of artists offer us a way of perceiving and understanding the reality we actually live in. Pornographers, by contrast, simply seek to refashion reality as the compliant object of our desires and fantasies (Scruton 2005: 13). Pornography depicts the world as its consumers would want it to be: a 'pornotopia' full of healthy, attractive men and women who seem to wish nothing more than to satisfy every possible sexual desire.[4] It offers a realm of pure wish fulfilment, immune to constraints of plausibility, truth to life, or insight (Kieran 2001: 39). For Gordon Graham, art offers the exact opposite: it 'does not merely pander to taste but tries to educate it' (2008: 160).

(4) *Prescribed response*. Pornography is also often characterized as an enemy of imaginative *activity*. George Steiner, for instance, accuses pornographers of doing our imagining for us and hence of showing no respect for the audience (1975: 210). While a poet (or painter) will invite the consciousness of the reader (or spectator) to collaborate with her own in what is basically a joint creative effort, the pornographer treats her audience as mere consumers whose imaginative means are set at nil. Indeed, the fact that we speak of *consuming* pornography and of *appreciating* art indicates that there is a fundamental difference in how we are meant to engage with both kinds of representation. The term 'consumer' suggests that there is less of an intellectually rewarding effort involved. It also fits with the common view of pornography as having nothing but instrumental value. Unlike a work of art, which is thought to be intrinsically valuable, a pornographic film or photograph is simply used to satisfy a need or gratify a desire; and when it has fulfilled that purpose, that is, when the product has been consumed, it is no longer of any interest.

Of course, in itself the distinction between consumption and appreciation is not going to be sufficient to draw a strict line between art and pornography. After all, consuming and appreciating something can go hand in hand. Think of a good wine or a nice meal. We can perfectly appreciate the intrinsic taste of a meal whilst knowing that it is also nourishing us.[5] And a dish can be prepared with both aims in mind. So, more is needed if

[4] The term 'pornotopia' was first coined by Steven Marcus in his book *The Other Victorians*, published in 1964.

[5] One finds this observation in Shusterman 2007: 61.

one wants to build a case for the incompatibility of art and pornography based on the kind of response that both invite or prescribe.

For instance, one could argue that art is to be contemplated in and for itself, whereas the lustful feelings evoked by pornography make contemplation impossible. St Augustine already noted how the 'promptings of sensuality' typically block out all other functions, including most notably our rational faculties (Blackburn 2006: 52). But it is Schopenhauer who drives the point home with regard to the 'charming' in art. When paintings are designed to excite lustful feelings in the beholder, he states firmly, aesthetic contemplation is abolished and the purpose of art is defeated (1965: 207–8).[6] In his testimony to the Longford committee on pornography Kenneth Clark voiced a similar complaint: 'To my mind art exists in the realm of contemplation ... the moment art becomes an incentive to action it loses its true character. That is my objection to painting with a communist programme, and it would also apply to pornography' (*Pornography* 1972: 280). Scruton, too, has stressed that if a work of art 'arouses the viewer, then this is an aesthetic defect, a "fall" into another kind of interest than that which has beauty as its target' (2009: 160).[7]

In recent years, philosophers have proposed yet another way to spell out the difference between pornography and art in terms of the kind of regard for which they call. It is one that does not appeal to the notions of contemplation or imagination, but rather to a particular idea of what counts as an artistic or aesthetic interest. The latter, according to Christopher Bartel, 'requires one to take an interest in the formal qualities of the work' whereas a pornographic interest 'ignores these qualities in order to attend to the content of the work solely' (2010: 163). It is not hard to see how this distinction can be put to work in incompatibility arguments. The most influential of these is undoubtedly the one put forward by Jerrold Levinson (2005). His argument, in a nutshell, is that the set of pornographic artworks is an empty set because art is centrally aimed at aesthetic experience, which

[6] Shaftesbury also describes sexual feelings as 'a set of eager desires, wishes, and hopes, no way suitable ... to your rational and refined contemplation of beauty' (1999: 319).

[7] Before ascribing this firm stance exclusively to the arch-conservative worldview of Clark or Scruton, it is worth remembering that the very same view was put forward by the archetypal modernist, James Joyce, in his *A Portrait of the Artist as a Young Man*. (For Joyce, 'proper art' is static, inducing what one could call 'aesthetic arrest', i.e. a rapt suspension of ordinary behaviour. Art that excites desire for an object he thinks is pornographic. It is a form of 'improper art' in that it is kinetic instead of static.)

essentially involves attention to form/vehicle/medium/manner, and pornography is centrally aimed at sexual arousal, which essentially excludes or wars against attention to form/vehicle/medium/manner.

2. Shades of Grey

How successful are these attempts to differentiate art and pornography? The answer to this question will depend on how ambitious exactly one takes these attempts to be. If the aim is simply to articulate some of the ways in which works of art can be different from the standard products of the porn industry, then there is really very little to find fault with. One need only compare, say, Rembrandt's *Bathsheba at her Bath* to *Hustler Magazine* to see almost every single point confirmed. In *Hustler Magazine* we find formulaic, smutty pictures that focus on sexual organs and serve only one purpose. The thoughts or personality of the women depicted are of no importance. They are presented only as objects of male fantasy. The contrast with Rembrandt's painting could not be greater. The artist depicts the moment where Bathsheba receives King David's letter, asking her to come to the palace. Bathsheba realizes what this entails—she will have to sleep with the King and betray her husband—and sadly foresees the deceit and suffering that will be caused by this (see Gaut 2007: 14–24 for a more detailed analysis of the work). All this is subtly visible in her facial expression, which is the central focus of the painting. Instead of taking up a voyeuristic, objectifying gaze (the way King David presumably saw her), Rembrandt's work expresses a deep sympathy with this woman and her precarious situation, and it invites the spectator to reflect on the similar fate of so many other women. It is a multi-layered, serenely beautiful, supremely original work of art.

But most of the authors discussed in section 1 aim to do more than just draw a contrast between such prototypical instances of art and pornography. They want to establish that art and pornography are mutually exclusive, so that if something is pornography it cannot be art and vice versa. But to make *this* claim convincing it obviously does not suffice to discuss examples that fit neatly into one of the two categories. Rather, one needs to show that the proposed distinctions are immune to counterexamples. That is, before drawing a definite and strict line between art and pornography based on the above dichotomies, we need to be convinced that the qualities ascribed

to art are necessarily missing in pornography and, conversely, that there are no works of art that possess those features which supposedly disqualify pornography from the realm of art. That, I now want to argue, is a bridge too far. Counterexamples abound.

First, there are many works of pornography that actually possess the features exclusively ascribed to art in the list above. Examples that come to mind are films like *All About Anna*, made by Lars von Trier's production company Zentropa, Molly Kiely's graphic novel *That Kind of Girl*, or *Dirty Diaries*, a collection of Swedish movie shorts. All three belong to the rapidly growing subgenre of 'female friendly pornography' (or as the filmmakers of *Dirty Diaries* would have it, 'feminist pornography'). Far from being formulaic, they have original and imaginative scenarios, featuring lifelike characters in realistic situations. They are carefully crafted and beauty is a primary concern. Much attention is paid to the personal experiences and the personality of the female leads, and 'feelings, passions, sensuality, intimacy, and the lead-up must be emphasised', as it says in Zentropa's *Puzzy Power Manifesto*. Pornographic works of this sort not only avoid being vulgar or coarse, i.e. 'charientically flawed', but they also exhibit none of the moral flaws manifest in mainstream pornography (no exploitation, objectification, or denigration). What is more, in rejecting sexual repression, self-oppression, and hypocrisy, these works often have a positive, consciousness-raising force (McElroy 1995; Willis 1995). By offering insights into female desire and sexuality they frequently serve an educational and emancipatory purpose (see Waugh 1995: 150 for similar arguments in favour of gay porn).

Second, there are many undisputed artworks that would fall on the 'wrong' side of the divide if the distinction were drawn along the lines suggested above. To begin with, and most obviously, some works of art focus on sex that is aggressive and alienated, rather than emphasizing the love and equality between partners (Bernardo Bertolucci's *Last Tango in Paris* or Elfriede Jelinek's *The Piano Teacher* come to mind). Equally obvious is that not all works of art 'invite us into the subjectivity of another person' (Scruton 2009: 159). For instance, in Chrétien de Troyes's *Lancelot*, Francesco Petrarch's *Sonnets to Laura*, or the *Roman de la Rose*, the female is represented as an object of passion to be possessed, and her own autonomy and point of view are completely disregarded (Kieran 2001: 43). When Scruton praises the self-assured way in which the *Venus of Urbino* looks directly at the spectator, thereby signalling that she possesses her own body

in a confident way instead of just being an object on display, he conveniently disregards other masterpieces by Titian, such as *Venus and Adonis*, *Bacchanal of the Andrians*, and *Danae and the Shower of Gold*, where quite the opposite is true. In this regard, one could also point to more recent and more explicit works by Hans Bellmer or R. C. Hörsch where women and young girls are unmistakably objectified and remain without agency (Mey 2007: 22). The work of these artists also testifies to the fact not all art is, or is meant to be, beautiful.

Kenneth Clark claims that art loses its true character when it becomes an incentive to action, but clearly overlooks the fact that, besides communist posters, there are numerous religious paintings or politically inspired novels that call on people to change their lives and that we wouldn't want to deny the status of art. Similarly, Scruton believes that a work of art should never arouse the viewer or reader. But if one were to use this as a criterion to exclude pornography from the realm of art, one would also have to exclude erotic masterpieces such as D. H. Lawrence's *Lady Chatterly's Lover* or Gustave Courbet's *Sleep*. Surely, that is too high a price to pay.

Then there is the claim that pornography cannot be art because it is formulaic. One can reply to this argument in a number of ways. The simplest is to point out that being formulaic does not preclude a work from realizing other artistic values or additional aspects of expressivity (Kieran 2001: 37). But one could also argue that being formulaic is not necessarily an artistically bad-making feature. Canterbury cathedral, for instance, has all the formulaic features of Gothic architecture, but is not a worse building because of that. Similarly, *High Noon* and *The Searchers* are formulaic westerns which, I believe, cannot be faulted for being formulaic (note, furthermore, that both are products of an industry—the Hollywood industry).[8]

The same set of responses is available when facing criticism of the fantasy character of pornography. First, the fantastical nature of certain representations does not preclude them from realizing other artistic values, or even from being 'true to life.' Klimt's nude studies, for example, are inherently fantastical insofar as they portray idealized, blank, and even somnambulant

[8] There is also reason to suspect that the formulaic, repetitive character of most pornographic films and photographs is in fact not an inherent feature of the genre, something that automatically comes with the subject matter, but rather a contingent feature and a consequence of the cheap production methods that are typically used.

young women, but as studies in sexual self-absorption they do not fail to be true to life (Kieran 2001: 40). Moreover, being fantastical is not necessarily an artistically bad-making feature. In the words of Susan Sontag, an account 'that faults a work for being rooted in "fantasy" rather than in the realistic rendering of how lifelike persons in familiar situations live with each other couldn't even handle such venerable conventions as the pastoral, which depicts relations between people that are certainly reductive, vapid, and unconvincing' (1994: 41).

Apart from counterexamples, there are also more general and fundamental objections against the above characterization(s) of pornography. Take the claim that pornography is one dimensional. For Laura Kipnis, this idea is symptomatic of the prevalent desire among pornography commentators to vastly 'undercomplicate' the issue. Pornography offers a 'royal road to the cultural psyche' (2006: 118), she argues, and the experience of it is intensely complex and fraught with all the complications of personhood. As such, pornographic novels, photographs or films have many potential uses beyond the classic one-handed one. They can and often do serve as means of social criticism and cultural critique (Slade 2001: 293–4 also elaborates on the many different uses of pornography).

A similar argument was made by Susan Sontag in her famous defence of literary pornography. In this essay, with the telling title 'The Pornographic Imagination', Sontag also rejected the idea that pornography is necessarily unimaginative. Novels like *The Story of O* or *Story of the Eye*, she argues, are profound explorations of extreme states of human feeling and consciousness (1994: 42) and deserve to be ranked among the great achievements of the imagination. Linda Williams, author of *Hard Core* and editor of *Porn Studies*, has made similar claims about pornographic cinema, pointing out that one seriously underestimates the imagination if one thinks that it can only operate in the absence of, or only at the slightest suggestion of sexual representation (2008: 19).

It has already been noted how there are new forms of pornography, including pornography made by and for women, that do not seem morally objectionable. But even if one were to dispute this, and argue that there is something deeply wrong with any type of pornography, that in itself would still not be sufficient reason to exclude pornography entirely from realm or art—unless one adheres to an extreme form of moralism and thinks of moral value as the sole determinant of artistic status or artistic merit. But very few, if

any, philosophers would defend such a view. Every plausible account of the relation between moral and artistic value, whether it is autonomism, ethicism, or contextualism, will acknowledge that works of art, even great works of art, can be morally flawed. Moreover, whatever (moral) objection one wants to bring forward against mainstream pornography, there is a good chance that it will also apply to at least some erotic art. Harm may be inflicted when art is being produced (Brown 2002 tells the harrowing story of Cellini and the Nymph of Fontainebleau) or may occur in post-production. In fact, a compelling case is made in this volume (by, respectively, Cooke and Eaton) that neither exploitation nor objectification is unique to pornography and that both are present in many works of erotic art—a presence that is frequently unacknowledged precisely because critics tend to focus exclusively on pornography and too often consider art to be above (moral) criticism. In addition, some commentators have argued, *pace* Scruton, that it is 'the nude' and not 'the naked' which implies objectification and dehumanization. According to John Berger, 'to be naked is to be oneself,' whereas a naked body has to be seen as an object on display for the spectator in order to become a 'nude' (Berger 1972: 54).[9]

Finally, I have said little about what is arguably the most influential account arguing for the distinctness of art and pornography, the one developed by Jerrold Levinson (2005), but that is only because other authors in this volume (in particular Davies and Kania) offer a convincing in-depth critique of his view (see also Maes 2009, 2011a, 2011b).

3. Defining Pornography

The dichotomies presented in section 1 can help to illuminate the differences between certain prototypical instances of pornography and art, but they will not serve to justify the claim that pornography and art are mutually exclusive. Of course, pornographic works might be said to have, *by definition*, no significant artistic or aesthetic aspect. George P. Elliott, for instance, defines pornography as 'the representation of directly or indirectly erotic acts with an intrusive vividness which offends decency without

[9] For a detailed and more nuanced discussion of objectification in relation to the artistic tradition of 'the nude', see Anne Eaton's chapter in this volume.

aesthetic justification' (1970: 74–5) and Fred Berger thinks it involves work 'which explicitly depicts sexual activity or arousal in a manner having little or no artistic or literary value' (1977: 184). By adding phrases like 'without aesthetic justification' or 'having no artistic value' these authors simply stipulate that nothing can succeed as both art and pornography. There lies the difference with authors like Scruton who *argue*, rather than stipulate, that pornographic works cannot possess beauty. For Scruton, the lack of aesthetic quality is a consequential feature, rather than a defining one—it follows from the fact that pornographic pictures are objectifying. For Berger and Elliot, the lack of artistic or aesthetic value is part of the concept of pornography.

Berger and Elliot explicitly endorse a normative definition of pornography, i.e. a definition that employs evaluative terms.[10] Definitions of this kind inevitably bring to mind certain legal descriptions of obscenity such as the US Supreme Court's notorious Miller test, set forth in *Miller v. California* (1973). This test proposed a three-pronged criterion for obscenity: x is obscene if (1) it is found appealing to the prurient interest by an average person applying contemporary community standards, (2) it depicts sexual conduct, specifically defined by the applicable state law, in a patently offensive way, and (3) taken as a whole, it lacks serious literary, artistic, political, or scientific value. The Miller test has proved problematic in many respects, one of its most evident flaws being the conflation of two ideas— the pornographic and the obscene. Martha Nussbaum (2004), Jon Huer (1987), and others have pointed out that the category of obscenity includes many non-sexual instances of transgression, excess, or taboo and is thus considerably broader than the category of pornography. Recent philosophical attempts to define the obscene have taken this insight on board— allowing for non-pornographic obscenities as well as pornography that is not obscene. Some of these accounts also do not exclude the possibility of obscene art (e.g. Kieran 2002).

Yet, what to think of definitions that exclude the possibility of *pornographic* art by reserving the term 'pornography' exclusively for representations that have no aesthetic or artistic value? In answering this question it may be

[10] Even those who subscribe to a normative definition of pornography may believe that there is some pornography that qualifies as art. But what they are forced to reject is that something can be a *successful* instance of both art and pornography. If there is some pornography that qualifies as art, it must be bad art.

helpful to look at a corresponding issue in moral debates on pornography, where some authors have proposed to use the term 'pornography' only for those sexually explicit representations that are considered morally objectionable. One obvious example of such a normative characterization would be Susan Brownmiller who characterizes pornography as 'the undiluted essence of anti-female propaganda' (1975: 394).

Susan Dwyer (2008) has argued that normative characterizations of this kind are ideally suited to motivate people into doing (or not doing) certain things. In her terminology, a normative characterization is ideal to perform the 'strategic function' of language. For instance, if you wish to convince the local authorities to ban pornography from newsstands, then a normative characterization will prove a powerful tool. It's hard to imagine that local officials would not be motivated to remove instances of undiluted anti-female propaganda from public view . . . However, if one wants to use words simply to pick out things in the world for further investigation, that is, to perform the 'identification function' of language, then, she argues, a descriptive, value-neutral characterization is needed. So, a philosophical enquiry into the moral status of pornography should start with a value-neutral description of what pornography is. Only once we know what it is, are we in a position to evaluate its moral status. Similarly, one could say that a philosophical enquiry into the artistic status (or aesthetic dimension) of pornography should start with a value-neutral characterization of pornography. Of course, this presupposes that pornography is a non-evaluative concept that allows for a purely descriptive definition (unlike, say, the concept of 'kitsch'). But this is a reasonable presupposition. Indeed, the whole debate about whether or not something can succeed as both pornography and art rests on that assumption and would simply be a non-starter with a normative definition like the ones proposed by Elliott or Berger.

That being said, an adequate value-neutral definition of pornography that captures as much of the extension as possible of what we ordinarily think counts as pornography is not easy to find. Michael Rea (2001), one of the very few authors who has devoted an essay to the issue of defining pornography, proposes the following:

x is pornography if and only if it is reasonable to believe that x will be used (or treated) as pornography by most of the audience for which it was produced.

He then goes on to specify what it means for someone, S, to use something, x, as pornography. He lists four conditions (2001: 120):

(i) x is a token of some sort of communicative material;

(ii) S desires to be sexually aroused or gratified by the communicative content of x;

(iii) if S believes that the communicative content of x is intended to foster intimacy between S and the subject(s) of x, that belief is not among S's reasons for attending to x's content;

(iv) if S's desire to be sexually aroused or gratified by the communicative content of x were no longer among S's reasons for attending to that content, S would have at most a weak desire to attend to x's content.

One can have doubts about the third requirement—the 'no intimacy' requirement. It is meant to rule out such things as the pictures or videos that a person might make for the private viewing pleasure of his or her spouse. Yet, one may wonder whether these should in fact be ruled out, given that there are plenty of internet guides for couples who want to experiment in this way, with titles ('Make your own porn film'/'Star in your own porn movie') that suggest that such home videos are commonly regarded as pornography. But this is just a minor quibble. It is the fourth condition that poses a real problem. What it in fact does is exclude from the realm of pornography any pornographic material with enough educational or curiosity value to keep an audience fascinated beyond the moment of sexual release. More importantly, it also seems an oblique way of establishing that something will not count as pornography if it has sufficient *artistic* value to capture and sustain the audience's attention independent of any sexual interest. In other words, it looks as if, for Rea, too, the lack of artistic or aesthetic value is part of the concept of pornography. Hence, on close inspection, his apparently value-neutral definition turns out to be very much motivated by a normative agenda.

When Bernard Williams chaired the Committee on Obscenity and Film Censorship in the 1970s he proposed the following definition: 'a pornographic representation is one that combines two features: it has a certain function or intention, to arouse its audience sexually, and also has a certain content, explicit representations of sexual material (organs, postures, activity, etc.)' (8.2). The first condition is needed because there are sexually explicit representations that we would not ordinarily label as pornography, e.g.

didactic illustrations in medical handbooks or documentaries of sex workers. The second condition is added mainly to distinguish pornographic representations from those that are 'merely' erotic.

I think this comes close to how most of us understand the term. Still, as it stands, the definition seems too inclusive. Suppose a film or novel contains both an erotic but non-explicit love scene and an episode in a gynaecologist's office that is explicit, but not meant to be arousing. That film or novel would combine the two features listed above, but it would not count as pornography. So, the simple conjunction of explicitness and the intention to arouse is not enough. The two aspects must in some way be interrelated. Without formalizing things too much one could say that a pornographic representation is (1) made with the intention to arouse its audience sexually, (2) by prescribing attention to its sexually explicit representational content.[11]

The first condition, though absent in the definitions offered by Elliot and Berger is fairly uncontested nowadays. The second condition is more controversial. Levinson, for example, argues that some erotic paintings and photographs are just as explicit or even more explicit than pornographic pictures. He therefore proposes a different way of distinguishing between the two. According to Levinson, pornographic representations are essentially aimed at sexual arousal, whereas erotic images are aimed at sexual stimulation. The former he describes as 'the physiological state that is prelude and prerequisite to sexual release' whereas the latter should be understood as 'the inducing of sexual thoughts, feelings, imaginings, or desires' (2005: 229). However, given that sexual feelings, thoughts, and desires are typically accompanied by and conducive to sexual arousal, this way of distinguishing between the erotic and the pornographic threatens to evaporate in practice.

Other opponents of that second condition appeal to the fact that magazines directed at bondage fetishists (or shoe fetishists) need not be explicit to be arousing, which seems to indicate that sexual explicitness is not a necessary condition for something to count as pornography.[12] But this, too, I think, is hardly a knock-down argument. For why not call non-explicit

[11] Linda Williams offers a similar definition of pornography: 'the visual (and sometimes aural) representation of living, moving bodies engaged in explicit, usually unfaked, sexual acts with a primary intent of arousing viewers' (1989: 30). According to Matthew Kieran, pornography 'seeks, via the explicit representation of sexual behaviour and attributes, to elicit sexual arousal or desire' (2001: 32). See also the definition proposed by David Davies in this volume.

[12] One finds this argument in both Rea (2001) and Mag Uidhir (2009).

bondage pictures 'erotic', just like we call the suggestive, but non-explicit pictures of models in lingerie 'erotic' but not 'pornographic'? Surely, the fact that a model is wearing leather instead of lace cannot make all that much difference?

It is striking that those who insist that the category of pornography is purely one of function, and who reject an intrinsic feature like sexual explicitness as a suitable criterion of demarcation, often have no trouble in accepting another non-functional feature as part of the definition of pornography. Almost everyone seems to agree that pornography is a subcategory of the class of representations and that only a representation (or, as Michael Rea would have it, a token of some communicative material with communicative content) can come to qualify as pornography. It seems right to insist on this.[13] After all, there is no such thing as abstract pornography. And few people would be inclined to use the label 'pornography' for erotic massages, or Viagra, or Woody Allen's Orgasmatron.[14] But if the category of pornography really were to be purely one of function, then why draw the line at representations and rule out these other things? If one intrinsic feature (being a representation) is accepted as part of the definition, then why such strong resistance against that other intrinsic feature (being sexually explicit)? Opponents will point out that the 'connection between sexual arousal and sexual explicitness is purely contingent' (Mag Uidhir 2009: 196). But the connection between sexual arousal and representational character is even more contingent. That doesn't change the fact that the representational character of pornography is not just a contingent feature. It seems to me that the same is true for sexual explicitness.

For our purposes, whether or not one is willing to adopt the 'explicitness' condition is not such a pressing matter because in recent discussions on the artistic potential of pornography nothing really turns on that issue. It is not the fact that pornography is sexually explicit, but rather the fact that, and the way in which, it aims to bring about sexual arousal that is considered to be the big stumbling block for any artistic redemption of pornography. In the next section I will discuss the most recent argument put forward by a philosopher who believes not just that there are important differences

[13] The term 'pornography' is partly derived from the Greek word 'graphein', meaning 'writing' or 'representing'. Incidentally, this is one of the notable differences between the erotic and the pornographic. The erotic is not limited to the class of representations.

[14] A (fictional) electromechanical device designed to induce orgasms (from the film *Sleeper*).

between typical examples of pornography and art, but that art and pornography are fundamentally incompatible.

4. Pornography and Manner Specificity

In 'Why Pornography Can't Be Art' (2009: 194) Christy Mag Uidhir defends his uncompromising view as follows:

(1) If something is pornography, then that something has the purpose of sexual arousal (of some audience).

(2) If something is pornography, then that something has the purpose of sexual arousal and that purpose is manner inspecific.

(3) If something is art, then if that something has a purpose, then that purpose is manner specific.

(4) If something is art, then if that something has the purpose of sexual arousal, then that purpose is manner specific.

(5) A purpose cannot be both manner specific and manner inspecific.

(6) Therefore, if something is pornography, then it is not art.

The somewhat idiosyncratic notion of a manner specific purpose is defined as a purpose that is essentially constituted both by an action (or state of affairs) and a manner, such that the purpose is to perform that action (or bring about that state of affairs) in that particular manner (2009: 194). For a purpose to be manner inspecific, by contrast, is simply for it not to be manner specific. In other words, if a purpose is manner inspecific, then failure to bring about the state of affairs in the prescribed manner does not constitute failure to satisfy the purpose.

Mag Uidhir's account has a number of distinct virtues—originality not being the least of them. What he presents is an entirely new argument that does not seem to fit in any of the categories listed in section 1. Furthermore, his account is not based on any robust theories of art or pornography. Mag Uidhir only invokes a limited set of necessary conditions. Given how difficult it has proven in the past to define either what art or what pornography is, this certainly seems a commendable strategy. While, for instance, Levinson's argument is bogged down by the controversial claim that (erotic) art's main purpose is to create an aesthetic experience and draw attention to its own formal features, Mag Uidhir's argument does not rely on any such substantial claim. He does not even claim that art has or should have a

purpose. Mag Uidhir only asks us to accept that *if* a work of art has a purpose, including perhaps the purpose of sexual arousal, then that purpose must be manner specific. This brings us to another added bonus of Mag Uidhir's approach. Mag Uidhir leaves room for the idea that art, like pornography, can aim to bring about sexual arousal. Scruton and Clarke, among many others, have to deny this since their whole argument rests on the thought that sexual arousal and aesthetic contemplation are incompatible. Still, regarding the central issue, he aligns himself squarely with those who reject the possibility of pornographic art. He, too, thinks that artists or pornographers attempting to produce something that is both art and pornography, in fact attempt the impossible. But is his case ultimately a compelling one?

Mag Uidhir aims to demonstrate that art and pornography are radically separate categories by showing that the success conditions for these categories are fundamentally different. Premise (4) specifies that, for something to count as a sexually arousing work of art, i.e. a work of art that fulfils its purpose of bringing about sexual arousal, it needs to bring about sexual arousal in the prescribed way. Premise (2), by contrast, states that for something to count as a successful work of pornography, i.e. a work of pornography that fulfils its purpose, it needs to bring about sexual arousal, period. In Mag Uidhir's own words, the 'sexual arousal of the audience *simpliciter* matters . . . This is precisely what it means to be manner inspecific' (2009: 197). If these premises are accepted as true, then what has been established is that there is an important difference between the category of art and the category of pornography.

What has *not* been shown, however, is that these categories are mutually exclusive. In order to show that something cannot legitimately fall under both categories, it is simply not enough to argue that their respective success conditions are different. One needs to show that it is impossible for a particular object to fulfil both success conditions. And Mag Uidhir's argument does not do that. Not only is it perfectly possible for a particular work to satisfy both success conditions, but satisfying the success conditions for sexually arousing art even seems to *entail* satisfying the stated success conditions for pornography. For suppose that a novel, a photograph, or a film brings about sexual arousal in the prescribed way (and we can take this to mean whatever Mag Uidhir wants it to mean). Then it will have fulfilled the success condition for sexually arousing art ('for something to count as a sexually arousing work of art, it needs to bring about sexual arousal in the

prescribed way') *as well as* the success condition for pornography ('for something to count as a successful work of pornography it needs to bring about sexual arousal, period').

Still, Mag Uidhir may retort that if a novel, photograph, or film brings about sexual arousal in the prescribed way, then the particular manner in which it does that is either essential or not. It cannot be both. And, he might argue, whether we are dealing with pornography or art will depend on which of the two is the case. In other words, when one is confronted with a work that is sexually arousing in the prescribed way, rather than just accept that the work fulfils the success conditions for both art and pornography, one should engage in counterfactual reasoning and ask the following question: If this work had brought about sexual arousal, but not in the prescribed way, would it be considered a failure? If the answer is 'no', we are dealing with a work of pornography. If the answer is 'yes', it is a work of art. There is no middle ground.

However, this manoeuvre will not save Mag Uidhir's argument. For why could the answer to the counterfactual question not be 'yes' *and* 'no'? Yes, it would have failed *as a work of art* had it not brought about sexual arousal in the prescribed way. But it would not have failed *as a work of pornography*. And given that, factually, it does bring about sexual arousal in the prescribed way, it satisfies the success conditions of both art and pornography. A comparison that was originally suggested by Mag Uidhir himself may be helpful here.[15] Suppose two people are playing a ball game but we are not quite sure which game they are playing. We know that the winning condition of Game 1 is this:

(g1) A person wins the game if and only if that person throws the ball through all of the designated hoops in the order that person declared prior to the aforementioned throw.

And the winning condition of Game 2 is:

(g2) A person wins the game if and only if that person throws the ball through all of the designated hoops.

[15] Mag Uidhir suggested this in a personal communication to the author.

Now suppose that we see one of the players, let's call her A, throw the ball through all of the designated hoops in the order that she declared prior to her throw. She is the winner, that much is clear. But which game did she win?

Here is Mag Uidhir's take on this problem. It is true that satisfying the condition in (g1) entails that the state of affairs in condition (g2) obtains. It does not follow from this, however, that satisfying winning condition (g1) entails also satisfying winning condition (g2). Because it cannot be the case that (g1) and (g2) are both *winning conditions* for one and the same game of ball; for if one of the above stated winning conditions is true, the other must be false. So, the crucial question is a counterfactual one: had A thrown the ball through all the hoops, but not in the right order, would she still have won the game? If the answer is 'yes', then they were playing Game 2. If the answer is 'no', they were playing Game 1.

But, one might ask, what if they were playing both games at the same time? The fatal flaw in Mag Uidhir's argument is that he does not consider this possibility. Why could player A not try to win both games with one throw? The fact that the winning conditions of both games are incompatible, in the sense that one and the same game cannot have both winning conditions, does not make such an attempt incoherent or impossible.[16] If we return to the case of art and pornography, we see that the same holds true there. Granted, a purpose cannot be both manner specific and manner inspecific. But why could one not try to create a work that satisfies two purposes, one of which is manner specific, one of which is not? There seems to be nothing illogical about that. Why would an artist, after finishing a novel or film, not be able to say: 'As a pornographer, I'll be happy if people are sexually aroused by my work, but as an artist, I want to achieve more; I want to arouse my audience in such a way that they gain new insight into their own sexuality and desires.' If such a statement and that sort of ambition is intelligible and coherent, we cannot but conclude that Mag Uidhir's argument fails.[17]

[16] Only if satisfying success condition (g1) were to exclude satisfying success condition (g2) would it be incoherent to try to win both games with one attempt.

[17] There is a particular reading of the third premise of Mag Uidhir's argument that would nullify the objections I have raised. Premise 3, you will recall, states that if something is art, and if that something has a purpose, then that purpose is manner specific. Presumably, what Mag Uidhir wants to say here is that a work of art's *artistic* purposes—those that are constitutive of it as a work of art—are necessarily manner specific. Such a claim, though not uncontroversial, would at least not be wildly implausible. However, one could read the third premise literally as saying that any purpose a work of art may have will be a

In a sense, this outcome is not just reassuring for the advocates of pornographic art. If Mag Uidhir's argument had been successful it would have been very easy to construct similar arguments showing how nothing can be both religious iconography and art, or propaganda and art, or advertising and art—to name just a few other practices with so-called manner-inspecific purposes. The fact that Mag Uidhir's approach, applied consistently, would force us to exclude Toulouse-Lautrec's advertising posters or Eisenstein's propagandistic films from the realm of art, I consider to be just another consideration against the position that he defends.[18]

5. Practical Implications

To some, the whole debate may seem like the philosophical equivalent of shadowboxing—a mere fight over words, without any real world impact. But nothing could be further from the truth. Yes, the 'art or porn?' question is at heart a conceptual issue, but one with considerable practical implications. The fact that this is one of the very few philosophical questions that regularly appears as a newspaper headline is ample evidence for this. It can make a huge difference whether something is labelled as one or the other, and journalists know this all too well.

Being awarded the status of art brings with it social prestige and institutional recognition and makes a painting, novel, or film into a legitimate object of interest for the mainstream press and academia. In contrast, if a work is branded as pornography it will usually have to forgo any serious critical or academic attention. Worse still, the work may become the victim

manner specific one. Interpreted that way, a work of art can never have a manner inspecific purpose, which would undermine the objections raised above. If works of art only ever have manner specific purposes, and if one defines pornography as necessarily having a manner inspecific purpose, then nothing can be both art and pornography. But, of course, interpreted in this overly strict way the third premise is plainly false. Works of art can and do have all sorts of purposes—practical purposes, economic purposes, didactic or pedagogical purposes, political, social, or moral purposes, etc.—and many of these will not be manner specific. Denying this would be like denying that one can play two games at the same time.

[18] Another example would be Spike Jonze, who was nominated by the Directors' Guild of America in 2006 for his 'Outstanding Achievement in Commercials', notably for his 'Lamp' ad for IKEA and 'Hello Tomorrow' ad for Adidas. One commentator describes the latter as follows: 'Beautifully constructed and wonderfully scored it's a surprisingly affecting advert...A piece of art that just so happens to be affiliated with and paid for by a multinational sports clothing corporation' (Plumb 2011).

of censorship and be banned from museums, book stores, movie theatres—even to the point of being confiscated and destroyed.

Over the course of centuries, that fate has befallen many works of pornography, including works made by established and admired artists. J. M. W. Turner's pornographic drawings, for example, were burnt by John Ruskin,[19] while Richard Burton's daring translation of *The Scented Garden* was destroyed by his wife after his death. Giulio Romano, who was one of Raphael's most gifted pupils and helped to complete Raphael's *Transfiguration* and *Coronation of the Virgin*, made a series of sixteen drawings of couples in various sexual positions that were later made into engravings by Marcantonio Raimondi. None of the original engravings of *I modi* (The positions) have survived due to censorship and persecution (Talvacchia 1999).[20] And while several of the sexually explicit frescoes of Pompeii and Herculaneum were cut from the walls and kept in the (in)famous Pornographic Cabinet in the Naples Archaelogical Museum, many others were simply destroyed on the spot (Clarke 2003).

For works of this kind—works which are pornographic in content and aim but which also have undeniable artistic merit or credentials, the threat of marginalization and criminalization has persisted throughout the 20th and 21st centuries. Egon Schiele received a prison sentence in 1912 on charges that his work was pornographic and a local judge actually burnt one of his drawings in the courtroom. When *The Story of O* (Pauline Réage/Anne Desclos) was first published in 1954 obscenity charges were brought against the publisher and even though the attempt to ban the novel proved unsuccessful, a publicity ban was imposed for several years. In 1989, following strong conservative opposition to controversial funding made by the National Endowment for the Arts, the Corcoran Gallery of Art in Washington DC cancelled the exhibition, *Robert Mapplethorpe: The Perfect Moment*, which contained sexually explicit homoerotic images. More recently, Alan Moore's pornographic masterpiece, *Lost Girls* (2006), which he co-created

[19] Quite a number of these drawings have actually survived which has led some scholars to suspect that Ruskin may have invented the story to deflect the interest of the authorities after the Obscene Publications Act of 1857.

[20] Arthur Danto points out that Raphael 'was not above doing a bit of pornography himself now and then. His notorious 1516 frescoes of the history of Venus, commissioned for cardinal Bibbiena's bathroom in the Vatican, were whitewashed over in the nineteenth century as inconsistent with what was felt to be spiritually fitting for the artist of the Acts of Apostles' (2005: 123).

with his wife, Melinda Gebbie, received none of the mainstream attention that his other work has received (his celebrated graphic novels *From Hell*, *Watchmen*, *V for Vendetta*, *The League of Extraordinary Gentlemen* have all been turned into films, but, unsurprisingly, no one has offered to buy the film rights for *Lost Girls*).

What is interesting is that those who have taken up the defence of these and similar works, and have lobbied for their protection or rehabilitation, have almost always opted for the same strategy, namely to reject the label of pornography as forcefully as possible and make the case that such works qualify as 'erotic art' instead. This strategy is clearly rooted in the idea that art and pornography must be mutually exclusive. It is, however, not the only available or viable route to take. There is an alternative. One could see the choice between art and pornography for what I think it really is—a false dilemma—and acknowledge that certain works of art can also qualify as pornography and vice versa. The latter approach has almost never been adopted in the past (it is quite revealing, for instance, that there is not a single art historical book that carries the phrase 'pornographic art' in its title). This needs to change. For, as I have tried to show in this chapter, there are really no good theoretical reasons to believe that art and pornography are incompatible. Moreover, there are some compelling *practical* reasons to give up the strict dichotomy between art and pornography and start using the label 'pornographic art' instead of always, coyly and euphemistically, reverting to the category of erotic art. To substantiate this last claim, I will refer to the practice of art criticism and to past, current, and future art-making practices.

When artists such as Pauline Réage, Egon Schiele, Robert Mapplethorpe, created their sexually explicit and arousing works they were not only inspired and influenced by the long and respectable tradition of erotic art, but also by the pornography that was available in their day and which they often tried to imitate or emulate. Hence, a full and accurate appreciation of these works—one that can account for all the allusions, references, and borrowed imagery—is impossible if one ignores their pornographic pedigree. Furthermore, even if these works were to contain no direct references to particular pornographic predecessors, it would still be advisable, from an art critical point of view, to compare them to other works of pornography because this will allow the critic to evaluate how innovative and effective these works really are. As Alan Moore has put it bluntly: 'Pornography is very much like adolescent poetry: there's a great deal of it about because it is

a very easy thing to do, and much of it is absolutely fucking dreadful because it is very hard to do well' (2008: 9). It is precisely by drawing the comparison with other pornographic works, by investigating which genre markers are incorporated or subverted, and by asking to what extent the pornographic aim of arousal through explicitness is achieved, that one will be able to assess the success of these works.

In his influential essay, 'Categories of Art' (1970), Kendall Walton argues convincingly that the correct aesthetic evaluation of a work depends crucially on perceiving it in the correct category. Whether a work is correctly perceived in a particular category, he argues, is partly determined by (a) the fact that the artist who made the work intended it to be perceived in that category; and (b) the fact that the category is well established in the society in which the work was produced.[21] Given that the art critic is supposedly 'an expert concerning the categories of art' (Carroll 2009: 97) it is both surprising and regrettable that, when it comes to pornographic artworks, art critics as well as art historians are so reluctant to perceive them in the category of pornography for which these works were intended and that was well established at the time of creation.

Take the pornographic drawings and paintings by Egon Schiele. In art historical studies these are typically discussed within the broader context of the artist's oeuvre. Sometimes the chosen comparison class will include contemporary or classic works of erotic art. But they are rarely, if ever, compared to other works of pornography of the time, and their effectiveness in arousing the spectator is never a topic of discussion.[22] The same is true for pornographic literature. Critical discussions of Louis Paul Boon's 'Mieke Maaike's Obscene Jeugd' (1971), Alain Robbe-Grillet 'Un Roman Sentimental' (2009), Nicholson Baker's 'House of Holes' (2011) will refer to other novels by the same author or to some classics of erotic literature, but rarely does one find a meaningful or extensive comparison with examples of pulp pornography that were a direct source of inspiration for these authors.

[21] Walton does mention other criteria, including: the fact that a work is better, or more interesting or more pleasing aesthetically when perceived in that category. But this criterion has proved controversial and is rejected (rightly so, I think) by other philosophers such as Noël Carroll.

[22] Schiele's work is discussed in Alyce Mahon's *Eroticism & Art* and while the book contains many images and discussions of works which are non-erotic and non-explicit (including: Yolanda Lopez, *Portrait of the Artist as the Virgin of Guadalupe*, 1978; David Wojnarowitcz, *The Death of American Spirituality*, 1987; and Tracey Emin's *Bed*, 1998–9) Mahon remains silent on the genre of pornography and how it may have influenced artists like Schiele.

Take any other genre, from whatever art form, and such an omission would be unheard of (comparable to reviewing a masterpiece of science fiction or horror fiction—think of Kubrick's *2001* or *The Shining*—without mentioning any other film within that genre, or any of the genre's standards and requirements).

In 'Categories of Art' Walton also famously makes a distinction between standard and contra-standard properties. Features are standard relative to a certain category if they are among those in virtue of which works in a certain category belong to that category (think of the flatness of a painting), whereas contra-standard features tend to disqualify a work from a category in which we nevertheless perceive it (think of a three-dimensional object glued to the surface of a painting). How a work affects us aesthetically, Walton observes, depends on which of its features we see as standard and which as contra-standard. Standard features will typically not seem striking or noteworthy and are usually not commented on. Contra-standard features, however, will seem shocking, disconcerting, startling, or upsetting.

Applied to the subject at hand, we get another sense of what a fundamental difference it can make to see these works under one banner, rather than another. Relative to the classic category of erotic art, the blunt sexual explicitness of Schiele, Mapplethorpe, or Moore is a contra-standard feature and as such is perceived as shocking and disconcerting. It is the feature that is singled out, time and again, for critical attention and is continually dwelt and commented upon in reviews. Relative to the category of pornography (or pornographic art), however, sexual explicitness would be a standard feature. So, if critics were to see these works within that category, they would no longer feel frustrated or taken aback by that feature or feel the need to devote all their attention to it. Instead, they could focus freely on what Walton has called the 'variable features' of these works, i.e. the features that make a Schiele drawing or a Mapplethorpe photo precisely different from and superior to the average pornographic representation. This seems a more fruitful *and* more accurate way to approach these works—I say 'more accurate' because for Walton 'the correct way of perceiving a work is likely to be that in which it has a minimum number of contra-standard features for us' (1970: 360).

Finally, the rejection of a strict art–pornography divide is of vital importance not only for a proper critical appreciation of existing artworks but also for the production of future pornographic artworks. Most of pornography, it

should be granted, is terribly deficient on aesthetic and artistic grounds (not to mention moral grounds). There are in fact so few exceptions to this general rule that artists may be forgiven in thinking, along with the majority of the public, that art and pornography really are incompatible. Such a thought, that it is not just difficult but simply impossible to make something that is both art and pornography, will obviously prevent anyone with artistic ambition from experimenting in this direction. That is why the outcome of the philosophical debate is not without practical import. If philosophers of art were to conclude that art and pornography are indeed mutually exclusive, this will confirm the widespread misconception and help to turn the realm of pornography—already perceived as 'a toxic wasteland, poisonous to the reputation and alive with career pathogens' (Moore 2009: 17)—into a permanent 'no-go' zone for artists.

Cementing the (conscious or unconscious) self-censorship of artists in this regard would not be such a bad thing if sex was just a marginal, unimportant aspect of human life. But it clearly is not. Sexual experiences involve the deepest corners of our selves and are among the most intense, powerful, emotional, and profound experiences we have. If pornography, which offers the most direct representation of, and access to, such experiences, can in principle be lifted into the realm of art, and this is what I have argued for in this chapter, then I think we have every reason to encourage artists to attempt just that: to make intense, powerful, and profound works of pornographic art and rescue this much-maligned genre from the clutches of the seedy porn-barons.

References

Amis, Kingsley, and Howard, E. J. (1972) 'The Novelist's View'. *Pornography: The Longford Report*. London: Coronet Books. 150–61.

Bartel, Christopher (2010) 'The Fine Art of Pornography? The Conflict between Artistic Value and Pornographic Value'. In Dave Monroe (ed.), *Porn—Philosophy for Everyone: How to Think with Kink*. Oxford: Wiley-Blackwell. 153–65.

Berger, Fred (1977) 'Pornography, Sex, and Censorship'. *Social Theory and Practice* 4: 183–209.

Berger, John (1972) *Ways of Seeing*. London: Penguin.

Blackburn, Simon (2006) *Lust*. Oxford: Oxford University Press.

Bovens, Luc (1998) 'Moral Luck, Photojournalism, and Pornography'. *Journal of Value Inquiry* 32: 205–17.

Brown, Curtis (2002) 'Art, Oppression, and the Autonomy of Aesthetics'. In Alex Neill and Aaron Ridley (eds.), *Arguing about Art: Contemporary Philosophical Debates*. London: Routledge. 399–421.

Brownmiller, Susan (1975) *Against Our Will: Men, Women and Rape*. New York: Fawcett.

Carroll, Noël (2009) *On Criticism*. New York: Routledge.

Cembalest, Robin et al. (eds.) (1989) 'What is Pornography?' *Art News*, October Issue.

Chaucer, Lynn S. (1998) *Reconcilable Differences: Confronting Beauty, Pornography, and the Future of Feminism*. Berkeley: University of California Press, 1998.

Clark, Kenneth (1956) *The Nude: A Study in Ideal Beauty*. London: John Murray.

Clarke, John R. (2003) *Roman Sex*. New York: Harry N. Abrams.

Corliss, Richard (1999) 'In Defense of Dirty Movies'. *Time Magazine* 5 July.

Danto, Arthur C. (1995) *Playing with the Edge: The Photographic Achievement of Robert Mapplethorpe*. Berkeley: University of California Press.

—— (2003) *The Abuse of Beauty: Aesthetics and the Concept of Art*. Chicago: Open Court.

—— (2005) *Unnatural Wonders*. New York: Columbia University Press.

Dwyer, Susan (2008) 'Pornography'. In Paisley Livingston and Carl Plantinga (eds.), *Routledge Companion to Philosophy and Film*. London: Routledge. 515–26.

Eaton, Anne W. (2007) 'A Sensible Anti-Porn Feminism'. *Ethics* 117: 674–715.

Elliott, George P. (1970) 'Against Pornography'. In Douglas Hughes (ed.), *Perspectives on Pornography*. New York: St Martin's Press. 72–95.

Ellis, Havelock (2007) *Studies in the Psychology of Sex: Volume 4*. Charleston, SC: Bibliobazaar.

Ellis, John (2006) 'On Pornography'. In P. Lehman (ed.), *Pornography: Film and Culture*. New Brunswick: Rutgers University Press. 25–47.

Feinberg, Joel (1979) *The Idea of the Obscene*. Lawrence: University of Kansas Press.

—— (1985) *Offense to Others*. Oxford: Oxford University Press.

Freud, Sigmund (1961) *Civilization and its Discontents* (Standard Edition, vol. xxi). London: Hogarth Press and the Institute of Psycho-Analysis.

Gaut, Berys (2007) *Art, Emotion and Ethics*. Oxford: Oxford University Press.

Gracyk, Theodore (1987) 'Pornography as Representation: Aesthetic Considerations'. *The Journal of Aesthetic Education* 21(4): 103–21.

Graham, Gordon (2008) 'Sex and Violence in Fact and Fiction'. In Matthew Kieran (ed.), *Media-Ethics*. New York: Routledge. 152–64.

Huer, Jon (1987) *Art, Beauty, and Pornography: A Journey through American Culture*. Buffalo: Prometheus.

Irvin, Sherri (2008) 'The Pervasiveness of the Aesthetics in Ordinary Experience'. *British Journal of Aesthetics* 48: 29–44.

Kieran, Matthew (2001) 'Pornographic Art'. *Philosophy and Literature* 25: 31–45.

—— (2002) 'On Obscenity: The Thrill and Repulsion of the Morally Prohibited'. *Philosophy and Phenomenological Research* 64: 31–55.

Kipnis, Laura (2006) 'How to Look at Pornography'. In P. Lehman (ed.), *Pornography: Film and Culture*. New Brunswick: Rutgers University Press. 118–32.

Langton, Rae (1993) 'Speech Acts and Unspeakable Acts'. *Philosophy and Public Affairs* 22: 305–30.

Lawrence, D. H. (1929) *Pornography and Obscenity*. London: Faber & Faber.

Levinson, Jerrold (1998) 'Erotic Art'. In E. Craig (ed.), *The Routledge Encyclopedia of Philosophy*. London: Routledge. 406–9.

—— (2003) 'Sexual Perversity'. *The Monist* 86(1).

—— (2005) 'Erotic Art and Pornographic Pictures'. *Philosophy and Literature* 29: 228–40.

Longino, Helen (1980) 'Pornography, Oppression, and Freedom'. In Laura Lederer (ed.), *Take Back the Night: Women on Pornography*. New York: William Morrow, 40–54.

McElroy, Wendy (1995) *XXX: A Woman's Right to Pornography*. New York: St Martin's Press.

MacKinnon, Catharine (1987) 'Francis Biddle's Sister: Pornography, Civil Rights, and Speech'. In *Feminism Unmodified: Discourses on Life and Law*. Cambridge, Mass.: Harvard University Press. 163–97.

Maes, Hans (2009) 'Art and Pornography'. *Journal of Aesthetic Education* 43: 107–16.

—— (2011a) 'Art or Porn: Clear Division or False Dilemma?' *Philosophy and Literature*.

—— (2011b) 'Drawing the Line: Art versus Pornography'. *Philosophy Compass*.

Mag Uidhir, Christy (2009) 'Why Pornography Can't Be Art'. *Philosophy and Literature* 33: 193–203.

Mahon, Alyce (2005) *Eroticism & Art*. Oxford: OUP.

Marcus, Steven (1964) *The Other Victorians: A Study of Sexuality and Pornography in Mid- Nineteenth-Century England*. New York: Basic Books.

Mey, Kerstin (2007) *Art & Obscenity*. London: I. B. Tauris.

Moore, Alan (2008) 'Drawings of Harlots'. In Tim Pilcher (ed.), *Erotic Comics: A Graphic History*. Lewis: Ilex.

—— (2009) *Twenty-Five Thousand Years of Erotic Freedom*. New York: Abrams.

Nabokov, Vladimir (1995) 'On a Book Entitled *Lolita*'. In *Lolita*. London: Penguin. 311–17.

Nussbaum, Martha C. (1995) 'Objectification'. *Philosophy and Public Affairs* 24: 249–91.

——(2004) *Hiding from Humanity: Disgust, Shame and the Law*. Princeton: Princeton University Press.

Plumb, Ali (2011) '15 Amazing Adverts from 15 Amazing Directors'. *Empire Online*: <http://www.empireonline.com/features/amazing-adverts-from-amazing-directors/p7>.

Pornography: The Longford Report (1972) London: Coronet Books.

The Puzzy Power Manifesto: Statement on Women and Sensuality (1997) <http://www.puzzypower.dk/UK/index.php/om-os/manifest>.

Rea, Michael C. (2001) 'What is Pornography?' *Noûs* 35(1): 118–45.

Russell, Diana E. H. (1998) *Dangerous Relationships: Pornography, Misogyny, and Rape*. London: Sage.

Schopenhauer, Arthur (1965) *The World as Will and Representation*. vol. I, trans. E. F. J. Payne. New York: Dover.

Scruton, Roger (1986) *Sexual Desire*. New York: The Free Press.

——(2003) 'The Moral Birds and Bees'. *National Review*, 15 September. <http://www.nationalreview.com/flashback/flashback200602140942.asp>. Accessed 14 October 2007.

——(2005) 'Flesh from the Butcher: How to Distinguish Eroticism from Pornography'. *Times Literary Supplement* 15 Apr. 2005, 11–13.

——(2009) *Beauty*. Oxford: Oxford University Press.

Shaftesbury, Third Earl of (1999) *Characteristics of Men, Manners, Opinions, Times*. Ed. Lawrence Klein. Cambridge: Cambridge University Press.

Shusterman, Richard (2007) 'Asian Ars Erotica and the Question of Sexual Aesthetics'. *Journal of Aesthetics and Art Criticism* 65: 55–68.

——(2008) 'Aesthetic Experience: From Analysis to Eros'. In Richard Shusterman and Adele Tomlin (eds.), *Aesthetic Experience*. London: Routledge. 79–97.

Slade, Joseph W. (2001) *Pornography and Sexual Representation: A Reference Guide*. Westport, Conn.: Greenwood Press.

Sontag, Susan (1994) 'The Pornographic Imagination'. *Styles of Radical Will*. London: Vintage. 35–73.

Steinem, Gloria (1995) 'Erotica and Pornography: A Clear and Present Difference'. In Susan Dwyer (ed.), *The Problem of Pornography*. Belmont: Wadsworth. 29–33.

Steiner, George (1975) 'Night Words: High Pornography and Human Privacy'. In Ray C. Rist (ed.), *The Pornography Controversy*. New Brunswick: Transaction Books. 203–16.

Talvacchia, Bette (1999) *Taking Positions: On the Erotic in Renaissance Culture.* Princeton: Princeton University Press.

Wallace, Marina, Kemp, Martin, and Bernstein, Joanne (2007) *Seduced: Art & Sex from Antiquity to Now.* London: Merrel.

Walton, Kendall (1970) 'Categories of Art'. *Philosophical Review* 79: 334–67.

Waugh, Thomas (1995) 'Men's Pornography: Gay vs Straight'. In Susan Dwyer (ed.), *The Problem of Pornography.* Belmont: Wadsworth. 142–61.

Webb, Peter (1975) *The Erotic Arts.* London: Secker & Warburg.

Williams, Bernard (ed.) (1982) *Obscenity and Film Censorship: An Abridgement of the Williams Report.* Cambridge: Cambridge University Press.

Williams, Linda (1989) *Hard-Core: Power, Pleasure, and the 'Frenzy of the Visible'.* Berkeley: University of California Press.

—— (ed.) (2004) *Porn Studies.* Durham, NC: Duke University Press.

—— (2008) *Screening Sex.* Durham, NC: Duke University Press.

Willis, Ellen (1995) 'Feminism, Moralism, and Pornography'. In Susan Dwyer (ed.), *The Problem of Pornography.* Belmont: Wadsworth. 170–6.

2

The Pornographic, the Erotic, the Charming, and the Sublime

ALEX NEILL

In a brief discussion in Section 40 of the first volume of *The World as Will and Representation*, Schopenhauer notes that 'the real opposite of the sublime is something that is not at first sight recognised as such, namely the *charming* or *attractive*.'[1] The contrast that he appears to have in mind is that while 'the sublime' is a category of (objects of) aesthetic experience, 'the charming' is not only *non*-aesthetic, so to speak, but positively *anti*-aesthetic. It is, he stipulates, 'that which excites the will by directly presenting to it satisfaction, fulfillment' (Schopenhauer 1969: 207). And as such, it

draws the beholder down from pure contemplation, demanded by every apprehension of the beautiful, since it necessarily stirs his will by objects that directly appeal to it. Thus the beholder no longer remains pure subject of knowing, but becomes the needy and dependent subject of willing. (Ibid.)

It follows that the charming is not a fit subject for art, the proper purpose of which, as Schopenhauer understands it, is to facilitate will-less contemplation of the Ideas. Consider, he says, the depiction of 'edible objects' in 'the still life painting of the Dutch':

By their deceptive appearance these necessarily excite the appetite, and this is just a stimulation of the will which puts an end to any aesthetic contemplation of the

[1] Schopenhauer's term is 'das Reizende', which Payne translates, as do Haldane and Kemp (Schopenhauer 1883), as 'the charming or attractive'; Aquila (Schopenhauer 2008) renders it as 'the stimulating', which I think captures better what Schopenhauer has in mind, as might 'the appealing' or perhaps 'the seductive'.

object. Painted fruit ... is admissible, for it exhibits itself as a further development of the flower, and as a beautiful product of nature through form and colour, without our being positively forced to think of its edibility. But unfortunately we often find, depicted with deceptive naturalness, prepared and served-up dishes, oysters, herrings, crabs, bread and butter, beer, wine, and so on, all of which is wholly objectionable. In historical painting and in sculpture the charming consists in nude figures, the position, semi-drapery, and whole treatment of which are calculated to excite lustful feeling in the beholder. Purely aesthetic contemplation is at once abolished, and the purpose of art thus defeated. (Ibid. 207–8)

'[T]he charming', then, 'is everywhere to be avoided in art' (ibid. 208).

Thus far, it looks as though 'the charming', like 'the sublime', labels a category of objects of experience, but a category of objects, unlike those of the sublime, that cannot be experienced aesthetically. As Schopenhauer goes on, however, it becomes clear that with 'the charming' he has in mind not so much a category of objects or of experience as a concept of art criticism: everything he goes on to say about the matter suggests that 'charmingness' (for want of a better term) is a *manner* or *style* of representation or depiction. The Dutch still-life painters to whom he refers go wrong, as Schopenhauer sees it, not simply in depicting 'prepared and served-up dishes', but in depicting them with 'deceptive naturalness', in a manner that 'necessarily excite[s] the appetite', such that the spectator is 'positively forced to think of [their] edibility'. And the 'historical' painters and sculptors err not simply in virtue of depicting 'nude figures'—after all, 'the ancients' did so, as Schopenhauer says, 'almost always free from ... fault'—but rather in their *treatment* of those figures, treatment 'calculated to excite lustful feeling in the beholder', in 'the spirit of subjective, base sensuality' (ibid.) As Schopenhauer presents it, in short, 'the charming' refers not to a category of objects or experience, but to a manner or style of depiction that is likely, if not calculated, to excite the will in such a way as to make will-less aesthetic experience impossible. Given that the function of art is to facilitate aesthetic experience, then, it would indeed seem to follow that 'the charming ... is everywhere to be avoided in art.'

At this point one might ask in what sense 'the charming', if it refers to a mode or manner of depiction, could be supposed to be the 'opposite' of the sublime, which Schopenhauer takes to be a category of objects or of experience? We'll come back to this; first, however, it is worth reflecting further

on his remarks about 'nude figures'. As we have just seen, Schopenhauer distinguishes between representations in which nudity is treated in ways 'calculated to excite lustful feeling in the beholder', in 'the spirit of subject-ive, base sensuality', and representations of nudity that 'the artist himself created . . . with a purely objective spirit filled with ideal beauty' (ibid. 208). It is tempting to hear in these remarks an anticipation of certain intuitions that have informed recent discussion of the differences between porno-graphic and erotic representation. First, I take it to be uncontroversial that pornography, at a minimum,[2] is representation that, through the depiction of material that appeals to the sexual instincts of the consumer, is designed to arouse sexually. And representations of this sort seem to be just what Schopenhauer has in mind in his reference to painting and sculpture in which nudity is treated in a way 'calculated to excite lustful feeling in the beholder'. Thus there seems to be at least a significant overlap between certain instances of what Schopenhauer refers to as the charming and what is plausibly understood as the pornographic.

Second, pornography, even thus minimally characterized, is of course likely to be seen as problematic along at least two dimensions. Against certain sorts of cultural backdrop, it will be worrying (doubtless in a number of ways) from a moral point of view. Against the backdrop of a certain tradition of aesthetic theory, one that emphasizes the disinterestedness of aesthetic experience and the non-instrumentality of works of art, it is bound to be worrying in the context of the philosophy of art. And with regard to the latter, Schopenhauer's suggestion that 'the charming . . . is everywhere to be avoided in art' anticipates the view of a number of recent authors that the pornographic and the artistic are mutually exclusive.[3]

One way of understanding the genesis of the concepts of 'erotica' and 'erotic art' is in terms of the fact that, in response to these and related worries, it will inevitably be noted (a) that not all representations that (are designed to) appeal to the sexual instincts are in virtue of that morally worrying, and (b) that some representations that are designed to appeal to the sexual

[2] That is, making no assumptions about the detail of its representational content, whether or not, or to what degree, the latter must be explicit, whether or not it necessarily objectifies or does violence, and so on.

[3] Philosophically the most interesting are Levinson 2005, Scruton 2005, and Mag Uidhir 2009. For criticism, see for example the chapters in this volume by Hans Maes, Andrew Kania, and David Davies.

instincts can despite (if not partly in virtue of) that be works of art.[4] 'Erotica' and 'erotic art', then, emerge as categories of representation that depict material that appeals to the sexual instincts of the consumer but that are nonetheless, to put it briefly, 'respectable': that is to say, morally acceptable and capable of constituting art.[5]

At this point, continuity with Schopenhauer's thought would seem to come to an end; any attempt to find an echo of this conception of erotica and erotic art in Schopenhauer's discussion of the sort of representation that he contrasts with representation that is charming (and as I have characterized it, pornographic) looks doomed to failure. The representations of nudity that he regards as 'free from . . . fault' are those that have been 'created . . . with a purely objective spirit'; that is, created to express a purely objective vision, a vision untainted by subjectivity, of what is represented. And this is a vision made possible by 'the abolition of individuality' (ibid. 169), by a mode of cognition that is free from the influence of desire or emotion, in which the intellect has broken free of the demands of the will. Once we have 'given ourselves up to pure, will-less knowing, we have stepped into another world, so to speak, where everything that moves our will, and thus violently agitates us, no longer exists' (ibid. 197). In short, aesthetic experience is supposed by Schopenhauer to be *will-less* experience. If a representation depicts material that appeals to the sexual (and very much will-*full*) instincts of the consumer, then, it would seem that Schopenhauer has no conceptual room for the idea that that representation could be experienced aesthetically or could constitute art. And that is to say, in effect, that it would seem that Schopenhauer has no room for the idea of erotic art, as characterized above, at all.

This may seem uncontroversial, an obvious corollary of Schopenhauer's take on the disinterested character of aesthetic experience. Nonetheless, I suggest that to draw this conclusion would be a mistake; and establishing this will be a main concern in what follows. To that end, I return to the question raised earlier: given that Schopenhauer regards 'the charming' as a mode or manner of depiction, in what sense can it be the 'opposite' of the

[4] Indeed, given an appropriately nuanced sense of 'appeal', it is not implausible to suppose that some works may be morally and aesthetically significant precisely in virtue of the fact that they appeal to the sexual instincts of their audience.

[5] Perhaps 'erotica' and 'erotic art' are best understood as distinct categories, as Levinson (2005), for example, suggests. In what follows, I am agnostic on this issue.

sublime, which he takes to be a category of (objects of) aesthetic experience? The short answer is that if we stick to the letter of what Schopenhauer actually says about the charming, it is hard to see any sense in the suggestion that it is the opposite of the sublime. But there is more to be said, and more that Schopenhauer himself should have said, about the matter. Articulating what that is will allow us to see both that there is an important sense in which something like 'the charming' is indeed opposite—or at least parallel—to 'the sublime', and that there is in fact conceptual room for the notion of erotic art in Schopenhauer's aesthetic theory.

Recall first that Schopenhauer distinguishes between the sublime and the beautiful—the only two categories of aesthetic experience that he allows in his theory—in terms of the readiness with which the transition from (normal, everyday) will-driven cognition to (disinterested, aesthetic) will-less contemplation comes about in a subject on a given occasion. This, he suggests, will depend in part on how pressing the demands of the subject's will are on that occasion; and the latter will in turn depend in part on the nature of the object(s) of perception on that occasion. *Beautiful* objects, Schopenhauer holds, are those that 'accommodate' the transition into the state of will-lessness in a perceiver; such objects 'easily become representatives of their Ideas' (ibid. 200) inasmuch as the perception of them does not provoke activity of will. *Sublime* objects or states of affairs, by contrast, stand in 'a hostile relation to the human will in general, as manifested in . . . the human body. They may be opposed to it, they may threaten it by their might that eliminates all resistance, or their immeasurable greatness may reduce it to nought' (ibid. 201). Sublime objects and states of affairs, that is, are recognized by the subject as threatening, in one sense or another, and that recognition is an impediment to transition into will-less contemplation of them. Despite this, Schopenhauer insists, such contemplation of the sublime is possible:

Nevertheless, the beholder may not direct his attention to this relation to his will which is so pressing and hostile, but, although he perceives it and acknowledges it, he may consciously turn away from it, forcibly tear himself from his will and its relations, and, giving himself up entirely to knowledge, may quietly contemplate, as pure, will-less subject of knowing, those very objects so terrible to the will. . . . In that case, he is then filled with the feeling of the sublime . . . and therefore the object that causes such a state is called *sublime*. (Ibid. 201–2)

The difference between the sublime and the beautiful, in short, is fundamentally to be understood in terms of their causal backgrounds:

> Thus what distinguishes the feeling of the sublime from that of the beautiful is that, with the beautiful, pure knowledge has gained the upper hand without a struggle . . . On the other hand, with the sublime, that state of pure knowing is obtained first of all by a conscious and violent tearing away from the relations of the . . . object to the will which are recognised as unfavourable . . . (Ibid. 202)

In light of this, it is hard to see why Schopenhauer does not acknowledge a further category of aesthetic experience, one that parallels that of the sublime. Given that 'a *hostile* relation to the human will' can be 'turned away' or 'forcibly torn' from, allowing objects that stand in such a relation to the will to be experienced aesthetically, as Schopenhauer holds with regard to the sublime, there seems no reason to suppose that a relation of *attraction* between 'objects that directly appeal' and the will to which they appeal is not in principle similarly 'turnable away' or 'forcibly tearable' from, allowing *those* objects to be experienced aesthetically.[6] That is, there is no reason why Schopenhauer should not have said of certain sorts of object, to paraphrase very closely:

> Nevertheless, the beholder may not direct his attention to this relation to his will which is so *appealing and seductive*, but, although he perceives it and acknowledges it, he may consciously turn away from it, forcibly tear himself from his will and its relations, and, giving himself up entirely to knowledge, may quietly contemplate, as pure, will-less subject of knowing, those very objects so *attractive* to the will. He may comprehend only their Idea that is foreign to all relation, gladly linger over its contemplation, and consequently be elevated precisely in this way above himself, his person, his willing, and all willing. In that case, he is then filled with the feeling of the *charming* . . . and therefore the object that causes such a state is called *charming*.

Indeed, there is every reason to think that Schopenhauer *should* have said something like this. After all, if 'every existing thing' is beautiful, as he claims—that is, if everything is such that it can in principle be perceived as an

[6] Doubtless there will be some things that, for some people, on some occasions, will be so attractive that the latter relation can't be turned away from, so that those things, for those people, on those occasions, will not be experienceable aesthetically. But, of course, just the same holds with regard to objects that stand in a hostile relation to the will.

expression of the Idea that it instantiates—surely that must include those things that have a relation of attraction to the human will.

My suggestion, then, is that Schopenhauer should have recognized a third category of aesthetic experience. Just as terrifying objects and situations may be will-lessly experienced as sublime if a subject is able to tear her attention away from the 'hostile relation' in which those objects stand to her will, so, he ought to have acknowledged, attractive—or charming—objects may be will-lessly experienced if a subject is able to tear his attention away from the relation of attraction in which those objects stand to his will.

Will-lessly experienced as *what*, however? In English, at least, we lack a clear and settled terminology here. In my paraphrase above I took the analogue of 'the sublime' to be 'the charming', but it makes better sense (and is closer to Schopenhauer's own use of the term) to think of 'the charming' as analogous to 'the terrifying'—as a category of things that may or may not be experienced aesthetically, depending on whether the subject is able to turn away from their attractiveness to him as an individual. (The pornographic would then be a variety of the charming, as 'the immeasurably great', for example, may be thought of as a variety of 'the terrifying'.) In any case, the fact is that we do not have a single term here that corresponds to 'the sublime'; that is, a single term for a variety of disinterested aesthetic experience that depends on in some sense 'turning away from' the attract-iveness or seductiveness of an object or situation.[7]

That is not to say, however, that the fact that there are varieties of aesthetic experience that have this character has gone unacknowledged: for example, in some of their uses in the history of aesthetics, the notions of 'the delightful' and 'the picturesque' have both been used to label objects of aesthetic experience of this variety. And so, I suggest, has the notion of 'the erotic'. Consider, for example, Levinson's thought that erotica is to be distinguished from pornography partly in terms of the fact that the former is designed to *stimulate* sexually, the latter to *arouse* in the interests of what Levinson delicately refers to as 'sexual release'. For a work of erotic art to succeed as an object of aesthetic appreciation—'where this is understood to entail some degree of disinterestedness'—Levinson argues, 'stimulation and arousal have to be held in check . . . ' (2005: 239). His thought, I take it, is

[7] 'The sublime', of course, is hardly a simple term; since Kant, we have distinguished between mathematical and dynamic variants, and that distinction is doubtless not the end of the story . . .

that they have to be 'held in check' by the work. But they may also have to be held in check by the appreciator—in Schopenhauerian terms, the sexual allure of the object will have to be 'turned away from'.

But that putting of Levinson's point 'in Schopenhauerian terms' is of course far too quick. To continue the quotation that I started a moment ago: in the aesthetic experience of erotic art, Levinson suggests, 'stimulation and arousal have to be held in check, *neither suppressed nor given completely free rein...*' If it is 'given completely free rein', I take the point to be, mere stimulation will turn into full-blooded arousal, and the possibility of disinterestedness, and hence of genuinely aesthetic experience, will evaporate. But if stimulation is entirely suppressed, on the other hand, the experience will be, as it were, point-missing: if the object in question does in fact appeal to the sexual instincts, then a response that involves the suppression of stimulation will simply not be adequate to that object, will not be a response to it as it really is. And this doesn't sound much like aesthetic experience, either.

But surely the complete suppression of stimulation is a condition of the possibility of aesthetic experience, as Schopenhauer construes the latter—that is, as 'purely objective', as free from the influence of desire or emotion, as experience in which 'everything that moves our will, and thus violently agitates us, no longer exists'? It may be said that Levinson owes us more by way of an account of how stimulation—even stimulation 'held in check'—is consistent with disinterestedness. But however difficult that account may be to come up with, showing that stimulation—to *any* degree—is consistent with Schopenhauerian will-lessness looks simply impossible. We have arrived again at the point that I made earlier: if an adequate response to erotica essentially involves stimulation, as Levinson, I think rightly, suggests, then it looks very much as though Schopenhauer has no room for the idea that erotica could be experienced aesthetically, or that there could be such a thing as erotic art.

Before we accept that, however, we should notice that something very like this issue would appear to arise for Schopenhauer with regard to the sublime.[8] For the sublime—which in the century or so before Schopenhauer started thinking about these matters had emerged as a fully-fledged category of aesthetic experience—was, and indeed is, standardly understood

[8] For more on this, see Neill 2012.

as a variety of experience in which pleasure is alloyed with one or another kind of *uneasiness*, in which the object of experience is perceived as in some sense disturbing or threatening or challenging. The feeling of the sublime is 'an agreeable kind of horror' (Joseph Addison), or an 'enthusiastic terror' (John Dennis); 'its strongest emotion is an emotion of distress' (Edmund Burke). But horror, terror, distress—indeed, all such forms of uneasiness—are in Schopenhauerian terms modifications or affections of the will. If this sort of feeling is at the heart of experience of the sublime, then—assuming that Schopenhauer is entitled to think of the sublime as a variety of aesthetic experience—there will have to be a Schopenhauerian account of how the experience of *unease* is consistent with will-less experience. And if such an account is available, then there may be a parallel account of how a state of *stimulation* is consistent with will-less experience.

And such an account surely must be available. Schopenhauer emphasizes, after all, that intuitive knowledge of the Ideas, which is what is given in aesthetic experience, is given through sensation: as he says at one point, 'knowledge of the Idea is necessarily knowledge through perception' (ibid. 186). That is to say, as Schopenhauer construes it, aesthetic experience is essentially *embodied* experience. And given that in his terms an individual's body is nothing other than the objectification of his will, and that sensation involves modification or 'stimulation' of the body, surely it follows that will-less cognition of the Ideas must not only be consistent with, but actually depends on, modification of the will.

What then can Schopenhauer mean by 'will-lessness'? What can 'will-less knowing' (ibid. 197) amount to, given that it cannot literally depend on the absence of will, or on the will's being unmoved or unaffected? The answer can only be that will-less knowing is a kind of cognition in which intellect is not operating *in the service of* the will.[9] Aesthetic experience involves not so much will-*less* cognition, that is, as cognition that is not so to speak *driven* by the demands of the individual's will—not driven, that is to say, by desire and emotion. Schopenhauer's tendency to describe this variety of experience in terms of will-lessness may be explicable in terms of the fact that his main concern is with the experience of beauty; experience in which, because of the nature of the kinds of object in question, the subject is not *conscious* of himself as a phenomenon of will, experience in which the will has been

[9] For a detailed discussion, see Neill 2007.

'forgotten', and 'the self-consciousness of the knower' is of a *pure, will-less subject of knowledge*' (ibid. 178, 195–6). But lack of consciousness of one's will does not entail the absence of will or of willing—indeed, it is not clear that the latter constitutes a coherent possibility for animal life. And more importantly for our purposes here, it is far from clear that lack of consciousness of the individual will—which is to say, of desires and emotions—is a necessary concomitant of cognitive experience that is not driven by the individual will. Nothing that Schopenhauer says rules out the possibility that non-will-driven experience may be experience in which one is aware of one's will and, for that matter, of acts of willing. All that his general conception of aesthetic experience rules out in this regard is that in such experience one's cognition or intellect could be *driven by*, or *functioning in service of*, one's will.

However, even if it is true that as Schopenhauer understands it will-less aesthetic experience may be continuous with awareness of oneself as a willing being, does this establish that there is conceptual room in his aesthetic theory for aesthetic experience that is *uneasy* (in the case of the sublime) or *stimulating* (in the case of erotica)?

Schopenhauer's own discussion of the matter is so sketchy that it is difficult to settle these questions decisively. But the reading of his position on the sublime that makes most sense of what he does say, I think, is as follows: when an object or situation is perceived as (even if only potentially) hostile or threatening, the possibility of experiencing it aesthetically depends on the subject's deliberately disregarding any threat that it may appear to pose *to him*. But this does not entail that the subject stops perceiving the object of perception as *by nature* threatening; by hypothesis, it *is* threatening, and a subject who loses sight of that fact would therefore not be seeing the object for what it really is—in Schopenhauerian terms, would not be perceiving its Idea, and hence would not be experiencing it aesthetically at all. In short, then, the subject of aesthetic experience of the sublime has to recognize the object of his perception as threatening without experiencing it as a threat *to him*. However, given that the natural function of intellect is to further the ends of the individual will, so that the default operating mode of intellect is in service of that will, the fact that a subject recognizes the object as threatening even in this general sense means that there will be a continuing pull towards the apprehension of that object as an individual, in terms of its hostile relation to the individual subject; a tendency to slide from

apprehending it as 'a threatening kind of thing' to seeing it as a threat to oneself. Sublime experience, that is, is in an important respect essentially *unstable*. This is the sense in which will-less experience of the sublime requires 'maintenance', as Schopenhauer puts it; more precisely, this kind of experience depends on the subject's maintaining focus on the relations of the Idea instantiated by the object in question to 'human willing in general', without sliding back into perception of it as an individual thing that is potentially or actually threatening to the individual subject. Unless the former focus is maintained, aesthetic experience of the sublime will be impossible: will-less cognition, if is has been attained at all, will simply collapse back into fear or terror or horror. If it *is* maintained, however, fear or terror or horror will, in Levinson's terms, have been 'held in check'.

Suppose that something like this reading of Schopenhauer's theory of the sublime is correct.[10] The question is: can a similar account be given with regard to the charming, so as to give a Schopenhauerian account of the latter? I don't see why not. In broad outline, the account will go as follows: when something is experienced as alluring, the possibility of experiencing it aesthetically depends on the subject's deliberately disregarding its allure *to her*. But this does not entail that the subject stops perceiving the object of perception as by nature alluring or stimulating; by hypothesis, it *is* such, and a subject who loses sight of that fact would therefore not be seeing the object for what it really is—in Schopenhauerian terms, would not be perceiving the Idea that it instantiates, and hence would not be experiencing it aesthetically at all. In short, then, a subject who experiences the erotic aesthetically perceives the object of her perception as stimulating—as in some sense alluring to human willing as a species, or to Will as it manifests itself in human beings 'in general'—but does not focus on the object's relation to her as an individual. And this is as plausible a way as any, I suggest, of understanding what it might be to hold stimulation 'in check'.

But doesn't 'stimulation held in check' now simply mean, in effect, stimulation cut off at the pass—stimulation suppressed? Isn't aesthetic experience of the erotic, as I have reconstructed it for Schopenhauer, just too bloodless to be recognizable as genuinely of the erotic? I suggest not. For on my reconstruction, aesthetic experience of the erotic shares what I have argued is an essential feature of the Schopenhauerian sublime, namely

[10] It is, of course, incomplete; again, see Neill 2012 for a more detailed discussion.

instability. I said a moment ago that since, as Schopenhauer understands it, the natural function of intellect is to further the ends of the individual will, the fact that a subject recognizes an object as in some sense 'opposed to' human willing 'in general' means that there will be a continuing pull towards the apprehension of that object from the point of view of an individual, in terms of its hostile relation to the individual subject; a tendency, that is, to slide from apprehending it as 'a threatening kind of thing' to seeing it as a threat to oneself. And the same will be true where a subject recognizes an object as alluring to human willing 'in general': there will be a tendency to slide from apprehending it as 'an alluring or seductive kind of thing' to experiencing it as arousing. Maintaining an aesthetic experience of such an object—holding stimulation 'in check'—demands resisting that slide. But the continuing pull towards it means that aesthetic experience of the erotic is likely to be experienced as far from bloodless; rather, it is likely to be experienced on a spectrum between mildly tense and highly difficult. Levinson suggests that an important aspect of our experience of erotic art is 'a kind of *tension*—one between life and art, to put it simply—a tension that generates an edgy pleasure akin to, if not identical with, that of the sublime' (Levinson 2005: 238). Levinson is right, I think, and what Schopenhauer offers us, on the reading of his aesthetic theory that I have offered above, is an account of the nature of this tension, and of its kinship with experience of the sublime.

There is room, then, in Schopenhauer's aesthetic theory for a category of aesthetic experience beyond those of the beautiful and the sublime; a category for which we lack a neat label, but which includes the disinterested or will-less experience of things initially experienced as stimulating or attractive, just as the category of the sublime covers the experience of things that are initially experienced as hostile or threatening. And erotic art, art that appeals to the sexual instincts of the consumer, a notion that that at first glance looks oxymoronic in Schopenhauerian terms, is in fact both coherent in those terms and a paradigm object of this variety of aesthetic experience.

References

Levinson, Jerrold (2005) 'Erotic Art and Pornographic Pictures'. *Philosophy and Literature* 29: 228–40.

Mag Uidhir, Christy (2009) 'Why Pornography Can't Be Art'. *Philosophy and Literature* 33: 193–203.

Neill, Alex (2007) 'Aesthetic Experience in Schopenhauer's Metaphysics of Will'. *European Journal of Philosophy* 16: 179–93.

——(2012) 'Schopenhauer on Tragedy and the Sublime'. In B. Vandenabeele (ed.), *The Blackwell Companion to Schopenhauer*. Oxford: Blackwell.

Schopenhauer, A. (1883) *The World as Will and Idea*, vol. i, trans. R. B. Haldane and J. Kemp. London: Routledge and Kegan Paul.

——(1969) *The World as Will and Representation*, vol. i, trans. E. F. Payne. New York: Dover Publications.

——(2008) *The World as Will and Presentation*, vol. i, trans. Richard E. Aquila with David Carus. New York: Pearson/Longman.

Scruton, Roger (2005) 'Flesh from the Butcher: How to Distinguish Eroticism from Pornography'. *Times Literary Supplement* 15 April 2005, 1f1–13.

3

Pornography, Art, and the Intended Response of the Receiver

DAVID DAVIES

1. The (Im)possibility of Pornographic Art: A Survey of the Terrain

It is clear that there are visual and verbal creations that are widely viewed as being works of art that also have as at least one of their aims the sexual stimulation or arousal of the intended receiver through the explicit representation of sexual activity. Verbal creations having this dual status include the *Story of O* and works by Bataille and de Sade. Visual creations having such a status include erotic drawings of women and girls by Schiele, Klimt, and Picasso. It is also obvious that one could get a fair measure of agreement at a gathering of the chattering classes if one suggested that most if not all of these putative 'artworks' are pornographic. This might be thought to show, by cunning appeal to linguistic intuitions, that there are at least some pornographic artworks. The latter is a view for which both Susan Sontag (1994) and Matthew Kieran (2001) have forcefully argued. Sontag, for example, focusing on literature, claims that 'relatively uncommon as they may be, there are writings which it seems reasonable to call pornographic . . . which, at the same time, cannot be refused accreditation as serious literature' (1994: 36). And Theodore Gracyk (1987) while he doesn't *argue* for this conclusion, implies that there can be pornographic art.

Some philosophers, however, have maintained with equal conviction not only that there are no pornographic artworks but that there never could be, since art and pornography have essentially certain features that are incompatible. The incompatibility, according to Jerrold Levinson (2005), resides in the intended responses at which art and pornography aim. This makes it impossible to appreciate something as art when one is 'appreciating' it as pornography. An alternative suggestion by Christy Mag Uidhir (2009) is that the incompatibility lies in the purposes relative to which we determine whether something succeeds or fails as art or as pornography. In both cases, this is taken to show that one cannot coherently have the intentions necessary to make one's creation be both pornography and art.

A superficial glance at the literature might suggest that this disagreement is more terminological than substantive. Take one of the examples with which I began. Kieran considers Schiele's drawings to be an obvious example of pornographic art. He classifies pornographic representations as a subspecies of erotic representations. An erotic representation 'essentially aims at eliciting sexual thoughts, feelings and associations found to be arousing' (2001: 32). The distinguishing feature of *pornographic* erotic representations is that they are sexually explicit. Kieran further characterizes an artistic interest as an interest in *how* a given representation represents its subject. This may involve both the skill of the artist in manipulating the medium and the attitude towards the subject expressed through such manipulations. Since no one disputes that an artistic interest is proper to at least some non-pornographic erotic representations and that these representations are correctly classified as artworks, Kieran asks why the same should not apply to at least some pornographic images.

Levinson (2005), however, arguing against the possibility of pornographic art, characterizes pornography not in terms of explicitness of sexual imagery, but in terms of the kind of response at which a representation aims. Erotic art involves representations that are intended both to sexually stimulate the viewer and to reward her artistic interest. Pornography, on the other hand, involves representations that are intended to arouse sexually in the interests of sexual release. He accords an intermediate position to 'erotica'— for example, the images in a *Victoria's Secret* catalogue—where there is no intention that one take an artistic interest in the erotic representation. On Levinson's account, erotic art differs from pornography not in the explicitness of the representations but in the responses each is designed to evoke.

Erotic art aims at sexual stimulation while pornography aims at sexual arousal, and while erotic art invites artistic interest, pornography positively deflects it.

Levinson, like Kieran, takes an *artistic interest* in a content-bearing manifold to be an interest in its form and the relation of form to content, 'the way content is embodied in form, the way medium has been employed to convey content' (2005: 232). For the sake of clarity, I shall term this an artistic interest in the Levinsonian sense, or an 'L-artistic interest', to distinguish it from what I shall later term an 'artistic regard'. But, given his characterization of pornography in terms of intended response, Levinson argues that the aim of pornography is incompatible with a necessary condition for something to be an artwork, namely its being something in which we are intended to take an L-artistic interest: '[Pornography] induces you, in the name of arousal and release, to ignore the representation so as to get at what is represented, [erotic art] induces you, in the name of aesthetic delight, to dwell on the representation and to contemplate it in relation to the stimulatingness or arousingness of what is represented' (2005: 234).

Mag Uidhir (2009) offers a related argument. He claims that Levinson's account rests on the questionable assumption that, because pornography aims to produce arousal, we cannot take an L-artistic interest in something while we are appreciating it *as* pornography. As we shall see, the problem cases are ones involving what Levinson terms 'artful pornography'. This arguably brings together artistic interest and pornographic interest in a single endeavour, with the former being a necessary means towards the achievement of the latter. Mag Uidhir proposes, instead, that the incompatibility between art and pornography resides not in their intended responses but in the conditions for success in realizing their respective purposes, given their different aims. Art, he maintains, succeeds only if its intended response is brought about in a particular manner—art is therefore 'manner-specific'— but pornography succeeds however its intended response is brought about and is therefore 'manner-inspecific'.

I shall not discuss Mag Uidhir's proposal in the body of this chapter. Let me note, however, a difficulty that it faces in dealing with the kind of example said to cause problems for Levinson—'artful pornography'. Unlike the cases of pornography cited by Mag Uidhur—images that appear in publications such as *Penthouse*—the success of 'artful pornography'—for example, certain literary works by Bataille and drawings by Schiele—surely

is 'manner-specific'. As we shall see, its success requires not merely that sexual arousal occur but that it be produced by the artful representation of sexually explicit material. If readers of Bataille were only aroused by imagining the text read in a deep French accent, for example, or if viewers of Schiele's drawings were only aroused by the coiffure of the models, this would surely count as a failure in these pieces. Of course, Mag Uidhir can respond that such works of 'artful pornography' are therefore not pornography. But since, as we shall see, this mirrors Levinson's strategy with the same examples, this response would seriously weaken Mag Uidhir's attempt to distance himself from Levinson's account.

Thus far, nothing we have seen might disturb our initial suspicion that what is going on here is largely a terminological disagreement. If we define pornography as *explicit* erotic representation aimed at sexual stimulation *or* arousal, then we can simply deny that it is in any way necessary that pornographic images are single-mindedly directed at such stimulation or arousal or dependent for their success merely upon arousal no matter how achieved. We can thereby evade the objections levied by Levinson and Mag Uidhir. If, on the other hand, such intended receptions or conditions for success are taken to be what is definitive of pornographic images, then one can, with Levinson, simply redescribe Kieran's examples of 'pornographic art' as works of erotic art whose very artistic qualities prevent them from being classified as pornography.

But Levinson also offers a couple of reasons why we should prefer his account of what is essential to pornography. First, he maintains, explicitness cannot be what distinguishes pornography from erotic art because there can be explicit erotic art. But, since the examples of erotic art that he cites are the erotic drawings of artists such as Schiele and Klimt, this seems to beg the question against someone like Kieran. For if we assume that there is a distinction to be drawn between the erotic and the pornographic, then Schiele's drawings are an example of explicit art that isn't pornographic only if their explicitness doesn't *make* them pornographic—the very point at issue.

Levinson also offers two reasons why the urge to find a place for pornographic art should be resisted. First, he claims that, if we allow there to be pornographic art, we have no way of distinguishing between pornography and erotic art. But this will be so only if we have already rejected Kieran's criterion of explicitness, and the argument offered against this, as we have

just seen, is question-begging. Also, it is as yet unclear why Levinson's own account of the distinction—in terms of intended response—cannot allow for pornographic art. This, however, brings us to Levinson's second reason for resisting the urge to find a place for pornographic art. As noted earlier, he holds that pornography and art intend *incompatible responses* on the part of the receiver. I shall consider this argument at some length in the final section of the chapter.

I have suggested that one might consistently hold to the idea of pornographic art if, while adhering to the Levinson/Kieran line on the nature of our distinctive *interest* in artworks, one followed Kieran in taking the defining feature of pornography to be the sexually explicit nature of the representation offered for sexual stimulation or arousal. But one could also consistently hold to the idea of pornographic art by departing from Levinson's conceptions of art and pornography in other ways.

For example, one could, like Susan Sontag, subscribe to an alternative view of what it is that makes something art. Sontag characterizes art and art-making as 'a form of consciousness', where 'the materials of art are the variety of forms of consciousness' (1994: 44). There is then no aesthetic reason for excluding *extreme* forms of consciousness, and it is these that are the material for the pornographic books that count as literature. What makes a work of pornography part of the history of art, for Sontag, is not aesthetic distance, but rather 'the originality, thoroughness, authenticity, and power of that deranged consciousness itself, as incarnated in a work' (1994: 47). The true aim of pornography, as a branch of literature, she maintains, is not to sexually excite the reader but to produce disorientation and psychic disloca-tion: 'What pornographic literature does is precisely to drive a wedge between one's existence as a full human being and one's existence as a sexual being' (1994: 58).

One can also allow for pornographic art if, like Theodore Gracyk, one takes the defining feature of pornography to be neither the explicit nature of the representation nor the general attitude that the receiver is invited to adopt towards it, but the attitude that the representation itself adopts towards its subject matter and thereby prescribes to the receiver. For there is no obvious incompatibility between being art and being expressive of, and thereby prescribing, a questionable attitude towards represented content. While the fact that *Triumph of the Will* expresses and prescribes an attitude of

approval of Nazism might, for some, make it a radically *flawed* work of art (see e.g. Devereaux 1998; Gaut 2007), it doesn't impugn its status as art.

I don't want to defend the idea of pornographic art in any of these ways, however. What I want to argue is that there is room for a notion of pornographic art even if we grant both of the key assumptions in Levinson's argument to the contrary. These assumptions, we may recall, are that (a) what is definitive of pornography is a particular kind of intended response and (b) what is at least necessary for art is an intended L-artistic interest. More generally, I shall suggest, with Levinson, that both the nature of art and the nature of pornography might be usefully elucidated at least partly in terms of the kind of response intended by the generator of a representation and that, in this sense at least, both art and pornography are in the intended response of the receiver. I shall, however, supplement Levinson's account of the kind of intended response for which artworks call. I shall then argue that, although art and pornography call for different kinds of response, this is no obstacle to something's being both art and pornography in a sense that justifies the label 'pornographic art', where this is not simply a matter of something lending itself independently to both artistic and pornographic uses. It is, I shall argue, no more difficult to see how there can be pornographic art than it is to see how there can be art that has a primary religious, satirical, or political function, or indeed any other kind of non-artistic primary intended function. In all such cases, I shall suggest, what makes an artefact an artwork is the kind of response solicited in the receiver in virtue of how the artefact articulates those contents that bear upon the fulfilment of its non-artistic function. Given this way of determining when we are dealing with art, we can further classify artworks in terms of those non-artistic purposes that they are intended to serve in virtue of those qualities that make them artworks in the first place.

2. Responding to Art and Pornography

The Levinsonian view of pornography that I shall grant for the purposes of this chapter—that what makes something pornography is the way in which it is intended that the receiver respond—differs significantly from Gracyk's view—cited above—that something is pornography if it manifests the 'pornographic attitude'. Gracyk distinguishes between attitudes expressed

in a representation and attitudes expressed *by* a representation. For example, while little Alex and his droogs are represented in Anthony Burgess's *A Clockwork Orange* as taking great pleasure in committing acts of rape and ultraviolence at the expense of their innocent victims, this attitude to such activities is not endorsed by the representation itself. The novel takes the social deviance of little Alex as a given and critically appraises various methods that might be used to deal with such deviance. Indeed, the socially critical function of artistic representations often involves representing attitudes *within* the representation that are the subject of critical appraisal *by* the representation in this way.

Gracyk's 'pornographic attitude' is an attitude that a representation can take towards what is represented within it. As Gracyk describes it, it involves the expression of contempt for women as sexually autonomous equal persons, but presumably we can expand this to include representations where it is male rather than female subjects that are the objects of such contempt. As such, it can be present in respect of representational content that is not itself sexually explicit, and may be lacking where we do have sexually explicit content, as is arguably the case in Schiele's paintings. Thus Gracyk *agrees with* Levinson in rejecting the idea that the distinguishing feature of pornographic representations is their sexual explicitness. He *differs from* Levinson, however, in characterizing pornography in terms of the particular attitude that a representation expresses towards its subject—and thereby prescribes to the viewer—rather than in terms of the response at which it aims more generally conceived—the response of sexual arousal and release.

For Levinson, then, but not for Gracyk, pornography and art differ in terms of the general kind of looking or regard for which they call, and this is key to his argument against the possibility of pornographic art. The pornographic aim of sexual arousal and release, he maintains, is best served by attending to *what* is represented and ignoring *how* it is represented. It is because an L-artistic interest in a representation is defined as an interest in the 'how' rather than the 'what' of that representation that the kind of regard for which pornography calls is taken to be incompatible with such an artistic interest.

I think it is undeniable that artworks, representational or not, require, for their appreciation, an L-artistic interest on the part of the receiver. But this kind of interest, as specified, is quite general once we broaden the notion of

artistic content to include non-representational content—which we must, if we are to have a notion of 'L-artistic interest' applicable to non-representational artworks. If an L-artistic interest is defined merely as an interest in how a medium has been employed in realizing a given end, then it seems to apply to a kind of appreciative interest that can be taken in artefacts in general. Michael Baxandall (1985: chapter 1) indicates how this might go for a (presumably) non-representational artefact—the Forth Bridge. Proper appreciation of the latter arguably requires that we take account of how some of its properties bear upon the solution of the imaginative problems posed to Baker, its designer, as part of his 'brief'. It might be said that, in this case, there is no articulated content, representational or non-representational. But we could also take an L-artistic interest in the design of a non-artistic artefact that does bear a content, and, indeed, a representational one—for example, the poster designed to promote a conference.

If artworks call for a particular kind of regard, therefore, it cannot be defined purely in terms of an L-artistic interest. I have argued elsewhere (Davies 2007 ch. 1; 2011 ch. 1) for an understanding of the notion of *artistic regard* under which such a regard *is* arguably specific to artworks. This allows the notion of an *intended* artistic regard to play a more substantial role in our understanding of what it is to be an artwork. An artwork, I have argued, is, or contains as a constitutive element,[1] something towards which it is intended that we adopt a particular kind of regard. But the kind of regard for which an artwork calls is grounded in the kind of thing that an artwork is and does. If this is the case, it might allow us to recognize certain things as artworks while allowing that they may also qualify as pornographic in that they aim at the sexual arousal of the receiver.

Before returning in this way to the issue of pornographic art, let me briefly explain the notion of artistic regard for which I have argued elsewhere and the sorts of reasons offered in defense of this notion. I draw on suggestions to be found in the work of Richard Wollheim and Nelson Goodman. Wollheim (1980: 96ff.) criticizes traditional 'aesthetic attitude' theories of artistic appreciation for assuming that the attitude required for artistic appreciation is specifiable as a more general kind of attitude that we can adopt to any object whatever. He suggests, to the contrary, that we start with the idea of an

[1] I insert this rider to accommodate an ontological view like my own (Davies 2004), which takes the artwork to be an action that specifies a focus of appreciation rather than the focus itself.

'aesthetic attitude' as, by definition, the kind of regard proper to something we take to be a work of art.

He initially specifies this kind of regard as one addressed to something taken to be an artefact, whose features ('form') must therefore be seen as organized for some purpose. An artistic manifold thus calls for an 'interrogative' exploration—one that seeks to make sense of the manifold in terms of reasons for its being ordered in the way that it is. But, as in the case of the L-artistic interest, this, as it stands, fails to identify a kind of regard that is distinctive of our appreciative attention to artworks. For such an informed and interrogative regard may also be proper to non-artistic artefacts. Later, however, (1980: 118 ff.), Wollheim further reflects upon the nature of the spectator's attitude to an artistic vehicle. He suggests that 'it is part of the spectator's attitude to art that he should adopt *this* attitude towards the work: that he should make it the object of an ever-increasing or deepening attention,' so that more and more of the properties of the art object 'may become incorporated into its aesthetic nature' (1980: 123). In developing this suggestion. I consider cases where the artistic vehicle of an artwork is perceptually indistinguishable from a mere 'real thing'. The salient question in such cases, I maintain, is how our manner of *regarding*—attending to—the artistic vehicle differs from our manner of attending to the mere real thing. I take, as examples, recent works in the performing arts and the visual arts.

In one such work—Yvonne Rainer's *Room Service*—the dancers work in three teams performing a series of ordinary movements that involve, among other things, moving, arranging, and rearranging objects such as mattresses and ladders. In a central sequence in the piece, two dancers carry a mattress up an aisle in the theatre, leave through one exit, and return through another. Crucially, the movements of the dancers are in no visible way intensified so as to differentiate them from ordinary activities such as—indeed—moving a mattress around in a sequence of rooms. Noël Carroll and Sally Banes comment that 'the *raison d'être* of the piece is to display the practical intelligence of the body in pursuit of a mundane goal-oriented type of action—moving a mattress' (1982: 292).

In discussing this and other examples, I argue that the difference between something that serves as an artistic vehicle and something, indistinguishable in terms of its manifest properties, that does not so serve, is to be explained in terms of the kind of regard for which the first entity calls *if we are to grasp the artistic content thereby articulated*—what is represented, expressed, or

exemplified at different levels through that vehicle. In Rainer's piece the artistic vehicle is a certain type of sequence of movements, tokens of which are performances of the piece. She wants the audience to attend to the movements with the same sort of care and intensity, and the same kind of interest in grasping the point of the movements, as they would if they were watching a performance of a more traditional work of dance.

We can note a couple of features of this attention. First, there are many details of the movements to which we would pay no attention if observing two people moving a mattress in a furniture showroom, but which are significant if we attend to those movements as a work of dance. In fact, every visible inflection of the body through which the act of moving the mattress is executed is significant in this way. We are therefore required to attend much more closely to the nuances of the movements than if we were observing the same movements executed in an ordinary setting.

Second, as Carroll and Banes make clear, we are expected to look for a 'point' to the sequence of movements performed that is not merely the practical point of moving a mattress. What we seek to determine is the point of presenting such a sequence of movements to us in a context where we are asked to attend to them in the close and discriminating way just described. The actions of the dancers stand as *examples* of how the human body serves us as an instrument of our desires and purposes. By being presented to us as such examples, they also serve as the kind of comment on our embodiment described by Carroll and Banes. The artist presents the artistic vehicle with the intention that it articulate a particular artistic content. She assumes that the audience will know that it is supposed to treat the vehicle in particular kinds of ways, to attend to it in an interrogative manner informed by the belief that there is a more general 'point' behind the vehicle's manifest properties, and that this point is being made by means of the piece's more obvious representational, expressive, and exemplificational properties.

Furthermore, such art-making involves not only the articulation of a content by means of a vehicle, but also shared understandings that enable content to be articulated *in distinctive ways*. We noted Wollheim's own characterization of what is distinctive about the kind of regard required to grasp the artistic statement articulated through an artistic vehicle—his claim that the spectator should make the artistic vehicle 'the object of an ever-increasing or deepening attention'. But, as just described, these distinctive

ways of articulating content resemble what Goodman (1976: 252–5; 1978: 67–70) described as 'symptoms of the aesthetic'.

In the Rainer example and, I have argued, other artistic examples,

(1) *close attention* to the details of the artistic vehicle is necessary if we are to correctly determine the content articulated,

(2) artistic vehicles often serve to *exemplify* some of their properties,

(3) many of the *different properties* of the vehicle contribute to the articulation of content, and finally .

(4) the vehicle not only serves a number of distinct articulatory functions, but does so in a '*hierarchical*' manner, 'higher level' content—up to the assumed 'point' of the work—being articulated through lower level content.

These features seem to be those characterized in more technical terms by Goodman as the 'syntactic' and 'semantic' density of the symbol system to which the artistic vehicle belongs, the use of exemplification, the relative 'repleteness' of the artistic symbol, and the serving of multiple and complexly interrelated referential functions.

The suggestion, then, is that what distinguishes artworks from other artefacts in which we may take an interrogative interest is not, per se, the elements of which they are composed or the way in which those elements are put together, but how the assemblage of elements that make up the artistic vehicle is intended to function in the articulation of content. It is in virtue of these distinctive ways of articulating content—let us call them, for convenience, 'Goodmanian'—that artworks must be regarded in a distinctive way. Art presupposes shared understandings in the community of intended receivers that 'getting' certain artefacts requires such a regard. Makers of artworks presuppose such understandings in articulating content in their works. While an L-artistic interest—that is, an interest in the manner in which a content is articulated in a medium—is indeed a necessary ingredient in the appreciation of something as an artwork, such appreciation also requires an artistic regard in the sense just described in virtue of how the content of a work is articulated by the maker of the artistic vehicle.

3. The Art of 'Artful Pornography'

The question to which we can now return is whether there can be artworks, so conceived, that are also works of pornography, in a sense that justifies saying that we have pornographic art that can be appreciated as such. We have assumed, with Levinson, that a pornographic representation is one whose intended purpose is to produce sexual arousal and possible release through the receiver's attention to its representational content. Two necessary conditions for a pornographic representation to be an artwork, on the proposed account of artworks, are that (a) it should intentionally articulate its content in a Goodmanian manner and thereby call for an artistic regard on the part of the receiver if that content is to be grasped, and that (b) it should require the taking of a L-artistic interest for its proper appreciation. Are there examples of pornographic representations—defined in terms of their intended responses—that meet these conditions?

We may first set aside certain cases that might initially appear promising to those in search of pornographic art. In such cases, we have, as we might put it, the use of pornographic means for artistic ends. Material that would characteristically be offered with pornographic intent—with the intention of producing sexual arousal—is used as a resource in the generation of something in which we are intended to take an L-artistic interest. Levinson offers, as an example, Nicholson Baker's *Vox*, which, he argues, is a work that *mimics* pornography for literary ends. Such a work can be sexually stimulating, since a simulacrum of something often has some of the same powers as the thing itself. But this is literary art rather than pornography because its paramount aim is not pornographic—to produce sexual arousal and release—but 'psychological, parodistic, and pyrotechnic' (2005: 234), the simulation of pornography being a necessary means to these ends. One might offer a similar analysis of a visual work such as Jeff Koons's *Red Butt*. Indeed, many of the purported examples of 'pornographic literature' presented by Sontag might also fit into this category, given her claim that the real aim of such pieces is not sexual arousal but the psychic dislocation of the receiver.

The interesting cases are instances of what Levinson terms 'artful pornography', pornography that works precisely by engaging the artistic discriminations of the viewer. Artful pornography is *pornographic* because it aims at

sexual arousal and release, and *artful* because it employs the devices of art as a means to this end. It does so because 'some images are taken to be more arousing when we attend to aspects of the image as such, such as form, style, or embodied point of view' (2005: 236). Here, rather than using pornographic means to further an artistic end, we have the use of artistic means to further a pornographic end.

Levinson grants that artful pornography poses the most serious challenge to his claim that there cannot be pornographic art. Our previous reflections suggest that whether at least some artful pornography can qualify as pornographic art will depend upon two things:

(a) does artful pornography include cases where we have a Goodmanian articulation of the representational content of a pornographic representation so that the content intended to be arousing can only be fully accessed by means of an artistic regard? And, if so,

(b) does the fact that the overriding aim of the representation is sexual arousal prevent the representation from being art by preventing us from taking an L-artistic interest in it?

I think there are clear examples of artful pornography that justify a positive answer to the first of these questions. Kieran, for example, writes, of certain of Rodin's nude drawings, that

in such drawings we have an emphasis on compositional and design elements, some of which are a striking deviation from classical nude studies, in order to evoke sexual stimulation by sexually explicit means... The specifically artistically innovative developments in Rodin's line drawing enabled him to characterize the lines of action, sexual embraces, and actions in a more athletic, impulsive, vigorous manner which enhances the evocation of sexual arousal. (2001: 37)

And of Klimt's erotic drawings, he notes that

formal artistic techniques are deployed in a highly imaginative manner in order to emphasize explicitly sexual parts, features, actions, and states—including the use of extreme close-up views, foreshortening, exaggerated perspective, distortions of posture and proportion, shifts in framing, heightened contrasts between right-angles and curves of the body. The effect is not only beautiful in terms of the grace of line drawing and structural composition, but serves to draw attention to sexual features such as the genitals, breasts, buttocks and open legs. Furthermore, these formal

artistic techniques are used to emphasize our awareness of the states of sexual absorption, sensual pleasure, or languid sexuality represented. (2001: 39–40)

Since Levinson grants the possibility of pornographic representations that use artistic means in this way, we can turn to our second concern. Does the fact that the aim (or the overriding aim) of the representation is sexual arousal prevent artful pornography from being art?

Levinson thinks he can accommodate works of artful pornography without allowing for pornographic art. Either such artefacts are works of erotic art or they are not works of art at all. He maintains that 'so long as the image is being regarded as pornography, aspects of the image are not being appreciated for their own sakes, but only as instruments to more effective arousal, fantasy and release' (2005: 236). The suggestion, I take it, is that one cannot at a given time both take an L-artistic interest in a representation and 'appreciate' that image as pornography. If we are led by the 'art' of artful pornography to take an L-artistic interest in it, then it will, in proportion to our L-artistic interest, fail to achieve its purpose as pornography. On the other hand, where the latter purpose is achieved, then, 'if such drawing of attention [to the artistic aspect of the image] is entirely in the service of arousal aimed at, the image remains pornography, however artful, and not art' (2005: 237).

The most difficult cases, Levinson acknowledges, are works like Courbet's *The Origin of the World* and some of Schiele's explicit drawings of women and young girls. These were created with the non-artistic primary intended function of sexually arousing those who commissioned or bought them. Levinson maintains that the artistic status of these pieces as erotic art can be upheld, in spite of this, as long as there was also an 'equally robust' intention on the part of the artist that we take an L-artistic interest in them. Otherwise we must view such pieces as pornography, and thus not art, even though they may *reward* our taking an L-artistic interest in them.

In assessing these claims, it is important to distinguish three things: (i) the nature of a pornographic *interest* or purpose; (ii) the nature of *pornography*, and (iii) the conditions under which we would have *pornographic art*.

(i) To take a pornographic interest in a representation, Levinson claims with some plausibility, precludes taking at the same time an interest in the artistic aspects of that representation. Even if an engagement with a representation R as an artistic manifold is necessary in order to grasp its

sexually arousing content, satisfying the pornographic interest in R at t is not compatible with taking an L-artistic interest in R at t. This is a claim about the impossibility at a time of jointly satisfying distinct interests in an object.

(ii) It is a separate claim that something made with the intention that it satisfy a pornographic interest by producing sexual arousal and release *counts as pornography* only if the maker lacks a counterbalancing intention that it be used to satisfy an L-artistic interest, and that, if there is such a counterbalancing intention, then we have erotic art. This is a very puzzling claim on Levinson's part, given his distinction between the erotic, which aims at sexual *stimulation*, and the pornographic, which aims at sexual *arousal*. If an intended function of some works by Courbet and Schiele was to produce sexual arousal rather than stimulation, how could a counterbalancing intention that they satisfy an L-artistic interest make them *erotic* art?

(iii) More crucially, it is also a separate claim that, for an artfully pornographic artefact to qualify as pornographic art, it must be possible for receivers to satisfy both a pornographic interest and an L-artistic interest in that artefact at the very same time. Such a requirement seems ill-motivated, for at least two reasons.

First, it is not entailed by the thesis that a pornographic interest and an L-artistic interest in an object cannot be jointly satisfied at a time. It is quite compatible with this thesis that a maker can intend that receivers take both a pornographic and an artistic interest in an artefact, albeit *not at the same time*, or that *some* receivers take a pornographic interest and *others* an artistic interest in that artefact. Why would this not suffice for pornographic art? In the latter case, it might be questioned whether we really have something that counts as—and can be appreciated as—pornographic art, rather than something admitting of two unrelated uses.[2] The former case is more interesting however, as we shall now see.

Second, Levinson's suggestion that something can be pornographic art only if it can be appreciated as both art and pornography at the same time seems inconsistent with our more general practice concerning representations that have a non-artistic primary intended function. Consider, for

[2] Levinson raised this concern in responding to an earlier draft of this chapter.

example, the religious images produced by Renaissance artists such as Perugino as discussed by Michael Baxandall (1988: 40–56). These images are religious not merely in their subject matter but also in having the primary intended function of serving as stimuli to religious reflection. They were intended to serve this function by providing a template upon which the religious consumer could project her pre-existing concrete imaginings, associating biblical scenes and characters with people and places in her own experience, so as to more effectively and affectively engage with biblical stories and themes. In the case of such paintings, we can give arguments that parallel those given by Levinson for the mutual exclusivity at a particular time of a pornographic interest and an L-artistic interest in a representation. The intended effect on the receiver of such a religious painting is presumably tempered if, while gazing on the image, she admires the artful way in which the medium has been used to articulate the content bearing on its religious function.

The problem is structurally the same in each case: in serving the non-artistic primary intended function, the 'artful' properties of the artistic manifold are used as a means to elicit responses not to the manifold itself but to the imaginings generated through paying artistic regard to the manifold. In fact, it is rarely the case that we can simultaneously do what is necessary to 'appreciate' an artefact with a non-artistic primary intended function *as fulfilling that function*—that is, to have it fulfil that function for us—and do what is necessary to appreciate such an artwork *on the basis of its artistic qualities*—that is, take an L-artistic interest in it. Indeed, even in the case of art with an *artistic* primary intended function, we often cannot simultaneously both (a) respond aesthetically and emotionally to a work in the way that the artist intended, and (b) take an L-artistic interest in it—although much of the pleasure we get in appreciating art resides not in our immediate aesthetic or emotional response to the artistic manifold per se, but in our delight and wonder at how the artist has used that manifold to elicit such a response.

Why don't we think that this undermines the claim that Perugino's paintings are works of religious art, and the same, *mutatis mutandis*, for other artefacts with non-artistic primary intended functions that are generally treated as artworks? It is, it would seem, because in such cases two conditions are generally satisfied:

(a) the articulation of the artistic content whereby the work is intended to serve its primary non-artistic function is 'Goodmanian' in the specified sense, so that grasping that content requires an artistic regard;

(b) we assume that it is intended that the artefact also be appreciable for the way in which it so articulates its content, and thus that we take an L-artistic interest in it.

If these conditions are satisfied, we surely have a work of religious art, and not merely a religious artefact that can also be appreciated as an artwork.

Levinson, as we have seen, thinks there is a further requirement if something is to count as pornographic art: that 'attending to an image in order to be sexually aroused by it does not conflict with attending to an image for its artistic features' (2005: 236). But this requirement, extended more generally to artefacts with non-artistic primary intended functions, would artistically disenfranchise many artefacts with religious and political primary intended functions generally regarded as artworks, and also most 'tribal' artefacts designed for use in religious or cultural ceremonies. This suggests that we should follow our practice elsewhere, and classify something generated with a primary pornographic interest as pornographic art if it is 'artful' and that interest is, and is intended to be, compatible with an L-artistic interest, as it surely is in the case of Schiele's drawings.

We may recall that one motivation for Levinson's insistence on the foregoing requirement for pornographic art is his claim that only if an artefact can be appreciated both pornographically and artistically at the same time can it be appreciated as pornographic art—otherwise, it is rightly viewed as pornography in which we can take a separate artistic interest. Again, however, the parallel with artefacts having a religious function is informative. To appreciate a painting by Perugino as a work of religious art is not to simultaneously (a) take an L-artistic interest in the Goodmanian ways it which it articulates its religious content, and (b) 'appreciate' it as a religious artefact by using it as a stimulus to religious meditation. It is, rather, to do the former while taking proper account of the demands that the religious function of the work imposes on its contents. Analogously, we appreciate an artefact as a work of pornographic art insofar our L-artistic interest in the Goodmanian articulation of its content takes proper account of the demands imposed on *this* content by its pornographic function. Indeed, the same basic

model applies to the appreciation of any artwork qua artwork, whether its primary intended function is artistic or non-artistic.

We noted earlier Levinson's proposed distinction between erotic art and pornography in terms of aiming at sexual *stimulation* and aiming at sexual *arousal*. As we saw earlier, he also suggests that there is a middle position—erotica—between pornography and erotic art. But erotica is not actually intermediate between the other two: it is erotic art without the counterbalancing artistic intention—in other words, it is the erotic equivalent of pornography as Levinson proposes to understand it. But where, then, is the pornographic equivalent of erotic art, something that aims at sexual arousal yet also intends an L-artistic interest? As noted above, Levinson's own schema counts against his suggestion that we can 'save' the graphic works of Schiele and Courbet by classifying them as erotic art. They are rightly viewed, I think, as the pornographic equivalent of erotic art, a missing but necessary category in Levinson's schematic representation of the terrain.

4. Conclusion

Pornographic art, I have suggested, is no more problematic than other categories of artworks defined in terms of a non-artistic primary intended function. I have defended the idea that we can have pornographic art when

(1) we have a representation with primary pornographic intent whose focus of pornographic interest is articulated in a 'Goodmanian' manner requiring an artistic regard, and

(2) there is a further intention that the representation be appreciable in virtue of this fact—an intention that we take an L-artistic interest in the representation.

In such a case, we have something that is an artwork in virtue of the manner in which it articulates its content and its intended artistic interest, and is pornography in virtue of its primary intended function. As with religious and political art, we classify certain artworks as pornographic art by reference to their non-artistic primary intended functions. It isn't necessary, for such things to be artworks, that in putting the work to its primary use we can, or do, at the same time take an artistic interest in it. All that is required, over and

above the use of Goodmanian techniques in realizing the primary intended non-artistic purpose, is a realistic and realizable intention that receivers also take an L-artistic interest in the representation. Such an intention is clearly present in the case of religious paintings by artists such as Perugino and pornographic representations by artists such as Schiele.

In closing, however, I want to suggest a more radical conclusion. I have granted thus far Levinson's claim that it is a *necessary* condition for the arthood of an artefact that its maker intend that receivers takes an L-artistic interest in it, an interest 'for its own sake' in how the artefact articulates its content. As applied to artefacts generated with a non-artistic primary intended function, the requirement is that the maker also intend such an interest. But there is a more intimate relation between the adoption of an artistic regard, in my sense, towards certain artefacts, and the success of those artefacts in satisfying an ulterior non-artistic interest. In the case of artful pornography, or 'artful' representations with any non-artistic primary intended function, the receiver's artistic regard directed at the artefact is a precondition for the intended satisfaction of the non-artistic interest at which the artefact aims.

Is it also necessary, if such images are to be artworks, that their makers intend that receivers take in them an L-artistic interest? Consider the cinema of Godard's Dziga-Vertov period. It is undeniable that we can take an L-artistic interest in such films, commensurate with the interest that we take in Godard's earlier and later films. And in grasping the content of the Dziga-Vertov period films and grasping the points that Godard is making, we surely need to subject the films to an artistic regard in the sense elucidated earlier. But it is very implausible that, in taking such an L-artistic interest in these films, we are complying with Godard's intentions. While the films articulate their content in a 'Goodmanian' manner that requires that we subject them to such a regard, the intention is arguably that we then respond to the content thereby articulated, not that we 'dwell on the representation' in the name of aesthetic delight. Yet surely these films are artworks.

What should we say about such cases? To pursue this question would, I think, make apparent much deeper differences between Levinson's views about the nature of art and the views sketched in this chapter. While both Levinson and I make the notion of artistic regard central to our understanding what makes certain artefacts artworks, our elucidations of this notion reflect very different methodological assumptions.

Levinson appeals to a notion of 'artistic regard' in developing his histor-ical/intentional definition of art (1979). He claims that what it is to correctly regard an artwork varies both synchronically and diachronically. Neverthe-less, we can define what it is for an artefact to be an artwork in terms of its maker's intention, opaquely or transparently construed, that the artefact be regarded in a way that is a correct way of regarding those things already accepted as artworks. Crucially, 'correct regard' here is correct regard *as an artwork*. The fact that Perugino's paintings—undeniably artworks—were correctly regarded as objects to stimulate religious meditation does not mean, for Levinson, that if I now create an artefact that is correctly regarded as a stimulus to religious meditation—say, a poster announcing that the rapture is impending—what I create is an artwork. What the various kinds of artistic regards that play a role in Levinson's definition of art *do* have in common, therefore, is that they are all ways of *appreciating artefacts as artworks*. Thus there is in fact no contradiction between the historical/intentional definition of art and Levinson's assumption, in discussing pornography, that the maker of an artwork must intend that receivers take an L-artistic interest in her product. L-artistic interest is just the genus of which different kinds of historically varying artistic regard, in Levinson's sense, are the species. This is why Levinson cannot countenance my present proposal that an intended L-artistic interest is *not* necessary for an artefact to be an artwork. For, without such an intended interest, there can be no intention that the product be regarded, opaquely or transparently, in a way it is correct to regard existing artworks: any such intention is, for Levinson, a species of intended L-artistic interest.

Levinson assumes, therefore, that at least one of the primary intended functions of any artefact that is an artwork is to satisfy an L-artistic interest, to be appreciated 'for its own sake' as an artwork, whatever other functions it may have. I, however, begin from the assumption that, viewed historically and cross-culturally, the very idea of artworks as artefacts intended princi-pally to be appreciated 'for their own sake' is somewhat of an aberration, historically grounded in a misunderstanding of 'German Aesthetics', and in particular of Kantian talk of 'disinterested pleasure' in the *Third Critique* (see Wilcox 1953). Viewed historically and cross-culturally, the vast majority of those artefacts generally and rightly viewed as artworks were made with a non-artistic primary-intended function. I therefore begin with the question, what makes something art when it is *not* 'for art's sake'—when, that is, it is

not primarily intended to serve an L-artistic interest? I draw on Wollheim and Goodman in identifying a distinctive way in which certain artefacts articulate those contents that bear upon their performance of their artistic or non-artistic primary intended function. 'Art for art's sake' then, articulates its content in a Goodmanian manner without there being a *non-artistic* function that those contents are primarily intended to serve: the contents thereby articulated are intended to promote aesthetic delight. On my account, nothing necessitates that the maker of an artefact that is an artwork *intend* that receivers take an L-artistic interest in that artefact, although our *appreciation* of that artefact as an artwork requires that we take such an interest.

It is, I think, in terms of this underlying disagreement that we can best understand the different conclusions at which Levinson and I arrive when we ask whether there can be pornographic art. If so, it brings out another respect in which apparently peripheral questions in the philosophy of art, such as whether there can be pornographic artworks, can be valuable. For they help to bring to our attention more fundamental differences in our views as aestheticians.

References

Baxandall, M. (1985) *Patterns of Intention*. New Haven: Yale University Press.

—— (1988) *Painting and Experience in 15ᵗʰ Century Italy*, 2nd edn. Oxford: Oxford University Press.

Carroll, N., and Banes, S. (1982) 'Working and Dancing'. *Dance Research Journal* 15(1): 37–41.

Davies, D. (2004) *Art as Performance*. Oxford: Blackwell.

—— (2007) *Aesthetics and Literature*. London: Continuum.

—— (2011) *Philosophy of the Performing Arts*. Oxford: Blackwell.

Devereaux, M. (1998) 'Beauty and Evil: The Case of Leni Riefenstahl's *Triumph of the Will*'. In J. Levinson (ed.), *Aesthetics and Ethics: Essays at the Intersection*. Cambridge: Cambridge University Press, 227–56.

Gaut, B. (2007) *Art, Emotion and Ethics*. Oxford: Oxford University Press.

Goodman, N. (1976) *Languages of Art*, 2nd edn. Indianapolis: Hackett.

—— (1978) *Ways of Worldmaking*. Indianapolis: Hackett.

Gracyk, T. (1987) 'Pornography as Representation: Aesthetic Considerations'. *Journal of Aesthetic Education* 21(4): 103–21.

Kieran, M. (2001) 'Pornographic Art'. *Philosophy and Literature* 25(1): 31–45.

Levinson, J. (1979) 'Defining Art Historically'. *British Journal of Aesthetics* 19: 232–50.

—— (2005) 'Erotic Art and Pornographic Pictures'. *Philosophy of Literature* 29(1): 228–40.

Mag Uidhir, C. (2009) 'Why Pornography Can't Be Art'. *Philosophy and Literature* 33(1): 193–203.

Sontag, S. (1994) 'The Pornographic Imagination'. In *Styles of Radical Will*. London: Vintage. 35–73.

Wilcox, J. (1953) 'The Beginning of *L'art pour l'art*'. *Journal of Aesthetics and Art Criticism* 11(4): 360–77.

Wollheim, R. (1980) *Art and Its Objects*, 2nd edn. Cambridge: Cambridge University Press.

4

Is Pornographic Art Comparable to Religious Art? Reply to Davies

JERROLD LEVINSON

1. In the interests of simplicity and unambiguousness, when I speak of pornography in this commentary on David Davies's chapter I restrict myself to visual pornography, and moreover, to still pictures rather than moving ones. And along the way I will also confront, if only partially, some related criticisms of my position on pornography that have been offered elsewhere.[1]

How much of the issue about 'art versus pornography' is at root a verbal one? Certainly some of it is. However, that is not to say that how we make that distinction is without importance. For as we all know, firstly, language is power, and secondly, thoughts and words are intimately intertwined. In any case, if we define *pornography* as images whose primary, central, and justifying aim is to produce sexual *arousal*, and in the normal course of events, sexual *release*, in a target audience, then it seems unhelpful to insist that such images may also count as *art* simply because they sometimes display aesthetic properties typical of art, or because they might be appreciated for such properties as they possess when not being engaged with as pornography.

[1] In view of the fact that several of the chapters in this volume contain substantial critical discussion of the position taken in my paper 'Erotic Art and Pornographic Pictures', *Philosophy and Literature* 29 (2005), 228–40, and reprinted in *Contemplating Art* (Oxford University Press, 2006), a word of explanation is in order as to why I am responding only to the chapter by David Davies. The reason is twofold. First, it was to Davies's essay that I was specifically asked to respond when it was presented during one of the two conferences organized in connection with this volume, 'Aesthetics, Art, and Pornography' (Institute of Philosophy, London, June 2011). Second, to respond properly to all my critics in this volume would have been beyond both my powers and my patience.

If, on the other hand, one wants only to affirm that some works of art can have a significant pornographic *character* without ceasing to be art, and without becoming impossible to *appreciate* as art, then there is little objection to be made. Of course I here address only those who would crudely enfranchise as art almost all pornography that either lends itself to aesthetic appreciation or else succeeds as pornography partly in virtue of its formal fashioning. The case that David Davies presents for recognizing some pornography as art is, as one might expect, much more subtle than that, and will be examined in due course.

The issue of the proper boundaries of *art* and *porn* is thus not unimportant, but the more important issue concerns rather the relationship between a *pornographic* engagement with something and an *artistic* engagement with that same thing. More specifically, and dividing it into two parts, the issue is this. First, there is the question of the extent to which pornographic appreciation of images is *compatible* with artistic appreciation of them, where the latter involves at a minimum some concern for the form of the image in relation to its subject and perhaps, as Davies puts it, the manner in which the visual medium has been deployed to articulate some sort of content. Second, even if these two sorts of appreciation are in some fashion compatible, there is the question of whether they can reinforce one another in a *positive* way, rather than simply warring against one another.

2. Two minor points before I get to my main point, which concerns the twofold issue just sketched, and to which Davies's lucid chapter is largely devoted. The first such point is whether sexual explicitness might provide the principle of demarcation between erotic art and pornography among images aimed at evoking sexual interest, a suggestion to which Davies is friendlier than I am, though he does not ultimately embrace it. Even if the class of sexually explicit images and the class of pornographic images happens to coincide, thinking that the distinction between pornography and non-pornography really resides there would seem to be a sort of category mistake. I don't know how to argue it further, but categories such as that of pornography strike me as so clearly ones of either intention or function that an intrinsic feature such as explicitness of representation just appears to be of the wrong sort to mark out its boundaries as a class of representations.

The second such point is whether the characterization that Davies gives of the sort of interest calling for which serves to differentiate artworks 'from

other artefacts in which we may take an interrogative interest' is adequate to distinguish *artworks* from objects of *fine design*, such as a Mies van der Rohe chairs, a Wiener Werkstätte tea service, or even a Michael Graves household utensil for Target. And that is because it could be argued that the form of such objects, including how their component elements are related to one another, is indeed intended to articulate a content, and in much the same way that unequivocal artworks do. If that doubt is sustained it might incline one to introduce an intentional-historical element into the characterization of art in the broadest sense, such as I have argued for elsewhere. Davies's conception of the domain of artworks as circumscribed by distinctive ways in which such objects articulate their contents is by no means unattractive, but it would seem to have the defect of including too much, encompassing all artefacts whose design can be said to embody a meaning; it has perhaps also the defect of excluding too much, involving as it does a notion of success in articulation of content, something that leaves little or no room for failed or thoroughly bad art.

3. I turn now to the main business of Davies's chapter. The heart of Davies's opposition to my claim that the spheres of *art* and *pornography*, where the latter is understood in a strong sense, cannot overlap—and relatedly, that *pornographic* appreciation of an image on a given occasion effectively precludes *artistic* appreciation of that image—is the proposed analogy between *religious* art and alleged *pornographic* art, that is to say, the genre of images claimed by Davies and others to be both art *and* pornography. The idea is that religious art is art that, apart from its purely artistic mission, aims also to serve *religious* ends, and that it succeeds in doing so in many cases without failing in its *artistic* mission, which is to say, more or less, that it can be appreciated artistically and devotionally at the same time, and that there is no incompatibility between an artistic response and a devotional response to the image. Here is a concise statement of Davies' position on this point:

I shall argue that, although the kinds of response demanded by art and pornography differ, this is no obstacle to something's being both art and pornography in a sense that justifies the label 'pornographic art', where this is not simply a matter of lending itself to both artistic and pornographic uses. It is, I shall argue, no more difficult to see how there can be pornographic art than it is to see how there can be religious art, or satirical art, or political art, or indeed art that has any non-artistic primary intended function.

My disagreement with Davies here is located precisely at the phrase 'no more difficult' in the second sentence above. In my view it is *rather more* difficult to see how there can be pornographic art than to see how there can be those other sorts of art—religious, political, satirical, and so on—possessing primary functions apart from the purely artistic one. And that is because some non-artistic functions, and perhaps foremost among them, that to which pornography is devoted, *conflict strenuously* with the purely artistic function, while others do not. The question, as Davies succinctly puts it, is whether there can be 'pornographic art that is appreciated *as such*', that is, both pornographically and artistically. And after all I have heard and read to the contrary, I remain skeptical that there can be.

As Davies admits, we will not find plausible candidates among items that use pornographic *means*, mimicking or appropriating pornographic style or appearance, for artistic *ends*, such as certain novels by Henry Miller or Nicholson Baker, some paintings by Mel Ramos or Balthus, or some photographs by Cindy Sherman. Rather, as Davies goes on to say, plausible candidates for pornographic art are more likely to be found among items that use *artistic* means to further *pornographic* ends. Davies gives two conditions for such an item counting as an artwork, and a pornographic one, apart from its containing manifest sexual imagery. The first condition is that its representational content be articulated in an *artistic manner*, to which one must thus bring an *artistic regard* in order for that content to be grasped; the second condition, in effect, is that the sexual arousal which is to be achieved through grasp of such content if the item is also to be pornographic does not *preclude adoption* of an artistic regard toward the item in question.

Davies notes that we are agreed on the first condition's being met by a number of items, which yet leaves it open whether they should be classified as pornography rather than as erotic art. Our disagreement turns on the second condition. As Davies recalls, what I claim in my original essay is that it is effectively impossible at a given time to take both an artistic interest and a pornographic interest in an image. Thus of such an image, 'if we are led by the 'art' of artful pornography to take an artistic interest in it, then it will, in proportion to our artistic interest, fail to achieve its purpose as pornography.'[2]

[2] Davies, 'Pornography, Art, and the Intended Response of the Receiver', this volume.

This brings us to the heart of Davies's brief against my position, which I quote at length:

To take a pornographic interest in a representation, Levinson claims with some plausibility, precludes taking at the same time an interest in the artistic aspects of that representation. Even if an engagement with a representation R as an artistic manifold is necessary in order to grasp its sexually arousing content, satisfying the pornographic interest in R at t is not compatible with taking an artistic interest in R at t. This is a claim about the impossibility at a time of jointly satisfying distinct interests in an object. But it is a separate claim that something *counts as pornography* only if the maker intends that it *only* be used to satisfy a pornographic interest. Such a characterization of pornography as *exclusively* aimed at sexual arousal seems ill-motivated, for at least two reasons. First, it is not entailed by the thesis that a pornographic interest and an artistic interest in an object cannot be jointly satisfied at a time. It is quite compatible with this thesis that one can intend that receivers take *both* a pornographic and an artistic interest in the image, albeit *not at the same time*, or that *some* receivers take a pornographic interest and *others* an artistic interest in that artefact.

In that last sentence Davies identifies two ways in which something we might want to recognize as both art and pornography might come about. Regarding the second way, if there are such cases, they strike me as ones in which the creator's intention is in conflict with itself. At the very least, such a divided intention for the end with which an item is to be regarded—call that a *substantively* divided intention—would seem to doom such an item to unclear status as regards arthood, ending up as art *with respect to* some persons, and pornography *with respect to* other persons. Such relativity is not, I think, a result we should hasten to embrace. Regarding the first way, I offer two observations. The first observation is that a divided intention of that sort for the schedule on which an item is to be regarded—call that a *temporally* divided intention—is not a plausible attribution to artists such Egon Schiele, many of whose works clearly verge on pornography, yet arguably do not call for an oscillation between opposed kinds of regard but instead for a unitary if difficult to sustain regard just this side of pornographic.[3] The second

[3] Speaking of a highly erotic watercolor of Schiele of 1911, *Die Traum-Beschaute*, in which a relaxed, partly reclining woman unashamedly spreads her genitals for inspection, one art historian remarks as follows: 'The suggestive character of other works of his is here pushed further, yielding a vision profoundly concrete and direct. Through a delicate balance between realism and allusion Schiele holds to the razor's edge separating art from pure pornography' (Wolfgang Georg Fischer, *Schiele* (Cologne:

observation is that a temporally divided intention is not what is standardly found in other cases of artworks having other than purely artistic primary purposes, as I hope to show in a moment. But first I must recall Davies's second reason for resisting the idea that there is something problematic about a putative artwork inviting pornographic interest while also inviting artistic interest, and hence that art and pornography are best regarded as non-overlapping categories:

Levinson's suggestion that something can be pornography only if it is exclusively aimed at sexual arousal seems inconsistent with our more general practice concerning representations that have a non-artistic primary intended function. Consider, for example, the religious images produced by Renaissance artists such as Perugino . . . These images are religious not merely in their subject matter but also in having the primary intended function of serving as stimuli to religious reflection. They were intended to serve this function by providing a template upon which the religious consumer could project her pre-existing concrete imaginings . . . In the case of such paintings, we can give arguments that parallel those given by Levinson for the mutual exclusivity at a particular time of a pornographic interest and an L-artistic interest in a representation. The intended effect on the receiver of such a religious painting is presumably tempered if, while gazing on the image, she admires the artful way in which the medium has been used to articulate the content bearing on its religious function . . . It is in fact rarely the case that we can simultaneously do what is necessary to 'appreciate' an artefact with a non-artistic primary intended function *as fulfilling that function*—that is, to have it fulfil that function for us—and do what is necessary to appreciate such an artwork *on the basis of its artistic qualities*—that is, take an L-artistic interest in it.

Davies accordingly concludes that since none of that would be taken as a reason to deny that such paintings are both intended to serve religious purposes and at the same time unequivocally works of art, by parity there is no reason to deny that images intended to serve pornographic purposes through artistic means, and thus appreciable for their artistry, at least on other occasions, might also be at the same time works of art.

But with religious, political, and satirical art, the gambit of appeal to different times to appreciate, on the one hand, the artistry, and on the other hand, the fulfillment of a further function, is both misplaced and

Taschen, 2004), 52). The emphasis here on delicate balance, rather than unsteady oscillation, seems to me exactly right.

unnecessary. This should give us pause as to the validity of the parallel proposed. For with such art, appreciation of the artistry generally fuses with, goes hand in hand with, appreciation of the extra-artistic functioning. There is generally no real conflict between the two appreciations, no real obstacle to maintaining them together, no serious competition between them, no need to seesaw from one to the other. The religious, political, or satirical content is normally grasped in and through the vehicle in which it is embodied. What is required for appreciation of the whole is only a modicum of distributed attention and a small effort at integration of the formal and contentful dimensions of the experience.

I thus question the proposed analogy of pornographic art with religious or political or satirical art. In those latter cases the extra-artistic function does not present the same *kind* or *degree* of distracting conflict with the purely artistic function as it does in the pornographic case. The tempering of artistic attention is one thing, the undermining of it quite another. Otherwise put, we *can* appreciate, and on a given occasion of engagement, religious, political, and satirical artworks *both* as artistic articulations of a specific content *and* as fulfilling further functions—facilitating devout meditation, promoting social change, skewering human foibles, or the like—through such articulations. Whereas we *cannot*, or at any rate, cannot easily, do so with pornographic images treated as such, and not simply as erotic art that flirts with porn.

Pornographic pictures, even ones that seek to accomplish their pornographic mission through artistic means, are thus not, I claim, on a par with pictures having the other sorts of extra-artistic function that have been evoked. A pornographic picture is less like a religious painting meant in part to inspire devout meditation while beholding the image in question than it is like a totemic object meant to transport one to another state of mind and body altogether, in which one at some point inevitably loses contact with the image as an image. And that is so even in the posited cases of 'artful' pornography, where an artistic regard focused on the artistic articulation of the represented content is both intended and required in order for sexual arousal to occur. Because once it does, it is off to the races, and you can effectively kiss the image and its artistic appeal goodbye, while embracing in imagination—and embracing is here a euphemism—the object the image has, however artfully, put before you.

It might be objected that what I have characterized as a totemic way to take a representational artefact is precisely the way religious paintings such as Perugino's were treated in their day, and were expected to be treated, as fundamentally prompts to imaginative devotional absorption in Jesus, the Virgin Mary, or the Holy Spirit, perceptual interaction with the painting as a visual object being quite permissibly left by the wayside once such devotional absorption was launched. But if that is so, then in terms of what we *now* understand it to mean to treat something as art or engage with something as art, the consumers of such paintings simply were *not* doing that with those paintings, were *not* treating or engaging them as artworks.

Paintings such as Perugino's are unquestionably artworks, they were so when created, and they will always be so—provided, of course, that they continue to exist. But what does and has evolved over time is what it is to *appreciate something as art*—to regard it, treat it, interact with it as art. As we currently conceive that, and for at least two hundred years have roughly conceived that, appreciating something as art requires, at a minimum, appreciating its form, its content, and the relation between them, or perhaps equivalently, the way the given medium has been formally deployed to articulate a content, whether representational, expressive, or symbolic.

It is important to distinguish what is required for something to *be* or to *count* as art—which is what a theory of *arthood* attempts to elucidate—and what it is to *treat* or *regard* something as art, by our current conception of that—which is what a theory of *artistic appreciation* attempts to provide. The former I take to be handled by a suitably refined and extended intentional-historical account of arthood, where having the status of art is roughly being related to a preexisting history and tradition of art in the right way, while the latter I take to be handled by the idea that such appreciation involves at its core attention to the relation of form to content in a work, or alternatively, the manner in which its content is concretely articulated through the specific shaping of a medium.

So contrary to what Davies maintains, regarding-as-an-artwork as it is meant to function in my intentional-historical definition of art is *not* equivalent to, or even necessarily inclusive of, regarding-as-an-artwork in the *current*, more or less modernist, conception of that attitude. Roughly put, the former implies regard in any ensemble of ways that other ostensible, and normally preceding, artworks were or are correctly regarded as artworks, including among such ways those regarding their 'extra-artistic' functions

where present. So no more than Davies do I hold arthood to invariably require the specific intention of a maker of objects 'that receivers take in them an L-artistic interest', that is, an interest in them as works of art in the current, modernist sense. While it is true that, on my definitional character-ization of art, having the status of artwork involves reference to whatever was *accepted* as art at a given time and what it was, at that time, to correctly *regard* or *treat* such objects as art, that may not comport what we *now* take correctly regarding or treating artworks as artworks to require.

4. The notion of an item meant for both artistic and pornographic reception, if at different times and by different agents, as we have seen, is one evoked by Davies and others to support the conclusion that something can count as both pornography and as art. But consider a clothes brush with a broad and rounded handle that, as it happens, can be used as a dildo. Let us suppose it is even marketed as such, and suppose further that it is even a better clothes brush for having a handle of that sort. Is this item unequivocally a dildo? I suggest not. And yet this seems quite analogous to an image proposed for pornographic engagement, whose artistic qualities play a role in its so functioning, but where those qualities can also be appreciated for their own sake when they are not so functioning. And if that is so, then we would seem justified in returning the same negative answer to the question of whether such an image is unequivocally an artwork.

Consider a last, not entirely facetious, argument for why it is reasonable to operate pornography as a narrow category, one comprising erotic images wholly or predominantly intended as instruments of sexual arousal and release. Suppose one asks, What is a *whisky?*, meaning by that, the sort of alcoholic drink one might order in a bar. Would one count as a whisky a *whisky sour*, a *whisky and soda*, or—God forbid—a *Manhattan?* Clearly not. A *whisky* is whisky in a glass and nothing but—or at worst, an ice cube or two. I suggest, then, that we treat similarly the honorable—or perhaps not so honorable—category of *pornography*, and exclude from its scope produc-tions in which the pornographic element is significantly overlaid by the artistic element, often to the detriment of the former. The term 'artful quasi-porn' is perhaps an apt designation for productions of that sort, constituting a distinct category of items which are, strictly speaking, neither art nor porn.

II
Pornography, Imagination, and Fiction

5

Imagination, Fantasy, and Sexual Desire[1]

CAIN TODD

1. Transparent Appreciation

The main issue I am concerned with in this chapter is the nature of our appreciation of pornography; specifically with the question of whether such appreciation can be aesthetic, and hence whether pornography can have aesthetic value.[2] This issue, which I shall dub the 'appreciation problem', has generally been addressed in the context of the definitional debate about whether pornography can be art, and how to differentiate among art, erotic art, and pornography. I will not be concerned with the definitional issue here, at least not directly, but what I have to say about the nature of appreciation will have certain implications for it. In order to address these issues about appreciation I shall focus on visual pornographic representations, and I shall explore the nature of sexual desire and its relationship to the imagination. It will be important, in particular, to foreground three important distinctions: (i) between 'real' desire and imaginary desire; (ii) between

[1] The research for this chapter was partly funded by the Swiss National Science Foundation's NCCR for Affective Sciences. I would like to thank CISA and the Department of Philosophy at the University of Geneva for hosting me during this period and for stimulating discussion of some of the issues touched upon here. I would also like to thank Jerry Levinson and Hans Maes for the conference on art and pornography at the University of Kent at which this paper was first presented and for their help with preparing it for publication.
[2] Although in other contexts one might want to distinguish them, I will use the terms 'aesthetic' and 'artistic' interchangeably throughout.

fantasy and imagination; and (iii) between what I shall term 'fictional pornography' and 'non-fictional pornography'.

A particularly cogent and provocative way of articulating the kind of position I shall be concerned to reject consists in the following claim, which for reasons that will quickly become apparent I will refer to as the 'transparency thesis': even if a pornographic work may aim at and achieve a certain artistic/aesthetic interest and value, this is at best incidental to its pornographic interest and value, and it cannot be appreciated as both art and pornography at one and the same time. Why? Because attention to and appreciation of its aesthetic features, qua aesthetic, somehow precludes attention to and appreciation of its pornographic content, qua pornographic—and vice versa. This view can be drawn, for instance, from Jerrold Levinson's (2005) paper 'Erotic Art and Pornographic Pictures':

an image that has an artistic interest, dimension, or intent is one that is not simply *seen through*, or *seen past*, leaving one, at least in imagination, face to face with its subject. Images with an artistic dimension are thus to some extent *opaque*, rather than *transparent*. In other words, with artistic images we are invited to dwell on features of the image itself, and not merely on what the image represents. Both erotica and pornography predominantly aim at sexually affecting the viewer, one with an eye toward stimulation, the other with an eye toward arousal. They accordingly do not seek to have attention rest on the vehicle of such stimulation or arousal, the medium through which the sexual content is communicated or presented. (232)[3]

Essentially a surrogate for sex, the aims of pornography, Levinson holds, are best fulfilled by media that exhibit the most transparency, namely film and photography. For in appreciating pornography we are interested in focusing on the objects (or rather, subjects) represented, not in appreciating the various imagistic and stylistic features employed to convey this representational content. In fact, the claim is stronger than this might suggest. It is not just that we are not interested in, or that the aim is not to focus attention on the form/vehicle/medium conveying the pornographic content; it is that attending to the medium itself necessarily *hinders* or *undermines* attention to

[3] 'Erotic art, though aimed in part at sexually affecting the viewer, at stimulating sexual thoughts and feelings . . . also aims in some measure to draw the viewer's attention to the vehicle, inviting the viewer to contemplate the relationship between the stimulation achieved and the means employed to achieve it . . .' (232).

what the image represents. This is clear in his objection to Matthew Kieran's (2001) attempt to argue that certain works of art, such as Klimt's erotic drawings, are pornographic but not thereby bereft of artistic value and interest:

It is one thing to say that certain artistic *devices*, masterfully deployed, can enhance the erotic charge of a representation. It is quite another to say that a viewer's *focusing on* those devices will enhance the representation's erotic charge for the viewer, that is, render it more stimulating or arousing. There is every reason to think it would not, that it will rather temper the stimulation or arousal involved, replacing what is thus lost, however, with a portion of aesthetic pleasure. (Ibid. 234)

Pornography and art are, Levinson claims, to be differentiated in virtue of their aims as these relate to the role of the features of the medium in inviting our attention and interest. Pornography 'enjoins treatment of the image as transparent, as simply presenting its subject for sexual fantasizing, thus *entailing inattention* to the form or fashioning of the image' (Ibid. 236–7).[4]

It is important to note that aesthetic interest is here being identified with interest in the properties and features of the medium itself, an identification that in turn rests on a presupposed distinction between what for the moment we may loosely call 'form' and 'content'. In order to assess these claims and to gain a clearer grasp of just what this distinction consists in, we need to look more closely at what the relevant 'medium awareness' is. What are the relevant features of the representational medium to which we attend when aesthetically engaging with an artwork, features that, in the case of visual works such as films, render their images opaque rather than transparent?

I shall indiscriminately refer to such features as 'formal features', 'aesthetic features', 'features of the medium' or 'representational features'. Roughly, they constitute any of those elements that serve as the vehicles whereby the content is represented, and which determine the way in which the content is conveyed and perceived. We can divide such features into two broad classes: (a) perceptual features, and (b) non-perceptual features. In the case of film, in class (a), for example, we find sound, lighting, camera angles and

[4] '[Pornography] induces you, in the name of arousal and release, to ignore the representation so as to get at the represented, [erotic art] induces you, in the name of aesthetic delight, to dwell on the representation and to contemplate it in relation to the stimulating or arousing qualities of what is represented' (234).

perspectives, the screen itself—roughly all those elements which combine to give the film the 'look' that it has, that constitute our perceptual experience of the film. In class (b) are located elements that seem to be strictly non-perceptual but that nonetheless play some sort of role in our overall film experience, such as background knowledge that in some yet to be specified way imbues and organizes this experience. For example, narrative structure, genre, authorial intentions, directorial decisions, and so on.

The precise relationship between these two classes, and the connection between them and our attention to and appreciation of the 'content' that is represented through them, is a complex and controversial issue, particularly in philosophical discussions of film experience (see Davies 2003). At least one influential account, however, suggests that the transparency of which Levinson speaks simply does not occur in our experience of film, pornographic or otherwise.

Greg Currie (1995) holds that when watching a film the content of my experience is never simply 'as of seeing' X, but always of seeing X-as-representation. That is, I am always experiencing what is represented in a film *as* representations, not directly *as* what is represented, which would be the case were I, for instance, to have the perceptual illusion that I am really seeing Xs. In other words, we are always aware of the representational nature of what we are watching. However 'realistic', our film experience, we never suffer from perceptual illusion. We are always medium-aware in the sense that we experience or see the film *as an X-representation*, rather than seeing it *as an X*.

Put like this, however, it does little to undermine the transparency thesis, for our awareness of pornography as a representation is not obviously incompatible with us not dwelling on the features of the representational images when appreciating the pornographic content of those images. We do not suffer from the perceptual illusion that we are *actually* watching, say, some people indulging their sexual appetites, but we are arguably nonetheless appreciating what is depicted *solely for* its sexually arousing content when appreciating it qua pornography.[5]

[5] One could compare this to a similar position that might be adopted with respect to the paradox of fiction—the problem of how one can respond emotionally to what one knows is merely fictional. That is, it could be argued that our normal emotional responses require that one is not *fully*, occurrently, actively attending to the fictionality *as such* of the object (and hence one's epistemic relation to this object) towards which one's emotions are directed. This is compatible with our being *passively* aware of p-as-

It seems, however, that our film experience is also necessarily penetrated by an awareness of extra-narrative or extra-fictional features, such as the inferences we make about the fictional truths in a story which require some attention to elements in class (b): authorial intentions, hypothetical narrators, genre knowledge, and so on. It is, after all, central to the appreciation and understanding of a fictional narrative that we recognize that things are told *for a reason*. In other words, the content of our perceptual experience is somehow penetrated or imbued by those extra-perceptual elements I listed in class (b).

There is some debate about whether this strongly cognitivist account can adequately explain the perceptual content of film experience. I will not enter this debate here, but it is sufficient for our purposes to note that in film experience not only can we switch between attention to formal features, such as the style and camera angles, and the content which these convey; we can also experience the kind of 'twofoldness' that Richard Wollheim thought characterized our experience of painted depictions. Indeed, it is arguably a *sine qua non* of normal film experience that we simultaneously attend to something both as a representation and as what is represented. Appealing to trompe l'oeil depictions, David Davies (2003), in the process of attacking Currie's account, argues that we must be able to differentiate between the following two situations: (a) I look at the trompe l'oeil, realizing it is a trompe l'oeil, but I still see it *as* what it represents; (b) I look at the same trompe l'oeil, still realizing that it is a trompe l'oeil, but now I see it *as* a representation (Davies 2003: 240–1). The difference here, he rightly holds, lies in the perception, and not, *contra* Currie, in the thought. The thought, as it were, pervades the perception.

The important point here is that our perceptual experience of what is represented in a film is necessarily 'imbued' with the features in class (a) that govern the way in which it is represented, and also by the non-perceptual elements listed in class (b). In short, it looks like any plausible account of film experience must require that form and content cannot be separated in the way that Levinson's transparency thesis apparently requires, and presupposes, in order to differentiate between pornographic and artistic appreciation. There simply is no such thing as complete transparency in film viewing.

fiction, however, since all that this requires is not *actively* attending *fully* to this fact whilst involved in the relevant propositional imagining.

Yet this too fails to get to the heart of the transparency thesis. To see why, we must note that the nature of our awareness of 'formal features' may refer to a number of different types and degrees of attention, interest, and perceptual content. There seem to me to be at least three ways of under-standing this awareness that require careful differentiating: (i) the features play some more or less peripheral role in determining how the content is perceived; (ii) we can pay more or less disinterested attention to the features, perhaps oscillating between attending to them and attending to the content they are used to represent; (iii) we focus fully and attentively on the formal features with the intention of appreciating them, as it were, for their own sake.

It seems that the transparency claim is properly construed as concerning the last category just listed; that is, with the role of occurrent attention to and appreciation of formal features, that is, features of aesthetic interest. Inter-preted this way, the claim is not that, *generally*, opaqueness of and attention to the medium, to the representation *as* representation, undermines or hinders attention to what is represented. For this is clearly not the case in our usual appreciation of artworks, including films, where it seems that our attention just is devoted equally to both form and content and the relation between them. The issue concerns the possibility of *simultaneous* appreci-ation of something *as* art and *as* pornography.

The problem thus appears to be specific to the appreciation of pornog-raphy qua pornography. To the extent that we attend to the formal features of the medium, appreciating them for their own sake, we cease to take a pornographic interest in the representation—its pornographic content is occluded from our attention and interest. This is brought out in Levinson's reply to the objection that 'some pornography works *precisely by engaging* the artistic interest of the viewer...[inviting] attention to their artistic aspects *precisely so as to* enhance sexual arousal or fantasy involvement on the viewer's part' (Levinson 2005: 236). Suggesting that this represents a complex mode of pornography aimed at a cognitively atypical viewer, he responds thus:

even in such cases, so long as the image is being regarded as pornography, aspects of the image are not being appreciated for their own sakes, but only as instruments to more effective arousal, fantasy, and release . . . if such drawing of attention [to artistic

aspects of the image] is entirely in the service of arousal aimed at, then the image remains pornography, however artful, and not art. (236–7)

Thus the transparency thesis seems to be twofold: (1) Generally, (invited) attention to the medium [i.e. opacity] hinders or undermines (invited) pornographic interest (which requires transparency); (2) However, in unusual, cognitively odd cases where opacity actually accentuates the sexually arousing nature of the pornographic content, (i) the images' features are not being appreciated *for their own sakes*, and [hence] (ii) the image remains pornography.

Pornography can thus be distinguished from art and erotic art in virtue of the kind of attention it invites and sustains. Levinson's own position seems to be aimed directly at this question, and he concentrates on defending the idea that one cannot coherently and successfully aim at two incompatible audience responses. But as we are more interested in the nature of this attention and the appreciative states involved, we can avoid the definitional question and can formulate it instead as a claim about the psychological possibility of particular types of appreciative attitudes. Aesthetic interest requires, and pornographic interest requires the absence of, either opaqueness and/or appreciation of the relevant formal features *for their own sake*. To the extent that one pays attention to and appreciates formal features for their own sake, to that extent our interest ceases to be in the pornographic content qua pornographic. Hence we have this:

Transparency Thesis: Simultaneous and full occurrent attention to and appreciation of pornographic content (qua pornographic) and the formal and/or aesthetic features in virtue of which it is represented (qua aesthetic) is psychologically impossible.

So the question we must address is whether this is true, and if so what makes it true.[6] It appears that its truth must depend essentially on the specifically *sexually* arousing aim of the pornographic content, and that this is undermined by (and in turn undermines) aesthetic attention to and appreciation of the medium features for their own sake. But what is it about the nature of the sexual arousal and desire involved in an interest in

[6] Although he attacks Levinson's argument understood as a claim about simultaneous intentions, Maes (2011) nonetheless upholds the transparency thesis as I formulate it here.

pornographic images that is necessarily precluded or hindered (or at least weakened) by our attention to those features of the image 'for their own sake' that constitute the vehicle for such content?

2. Fantasy Desire

Some light is shed on this question in Roger Scruton's (1983) account of the nature of fantasy and desire, including sexual desire, an account that appears to lend independent support to the transparency thesis. Scruton argues that fantasy is a property of a desire, and a desire exhibits fantasy when: (i) its object in thought is not the object towards which it is expressed, or which it pursues; (ii) the object pursued acts as substitute for the object in thought; and (iii) the pursuit of the substitute is to be explained in terms of a personal prohibition (129). Thus, in short, fantasy is 'real desire which, through prohibition, seeks an unreal, but realized, object' (130).

The idea is that fantasy desires seek satisfaction in objects that serve as surrogates for the real thing which is prohibited from being, so to speak, 'really' pursued. Scruton gives the example of a fascination with death and suffering where the desire to see real cases is prohibited from being fulfilled and hence turns instead to realistic portrayals that substitute for, or serve as surrogate objects for, its satisfaction. Importantly for our discussion thus far, Scruton makes two central claims. The first concerns the nature of the fantasy object, and offers an insightful way of understanding the transparency claim with respect to cinematic representations:

a fantasy will seek to gratify itself, not in the delicately suggestive, but in the grossly obvious, or explicit. Thus a fantasy desire will characteristically seek, not a highly mannered or literary description, nor a painterly portrayal, of its chosen subject, but a perfect simulacrum—such as a waxwork, or a photograph. It eschews style and convention, since these constitute impediments to the construction of the surrogate object...The ideal fantasy object is perfectly 'realized', while remaining wholly unreal. It 'leaves nothing to the imagination': at the same time it is to be understood only as a simulacrum and not as the thing itself. (129)

Scruton thus argues that much interest in the cinema is fantasy interest, in which the camera is subject to a 'realization principle'. The second relevant claim concerns the nature of the fantasy desire, which Scruton stresses is a real desire:

The subject of a fantasy really does want something. This is brought out by the fact that, in the case of sexual fantasy, the sexual experience may be pursued *through* the fantasy object, and attached to it by a definite onanistic activity. The subject wants something, but he wants it *in the form of a substitute*. This desire has its origin in, and is nurtured by, impulses which govern his general behaviour. Objects can be found to gratify his fantasy; but the fantasy is grounded in something that he really feels. (130)

Scruton's account thus appears to shed some light on what it is about the sexual interest involved in appreciating visual pornography that precludes simultaneous aesthetic appreciation. The desire born of sexual fantasy necessarily seeks satisfaction in the kinds of surrogate objects that pornographic images readily provide. Moreover, by its very nature, this fantasy desire requires the utmost transparency for its satisfaction and accordingly will shun the frustrating diversion that attention to artifice creates. Hence, in cases where we are caught up in attending to features of the medium that thereby serve to enhance our arousal, our *aim* is nonetheless governed *solely* by a real desire to satisfy our fantasy. The appreciation of the features of the image is therefore entirely subservient to this aim, which by its very nature undermines the capacity simultaneously to appreciate them for their own sake.

This idea is explicated more fully by the central distinction Scruton draws between fantasy and imagination. The imagination, he holds, unlike fantasy, is constrained by a 'reality principle' consisting in the aim of understanding the true nature of its objects. As such, genuine artistic appreciation, governed by the imagination, is concerned with plausibility and objective truth; the responses to art dependent upon the imagination are 'disciplined by the world, whereas the nature of the fantasy object is, in contrast, *dictated* by the passion which seeks to realize it' (131). The desires concomitant with our imaginative engagement with art are not real desires, whereas in fantasy 'there is a real feeling which, in being prohibited, compels an unreal object for its gratification' (132). It is thus this distinction that underpins the difference, for Scruton, between pornography and erotic art. (See also Scruton 2006.)

Thus, we have a distinction drawn here between, on the one hand, those sexual desires that exhibit fantasy, and which aim at their satisfaction through a transparent engagement with the kinds of substitutes readily provided by visual pornographic representations; and on the other hand, 'non-fantasy'

sexual desires which aim at the 'imaginative identification with the sexual activity of another' (Scruton 2006: 346). Fantasy and imagination, one might say, have different directions of fit: the former, like desire, involves a world-to-mind fit, whereas imagination resembles belief in involving a mind-to-world direction of fit.

It seems to follow from this that sexual desires that exhibit fantasy will most naturally find their satisfaction in pornographic representations—and similar media that provide the required transparency and surrogate objects—but it does not seem to follow that all types of appreciation of pornography qua pornography necessarily invite and involve only fantasy, in Scruton's sense, as opposed to non-fantasy, sexual desires. Some pornography may involve fantasy essentially, but it does not thereby follow that all pornography essentially does. Why, after all, could there not be non-fantasy sexual desires aimed at an imaginative engagement with the sexual activity and desires of another through pornographic means? In the absence of an argument against such a possibility we have little reason to hold that, given the nature of non-fantasy sexual desire, transparency is essential to pornography qua pornography.

I don't wish to quibble with Scruton's particular account of fantasy desire, and indeed I think it is important to distinguish the types of imaginative engagement that give rise to fantasy desires in his sense, from those which seek a type of aesthetic understanding. There is, in this way, an important distinction to be made between the different functional roles played by sexual desire in different appreciative projects that I shall return to below.

But let us first address the notion that pornography necessarily affords surrogate objects to satiate the real desires of sexual fantasy. Even on its own terms, this appears doubtful. For even if watching pornography is a substitute for actual sex, it seems false to say, as Scruton does, that the subject thereby desires the object of his lust *in the form of a substitute*. In fact, it's difficult to know exactly what this means in the current context, but however it is interpreted, it seems rather to be the case that many pornography consumers want the real thing that they cannot, for whatever reason, obtain. It might be the case that some pornography consumers, for whom there exist no potential partners in real life who approach the relevant perfections of pornographic 'actors', in fact prefer the pornographic experience to the real life encounter. Yet arguably, in that case too, the pornographic representation does not supply surrogates, but rather the real thing.

Naturally there may be people whose sexual desires stem partly from some kind of prohibition, and perhaps the prohibited nature thereof colours the nature of those desires. No doubt engaging in sexual taboos carries its own special sexual frisson. Yet it is surely not the case that all consumers of pornography necessarily subject themselves to the relevant prohibitions, and again, even where they do, it is still not clear that they want the surrogate qua surrogate. A more obvious candidate for a fantasy surrogate object of sexual desires that meets Scruton's stipulations would seem to be the prostitute. The customer wants the prostitute *as* a substitute for sex with unpaid 'real' women, precisely because, for example, he prohibits himself from fulfilling his particular real desires with women from 'real life'.

The scope of Scruton's claim is thus limited to those sexual desires arising from fantasy in his sense, but at best this will include only a certain limited range of pornographic appreciations, namely those where pornographic representations are desired *as* surrogates that stem from the relevant prohibitions. We still have little reason to assume that pornographic appreciation necessarily involves only fantasy sexual desires and the concomitant transparency that necessarily precludes simultaneous aesthetic interest.

3. Fictional Pornography

There is, nonetheless, clearly something intuitively right about the transparency thesis. Manifestations of strong sexual desire do seem to consist, at least in large part, in the subject eschewing everything that might hinder or distract from the primary goal of achieving sexual union with another person (or whatever the object of their sexual desire happens to be). In this way, it might seem that the appreciation of pornographic representations, aiming essentially at satisfying sexual desire—though generally through masturbation rather than sexual union—will achieve this best through transparency, that is, through ignoring the mere medium features to concentrate exclusively on the sexual content, and ideally being helped to do so by the representation itself. After all, sexual arousal can be a fickle beast, easily deflated in reality by any number of events and shifts in awareness that deflect attention from the task at hand. Likewise in attending to pornography, where arousal can easily be undermined by unwanted attention being

drawn to the awkward acting, poor camera angles, or background chatter amongst the camera crew about the latest cricket score.

Insofar as sexual desire operates like this, requiring a particular kind of unitary, direct, immediate satisfaction, transparency in representation may well be crucial. However, quick reflection on the various forms and content of real sexual arousal and desire shows that such a story offers an overly simplified picture, describing just one aspect of the psychologically complex phenomenon that is human sexual desire. Even excluding the extreme cases of pathological desires and sexual perversions, this phenomenon is incredibly heterogeneous, and the vast and intricate panoply of forms and objects that it involves in reality is naturally transferred to the quintessential object of appreciation that we have invented to help satisfy our sexual urges: pornography.

In reality, our perception of the object of our sexual desires is not governed solely by brute physical lust, but indelibly coloured by the complex psychological nature of those desires. These are heavily affected by changeable factors such as mood and attitude, our own and those of the people we are sexually assessing—what we find sexually desirable one moment may leave us indifferent, or even repel us, the next. Sexual arousal and desire also depend crucially on the perception and evaluation of subtle and particular movements and gestures, a particular look, a particular phrase or vocal tone, particular textures, colours, clothes and surroundings, all of which may play important roles in the formation and maintenance of our desires.

This much is obvious. But it is equally obvious both that there is a vast array of types of pornography devoted to satisfying particular desires, and that our ways of appreciating any given instance of any type of pornography will be equally subject to all the variety and complexity governing our sexual desires in general. Some pornography will simply involve depicting in various ways brute sexual acts, while some will involve various narrative elements that, as it were, lead up to these sexual acts. Some pornography, for instance, may involve lengthy story lines and have the titillation involved in expectation as its main goal, perhaps even avoiding the representation of explicit sexual acts altogether. Sometimes we may desire one type one day, another the next; sometimes we may be aroused by the very same representation that previously left us unmoved. We may sometimes, in watching a pornographic film, skip ahead to the more explicit parts, at other times we

may linger on certain narrative elements, savouring the excited state of expectation of sexual satisfaction. Such are the whims and heterogeneity of sexual desire in general, and they apply equally to our sexual engagement with pornography.

Clearly there is no space here to make a comprehensive list of the types of pornographic representations and the variegated sexual interests they aim to satisfy. However, in order to demonstrate that pornographic appreciation may involve as an essential element simultaneous aesthetic appreciation, it is important to invoke a central distinction between what I shall call 'fictional' and 'non-fictional' pornography. This distinction, like that between art and pornography, is a blurry and relatively indeterminate one, subject to degree, and resting on a hazy web of threads connecting the intentions of the filmmaker and various conventions, but most importantly, on the apprecia-tive goals and attitudes of the spectator. A failure to recognize this distinction and the heterogeneity of our sexual desires and pornographic appreciation undermines the scope and plausibility of both the transparency thesis and Scruton's account of fantasy.

Roughly, non-fictional pornography simply presents—or is taken to present—real people having sex, and the objects of sexual desire will in such cases often be the real people and scenes therein depicted. Fictional pornography, on the other hand, presents—or is taken to present—fictional narratives, where actors take on character roles and where fictional actions and events are represented for us to be imaginatively engaged with. Here the object of the sexual desire may be a fictional character or fictional state of affairs.

In the appreciation of non-fictional pornography, the transparency thesis seems most applicable. The straightforward depiction of real people simply having sex will often fulfil its aims by eschewing anything like style, just as our attention to it will normally avoid engaging with the aesthetic features of the image for their own sake. To the extent that we become distracted by them, to that extent our sexual arousal will be hindered and the aim of sexual desire potentially thwarted. This desire is real, involving our own sexual selves, but we engage with the scenes being presented merely as spectators, as voyeurs of the activities of the chief performers which serve as instruments for our own onanistic actions. If, however, we begin to imagine ourselves implicated in the scene, or using the scene as a 'prop' in some imaginary

project that goes beyond what is literally being presented, we have thereby begun to regard the film, at least in part, as a piece of fictional pornography.

Fictional pornography invites us to imagine that some situation or other is taking place and to view the actors as fictional characters in the drama. For example, we see a storyline unfold in which a pizza delivery boy arrives at a house where an older lady proceeds to take advantage of him; or we see actors dressed as doctors and nurses, or secretaries and bosses, or whatever, and we are to imagine of them that they are really doctors and nurses engaged in sexual acts with each other. Often we remain imaginary voyeurs of such representations, but we may also participate in imagination in the fictional scenes, either as ourselves, or as standing in the shoes (or embroiled in the bedclothes) of the participants we are observing. Our sexual fantasies are generally fantasies about ourselves involved sexually with others (even if merely implicated in the scene as voyeurs), and fictional pornography offers us concrete representations to serve as the context for such fantasies.

In contrast to the type of engagement characteristic of at least some instances of non-fictional pornographic appreciation, I suggest that in the case of fictional pornography there is every reason to think not just that we are generally interested in the formal features of the images for their own sake, nor that this interest merely enables us to enjoy the content, but that such features may themselves constitute an essential part of the sexually arousing content. Form and content are inextricably intertwined in fictional pornography because appreciation of the way in which the content is presented plays an essential—and not merely instrumental—role in our imaginative engagement with the sexually arousing nature of this content.

Particularly striking examples of such cases occur when one finds the projected point of view of the implied voyeur or narrator itself sexually arousing. It is the precise, erotic way in which our gaze is directed to the scene and its participants by the camera, and perhaps also by the dialogue, and hence the way in which they are presented for us, that we find sexually arousing. In such cases both the perceptual features of the medium and the way in which one's gaze is directed to them (both really and in imagination) can be appreciated for their own sake as well as in virtue of the sexually arousing content they are employed to convey. In other words, what is simultaneously appreciated is both the form and the content *and* the particular relationship between them. More prosaic examples can be pointed to: the costumes that the participants are wearing, the background scenery, and

the way in which the narrative develops, may all be aesthetically appreciated, and are the features in virtue of which we simultaneously find the content thereby manifested to be sexually arousing.

It would be wrong to say that such aesthetic attention can play only an instrumental role and otherwise necessarily entails some loss of pornographic appreciation. Even if this may be true of some cases of individual sexual psychology, it seems perfectly possible, even relatively normal, to be sexually aroused *in virtue of* the appreciation of these sorts of features when engaged with much fictional pornography—and even perhaps to a more limited extent when engaged sometimes with non-fictional pornography. There simply seems to be no good reason to deny that any of the representational features—camera angles, lighting, clothing, backdrop, script, narrative structure and so on—constituting the fictional narrative, however simple, with which we are imaginatively engaged can be appreciated simultaneously with the content that is determined by them.

This denial gets all of its force from (a) an implicit and rigid separation of form and content that need not exist in practice, and (b) the consideration of cases where medium awareness does indeed distract us from the content we are trying to appreciate and thereby impede sexual arousal. But there doesn't seem to be anything about the nature of sexual desire as such which entails that such cases are essential to pornography qua pornography, or to the type of appreciative attention we pay to them.

More generally, the difference between the transparent appreciation typical—though subject to degree—of our engagement with non-fictional pornography, and the opaque 'form-content' appreciation typical—also subject to degree—of our attention to fictional pornography depends in part on the different functional role of sexual desire in each. Indeed, it is even arguable that they involve different conative states.

4. Sexual I-Desire

Some philosophers have argued that engaging with fictional narratives requires not only imaginative correlates of belief, but also of desire—or 'I-desires' as they have been called (e.g. Currie 2002; Dogget and Egan 2007; cf. Scruton 1983). Our affective responses to the tragic deaths of Romeo and Juliet, for example, require not merely our *imagining that* the

story unfolds in the way that it does, but also our *desiring in imagination* that they do not die. Without appealing to the presence of some relevant desire-like state, we simply cannot explain these types of reactions. If we had no desires or desire-like attitudes about the welfare of Romeo and Juliet, we would be indifferent to their tragedy. In practical reasoning scenarios, too, we frequently need to imagine ourselves deciding to act in certain circum-stances, and taking on in imagination desires that we do not actually possess. I-desires can thus be broadly, and not very informatively, characterized as 'mental representations whose functional role is analogous to, though not the same as, that played by desires' (Dogget and Egan 2007: 9).

Why not hold that these are real desires? First, normal desires are generally conceived of as essentially motivational states: to desire X is to be disposed to bring it about that X. But our I-desires, it is argued, do not necessarily have motivational consequences, or at least not the same ones as ordinary desires, which is just as well because the actions they would lead to would run a problematic spectrum from the ludicrous (e.g. jumping on stage to save Desdemona) to the downright dangerous (e.g. jumping off a cliff in order to fly). Second, I-desires violate the normative constraints governing real desires:

Desires can be shown to be unreasonable, or at east unjustified, if they fail to connect in various ways with the facts; the reasonableness of my desiring punish-ment for someone depends on the facts about what they did. But the reasonableness of my . . . wanting punishment for Macbeth . . . is not undercut by the fact that there is no such person . . . (Currie 2002: 211)

Of course, some philosophers have expressed strong scepticism about the existence of this distinct class of mental representations (e.g. Nichols and Stich 2000; Funkhouser and Spaulding 2009; Kind 2011). There is no space here to enter into this debate, but whether we wish to anoint the distinctive role played by sexual desire in fictional imaginative engagement with a distinctive I-identity or not, the important point is to stress the different role played by sexual desire in fictional pornography versus the role it plays in transparent and non-fictional cases. It is thus useful to make this distinc-tion in terms of I-desires, while remaining neutral about their ultimate neuro-psychological status.

As I noted above, our appreciation of non-fictional pornography appears to involve real sexual desires aiming at and achieving satisfaction partly in

virtue of the degree of transparency employed in these representations. Of course, given their actual non-presence, the nature of the desire that is satisfied, in the normal case, will be in part determined by the awareness of X-as-representation. Nonetheless, the objects of the real desire are in some sense the real people as depicted. A natural suggestion is thus that the desires aroused in the appreciation of fictional pornography are really sexual I-desires, functioning in exactly the same way that non-sexual I-desires operate in our engagement with non-pornographic fictions. We I-desire to have sex with the fictional characters depicted, or we I-desire that the secretary seduces her boss, or the like.

This is an attractive view because, plausibly, the I-desires that are involved in our appreciation of standard, non-pornographic fiction are indelibly coloured and formed by an awareness and appreciation of formal features. The ways in which fictional content is conveyed through a work's formal features play a central role in the vividness, coherence, and richness of our imaginative engagement and in the nature of our emotional responses arising from it. It is the powerful way in which Shakespeare uses poetic language to depict Hamlet's deep psychological conflicts that partly grounds our sympathy for him, and our appreciation for and interest in the complexity of his character. It is the way in which suspense is built, through the careful editing and directing choices made about lighting, sound, staging, and so on, that partly render many films—pornographic and non-pornographic alike—so affecting and arousing.

Unless we are suffering from some sort of illusion or irrationality, we are never unaware of formal features, and although it seems evident that we can switch between more or less attention to formal features or to the content which these are used to convey, it is arguably a *sine qua non* of normal fictional experience that we simultaneously attend to and appreciate both form and content, as I outlined earlier. Moreover, part of what we appreciate in fiction, and art in general, just is the interconnection of form and content in these ways.

In short, it looks like any plausible account of fictional experience must require that our experience of form and content cannot be readily separated. Moreover, it is down to the skill of the artist/author/director to combine form and content in such a way that our attention is not undesirably and wholly drawn to the ways in which the fictional world is manifested, at the expense of attending to the emotionally relevant content.

There thus appears to be little reason—given the heterogeneous nature of sexual desire in general, and of pornographic representations—to think that, in respect of the role of I-desires, our appreciation of pornography qua pornography is saliently different from our appreciation of standard fiction. On the one hand, our sexual I-desires generally appear to follow our real sexual desires quite closely, just as fiction arouses our affective states by engaging exact I-desire correlates of our real desires. We naturally fantasize about and are attracted to those things that mirror the satisfaction of our current real sexual desires. Significantly, too, the imaginative engagement of our sexual I-desires is sufficient to cause certain physiological states of arousal, and the upshot of the appreciation of non-fictional and fictional pornography seems to be more or less the same—some form of physiological sexual arousal combined with prolonged attention to the arousing scenes and masturbation.

On the other hand, however, it does seem to be in the nature of sexual fantasy, and of the kind of engagement we have with fictional pornography, that our desires *may* violate the normative constraints governing normal desires. We may be sexually aroused by scenarios that in real life would not be arousing at all, and we might imaginatively adopt sexual desires at odds with our current sexual desires. Indeed, many fantasy sexual desires do seem to aim precisely at the fantastical nature of what is desired.

In these ways, real sexual desires may encourage the appreciation of transparent non-fictional pornography, but our engagement with fictional pornography will draw also on sexual I-desires, the satisfaction of which will generally involve—or at least can happily accommodate—an aesthetic appreciation of the formal features of the representational medium.

An all-too-easy objection one might make to everything I have said concerning the differences between types of pornography and their concomitant desires and appreciative projects, is simply to point out that the relevant differences are precisely those between erotic art and pornography. After all, it was partly in respect to this difference that the transparency thesis was initially formulated. That is, pornographic works are necessarily those governed by transparency and which are aimed at satisfying a certain type of engagement satisfying real sexual desires. Erotic art, in contrast, forms the class of what I have been calling fictional pornography.

This now looks, however, like a merely verbal dispute about classification, and hence without much philosophical interest. But in any case, it is

not, I have tried to show, the classification of works that is important, so much as differentiating between different appreciative projects and the different roles played by imagination and desire therein. It is thus crucial to recognize that the way in which we make the distinction between fictional and non-fictional pornography depends profoundly on particular, contingent circumstances involving degrees of attention, and an indefinite range of possible imaginative appreciative engagements, sexual desires and fantasies, and types of pornographic works. The supposed distinction between erotic art and pornography is thus at best a blurry one, and cannot be drawn independently of an appeal to contingent individual psychological acts of appreciation. Even if most non-fictional pornography is often formulaic, unimaginative, and artistically uninteresting, enjoining no sustained attention to formal features and offering the utmost transparency, there is still no reason to think that it must necessarily be so. In short, the transparency thesis looks, at best, contingently true of only a limited class of objects and appreciative projects.

So, to recap. I have argued against the view that visual pornography qua pornography—that is, regarded as such—cannot be simultaneously viewed with aesthetic interest. I contended that where it is so regarded it engages states of imagining that are desire-like, rather than real desires. My argument depended on the idea that the appreciation of pornographic representations is heterogeneous; in particular, I held that we must make a distinction between two different appreciative attitudes or states: regarding pornography as fiction, and regarding it as non-fiction. The latter does not involve the imagination, but involves instead the voyeuristic-like 'transparency' that, as some philosophers have argued, precludes aesthetic interest, and in virtue of doing so it involves real sexual desire. Indeed, this is what partially explains the phenomenon and phenomenology of transparency. In contrast, the appreciation of pornography as fictional, I maintained, essentially involves the imagination and the 'opaque' aesthetic attention to and appreciation of the 'formal features' of the work. This constitutes an awareness of fictionality and ensures that our imaginative engagement is one involving merely imagined 'desire-like' states involving some aspects of the self as a character in the fictional world. Significantly, this imaginative engagement is sufficient to cause certain physiological and emotional sexual responses, but ones that we are sufficiently detached from such that they can serve as objects of reflection, of meta-responses of approval and disapproval. It is to

this last claim that I now turn, by offering a very brief reflection on the value of pornography, given the account of appreciation I have outlined.

5. *De Se* Imagining and Cognitive Value

Fictional pornography in particular has the potential to possess a certain cognitive value concerning our own sexual nature and desires. As some philosophers have noted, it is generally more difficult to get people to adopt imaginative desires that conflict with their own real desires (e.g. Gendler 2000; Currie 2002). The reasons for this are disputed, but plausibly our I-desires are closely connected to our real desires, generally mirroring them without being subject (as discussed above) to quite the same constraints. By engaging in the *de se* imaginative projects characteristic of much of our engagement with fictional pornography, we can clearly come to learn about our own real, current desires, and of desires of which we may even be unaware. This will especially be the case where our fantasizing engages desires that actively conflict both with what we think we desire, and with what we would normatively, morally endorse as worthy of desire.[7]

The ability of fictional pornography—no less than standard non-porno-graphic fiction—to encourage such engagement, therefore, clearly has the potential to enlighten us about our own sexual desires, but also to induce reflection on the norms governing them. Because I-desires, rather than 'real' desires, are centrally involved, we remain sufficiently detached (through medium awareness) from the representational content we are aroused by to reflect on these aspects of ourselves. We may realize that we actually desire something we thought we did not, or we may come to realize that this new object of desire, were it to be actualized, would no longer be really desired, and hence endorse its remaining mere fantasy. We may thereby hold ourselves and others responsible for our sexual I-desires as much as for our real desires, for the former reveal much about the latter.

Finally, because of the intimate connection between sexual desires, im-agination, and physical arousal, part of what we develop in pornographic appreciation may even be construed as a kind of kinaesthetic awareness. Indeed, certain types of fictional pornography, including the prospect of

[7] Cf. Scruton (1983: 133) on the difference between fantasy and imagination, mentioned earlier.

virtual, interactive pornographic representations, might serve to further this kind of awareness, and thereby awaken and illuminate uncharted depths of human sexuality. Whether such cases would be best thought of as pornography at all, however, is a question that must be left for another day.

References

Currie, G. (1995) *Image and Mind: Film, Philosophy and Cognitive Science*. Cambridge: Cambridge University Press.

——(2002) 'Desire in Imagination'. In T. Gendler and J. Hawthorne (eds.), *Conceivability and Possibility*. Oxford: Clarendon Press. 201–22.

Davies, D. (2003) 'The Imaged, the Imagined, and the Imaginary'. In M. Kieran and D. Lopes (eds.), *Imagination, Philosophy, and the Arts*. London: Routledge. 225–44.

Dogget, T., and Egan, T. (2007). 'Wanting Things You Don't Want: The Case for an Imaginative Analogue of Desire'. *Philosophers' Imprint* 7: 1–17.

Funkhouser, E., and Spaulding, S. (2009) 'Imagination and Other Scripts'. *Philosophical Studies* 143: 291–314.

Gendler, T. (2000) 'The Puzzle of Imaginative Resistance'. *Journal of Philosophy* 47: 55–80.

Kieran, M. (2001) 'Pornographic Art'. *Philosophy and Literature* 25: 31–45.

Kind, A. (2011) 'The Puzzle of Imaginative Desire'. *Australasian Journal of Philosophy* 89(3): 421–39.

Levinson, J. (2005) 'Erotic Art and Pornographic Pictures'. *Philosophy and Literature* 29: 228–39.

Maes, H. (2011) 'Art of Porn: Clear Division or False Dilemma'. *Philosophy and Literature* 35(1): 51–64.

Nichols, S., and Stich, S. (2000) 'A Cognitive Theory of Pretense'. *Cognition* 74: 114–47.

Scruton, R. (1983) 'Fantasy, Imagination, and the Screen'. In R. Scruton, *The Aesthetic Understanding*. London: Carcanet. 149–60.

——(2006) *Sexual Desire: A Philosophical Investigation*. London: Continuum.

6

Pornography and Imagining about Oneself

KATHLEEN STOCK

1. Introduction

In this chapter I want to explore, and ultimately reject, the thought that enjoying erotica or pornography must involve imagining something about oneself. We find this thought expressed in the work of Roger Scruton, according to whom:

The genuinely erotic work is one which invites the reader to re-create in imagination the first-person point of view of someone party to an erotic encounter. The pornographic work retains as a rule the third-person perspective of the voyeuristic observer.[1]

As this indicates, one way of distinguishing between erotic work and pornography is that the former invites imaginatively inhabiting the visual position of a participant, and the latter invites imaginatively inhabiting the visual position of a voyeur. The distinction between the erotic and the pornographic is not my concern here, but rather the assumption that either way, one is imagining something about oneself (imagining *de se*); that is, that one is imagining seeing, or otherwise being aware of the activity represented. Addressing this question will shed light on a wider question: whether we should think of fiction generally as prescribing imagining *de se*.

[1] Scruton (2006: 139).

2. Imagining *De Se*

It seems likely that the reader, attracted to a book about the philosophy of pornography, will be disappointed in an article that does not immediately discuss it. Unfortunately, to set up my argument I have to do quite a bit of preliminary background work on imagining *de se*.

Following Francois Recanati, we can distinguish between three ways in which imagining might count as *de se*.[2] One is peripheral and not relevant to present discussion: where one accidentally figures in the content of what one imagines, as for instance, where I imagine, of the person in the mirror, that she does something or other, but do not know that I am the person in the mirror. No one is likely to claim that imagining in relation to fiction should be *de se* in this sense. The other two ways in which imagining may count as *de se* are more relevant to our concerns. The first is the 'explicit' sense that the self is a constituent of the content of the thought: as where I imagine that a given property is possessed by someone, and I further (explicitly) imagine that that someone is myself.[3] So for instance I might imagine, as witnessed from a third-personal perspective, the activity of a person, who is me, Kathleen Stock: or I might explicitly imagine a certain first-personal visual perspective on the world, and imagine that it is mine, Kathleen Stock's.

A different sense in which imagining could be *de se* is an 'implicit' sense, where the self features not as an explicit constituent of the content of the thought, but arguably rather as a 'mode of presentation'.[4] Implicitly *de se* imagining often takes the grammatical form 'imagining, from the inside, *x*-ing'. It is sometimes argued that mental imagery must be *de se* in this sense, in a claim which is sometimes known as the Experiential Hypothesis,[5] and sometimes as, the Dependency Thesis.[6] Roughly, the claim is that having a mental image of, say, a cat, necessarily involves imagining seeing a cat; where 'imagining seeing a cat' is to be read as something like 'imagining, from the inside, the visual experience of a cat':[7] it is not that in having a mental image of a cat, I imagine that I, Kathleen Stock, see a cat (that is, explicitly imagining something about myself as part of the content of the imagining). Rather, I implicitly imagine something about myself in the sense that a 'bare'

[2] Recanati (2007). [3] Recanati (2007: 4).
[4] Recanati (1997: 2). [5] Peacocke (1985).
[6] Martin (2002); Noordhof (2002). [7] Peacocke (1985).

seat of experience is logically implied by the structure of the image. Often, the arguments advanced for this claim are based on the similarities between the content of a mental image and visual experience: the perspectival nature of each, for instance.[8]

Because, properly articulated, the claim that some imagining is implicitly *de se* does *not* entail that one imagines anything very detailed about oneself as part of the content of what one imagines, it is relatively easy in discussion to lose one's grip on whether one is talking about implicitly *de se* imagining, or some other imagining which is either explicitly *de se* or not *de se* at all. Matters aren't helped by the fact that grammatically we are not often scrupulous in marking any such distinction.

For this reason it will be helpful to introduce a further important distinguishing feature of *imagining, from the inside, x-ing* (in other words, implicitly *de se* imagining), which I take to fit all paradigmatic cases of it. In marking this feature I intend a contrast between *imagining, from the inside, x-ing*, and simply *imagining that there is x-ing*, either by oneself (explicitly *de se*) or by others (not *de se* at all). I also intend to mark a contrast between *imagining, from the inside, perceiving (or otherwise becoming aware of) a situation S,* and more simply *imagining that S occurs*, which will be of particular interest later.

The relevant feature of *imagining from the inside, x-ing* I wish to highlight is that it necessarily involves imagining an *activity conceived of as a process*: a process unfolding in some determinate way over time, with distinct stages, each conceived of as parts of the same activity. For instance, *imagining, from the inside, swimming*, necessarily involves imagining the process of swimming (albeit perhaps not a complete process, nor a complete time sequence). One must imagine some sequence of events as constituting parts of the overarching activity: for instance, kicking one's legs, taking a stroke, feeling the water splash in one's eyes, and tasting salt in one's mouth. It is perhaps this which at least partly justifies the claim that such imagining is implicitly *de se*: for it is a natural enough thought that, once distinct events are conceived of in imagination as parts of a process—a process which is, moreover, an activity—then in thinking of them as such, one must be implicitly representing the self who is the author of that activity.

In contrast, simply to *imagine that* a given person (oneself or someone else) swims, does not require any determinately specified thought about the stages

[8] There is a summary of such arguments in Smith (2006).

via which that activity of swimming is achieved. As this suggests, my claim is not that *imagining that* may not refer to any activity or process at all. I may perfectly unproblematically *imagine that* a certain activity or process takes place, or has taken place. It is to say that implicitly imagining *de se* must be more than this: it must be about an activity conceived of as process, and moreover, must involve the thought of that process unfolding through time via various determinate stages which are proper parts of it.

In what follows, whenever 'implicitly *de se* imagining' is mentioned it should be understood as equivalent to (a) imagining which takes the form 'imagining, from the inside, *x*-ing' and which moreover (b) involves the unfolding of a process of *x*-ing, with various distinct stages, determinately specified and conceived of in imagination as part of that overarching activity. Without this point, I suggest, we lose a grip on the difference between *imagining, from the inside, x-ing* and simply *imagining that some x-ing is taking place*.

3. Walton on Fiction and Imagining *De Se*

In philosophical accounts of the nature of fiction, it is common, though not ubiquitous, to think it a necessary feature of fiction that it makes imagining appropriate.[9] I think this is true: I shall assume it in what follows.[10] A further question is whether fiction generally, or even just a particular kind of fiction, prescribes imagining that is *de se*.

Kendall Walton has argued that imagining *generally* is essentially *de se*: 'the minimal self-imagining that seems to accompany all imagining is that of being aware of whatever else it is that one imagines'.[11] He also suggests that there are two ways of imagining *de se*, which respectively seem to correspond to those just identified (explicitly and implicitly *de se*).[12] So he seems here to be saying that, for any situation S that one imagines, *either* one also imagines that one is aware of S, so that the self is explicitly referred to in the content of the thought; *or* (more commonly) one imagines, from the inside, being aware of S, so that the self is implicitly part of the mode of presentation of the thought but not referred to explicitly via its content.

[9] See for instance Currie (1990); Walton (1990); Lamarque and Olsen (1994); Davies (2007).
[10] For further discussion, see Stock 2011.
[11] Walton (1990: 29). [12] Walton (1990: 30).

This sort of general claim is not particularly persuasive, however, given the absence of any supportive argument. That is, there seems no reason to grant that any imagining which is not implicitly *de se* must be explicitly so. Why can't there just be *imagining that* certain things occur or occurred, without either imagining being aware, or imagining that one is aware of them? It certainly seems as if there can. One supportive thought might be that all imagining necessarily involves mental imagery.[13] But Walton denies this.[14]

In any case, we can leave this question aside, because Walton later suggests that any fiction that is about some particular thing(s) prescribes imagining, from the inside, knowing about/ being aware of those things.[15] It follows from this claim that nearly all fiction makes appropriate imagining which is implicitly *de se*.

One source for the claim is the thought that what it is to have an imagining about a particular fictional entity *E*, as opposed to imagining about some entity or other, but no particular one, is just to *imagine, from the inside, knowing about a particular E*. For instance, imagining something about a particular ghost, George, is best expressed, according to Walton, as *imagining, from the inside, knowing about a ghost called George*; whereas imagining simply that there are some ghosts or other about is best expressed as *imagining that one knows that there are ghosts about*.[16] Why we should agree with the latter point, that imagining about general states of affairs is *explicitly de se* in this way, is very unclear, and reinforces the doubt about Walton's claim that imagining must be either explicitly or implicitly *de se* already voiced. But just focusing on the former point—that imagining about particulars must be *implicitly de se*, so that, in effect, all imagining towards fiction is so as well—there is little reason to grant this.

For one thing, it leaves unexplained a different sort of case, where, for instance, one imagines, about some particular ghost George, that he engages in some activity or other, but no particular one. If this too is construed as *imagining, from the inside, knowing*, then implicitly *de se* imagining will turn out to be compatible with one's thought, at least partly, referring to something or other but to no particular thing. On the other hand, if it is not, then

[13] See Kind (2001). [14] Walton (1990: 13).

[15] In discussing this, I will follow Walton's lead in leaving to one side the separate issue of how fiction can refer to non-existent particulars.

[16] Walton (1990: 135–6).

it seems likely that imagining about particulars may occur, after all, without implicitly *de se* imagining.

Perhaps it is true that that one cannot have an implicitly *de se* imagining without thereby picking out, in thought, some particular entity. If so, then Walton's claim would be better expressed as the claim that necessarily, implicitly *de se* imagining—e.g. imagining, from the inside, *x*-ing—involves the picking out of at least one particular. But that would be consistent with it being true, as I think it obviously is, that *imagining that* may also refer to particulars. I can imagine that Barack Obama rides a unicycle, or I can imagine, from the inside, seeing Barack Obama riding a unicycle. Equally (ignoring general problems about how propositional attitudes can be 'about' non-existent states of affairs, whether particular or general) I can imagine that Anna Karenina dances a mazurka, or I can imagine, from the inside, her doing so. This point will be important later.

As noted, Walton thinks that all imagining towards fictional particulars is implicitly *de se*, in the sense that the reader imagines, from the inside, *knowing or being aware* of those particulars. So far I haven't questioned what makes this imagining genuinely *de se*. But in fact I think this bears further scrutiny.

Recall that the claim that one imagines *x*-ing in a way that is *implicitly de se*, as opposed to *explicitly* so, is the claim that one imagines, from the inside, *x*-ing, but where nothing about one's concrete contingent self is present in the content of what is imagined. Rather, the self features skeletally as something like a mode of presentation. This is confirmed by Walton when he writes, of imagining seeing a rhinoceros:

> The notion of the self that figures in imaginings *de se* need not be a very rich or full one ... No verbal representation of myself (neither my name nor a description of myself nor a first-person pronoun) need figure in my thoughts as I imagine: I may think something like 'That is a rhinoceros,' rather than 'I see a rhinoceros,' although the former imaginatively locates the rhinoceros in relation to me.[17]

Now, were we supposed automatically to construe 'imagining, from the inside, knowing about/being aware of situation *S*' as 'having a mental image of *S*' then this absence of any concrete representation of one's contingent self as part of the content of the imagining would be relatively unproblematic for Walton's claim that such imagining was genuinely implicitly *de se*. We

[17] Walton (1990: 31–2).

would still have a grip on what might be supposed to make the imagining *implicitly* about oneself. One might, for instance, argue that one's mental image was perspectival in structure, in a way that logically implied a subject whose perspective was being represented.[18] Indeed, when in the passage just quoted, Walton talks about imagining seeing a rhinoceros, and of his thought 'That is a rhinoceros' imaginatively locating 'the rhinoceros in relation to me', it seems as if he must have this sort of point in mind.

But it is problematic to connect *imagining, from the inside, knowing/being aware of* to mental imagery, however. For one thing, there are things which are known which cannot be seen: for instance, that *2 + 2 = 4*, or that *utilitarianism is flawed*, or that *Germany lost World War II*. Equally, we can imagine things that we could not perceive, even if they were true: that utilitarianism *is a perfect theory*, or that *Germany won World War II*. Fictions might well ask us to imagine such things; yet insofar as they would be imperceptible, arguably they don't look like suitable candidates for the objects of mental images. Meanwhile, imaginative engagement with film fiction, for instance, looks as if it can't be analysed in terms of the having of mental images, insofar as it requires seeing, and so arguably seems to *exclude* simultaneous mental imagery, rather than encourage it. In any case, Walton denies that imagining, from the inside, seeing or otherwise being aware of something, must be accompanied by mental imagery.[19]

So, in the absence of any firm association between what we might colloquially refer to as cases of 'imagining, from the inside, knowing about/ being aware of *S*' and mental imagery of *S*, we are still looking for something which would justify the assumption that such imagining is implicitly *de se*: that is, that it implicitly contains the self as a mode of presentation. If we can't find one, then the worry is that we cannot genuinely distinguish this from simply imagining that *S*. If we can't find anything to play the right role, then Walton's insistence that imagining in response to fiction must be implicitly *de se* looks unconvincing.

One promising line of thought has already been mentioned: the claim that necessarily, *imagining, from the inside, x-ing*, involves imagining *x*-ing as an activity that is a process, unfolding via determinate stages, and where each stage is imagined precisely as a stage in the overarching activity. I suggested that it might be this feature of *imagining, from the inside, x-ing*, that makes it

[18] See Smith (2006). [19] Walton (1990: 133).

implicitly *de se*, and distinguishes it from merely *imagining that*. For once otherwise disparate events are conceived of in imagination as parts of an activity which is a process, then one can analyse such imagining as *de se* in that one is implicitly referring to the self who is the agent of that activity.

This thought would allow us to analyse imagining *perceiving* an object as genuinely implicitly *de se*. Perceiving, after all, is an activity that extends through time, and that at least sometimes has distinct stages: as when one perceives a tree by perceiving first the trunk, and then the branches. However, it does not so obviously apply to any alleged *imagining knowing* something which is not *imagining perceiving*. Knowing, as distinct from perceiving, looks much more like a standing state than an ongoing process.

One suggestion here, which would fit well with Walton's wider view, is that, in cases where imagining perceiving S is not an appropriate construction for a given instance of imagining in relation to fiction, we should analyse the imagining as imagining, from the inside, *coming to know about S*. Coming to know something, as opposed to knowing it, is a genuine process, about which one might imagine determinate stages. For this suggestion to work, it would seem that we must also posit, on the reader's part, imaginings about *how it is* that she comes to know about S. In other words, we should imaginatively posit on the reader's behalf a fictional narrator or, at least, vehicle of narration, which describes S, and via which, the consumer imagines, she comes to know about S.[20] In arguing thus, I am not assenting to the general thought that when one imagines a scenario S, one has to also imagine something about one's means of epistemic access to S. Rather, my claim pertains to *imagining, from the inside, coming to know S* specifically: doing *this* requires imagining something about how one comes to know S. Were this denied, it would be hard to say in what imagining coming to know S consisted.

Insofar as the reader of a fiction imagined, among other things, that she was coming to know what the fiction described, via some act or documentary record of the telling of it, we could perhaps legitimately construe her imagining as implicitly containing a reference to herself in relation to this action or document. But note the baroque complications to which we have been led in order to preserve the claim that all imagining in response to fictions representing particulars is implicitly *de se*! We have been forced to construe imagining in response to fictional statement 'p' either as involving

[20] Walton is mildly positive about this as a general move for all fictions (1990: section 9.5).

imagining, from the inside, *perceiving* the state of affairs described by 'p'; or as imagining, from the inside, *coming to know about it*; a point which has necessitated the positing of further imaginings about the means by which such knowledge arises. Yet so far, no real reason has emerged to support this complicated structure, rather than the more simple suggestion that we analyse the imagining in such cases as, straightforwardly, *imagining that p*. I shall now examine one of the main proposed candidates for what counts as such a reason.[21]

4. The Argument from Affective Response

This is the claim that only if we construe imaginings in relation to fiction as implicitly *de se*, can we explain or rationalize their powerful emotional effects on us. Walton offers a version of this claim as follows:

Our own involvement in the worlds of our games is the key to understanding much of the importance representations have for us. If to read a novel or contemplate a painting were merely to stand outside a fictional world pressing one's nose against the glass and peering in, noticing what is fictional but not fictionally noticing anything,[22] our interest in novels and paintings would indeed by mysterious. We might expect to have a certain clinical curiosity about fictional worlds viewed from afar, but it is hard to see how that could account for the significance of representation, their capacity to be deeply moving, sometimes even to change our lives.[23]

A related claim is made by Jerrold Levinson when he argues that imagining towards a film necessarily involves imagining seeing whatever the film depicts by visual means. In support, he, like Walton, argues that this claim is a 'natural and convincing explanation of the immediacy of our involvement in, our extraordinary capacity to be affected, cognitively and emotionally, by cinema viewing'.[24]

So between them, Walton and Levinson intimate that only if we construe imagining in relation to (film) fiction as implicitly *de se* can we explain the power of our affective responses to it. I'll call this point 'the argument from affective response'. Of course, Levinson makes his argument only with

[21] A different candidate is dismissed by Alward (2006).

[22] By 'fictionally noticing' Walton means, at least, *imagining, from the inside, becoming aware of*.

[23] Walton (1990: 273). [24] Levinson (1993: 78).

respect to film fictions, and his view is undoubtedly partly motivated by considerations to do with the perspectival and manifestly sensuous nature of the film medium. But the argument from affective response looks like a separate ground of support for the claim that imagining in relation to film is implicitly *de se*, and one which might be extended, in principle, to non-visual fictional mediums as well, as it is by Walton.

It should be noted that in discussing this issue, we are not here concerned with the historically more tendentious issue of whether one *imagines* emotionally responding to fictions or not, rather than responding in a way that is of a kind with 'real-life' responses.[25] That is, I'm not interested here about whether to construe our affective responses to fictional situations as real emotions or instead quasi-emotions. The guiding question here is rather whether we must construe the imagining that takes place generally with respect to fictions as implicitly *de se*, in order to account for the affective responses that we have towards those fictions—of whatever nature they turn out to be, real or imagined. If it were independently argued that affective responses to fiction were imagined or imaginary, it might then follow that they were *de se*. But I take it that when, for instance, Walton argues that imagining in response to fiction is implicitly *de se*, he is not doing so merely as a result of his prior commitment to thinking of emotional responses to fiction as imagined.

5. Affective Properties

Affective responses in real-life situations can be understood, relatively plati-tudinously, as responses to a particular kind of property: affective properties. In characterizing affective properties, I shall follow the account of Mark Johnston, though remaining neutral about the metaphysical conclusions he draws with respect to them. By affective properties, I mean, as Johnston puts it:

the utterly determinate versions of such determinables as the beautiful, the charming, the erotic (in the narrower sense), the banal, the sublime, the horrific and the plain old appealing and the repellent.[26]

[25] See e.g. Gaut (2003). [26] Johnston (2001: 182).

Since such properties are 'utterly determinate', they are not neatly characterizable in terms of names. The (for this reason, necessarily inadequate) examples given by Johnston tend to take the form of an adjective preceded by a qualifying adverb (e.g. 'ethereally beautiful', 'naggingly vulnerable' 'deceptively weak'). The properties picked out by such descriptors are 'inherently sensuous' in that one could not recognize their presence except by being in possession of a certain evaluative sensibility.[27] Such recognition is inherently moving or affecting, in some direction, though not always strongly.[28]

Let's assume that affective response, broadly construed, is in response to the recognition of such properties, whilst leaving aside for the moment the question of the metaphysics of those properties (including whether, properly speaking, they are properties at all). Let's also assume that *fictions* can and often do *represent* affective properties, by way of representing people and actions and states of affairs as exemplifying them. Let's further assume that where a fiction represents an affective property, it is appropriate for someone imaginatively engaged with that fiction to (at least) *imagine* the existence of that property. This is just a consequence of my prior assumption, announced at the outset, that fictional representations make imaginings appropriate. Putting the matter thus is obviously intended to be neutral at this stage about whether this imaginative response to the representation of affective properties is supposed to be implicitly *de se*.

Now, against this background, in conjunction with points made earlier, the argument of Walton and Levinson just rehearsed can be construed as saying that, where a person emotionally responds to the fictional representation of some affective property AP, the best or most natural explanation of that response is that it involves *imagining, from the inside, perceiving* or *coming to know of AP*.

It is here that I can finally start to discuss pornography. In the rest of this chapter, I'll examine the argument from affective response with respect to a subset of affective properties, 'erotic' properties, and a subset of affective responses to fiction, sexually aroused responses to pornographic fiction. Though it may seem that an aroused response to pornographic fiction requires imagining, from the inside, being aware of the fictional action, I will suggest that it may also be strongly present as a result of simply

[27] Johnston (2001: 182). [28] Johnston (2001: 188).

imagining *that* certain things occur. Since, I take it, an aroused response to pornographic fiction is a kind of affective response, in so arguing I will thereby have also shown that not every affective response to fiction is best explained by the presence of implicitly imagining *de se*. It might more simply be that one imagines that there are affective properties, and responds to them affectively.

5. Erotic Properties and their Representation

Just as I have claimed, relatively platitudinously, that affective response occurs upon detection of affective properties (regardless of their metaphysical status), so too, sexual arousal—a subspecies of affective response—occurs upon detection of a subset of affective properties, which I'll call 'erotic' properties.

Erotic properties, in other words, are those properties detection of which moves the agent to be aroused. As before, being utterly determinate, such properties are not readily nameable: necessarily inadequate examples might be being *excitingly arrogant, provocatively insolent; thrillingly docile; vulnerably slender; lushly curvaceous; enticingly breathy,* or *shockingly bare.* But arousal need not be in response to features that one can identify very precisely, or that have vocabulary neatly associated with them ('something about the way he stood', etc.).

Also as with affective properties generally, it is not as if in experiencing such properties one first discerns purely descriptive properties of an object and then infers what evaluation, in terms of attraction or repulsion, to make of those properties. Rather, one's apprehension of the property is experienced as already evaluative in some direction. Phenomenologically, there are not two levels of experience of sexually arousing objects: a prior, evaluatively neutral level, and then an evaluative response to the former.

Somewhat surprisingly, this sort of rather modest claim sits rather awkwardly with some philosophical accounts of sexual arousal, which treat it as a wholly physiological, non-intentional state, which as such cannot easily be analysed as an evaluative response to properties in the world. For instance, Rockney Jacobsen analyses sexual arousal as an objectless, non-intentional bodily appetite or 'sensation state', akin to an itch, or a sensation of hunger, which can go through various phases of development to be brought to some

sense of 'assuagement'.[29] But this is to ignore a surely important difference between the causes of arousal: sometimes purely chemical, via Viagra, or mechanical, via masturbation, but much more often in response to some feature of the world, experienced as enticing.

When we turn to pornographic fiction and the aroused responses it characteristically provokes, it is tempting to construe this straightforwardly, in terms of (a) a pornographic fiction's representing erotic properties (*lush curvaceousness*, *provocative insolence*, etc.) as exemplified by certain people (or perhaps, as in fetish pornography, inanimate objects); where (b) the consumer of such fiction then imagines the existence of those erotic properties and becomes aroused in response. Here too, there is a difference with becoming aroused via masturbation or the ingestion of Viagra. The difference, as before, seems to be that in response to pornography, as in response to the real-life objects one finds attractive, one's arousal responds to the way features of people and objects are represented in thought.

To this pleasingly straightforward story, Walton and Levinson would, one presumes, have us add another layer: (c) the aroused consumer of pornography not only imagines the existence of those erotic properties, but also imagines seeing or otherwise coming to be aware of them. This constitutes the best available explanation of her aroused response.

6. Pornography and Imagining Seeing/Coming to be Aware

What further support might be given for this as a good explanation? Although neither Walton nor Levinson commits himself, perhaps someone might argue as follows. Typically, at least, an aroused response to the fictional representation of an erotic property—say, *lush curvaceousness*—psychologically requires, as a causal prerequisite, *imagining how lush curvaceousness is instantiated in a particular case*. Meanwhile, the argument might go on, *imagining how lush curvaceousness is instantiated in a particular case* is equivalent to *imagining, from the inside, seeing (or otherwise coming to be aware of) lush curvaceousness*.

[29] Jacobsen (1993: 628).

Though a version of this argument is available with respect to affective properties generally, it might seem particularly compelling in the case of erotic properties. Being sexually aroused in response to some feature of the world seems, on the face of it, especially bound up with the particular way that feature is instantiated. Arguably, I might get angry at a bald statement of an injustice, laconically expressed, without needing to know much about what the injustice was like. In contrast, in erotic response, the detail is always very important.

It may well be true that in order to be aroused in response to the imagining of an erotic property, one has to imagine in some detail how that property is instantiated. The problem is that this does not necessarily imply that one must imagine seeing or otherwise coming to be aware of it. On one natural reading of 'imagining how lush curvaceousness is instantiated', one need only imagine the features of a particular lushly curvaceous entity in a relatively detailed way. This is perfectly compatible with *imagining that*.

Most likely, one will imagine that a particular *person* is lushly curvaceous, in response to pornography representing her as such. Now, I have already argued that *imagining that* can take place with respect to particular people and things. Moreover, there is no reason to deny that one might imagine explicitly *that* a given particular (in this case, a particular person) has relatively many aspects, enumerating each of them in imagination individually, so that a detailed account is given of the situation. For instance, one might imagine that Jane has feature X ...; and has feature Y ...; and has feature Z ..., in a way that adds up to a detailed description of how her lush curvaceousness is instantiated, a way compatible with arousal. So far this looks perfectly compatible with *imagining that*.

Earlier I claimed it was a necessary feature of *imagining, from the inside, x-ing*, as opposed to simply *imagining that*, that one imagined in determinate detail the stages of the process of the activity of x-ing unfolding, as such. Only then, I argued, can we get a sense of how the self is supposed to be implicitly implicated in this thought, as a bare subject of experience. Might it then be argued that imagining *a process* of seeing or otherwise coming to be aware of e.g. lush curvaceousness, in the sense I have indicated, is essential to imagining how lush curvaceousness is instantiated?

I do not see why we should accept this. Take an episode of *imagining that*, which involves only imagining that Jane has feature X, and has feature Y,

and has feature Z, in a way which in total adds up to a detailed representation of how her lush curvaceousness is instantiated. Contrast it with an episode of imagining, from the inside, the activity of *seeing* or *coming to be aware of* these features of Jane, understood as not merely the consecutive entertaining of the features in question, but also the imaginative conception of them as objects of various stages of the same perceptual or cognitive activity. This latter fact looks irrelevant to whether one will be aroused or not, in most cases. After all, for most people, it will be the features which arouse, and not the thought of them being experienced as part of a single act of seeing or other sort of awareness.

Now, of course, for some people, it is not just certain features of the world which arouse, but also the thought of their own experience of those features. These people are voyeurs: excited not just by what they experience (usually visually) but also by the fact that they experience it. To argue that one must imagine, from the inside, perceiving or coming to be aware of situation S in order to be aroused by the thought of S is, effectively, to make all consumers of pornographic fiction satisfy what is, perhaps, the central and defining condition of the voyeur. And this is surely wrong. It is surely preferable to leave room for a varied sexual psychology amongst pornographic con-sumers: some are turned on by the imaginative thought of various erotic properties, in response to pornographic representations of them, *straightfor-wardly*, whilst others are turned on not just by the thought of such properties, but also by the imaginative representation of those properties *as experienced by oneself*.

Equally, a further point against the thought that arousal in response to pornographic representation of a situation S requires imagining, from the inside, perceiving or coming to know about S, is that for some people the positive imaginative representation of a process of perceiving or coming to awareness of S would be a turn off. It might be crucial to the sexual psychology of someone precisely *not* to think of themselves as in any sense present to a scenario in order to find it arousing. One's preferences might be such that any sense, however implicit, of one's own involvement in an otherwise erotic situation would be sufficient to bring about negative and self-conscious thoughts incompatible with arousal. This is particular pertin-ent if we take seriously the idea, which I have argued can be naturally read into Walton's view, that *imagining, from the inside, coming to awareness of S*, in response to a fiction representing S, must involve *either* perceiving S, *or*

positing a fictional narrator as the means by which awareness of S is reached. Much simpler, then, to deny that arousal in response to pornographic fiction requires implicitly imagining *de se* in the manner effectively indicated.

7. Pornography and Imagining Acting

Perhaps, though, we have been on the wrong track. Perhaps we can get to the claim that aroused imagining in relation to pornography involves imagining, from the inside, perceiving or coming to awareness of erotic properties, *derivatively*, via the prior claim that such arousal depends on imagining *acting* with respect to those properties.

Many erotic properties are experienced as inviting interaction. Think of the *touchableness* of skin, the *kissableness* of lips, and so on. One might think on the basis of such examples that to experience the arousingness of such properties is, constitutively, to want to act with respect to them. We might draw an analogy here with experiencing the desirable properties of food: what it is to look at a piece of cake and perceive its inviting soft chocolately moistness is precisely to want to feel that sensation in one's mouth as one eats.

One might then argue:

a) Wherever there is arousal in response to erotic properties of objects, there is a desire to act with respect to the bearer of the properties in question.

b) Analogously, wherever there is arousal in response to *imagined* erotic properties, here too there is a 'desire'[30] to act with respect to the imagined bearer of the properties in question. In response to this 'desire', one imagines acting in the relevant way.

c) Wherever one imagines acting with respect to the bearer of an erotic property, one also imagines perceiving or being aware of it.

So the claim here would be that, where, with the help of pornography, one imagines, for instance, touchable flesh, and is aroused by it, this is tantamount to experiencing a desire or at least an impulse to touch it; where in

[30] In inverted commas to recognize its apparently problematic status, given the non-existence of its object.

response to this impulse, one *imagines* touching the flesh. If this is conceded, then it will be a short step to the claim that one imagines perceiving the flesh as one touches it.

The plausibility of (b) might be thought further strengthened by a comparison with what is sometimes, and not inaptly, called 'food porn'— alluring photographs of food in magazines. As one looks at, and 'desires', the succulently moist chocolate cake in the picture, or the crackly burnt topping of a crème brulée, one can feel an impulse to bite: sometimes, one might even actually make the motion of doing so. Why not analyse this as imagining biting the food in question?

Of course, not every erotic property has an associated action as particularly appropriate to its nature. Some erotic properties dictate what action would be an appropriate response to them (e.g. touchableness of skin). But this is not always the case. One might experience *shocking bareness*, or *provocative insolence* and feel no impulsion to do anything in particular in response to the *property*, yet still be aroused by it. However, in such cases, I take it, at least sometimes there will still be a desire to act with respect to the bearer of the property.[31]

But leaving such details aside, there is a bigger problem with this argument. Namely, even where one is aroused in response to an erotic property, and with a desire to act with respect to the bearer of that property, one might still abstain from acting. Obviously this is so—we do not act on our sexual impulses whenever they strike. One might, for instance, abstain because one judges it immoral to act as one wants to, or unhealthy, or whatever. But this being so, there is no reason to grant that whenever one feels a 'desire' towards the *imagined* bearer of some *imagined* erotic property, one will *imagine* acting. Here too, one might judge, it would be immoral or unhealthy to imagine so acting. Many people believe moral or prudential norms genuinely govern imaginary sexual episodes as well as real ones. For such people, simply to 'desire' something with respect to an imagined entity would not licence imagining the fulfilment of that desire. Notwithstanding, it seems reasonable to admit that arousal may still accompany such episodes, insofar as arousal is not directly controllable by a moral or prudential act of will. Given, then, that arousal need not be accompanied by imagining

[31] I suppose an exception might be someone sexually inexperienced with no idea of what sex is or what you are supposed to do during it, yet still aroused. A similar point is made by Shaffer.

acting, the subsequent move to imagining perceiving or being aware is undermined.

7. Pornography and the Metaphysics of Erotic Properties

I will now consider a final argument, as follows. Affective properties, generally, are subjective: and erotic properties, out of all affective properties, are perhaps the most subjective of all. There may be general rules about what prompts affective response, at least, within cultures: but even within a given culture, what one person finds arousing will often leave another stone cold. This, one might argue, has a bearing on the metaphysics of such properties: erotic properties are plausibly not really 'in' the world as physical properties are; they are projections onto it. There is no sense to be made of an erotic property, existing in isolation from someone's experience of it.

This point might be then used as follows:

a) An erotic property is projected onto the world by a subject, as a result of her arousal.

b) Wherever one imagines an erotic property, one must therefore imagine it as projected onto the world by a subject, as a result of her arousal.

c) Imagining a property as projected onto the world by a subject is a kind of implicitly *de se* imagining.

Now, even if the projectivism expressed by (a) about erotic properties turned out to be true,[32] would this validate (b)? No. To imagine a property, one needs at most, to imagine how that property is instantiated. We've already established that this is not directly equivalent to imagining, from the inside, perceiving/coming to awareness of it, and can be done simply by *imagining that*. But more pertinently to the present argument, erotic proper-

[32] Like Johnston, I reject projectivism. However, it is somewhat disappointing to read Johnston referring to the projectivist's analysis of affective properties as wrongly implying a 'change of attentive focus from the appeal of other things and other people to their agreeable effects on us', as 'pornographic' (2001: 13). It seems to me that, even in imaginative encounters with pornography, there is often a focus on the appeal of 'other things', and only derivatively a focus on their agreeable affects on us.

ties are not experienced phenomenologically as dependent on our aroused experiences of them. They are experienced as out there, in the world.

This is true of most or all affective properties, but it is particularly true of those which we find sexually arousing. Where one is attracted to the look or feel of a person's body, or their taste or smell, the erotic properties which 'pull' one in are in no sense experienced as dependent on oneself. Rather, they are experienced as existing beyond one's control and responsibility. Indeed, arguably if they were experienced as dependent on the subject's own projections, for most people they would cease to be found arousing. So too, where one imagines, for instance, *touchable flesh* in response to pornography, and is aroused by it, then one does not imaginatively posit the touchableness, in the course of dwelling imaginatively upon it, as dependent on oneself.

The same can be said of a close relative of those properties which we find sexually arousing: those we find disgusting. This is noted even by arch anti-realist John Mackie, when he writes: 'If a fungus, say, fills us with disgust, we may be inclined to ascribe to the fungus itself a non-natural quality of foulness'.[33] There is no question that in the grip of revulsion at a fungus, we ascribe the disgust to the fungus rather than ourselves. We recoil from it. Similarly with sexual disgust, as the following quote from Musil's *The Confusions of Young Törless* vividly suggests, describing Törless's feelings of disgust in looking at his schoolmate:

And it was upon those hands, actually the most beautiful thing about Beineberg, that his greatest disgust was focused. There was something indecent about them. That was probably the right word. And there was also something indecent in the impression of dislocation that his body produced, in a sense it only appeared to collect in his hands, and it seemed to radiate from them like the presentiment of a touch, which sent a twinge of nausea over Törless's skin.[34]

Here too, the source of disgust is firmly located, phenomenologically, in the object, and only derivatively in the subject.

One might point out that for many erotic properties, it is impossible to apprehend them without perceptually experiencing them. I don't know if this is true, but let's say it is, taking *lush curvaceousness* as exemplary. That is, I will accept for the sake of argument that what is often called, in relation to

[33] Mackie (1990: 42). [34] Musil (2001: 24).

judgements of taste, an 'Acquaintance Principle'[35] holds for *lush curvaceousness*: namely, one cannot judge that a body has *lush curvaceousness* unless one is in direct perceptual contact with it. Even so, mental representation of the property of *lush curvaceousness* is not conceptually connected to mental representation of an experience of it. That an Acquaintance Principle holds for *lush curvaceousness* is a controversial metaphysical claim not revealed in its phenomenology. Yet it is only the phenomenology of an erotic property which is supposed to be captured in imaginatively representing it.

I conclude that there is no route from the supposed metaphysical facts about erotic properties to the claim that one's imaginings about them must be implicitly *de se*.

8. Conclusion

I have argued that there are no good grounds to insist that aroused responses to imagined erotic properties must involve imagining, from the inside, perceiving or coming to awareness of those properties, or be in any other way implicitly *de se*. As well as being of interest in its own right, I take it that this has consequences for the more general debate discussed in the first half of this chapter. If we take aroused responses to erotic properties as exemplary of emotional responses to affective properties, more generally, and so take aroused responses to *imagined* erotic properties as exemplary of emotional responses to *imagined* affective properties, support has been provided for the claim that we do not need to analyse imagining in relation to fiction as implicitly *de se*—as imagining, from the inside, perceiving or being aware of fictional events—in order to convincingly account for those emotional responses to it.

References

Alward, Peter (2006) 'Leave Me out of It: *De Re*, but Not *De Se*, Imaginative Engagement with Fiction'. *Journal of Aesthetics and Art Criticism* 64(4): 451–9.
Budd, Malcolm (2003) 'The Acquaintance Principle'. *British Journal of Aesthetics* 43 (4): 386–92.

[35] Budd (2003).

Currie, Gregory (1990) *The Nature of Fiction*. Cambridge University Press.

Davies, David (2007) *Aesthetics and Literature*. Palgrave Macmillan.

Gaut, Berys (2003) 'Reasons, Emotions and Fictions'. In M. Kieran and D. Lopes (eds.), *Imagination, Philosophy and the Arts*. Routledge.

Jacobsen, Rockney (1993) 'Arousal and the Ends of Desire'. *Philosophy and Phenomenological Research* 53(3): 617–32.

Johnston, Mark (2001) 'The Authority of Affect'. *Philosophy and Phenomenological Research* 63(1): 181–214.

Kind, Amy (2001) 'Putting the Image back in Imagination'. *Philosophy and Phenomenological Research* 62(1): 85–110.

Lamarque P. and Olsen S. (1994) *Truth, Fiction and Literature*. Oxford University Press.

Levinson, Jerrold (1993) 'Seeing Imaginarily at the Movies'. *Philosophical Quarterly* 42(170): 70–8.

Mackie, John (1990) *Ethics: Inventing Right and Wrong*. Penguin.

Martin, Michael (2002) 'The Transparency of Experience'. *Mind and Language* 17(4): 376–425.

Musil, Robert (2001) *The Confusions of Young Törless*. Penguin 20th Century Classics.

Noordhof, Paul (2002) 'Imagining Objects and Imagining Experiences'. *Mind and Language* 17(4): 426–55.

Peacocke, Christopher (1985) 'Imagination, Experience and Possibility', in J. Foster and H. Robinson (eds.), *Essays on Berkeley*. Clarendon Press.

Recanati, Francois (2007) 'Imagining *De Se*'. Paper presented at Mimesis, Metaphysics, and Make-Believe: A Conference in Honour of Kendall Walton, University of Leeds, Leeds, UK <http://halshs.archives-ouvertes.fr/docs/00/16/07/57/PDF/de_se_imagining11.pdf>.

Scruton, Roger (2006) *Sexual Desire: A Philosophical Investigation*. Continuum.

Shaffer, Jerome (1978) 'On Sexual Desire'. *Journal of Philosophy* 75(4): 175–89.

Smith, Joel (2006) 'Bodily Awareness, Imagination and Self'. *European Journal of Philosophy* 14: 49–68.

Stock, Kathleen (2011) 'Fictive Utterance and Imagining'. *Aristotelian Society Supplementary Volume* 85(1): 145–61.

Walton, Kendall (1990) *Mimesis as Make-Believe*. Harvard University Press.

7

Pornography at the Edge
Depiction, Fiction, and Sexual Predilection

CHRISTY MAG UIDHIR AND HENRY JOHN PRATT

1. Framing Pornography

Any attempt to characterize the pornographic is likely to be contentious. We do not intend to defend any such account here, but we should make our starting points clear. For our purposes, we merely assume the following:

> MINIMAL CHARACTERIZATION OF PORNOGRAPHY: A work w is a work of pornography only if (a) w is a depictive work (b) of which the (primary) purpose is sexual arousal of its audience, (c) the primary subject of which is of an explicitly sexual nature, and (d) w prescribes attention to (c) as the (primary) means of satisfying (b).[1]

Nothing in what follows should be taken to suggest allegiance to or dependence on any particular robust definition of pornography; we merely

[1] For our purposes here, we assume depiction to be representation in the *standard* sense. Although representations can be visual or verbal, we are primarily concerned with pornography as *visually* depictive. That said, we take visual depiction *standardly* to involve an object, a subject, and an agent, where the object admits at least some baseline degree of resemblance to that subject in virtue of that object being the product of some set of conventionally established activities successfully performed by that agent with the intention that the product of those actions possess at least some baseline degree of resemblance to that subject. This standard sense should be seen as broadly applicable, having no allegiance to any particular theory of depiction, and able to be formatted to fit specific views (Abell 2005; Hyman 2000; Lopes 2005). So, although there are many theories according to which neither resemblance nor intentions are necessary for depiction (e.g. Walton 2002; Newall 2006), we neither defend nor endorse the necessity of resemblance or intention for depiction *simpliciter*; we merely take depiction to *standardly* involve resemblance and intention.

offer the above eminently plausible necessary condition as a means by which we can ground the substantive discussions to come.

Of course, one might think that even the above modest necessary condition could be made more precise. Take (b), for example. Matthew Kieran (2001) claims that pornography's goal is to 'elicit sexual arousal or desire' (32), while Jerrold Levinson(2005) holds that pornography is supposed to do more: to 'sexually arouse in the interests of sexual release' (230). Both are careful about the type of sexual arousal characteristic of pornography and erotica precisely because they want to determine whether such arousal is compatible with being an artwork. However, both nonetheless agree that sexual arousal of some sort is the crucial intended effect, and since the art status of pornography is not our topic here, we only require a more coarse-grained understanding: pornography succeeds in its primary purpose when it causes sexual arousal.[2] Again, although our minimal characterization of pornography could be further specified, for our purposes we shall remain silent as what such further specifications there may be.

While we take pornography to be essentially depictive, we also take pornography to encompass a number of different depictive styles that depend on the technical possibilities afforded by the media in which they are created. However, even though not all pornography is stylistically realistic, this does seem to be an ideal to which much pornography aspires, for apparently straightforward reasons. Consider *when* pornography is typically consumed: in circumstances where one cannot engage in sexual activity of the desired type because the other participants in that activity are unavailable. As Levinson (2005) puts it, 'pornography is essentially a kind of substitute or surrogate for sex, whether a poor one or not we can leave aside' (385). When coupled with the idea that effectiveness in producing sexual arousal correlates directly with sensory access to the objects of sexual attraction, this implies that pornography is most successful at achieving its purposes when it affords to the consumer the most direct sensory access to the (absent) objects of attraction. The best way to do this would seem to be to make pornography as *realistic* as possible,[3] hence Levinson's claim that 'to fulfill that purpose its images should be as transparent as possible—they

[2] For a more detailed analysis of pornography's purpose and the relation to its prescribed manner of satisfaction, see Mag Uidhir (2009).

[3] For a detailed analysis of the notion of depictive realism to which we broadly subscribe, see Lopes (1995, 2006) and Abell (2006, 2007).

should present the object for sexual fantasy vividly, then, as it were, get out of the way' (385).

Presumably, then, we can assume that the contemporary paradigm (prototype, exemplar) of pornography involves the attempt to sexually arouse its audience via the depiction of actual people engaging in actual sexual activity. At least insofar as the purpose of sexual arousal is concerned, we ought to expect prototypical pornography to satisfy this purpose via employing or featuring sufficiently realistic depictions of a sexually explicit sort. Likewise, we ought to expect a target audience to be sexually aroused at least to the extent that the audience takes those depictions to be transparent (i.e. as a depictive record of actual persons engaged in actual sex acts) or realistic (i.e. as more or less conforming to relevant expectations about the actual world).[4]

We can now offer a more precise definition.

PROTOTYPICAL PORNOGRAPHY: A work of pornography is a work of *prototypical pornography* only if that work (i) employs a maximally realistic depictive style (given the technological and representational possibilities afforded to the pornographer) or a depictive style sufficiently realistic to maximally satisfy the purpose of sexual arousal, and (ii) features an explicitly sexual (primary) subject that is maximally realistic (*ceteris paribus*) or sufficiently realistic to maximally satisfy (*ceteris paribus*) the purpose of sexual arousal.

According to this view, we ought to expect prototypical pornography prior to the invention of photography to feature more or less sufficiently realistic depictions. Likewise, the degree to which a work's depictions are realistic should *ceteris paribus* be the degree to which that work is successful in sexually arousing its audience. We take depictive realism here to be indexed to time and cultural standards with respect to both sexual preferences and depictive style,[5] thereby allowing for multiple depictions with the same subject to be more or less equally realistic despite each featuring depictive styles radically divergent from the rest (e.g. second-century BCE Buddhist cave frescos, murals of Pompeii, Edo-period Japanese woodcuts, illustrations from de Sade's *L'Histoire de Juliette*). Of course, after the advent of photography,

[4] For a detailed analysis of realistic and unrealistic fictions, see Hazlett and Mag Uidhir (2011).
[5] For the defense of such an account, see Abell (2007).

transparency seems to have become the default form of depictive realism, and with it, prototypical pornography has shifted towards those media establishing direct causal connections to the world.

Nonetheless, we should be cautious to avoid the claim that unrealistic depictions cannot or do not sexually arouse or that prototypical works of pornography cannot also be works of fiction. For example, consider the to-date most expensive adult film ever made: *Pirates* (2005). This movie is patently not just a prototypical work of pornography (though one with an atypical production budget) but also a work of film-fiction.[6] Presumably, however, *Pirates* successfully sexually arouses its audience primarily via that audience engaging with the film as a maximally transparent depiction of actual persons engaging in actual sexual acts (e.g. between adult film actors Evan Stone and Jesse Jane) rather than as a cinematic representation of the fictional-world sexual escapades of the pirate-hunting libertine, Captain Edward Reynolds (played by Evan Stone) and his equally licentious first officer, Jules (played by Jesse Jane). Qua pornography, to satisfy the purpose of sexual arousal, the audience need not engage with *Pirates* as a work of fiction; they need only engage with *Pirates* as a sufficiently transparent photographic depiction of actual persons actually having sex.[7] Of course, the advent of the camera did not spell the end of non-photographic pictorial pornography anymore than it appears to have put the sketch artist permanently out of business.

It is noteworthy that even if a work is *pornographic*, it need not be a work of *pornography*. For instance, erotic birthday cakes, obscene phone messages, wet dreams, security footage of employee hanky-panky, naughty novelty key chains, and so forth are pornographic, but it would be strange indeed to call them pornography. Moreover, it appears that many works that are pornographic, far from aspiring to be prototypical pornography, have stylistic or referential properties that appear to be *antithetical* to prototypical pornography. Such works fall into at least three (overlapping) categories.

[6] Pornography is not a medium but rather a work-description that putatively applies to works specific to a variety of media: movies such as *Hot Shots Volume 30: Hot Jocks*; photos such as those contained in *Hustler* magazine; comics such as *Boku No Sexual Harrassment*; novels such as *Tropic of Cancer*; video games such as *Bible Black*; and music such as 2 Live Crew's 1989 album *As Nasty As They Wanna Be*.

[7] To this extent, contemporary prototypical pornography seems instructively similar to video surveillance: in order to satisfy their respective purposes, both rely on viewer assumptions about the objective purport of photographs.

First, though transparency is an obvious way to approach maximal realism, some pornographic works employ decidedly non-transparent depictive media. Second, though a range of stylistic choices is available within each depictive medium, some pornographic works are the result of deliberate decisions to depict their subjects less realistically than they could have been, even to the point of gross exaggeration. Third, while depictions of real-life people would seem to serve well the purposes of bringing the consumer closer to the objects of attraction, some pornographic works predominantly depict subjects that are known by the audience to be entirely fictional, for whom the audience is invited to feel sexually aroused.

This ought to strike one as puzzling. That is, everything pornographic, one might think, should aim towards the prototypical, which (if Levinson is to be believed) is the most successful type of pornography at achieving its primary goal. Given that, among depictive media available to us at present, photography and related technologies of film and video seem to yield maximally realistic depictions in the sense required for prototypical pornography, it might be thought that photographic technologies would have rendered all other pornographic media obsolete.[8] Yet pornographic works survive and even thrive in media that are opaque, unrealistic, or predominantly and thoroughly fictional in content. Why is this?

To best answer the question, let us distinguish between two senses of 'pornographic'.[9]

For a work *w* to be *work-pornographic* is for *w* to have sufficiently salient properties in common with prototypical pornography.

For a work *w* to be *genre-pornographic* is for *w* to be in a medium genre (or subgenre) for which prototypical works of that genre are both pornography and work-pornographic.

By making this distinction, we allow for there to be works of the following sorts:

Neither work-pornographic nor genre-pornographic.

[8] Levinson (2005) claims that photography is 'the prime medium for pornography, that which has displaced all other such media in that connection. For photography is the transparent medium *par excellence*, that is, the medium that comes closest to simply presenting the requisite object . . . directly, as material for sexual fantasy and gratification' (385).

[9] For a similar view about 'pornographic', see Mag Uidhir (2009).

For example, *Bambi* (1942) has no salient properties in common with prototypical pornography, and is in a medium genre (*animated film/family film*), for which prototypical works are neither pornography nor work-pornographic.

Both work-pornographic and genre-pornographic.

For example, *Deep Throat* (1972) and *Camera Sutra* (2004) are both part of a medium subgenre (*adult film*) that is prototypically pornographic and have many salient properties in common with prototypical pornography (e.g. feature several explicit and extended depictions of sexual intercourse).

Work-pornographic but not genre-pornographic.

Although Gaspar Noé's *Irréversible* (2007) contains a nine-minute anal-rape scene, the film is decidedly not genre-pornographic, as it belongs to a medium subgenre (e.g. *French art film*) for which prototypical works are not pornography.[10]

Genre-pornographic but not work-pornographic.

Consider that *Bat Pussy* (1973), although intended to be a mainstream pornographic movie, is so incompetently made that it hardly, if at all, shares salient properties with works of prototypical pornography.[11]

The goal of all the foregoing distinctions is to provide an informative and productive framework within which we can better understand the nature of (and issues surrounding) those putative works of pornography that nevertheless appear to be of the sort antithetical to prototypical pornography. In the end, we take our framework to be of substantial philosophical import not only for understanding pornography itself but also for specifying the scope and limits of its ascriptions. So, although we refrain from making either exclusionary or inclusionary claims about art and pornography, we nevertheless take our proposals to provide productive tools for framing such issues

[10] *Irréversible*, though in a decidedly subversive manner, may also belong to other genres, such as those of thriller or revenge fantasy.

[11] Notice that this distinction can be used to informatively characterize cases of censorship or banning of, e.g., films such as *A Clockwork Orange* (1971), *Brown Bunny* (2004), *Salo* (1975), *Fat Girl* (2001), and *Brokeback Mountain* (2005). It allows for plausible explanations of the motivations behind such bans while nevertheless remaining consistent with the position that the works so banned are in fact not pornography at all, but instead are at best work-pornographic films. Presumably, the ethical motivations behind censorship ought to, in the main, track the work-pornographic rather than the genre-pornographic.

precisely because the art-pornography debate looks to be located upon the very terrain we target for philosophical scrutiny—*at pornography's edge*.

Which works exist at that edge? While other examples could be chosen, we will be focusing on three sorts that, we will see, are far from the prototypical: Tijuana Bibles, *hentai manga*, and slash fiction.

TIJUANA BIBLES:[12] cheaply made pocket-sized comic books popular in the Depression-era United States that depict sexually explicit scenarios (both heterosexual and homosexual) involving celebrities and cartoon characters who were well known at the time (e.g. Popeye, Snow White, Nancy and Sluggo, Clark Gable, John Dillinger, Dorothy Lamour).

HENTAI MANGA: a subgenre of *manga*—Japanese comics—primarily aimed at adult consumers due to its preponderance of sexually explicit themes and graphic depictions of a veritable host of sexual orientations, acts, and fetishes (e.g. breasts, transsexuality, incest, bestiality, *alien hentai* or 'tentacle rape').

SLASH FICTION: a foundational subgenre of fan fiction chiefly featuring sexually explicit depictions of non-canonical homosexual relationships between otherwise heterosexual male characters. The first slash fiction consisted of stories depicting a homosexual relationship between *Star Trek*'s Captain Kirk and Mr. Spock, and were referred to as Kirk/Spock (K/S) stories—hence the name *slash* fiction.

Since they fit into the minimal characterization with which we began, we assume that such works are at least *putatively* pornography, and this allows us to investigate the following questions:

THE DEPICTIVE QUESTION: How might issues of depictive realism (in style or in subject) for such works bear, if at all, upon such works being pornographic (in either sense)? Does the lack of realism in Tijuana Bibles or *hentai* affect their status as pornographic?

THE FICTION QUESTION: How might the conditions for being a work of fiction (slash fiction or otherwise) fit, if at all, with the conditions for being a work of pornography? Are the primary aims of fiction and

[12] The origin of the term 'Tijuana Bible' is obscure, but seems to have little to do with Mexico save for their contraband status and corresponding need to be smuggled.

pornography compatible, and can a work be an excellent example of both?

In answering these questions, we will gain an understanding of how and why works at the edge can be putatively pornography despite clearly failing to be prototypical pornography, and we will arrive, in turn, at a deeper understanding of the aims of pornography and the reasons for which significant subgenres of pornography might diverge from the prototypical ideal.

2. Pornography and the Depictive Question

While Tijuana Bibles and *hentai manga* alike are putatively pornography, given that they are geared primarily towards sexual arousal, the depictive styles employed therein have interesting implications for their status, given the framework established in §1. Neither seems to be prototypical pornography; nevertheless, such works are both genre-pornographic and work-pornographic.

Tijuana Bibles and *hentai* are both created by drawing, clearly situating them alongside most of the other works in the broader medium to which they belong: comics. Before the advent of photographic technologies and economically viable ways of disseminating them, drawing afforded among the most realistic depictive techniques known. While *hentai* certainly arose after photographically based pornography was readily available, Tijuana Bibles did not. It is to be expected that the makers of Tijuana Bibles did not use photography; what is *not* expected is that they did not avail themselves of realistic drawing techniques, opting instead for gross exaggeration and caricature.[13] (In one Tijuana Bible, for instance, Popeye, already a bizarre caricature, is pictured with a penis roughly the size of his torso.) The makers of Tijuana Bibles *could* have drawn more realistically and produced more sexually realistic subjects, but did not. The case of *hentai* is even more clear-cut. *Hentai* also trades in exaggeration. In addition to the exaggerations of eye size and limb length characteristic of *manga* in general, works of *hentai* often grossly exaggerate penis and breast size. Moreover,

[13] For more on pictorial caricature, see Mag Uidhir (2011).

since the makers of *hentai* are technologically able to use photography (but do not) their works could easily be more realistic, both in general style and in the specific characters depicted. Obviously, neither Tijuana Bibles nor *hentai* are prototypical pornography.

Both, however, are genre-pornographic. Tijuana Bibles and *hentai* are among the drawn media, as mentioned earlier, but more specifically, both are subgenres of comics. While precise definitions of comics are controversial (McCloud 1993; Hayman and Pratt 2005; Meskin 2007), there seems to be a rough consensus that comics, prototypically, are a kind of sequential, pictorial narrative—the form in which Tijuana Bibles and *hentai* are presented. While the medium of comics is not itself characteristically pornography, it admits of subgenres that are, Tijuana Bibles and *hentai* among them—and *hentai*, in particular, is a very significant subgenre of comics.[14]

Most works in the Tijuana Bible and *hentai* genres are work-pornographic, save for those that are executed incompetently. While they do not exhibit the maximally realistic depictive styles characteristic of prototypical pornography, as noted above, they do share other salient properties: explicit representation of sexual intercourse and sexualized body parts, together with the intention to maximally satisfy the aim of sexual arousal.

We can now see why there is justification for thinking of Tijuana Bibles and *hentai* under the rubric of pornography even though they fail to be prototypical. Works that are both work-pornographic and genre-pornographic are still situated within the bounds of pornography, even if at the edge. But we still have a mystery before us: what is the point of creating pornographic works that are *not* prototypical when the prototypical depictive styles and technologies are readily available?

The solution lies in the idea that there are some things that can be done in Tijuana Bibles and *hentai* that cannot be done in prototypical pornography. To make such a claim is to endorse some degree of medium specificity. As Noël Carroll defines it (2008: 35–7), medium specificity is the view that the media associated with a given art form (both its material components and the processes by which those components are manipulated) entail specific possibilities for and constraints on representation and expression, which provides a normative framework for what artists working in that art form ought to

[14] In Japan, just one *hentai* genre, *redezu komikku* (targeted at women in their twenties and thirties) accounts for an estimated 103 million copies sold monthly (see Shamoon 2004: 78).

attempt. Carroll rejects medium specificity, largely due to problems he finds with the second clause, but the first clause is more plausible. Comics like Tijuana Bibles and *hentai* allow for specific depictive possibilities that more realistic technologies cannot without great difficulty match.

Because Tijuana Bibles and *hentai* are drawn, they can represent pornographic scenes that are difficult or even impossible to photograph. The representational capacities of drawings are limited only by the skills and imagination of the artist. The representational capacities of photographic technologies, in contrast, have additional limits: a 'pure' photograph (one with minimal digital or darkroom manipulation) can only depict the objects at which the camera is pointed.

Some people—audiences at the edge, if you will—become aroused by seeing or thinking about scenes and objects that, if not physically impossible, are at the least physically highly unlikely. These sorts of things are almost completely beyond the abilities of photography to capture. Examples include:

- Disproportionally sized body parts (particularly breasts and genitalia).
- Sexual intercourse between celebrities, sometimes contrary to the presumptive sexual orientation of those celebrities.
- Human sexual congress with animals, cartoon characters, monsters, and aliens.
- Sexual acts that require anatomically impossible degrees of flexibility.
- Visual representations of the female orgasm.
- Acts of penetration not visible on film, achieved through depictive devices such as transparent skin and clothing.[15]

The people for whom such representations are arousing are not going to be satisfied by pornographic photographs.

Tijuana Bibles and *hentai* have an additional advantage over prototypical pornography: they can be made without the help of anybody else. Imagination is required, but not cooperation or consent. A medium-specific feature of comics is ease of production; a feature of genre-pornographic comics is ease in producing works depicting actions that contravene mainstream sexual mores. Photographed objects and actions can, obviously, contravene such mores as well. But the more radical the departure, the more difficult it is

[15] See Shamoon (2004: 88).

to find willing subjects and to arrange the conditions under which they are photographed. Not so with comics. Since Tijuana Bibles and *hentai* are situated at the edges of pornography, they can, much more easily than photographs, cater to individuals whose sexual preferences are also at the edges.[16]

Still, it seems that one could best satisfy these sexual preferences, if not through photography, then by opting for a maximally realistic drawing style. Why do the makers of Tijuana Bibles and *hentai* make the opposite choice? In the case of Tijuana Bibles, the explanation could well be incompetence: it would be an act of great charity to describe the artistry in most of these as amateurish. But sometimes the choice is deliberate, particularly in *hentai* works where it is clear (sometimes from very realistically depicted background scenery) that the artist is capable of rendering his or her subjects in less cartoonish styles.

One reason why cartooning and caricature are common in comics in the first place also helps explain why there are non-prototypical pornographic comics. According to Scott McCloud, the simplicity and degree of abstraction involved in cartooning allows for the possibility of almost universal identification with the characters depicted.[17] The more realistically a person is depicted, the harder it is to relate to it as you relate to yourself. In contrast, any human being who is not horribly disfigured can picture his or her face as a simple circle with two dots for eyes and a line for a mouth. Comics use cartoons, in short, to facilitate reader identification. If cartooning allows for greater reader identification than photographs, then it allows the reader more easily to project himself or herself into the depicted scene. So if Levinson is correct in his claim that pornography is a substitute or surrogate for sex, and that effective pornography enables one to envision more closely that one is actually engaged in or with what is depicted, then there is a way that non-prototypical works can be *better* at delivering sexual arousal than prototypical works. A work that uses less realistic drawing techniques facilitates closeness with the characters therein, rather than (as in photographic pornography) forcing one to perform the far more difficult task of imagining that one is somebody else in all their extreme particularity.

[16] This prompts interesting questions about the ethical contrasts, if any, between pornographic drawings and pornographic photographs—an issue particularly salient in the case of pedophilia.

[17] McCloud (1993: 30–7). McCloud's view, it should be noted, is controversial.

At the same time that Tijuana Bibles and *hentai* allow readers to achieve greater *identification* with the characters, they provide a sense of *distance* that photographs cannot match. This is not as paradoxical as it appears. When prototypical pornography depicts a fictional narrative through the use of photographically based technologies, there are still very real people acting that fiction out—individuals with a subjectivity that includes personalities, hopes, desires, friends, family, and so on. The degree of transparency associated with photographs cannot help but to make this clear to the viewer. And though maximally realistic drawings need not have real persons as subjects, their realism prompts one to imagine strongly that those persons are real and individual.

The consumer of pornography, however, may not *want* his or her sexual fantasies or desires to be connected to real people in any way. In particular, a sense of distance may be sought when those fantasies or desires are taboo or believed to necessitate causing harm to oneself or another. Removal of concern for the particularities of the human beings in pornography, by thinking of them more abstractly, is a way to avoid feeling guilt.[18]

Pornographic narratives in photographic media often contain attempts to divert attention away from the actual personhood of the participants, both through the use of pseudonyms for the performers and the various devices aptly noted by Kieran:

> The characters are mere ciphers, stereotypical substitutes, precluding any need on our part to imagine in any depth their feelings, beliefs, and attitudes. Similarly, the plots, such as they are in narrative pornography, remain ludicrous caricatures of implausible situations, presented as if they were ordinary, everyday occurrences. (371)

Though *attempts* to distance can be made in maximally realistic styles, they cannot be *entirely* successful. Pornography at the edge has no such problem. Because the drawing is less than photorealistic, the persons depicted are more generic than real people—closer to a template or a blank object than a human being. While this means that the reader can identify with a character, it also implies that Tijuana Bibles and *hentai* that do not represent a particular

[18] But thinking of humans in the abstract, instead of as particular people, may be thought to be a variety of objectification—and hence ethically troubling. See Nussbaum (1995).

person cannot objectify any particular person, and so have the capacity to afford the sense that no particular person is being harmed.[19]

This allows for a felt moral superiority. Consumers of *hentai* and Tijuana Bibles (at least, those that do not depict celebrities) can claim that the indefinite persons represented by the drawings cannot be harmed. Since no real, particular person is harmed, the guilt that often accompanies consumption of pornography is alleviated. This moral superiority may be completely illusory—it is entirely possible that the moral status of Tijuana Bibles and *hentai* is exactly equal to that of prototypical pornography—but a felt superiority for its readership would go a long way towards explaining why pornography at the edge can have a certain appeal.

Selection of less than maximally realistic depictive styles may also be explained, finally, by the perception that those styles are, in some significant way, artistic. A common if controversial idea about art is that one's work must contain creative contributions that express distinctive visions of the world, rather than merely duplicating the world's appearance.[20] When a work's depictive style diverges from the realistic, it is easier to make the case that it is art. Even if art and pornography are incompatible, when pornography is thought of *as* art, it gains cultural currency (attaining, perhaps, the esteemed status of erotica rather than pornography). Because it is easier to think of Tijuana Bibles and works of *hentai* as art than it is to think of more realistic pornography as art, it is easier to defend possessing and appreciating them. One's significant other, for instance, is likely to have a very different reaction to an issue of a *hentai* series found around the house than he or she would to an issue of *Penthouse*, even if the comic and the magazine have identical sexual content.

Pornography, we agreed at the outset, has the primary purpose of sexual arousal of its audience. We have seen in this section that being prototypical is not the only way to be effective in this regard. Realism and transparency of pornographic media are not always desirable; rather, the lack of transparency afforded by pornography at the edge allows it to achieve a number of sexually arousing effects not available in prototypical pornography at all.

[19] This is not to say that Tijuana Bibles and *hentai* do not objectify, only that when they do, it is either in virtue of representing an actual person—in, say, a Tijuana Bible featuring a gay James Cagney—or derivatively, by objectifying a class of persons.

[20] This view is articulated prominently by Scruton (1981), who uses it to inveigh against photography and film as art forms.

3. Pornography and the Fiction Question

Given the minimal account of pornography laid out in section 1, we ought, at least prima facie, to expect works in the domain of *prototypical pornography* to be more or less unified with respect to subject, purpose, and manner—more or less to minimally satisfy the purpose of sexually arousing their audiences via prescribed audience attention to maximally realistic and transparent depictions of the same broad subject matter (i.e. human beings engaged in sexually explicit situations). Given that the more a work of putative pornography departs from depictive realism and transparency, *ceteris paribus*, the less capable that work is of sexually arousing its audience, one might reasonably conclude that a work of fiction ought to be less successful than its non-fiction counterpart in satisfying the primary purpose of pornography. Let us explore, then, the descriptive and evaluative tensions present in the overlap between pornography and fiction.

To that end, we will operate with the following:

MINIMAL CHARACTERIZATION OF FICTION: For F to be a work of fiction is (minimally) for F (i) to depict some fictional world [W_F], and (ii) to invite its audience to imagine W_F in accord with (as minimally specified in) that F.[21]

How might satisfying those conditions for being a work of fiction bear upon satisfying the minimal conditions for being a work of pornography?

One might reasonably expect few works in the domain of prototypical pornography to be works of fiction. There seems to be an intuitive sense in which fictions are depictive departures from reality, primarily inviting us to imagine fictional worlds rather than offering us testimony about the actual world. However, the briefest of reflection shows that works of fiction comprise quite a substantial subset of prototypical pornography, including the classic pornographic film-fictions of the 1970s such as *The Devil in Miss Jones* (1973), *Naked Afternoon* (1976), *Debbie Does Dallas* (1978); the utterly forgettable pornographic film-fictions from the decidedly not-so-classic video era of the 80s and 90s such as *The Sperminator* (1985), *Saturday Night Beaver* (1986), and *Spankenstein* (1998); and even the big-budget

[21] For more on this, see Lewis (1983), Currie (1990), Walton (1990), Gendler (2000), and Hazlett and Mag Uidhir (2011).

pornographic film-fictions from the largely fiction-free DVD/Internet era of the last decade such as *Manhunters* (2006), *Pirates* (2005), and *Upload* (2007). As such, our principal focus must shift to how, if at all, satisfying the conditions for being a work of prototypical pornography is compatible with satisfying the conditions for being a work of fiction *likewise prototypically construed*.

Fiction standardly prescribes for its audience certain responses among which are aesthetic, narrative, emotional, didactic, or cognitive experiences. Prototypically, such responses are in service to the same broad aim: the entertainment of the fiction's audience.[22] Entertainment value is a substantial part of the reason why we take engaging with fictions to be a prima-facie worthwhile activity. If being entertained is a prima-facie (if not *pro tanto*) good, and prototypical fictions, when engaged, provide a source of entertainment, then to that extent engaging with prototypical fictions is a worthwhile activity.

Prototypical pornography aims primarily at sexually arousing its audience via prescribed attention to maximally realistic and transparent depictions of its subject matter. Prototypical fiction aims primarily at imaginatively entertaining its audience via the prescribed imagining of the fictional world depicted. At first blush, the standard sorts of aims of prototypical pornography appear to run orthogonal or perhaps even directly counter to those for prototypical fiction. Given the primary aim of sexual arousal, depictive realism clearly constitutes a central if not essential concern for prototypical pornography, but given the primary aim of imaginative entertainment, depictive realism quickly becomes a peripheral matter for prototypical fiction—a central concern perhaps for certain genres of fiction (such as historical biopics, period romances) but never for fiction itself.

Although some works of prototypical fiction are sexually arousing (e.g. Adrian Lyne's film *9½ Weeks* (1986), Agnar Mykle's novel *The Song of Red Ruby* (1956), Alan Moore's comic *Lost Girls* (2006)), presumably their being sexually arousing is ultimately not an end itself but rather a means of satisfying fiction's entertainment aim. Qua fiction, works that depict sexually explicit situations do so either in direct service to the primary aim of

[22] For example, I assume the film *Days of Heaven* (1978), the novel *House Made of Dawn* (1968), the play *King Lear*, and the television series *Mad Men* all to be fictions that successfully entertain their audiences by being, respectively, beautifully shot, narratively complex, emotionally powerful, and richly historically informative about their subjects.

audience entertainment, or in order to elicit certain emotional responses, signal certain narrative shifts, heighten or relieve dramatic tension, draw certain thematic contrasts or comparisons, or similarly serve some such other prescribed uptake. We should neither expect nor find to be anything but peculiar a work that, qua fiction, aims to sexually arouse its audience *and nothing more*, as the satisfaction or frustration of such an aim looks utterly incidental to the satisfaction or frustration of the primary aim of that work qua fiction.

Likewise, while many works of prototypical pornography are also entertaining works of fiction, such works qua pornography depict sexually explicit situations so as to sexually arouse their audiences *simpliciter*. That is, even though such works qua fictions aim at entertaining their audiences, the satisfaction of that primary aim qua work of fiction can at best contribute only incidentally to the satisfaction of the primary aim qua work of pornography. Moreover, such works of prototypical pornography often fail to satisfy their primary aim qua pornography to the extent they succeed in satisfying their primary aim qua fiction. For example, *Café Flesh* (1982), a pornographic film-fiction, depicts sexually explicit situations sufficiently bizarre to advance its aims qua fiction (e.g. the oddly cold and mechanical nature of the sex depicted contributes both narratively and atmospherically to the work as an entertaining film-fiction) but also sufficiently bizarre to interfere with its aims qua pornography (e.g. the oddly cold and mechanical nature of the sex depicted detracts from the work as a sexually arousing pornographic film). The extent to which *Café Flesh* succeeds as an entertaining work of post-apocalyptic science fiction is the extent to which *Café Flesh* fails as a sexually arousing work of pornography. This suggests that, at least for some works within the fiction-pornography extensional overlap, not only do the good/bad making features of works qua fiction and those qua pornography come apart, but more importantly, good/bad making features qua fiction may be bad/good making features qua pornography. Discovering the descriptive conditions under which fiction and pornography possess antipodal evaluative criteria not only helps us better formulate boundary disputes between pornography and other genres (both fictive and depictive alike) but also reveals that the key to answering the pornography/art question lies squarely at pornography's edge.

In order to avoid conflating the fiction question with the depictive question, we think it best at this stage to abandon our focus on visual

depiction, lest we end up defending a purely fictive-pornographic tension (descriptive or evaluative) that upon closer inspection turns out to be a visually depictive-pornographic tension in clever disguise. To this end, we consider *slash fiction*.

Slash fiction is a sub-genre of fan-fiction—non-canonical texts written by fans of a particular fictional series (e.g. *Star Trek, Harry Potter*) that comprises a well-established, canonical fictional universe. What sets slash fiction apart from other fan-fiction is that it deliberately depicts a non-canonical homosexual relationship and/or sexually explicit homosexual activity between two canonically heterosexual male characters (some *Star Trek* slash has depicted Captain Kirk and Mr Spock as being engaged in a homosexual relationship; some *Harry Potter* slash has similarly paired Harry Potter and Professor Snape).[23]

How does slash fiction fit into the accounts of fiction and pornography sketched in the foregoing? Consider a Kirk/Spock fiction [*K/S*]. *K/S* depicts a fictional world that is non-canonical, in that it invites its audience to imagine Kirk and Spock in a sexually explicit relationship. And the audience (composed, incidentally, primarily of other slash fiction writers) is to be entertained via imagining that relationship. *K/S* is also putatively pornography.[24] It aims at sexually arousing its audience precisely by prescribing audience attention to its graphic depictions of sexually explicit (and non-canonical) interactions between Kirk and Spock.

K/S (and similar works of slash fiction), then, reveal a potential tension. To be a good work qua fiction, *K/S* must successfully entertain its audience. To be a good work qua pornography, *K/S* must successfully arouse its audience sexually. How might these evaluative standards bear upon each other? The answer depends on how the audience engages with the work. Consider the following possibilities:

[23] This may also be an illusion to Roland Barthes's *S/Z* (1970), in which he offers a structuralist analysis of Balzac's 'Sarrasine' revealing hidden homoerotic aspects—the titular '*S*' and '*Z*' being Sarrasine and the castrato, La Zambinella. Thanks to Jerrold Levinson for pointing this out.

[24] Or at least putatively both work-pornographic and genre-pornographic. Note that slash fiction is far more plausibly construed as a species of pornographic fiction—the standard pulp sort typically found in adult bookstores (e.g. *Midtown Queen* or *The Short Happy Sex Life of Stud Sorell*)—rather than of erotic literature—the standard literary minded sort of erotica found in academic libraries (e.g. *Lady Chatterly's Lover* or *The Story of O*).

- The audience for *K/S* skims the fiction, reading only the sexy bits. As a result, though the audience finds the sexy bits exceedingly sexually arousing, they nevertheless fail to be entertained by *K/S*.
- The audience for *K/S* is sexually aroused, not by imagining the fictional characters Kirk and Spock to be engaged in all manner of sexual congress in the fictional world, but by imagining the actual world actors William Shatner and Leonard Nimoy to be engaged in all manner of sexual congress (as minimally depicted in *K/S*) in the actual world.
- The audience for *K/S*, though wholly unfamiliar with the *Star Trek* canon and thereby clueless as to who this lusty fellow (called 'Kirk') and his sexually generous lover (called 'Spock') may be, nevertheless finds imagining their sexual union (as minimally depicted by *K/S*) to be exceedingly sexually arousing.

Clearly, each of the above constitutes a failure for *K/S* qua fiction. However, since slash fiction is putatively pornography, it appears that in each of the above, not only does *K/S* succeed as a work of pornography but also it does so despite its failure qua fiction. Therein lies the problem. If we assume, and we are no doubt correct to do so, that slash fiction is constitutively fiction, then upon pain of incoherence, it follows that slash fiction cannot also be constitutively pornography. So, the claim that slash fiction is putatively pornographic fiction is, more precisely, the decidedly tepid claim that works of slash fiction are constitutively fiction but non-constitutively pornography. For any work putatively in the extension of both fiction and pornography, *being constitutively fiction* entails *being incidentally pornography* (e.g. *K/S* as slash fiction can be work-pornographic only incidentally) and *being constitutively pornography* entails *being incidentally fiction* (e.g. *Pirates* as a work of prototypical pornography can be a work of fiction only incidentally).

Recall that quite a few works of prototypical pornography are also works of fiction (if not putatively prototypical fiction). *Pirates*, for example, quite clearly looks to be a work of fiction, specifically a big-budgeted, elaborately designed and costumed, more or less decently crafted (directed, edited, acted, written) work of narrative film-fiction. Nonetheless, it is prototypical pornography—and an audience may engage with it as such without engaging with it qua fiction. One could do this by watching the film with the

sound off, or by fast-forwarding past the narrative elements straight to the sexy bits, thereby becoming unable to imagine most of what *Pirates* qua fiction invites one to imagine. An audience adopting such viewing practices may quite easily become sexually aroused (as prescribed by *Pirates* qua pornography) by attending to the maximally realistic and transparent depiction of the actual world actors and actresses engaging in all manner of sexual congress in the actual world. However, this audience cannot be sexually aroused by *Pirates* qua fiction because such an audience fails to imaginatively engage with *Pirates* (qua fiction) in the manner *Pirates* (qua fiction) prescribes (i.e. to be sexually aroused by imagining the fictional Captain Skagnetti and his equally fictional, yet no less lusty, crew of salty sea dogs engaging in all manner of sexual congress with one another in the fictional world of *Pirates*).[25]

Pirates is, *ceteris paribus,* a far more entertaining work of fiction when its audience properly engages with it than when its audience does not. However, we should not presume *Pirates* to be, even prima facie, a more sexually arousing work of pornography when its audience properly attends to it qua fiction. This strongly suggests, not just for *Pirates*, but for all works in the extensional overlap between pornography and fiction, that *being fiction* has nothing constitutively to do with *being pornography*. For works in the extensional overlap being a successful work of fiction, *ceteris paribus*, neither entails nor suggests also being a successful work of pornography. And it also appears that possessing good-making properties for the one (e.g. satisfying the principal aim of fiction in the manner prescribed) suggests, if not entails, possessing bad-making properties for the other (e.g. failing to satisfy the principal aim of pornography in the manner prescribed, if not *simpliciter*).

Being a work of fiction looks incidental to being a work of pornography; however, the extent to which one construes such works in a manner explicitly or implicitly favoring one side over the other appears to be the extent to which satisfying the descriptive or evaluative conditions for one begins to interfere with satisfying the descriptive or evaluative conditions for the other. For instance, the greater the push to construe *Pirates* as constitutively fiction, the greater the evaluative tension for *Pirates* with respect to

[25] One could further imagine the absence of sound to be the fault of poor film production, such that no audience, no matter how attentive, could reasonably imagine what *Pirates* attempts to invite its audience to imagine.

being both successful qua pornography and successful qua fiction. To avoid this predicament, there are but two options: (i) accept the fiction-pornography extension to be nothing more than an uninformative, purely contingent, and ultimately incidental overlap, or (ii) commit to the overlap being both informative and constitutive but claim that the philosophically relevant area of overlap lies at pornography's edge rather than inside the domain of prototypical pornography.

Final Remarks

We take our analysis of the *depiction* and *fiction* questions for pornography also to apply *mutatis mutandis* to the *art* question for pornography. Accordingly, it follows that debates about the pornography-art extensional overlap cannot be about whether a work can be both a work of art and a work of pornography, but instead must be about the conditions under which a work comes to be located at pornography's edge and how a work of art might (if at all) come to satisfy such conditions so as to be similarly located. That is, should the extension of 'pornographic art' be the extension of works that are both art and pornography, one commits a grave philosophical error in assuming that such works bear any substantively meaningful resemblance either to prototypical pornography or to prototypical art. Instead, as we have shown, if there are such works, then surely they must be akin to the sorts of works we have discussed here (e.g. Tijuana Bibles, *hentai*, slash-fiction)— works that by their very constitution must be located at pornography's edge.

References

Abell, Catherine (2005) 'On Outlining the Shape of Depiction'. *Ratio* 18(1): 27–38.
—— (2006) 'Realism and the Riddle of Style'. *Contemporary Aesthetics* 4.
—— (2007) 'Pictorial Realism'. *Australasian Journal of Philosophy* 85: 1–17.
Carroll, Noël (2008) *The Philosophy of Motion Pictures*. Blackwell Publishing.
Currie, Gregory (1990) *The Nature of Fiction*. Cambridge University Press.
Gendler, Tamar (2000) 'The Puzzle of Imaginative Resistance'. *Journal of Philosophy* 97: 55–81.
Hazlett, Allan, and Mag Uidhir, Christy (2011) 'Unrealistic Fictions'. *American Philosophical Quarterly* 48: 36–43.

Hayman, George, and Pratt, Henry John (2005) 'What are Comics?' In David Goldblatt and Lee Brown (eds.), *A Reader in the Philosophy of the Arts* (Pearson Education, Inc.).

Hyman, John (2000) 'Pictorial Art and Visual Experience'. *The British Journal of Aesthetics* 40: 21–45.

Kieran, Matthew (2001) 'Pornographic Art'. *Philosophy and Literature* 25(1): 31–45.

Levinson, Jerrold (2005) 'Erotic Art and Pornographic Pictures'. *Philosophy and Literature* 29: 228–40.

Lewis, David (1983) 'Truth in Fiction'. In *Philosophical Papers I*. Oxford University Press. 261–80.

Lopes, Dominic (1995) 'Pictorial Realism'. *Journal of Aesthetics and Art Criticism* 55: 277–85.

—— (2005) *Sight and Sensibility: Evaluating Pictures*. Clarendon Press.

—— (2006) 'The Special and General Theory of Realism: Reply to Abell, Armstrong, and McMahon'. *Contemporary Aesthetics* 4.

McCloud, Scott (1993) *Understanding Comics*. HarperCollins.

Mag Uidhir, Christy (2009) 'Why Pornography Can't Be Art'. *Philosophy and Literature* 33: 193–203.

—— (2011) 'Drawn to Defection: The Epistemic Misuse & Abuse of Pictorial Caricature', manuscript.

Meskin, Aaron (2007) 'Defining Comics'. *Journal of Aesthetics and Art Criticism* 65: 369–79.

Newall, Michael (2006) 'Pictures, Colour, and Resemblance'. *Philosophical Quarterly* 56: 587–95.

Nussbaum, Martha (1995) 'Objectification'. *Philosophy and Public Affairs* 24: 249–91.

Scruton, Roger (1981) 'Photography and Representation'. *Critical Inquiry* 7: 577–603.

Shamoon, Deborah (2004) 'Office Sluts and Rebel Flowers'. In Linda Williams (ed.), *Porn Studies*. Duke University Press.

Walton, Kendall (1990) *Mimesis as Make Believe*. Harvard University Press.

—— (2002) 'Depiction, Perception, and Imagination: Responses to Richard Wollheim'. *Journal of Aesthetics and Art Criticism* 60: 27–35.

III
Pornography, Medium, and Genre

8

Why Do Porn Films Suck?

PETRA VAN BRABANDT AND JESSE PRINZ

Pornographic films are rarely classified as art, much less as good art. This is deeply puzzling. As we will argue, ordinary pornographic films share much in common with cherished artworks, yet there is little inclination to play them in art house theaters, or project them, non-ironically, in galleries. Is this mere prudery or is there a principled reason for thinking that porn lacks some feature crucial for aesthetic appreciation? Some authors argue that pornography cannot be art. We think they over-reach. But we think most pornography is not art, or at least not good art, and we want to know why.

We have four goals. First, we want to make the comparative dearth of artistic pornography vivid by explaining why that dearth is so surprising. Then we will critically assess an argument that says porn cannot be art, and we offer a new assessment of the distinction between the pornographic and the erotic. Third, we will offer a battery of broadly psychological reasons for thinking porn and art compatible. Fourth, we offer one explanation of why porn is so frequently bad from an aesthetic point of view, while also pointing to examples of more successful pornographic art.

Throughout this chapter, we focus on film, though many of the issues carry over to pictures and other media. Film is an instructive domain because it has become the dominant medium for pornographers, and it is also a medium in which the overlap between high art and entertainment is especially blurry. Thus, we might expect to find more artistic porn in movie theaters than in galleries, but this does not seem to be the case. We hope our discussion helps to explain why.

1. The Paradox of Porn

We will ultimately want to argue that some pornography qualifies as art. We will take it for granted, however, that the overwhelming majority doesn't. Most pornography is not art. In fact, when it comes to cinema, it is extremely hard to think of films that are both clearly pornographic and clearly art. This is all the more true when we raise the bar and look for pornographic films that qualify as *good* art. We will consider some candidates below, but it should be obvious that this is a rare species indeed.

At one level, the lack of (especially good) pornographic art films should not be surprising. Art films comprise a small subset of all cinema, and among art films, only a small subset are good. In addition, pornography is a highly profitable industry, which secures its audience by delivering sexual gratification, so makers of porn have little incentive to make films for the effete intellectuals who trickle in to art-house cinemas. The lack of pornographic art films is, to that extent, neither surprising nor interesting.

Viewed from another perspective, however, the dearth of art porn should come as quite a surprise. The reason for this is that pornography in general has features that one might think, for theoretical reasons, make it especially conducive to art. To see why, let's reflect briefly on the nature of art in general. Danto famously argued that, to be art, something must be presented to an artworld public. If this definition were right, it would be trivially easy to prove that most porn is not art, because most porn is not presented to the artworld. But this is too fast. Critics of Danto point out that there are many things that we recognize as art that are not intended as art. This includes most outsider art, and much of what we call 'low art' which is designed for mass consumption. We do not think that all things that people call low art qualify as art *simpliciter*. A garden variety advertisement for pet-food or tooth floss may fail to qualify. But there are many instances of low art that we consider worthy of exhibition alongside works that were created for exhibition in museums and art houses. This includes Lautrec's posters for the *Moulin Rouge*, Hitchcock's cinematic works, and the treasures of Tutankhamun. These are objects that cry out to be regarded as art even if they were not created with that intention. Drawing on J. J. Gibson's notion of affordances, we will say that these works afford an aesthetic stance. They have features

that invite us to view them as belonging to the same category as paradigm artworks.

In virtue of what characteristics does an object afford an aesthetic stance? To answer this question, we need an account of how art is recognized. According to some authors, a theory of art recognition is tantamount to a theory of what art is. Defenders of 'cluster theories' (Gaut 2000; Dean 2003) make this case. On this approach, there is not a single essence to art, but rather a disjunction of prototypical features, which count towards something being art. Presence of a preponderance of these features is sufficient for art status. Opponents of cluster theories think that the essence of art and the means by which we identify art are independent. But even these essentialists concede that cluster theories encompass features that people ordinarily *take to be* evidence that something is an artwork. This is all we need to set up our argument. We will suggest that standard porn has features that *should* lead it to be seen as art, while people in fact do not recognize it as such. This failure will lead us to ask what porn would need to be recognizable as art. We will assume, though we cannot make the case here, that if porn were made in a way that made it recognizable as art, it would actually qualify as art. Thus, we are inclined to agree with disjunctive theorists in aligning recognition and essence. But we think porn offers an opportunity to refine a theory of recognition. Those who want to distinguish recognition and essence could respond in one of two ways: they could argue that porn fails to qualify as art even if we recognize it as such or they could argue that porn really is art even when we fail to recognize it as such. We will criticize an influential argument of the first kind. And, for those who think standard porn is art, we will try to explain why this, if true, is far from obvious.

What, then, are some characteristics that we use to identify artworks? First, artworks are often made in a range of media that have been used throughout this history of art: painting, sculpture, and more recently photography, and film. Second, artworks tend to have aesthetic properties. By this, we mean the kinds of properties we express using aesthetic concepts (Sibley 1959). The canonical aesthetic concept is 'beautiful' and its cousins, such as 'stunning', 'lovely', or 'gorgeous'. Others include 'graceful', 'balanced', 'vivid', and 'captivating'. Third, artworks are generally exercises of the imagination: they do not merely reproduce reality—at least not blindly or mechanically. Fourth, artworks are characteristically executed with skill, or at least aspire to be so-executed; they seek to impress. Fifth, artworks

often belong to identifiable genres and obey genre conventions, or else they intentionally violate such conventions. Finally, artworks engage us emotionally, by either expressing emotions or arousing them in us.

These characteristics are good candidates for features used in recognizing something as art. The list is no doubt incomplete, but we think these are among the most typical characteristics that people use, and that, on the face of it, having a preponderance of these features is normally sufficient for classifying something as an artwork. We also think the same features can be used in aesthetic evaluation. A good work is one that has these features to a high degree, where possible: e.g. one to which aesthetic concepts can be applied emphatically, one that shows great skill, or one that arouses very strong emotions. When we see good works, we experience emotions such as wonder, marvel, and awe (Prinz 2011), or, in more extreme cases, we experience exhilaration and fear (cf. Burke 1757). As indicated earlier, we favor the view that identification relates to ontology: something is an artwork if, under good conditions, it would be classified as such. It does not follow, however, that there can be no bad art. The criteria we've listed can be used to evaluate a work as good, but some can also be applied to unsuccessful works. Something can be a bad painting, for instance, or an exercise of the imagination that fails.

In addition to these characteristics, which apply to artworks quite generally, there are sometimes characteristics by which we identify artworks within major media. For example, a graceful salsa dancer who exhibits talent on the dance floor may not be recognized as creating art because the dance isn't choreographed. Choreography is not a necessary condition for dance being art, but it plays a significant role in classification. Likewise, there are characteristics by which we recognize films as art. Indeed, there is a reasonably well-established category that we call 'art films' (Bordwell 1979). These vary in kind, but certain prototypical features can be used to identify positive instances. These include non-narrative structure and counter-normative themes. Many art films also have amateurish production values and Brechtian acting, thereby challenging the illusionism of conventional cinema (consider new wave cinema). Realist art films push in the opposite direction, presenting life in a way that is gritty and uncensored, capturing aspects of life that might be hidden from view in films made for mass consumption (consider neo-realism).

With these observations in hand, we can see why the dearth of porn art should surprise us. Standard pornographic films have many features that make them good candidates for art. Begin with our list of characteristics used to recognize artworks in general. First, and most obviously, pornographic films are made in a standard art medium. Second, when viewing pornography, it is not uncommon to use aesthetic concepts, such as 'beautiful' or 'gorgeous'. Third, pornography is clearly imaginative in the sense that it departs from everyday reality. Fourth, pornographic performances show considerable skill such as athleticism and stamina. Fifth, porn is clearly a genre. And finally, porn arouses strong emotions. Indeed, that is its primary function. If sexual excitement can be regarded as an emotional state (which we will assume here), porn is as evocative as any established form of art.

It might be objected that sexual excitement differs from the emotions aroused by canonical works. But here two things must be noted. First, art history is filled with pictures that are designed to be sexually exciting. Many famous paintings depict nudity, and other forms of sexual content, which would have been regarded as highly explicit for the time periods in which they were created. Consider famous works by Giorgione, Greuze, Goya, Ingres, Courbet, and Schiele. Pornographic films, like many canonical artworks, also idealize the human body. They are presentations of forms that are more attractive than those we encounter in daily life, and there can be little doubt that such idealizations were intended to intensify arousal. Second, there is something manifestly arbitrary about dictating *which* emotions qualify as worthy when considering the evocative nature of art. Some artworks are prized because they make us cry, others because they frighten us or make us laugh. In general, when an item created using a traditional art medium incites strong emotions in us, that indicates, all else equal, that it is an artwork, and, indeed a good one. The capacity to arouse strong feelings is generally regarded as a mark of artistic achievement. Pornography is arguably more effective in inducing strong feelings than almost anything lining the walls of a typical museum. Pornography might even be said to elicit wonder, fear, and exhilaration. Its raw carnality takes us out of our comfort zones. It thrills, excites, and surprises. If these emotions are a strong indicator of the artistic, we should be disposed as well to see pornography as art. If fact, we should regard porn as good art, since it is extremely evocative.

Standard porn films also have features that typify art films. They downplay narrative and challenge conventional morality. They feature Brechtian

performance styles, but also a kind of grittiness characteristic of cinema verité and other forms of realism. Watching a porn film side-by-side with a Bresson film is an instructive exercise. In both, actors deliver their lines in a wooden way; in both, characters do things that are regarded as morally suspect without remorse or elaborate justification; and both are more episodic than narrative.

In short, pornographic cinema shares so much in common with art that we might expect it to be immediately recognized as such. Porn films are made using an established art medium, and they arouse strong emotions in us by means of beautiful, idealized forms; they also violate narrative and moral conventions, much like famous art films. Of course, there are differences as well. For example, porn films are not presented to the artworld public. But it is difficult to see why any of the differences matter, since there are clear cases of art that lack prototypical features (outsider art, conceptual art, ugly art, etc.). Every new artwork differs from canonical works in some way, but a sufficient number of core similarities allows us to recognize membership in the class. We are suggesting that, in theory, standard porn films share enough in common with canonical artworks that we should be surprised that they are not recognized as art. Notice that this conclusion applies even for those theorists who want to distinguish essence and identification. Theorists who, say, reject cluster theories and argue that art status depends on some common essence will still have to grant that the characteristic features on our list are regularly used to recognize that something is an artwork. Such theorists could insist that porn fails to be art because it lacks some subtle feature that isn't on our list, but they still owe us an explanation of why porn doesn't immediately strike us as art given its possession of the features that we frequently use as a rough and ready classification. Ultimately, we are most interested in why standard porn doesn't *seem* like art, and we can be agnostic about whether or not it in fact is art.

By way of summary, we can now articulate the paradox of porn. Garden variety porn films share many properties in common with paradigmatic artworks (similarities in medium, form, content, and emotional engagement). Given their capacity to elicit strong emotions through visual forms, they also have a property that ordinarily leads to positive appraisal of artworks; given these commonalities, porn films should be readily recognized as artworks, and, indeed, as good artworks; but they are not. A solution to this paradox would specify why, in light of all the similarities,

we don't tend to classify porn as art, much less as good art. What prevents us from doing so?

In what follows, we will consider a number of responses to the paradox of porn. We will begin with an extended discussion of the proposal that porn and art are incompatible, which has been a central thesis in the philosophy of pornography. If the incompatibility thesis were true, we would have a possible explanation for the fact that porn is not recognized as art. This would be true especially if the alleged source of incompatibility were something glaring, something that overtly distracted away from the superficial features that might otherwise make porn seem like art. We, however, don't think the incompatibility thesis is defensible. Therefore, it cannot solve the paradox of porn. This leads us to survey several other alternatives, before settling on our own solution.

2. Are Art and Porn Incompatible? Renegotiating the Erotic/Pornographic Divide

Porn films are rarely recognized as art, let alone inspire the viewer to make the connection with the prototypical features of art film. One rarely thinks of Chantal Akerman while watching *Sinfully Sexy* (Suze Randall, 2005). This incongruity makes us wonder if aesthetic impotence is paradigmatic of porn films. Is there something specific about porn film that overrides its similarities with art film and deactivates its possible recognition as art? The puzzle can also be tackled from a different angle: did we overlook something essential about art that excludes porn film a priori?

A positive answer to these questions can be found in the incompatibility theories. These theories argue for the radical incompatibility of porn and art. This thesis is not convincing to us, because independently motivated theories of art recognition do not seem to entail it. For example, such features as fine craft, beauty, and originality, seem applicable, at least in principle, to porn. Yet the dearth of porn art film is such that we should at least consider the possibility that porn and art are incompatible. There are quite a few incompatibility theories out there; they all make sense of the a priori incompatibility of art and porn by first indicating the distinctive features of art and porn, or of aesthetic and pornographic reception, and then stating the incompatibility of these features. The conclusion that *art and porn are*

incompatible follows promptly. The main problem with these theories is the assumption of stability; their models have no place for the dynamics and pluralism that characterize the recognition, experience, and evaluation of both art and porn in time, audience, and attitude.

We will first briefly consider what we will call oppositional theories. These theories are not the most challenging, yet have a prima facie attractiveness and are for this reason popular, and thus worth considering. Afterwards, we will turn to Levinson's incompatibility theory. Levinson's theory has been revised by others (Mag Uidhir 2009; Bartel 2010), but our concerns apply to those versions as well, so we will use Levinson as our main target. We want to remind the reader that our aim here is not to make a full-fledged assessment of incompatibility theory; others have done that before us (Maes 2011a, 2011b); we only want to make sense of the dearth of porn art films, while all the conditions for their plentifulness seem to be guaranteed.

Maes (2011b) gives an extensive overview of the existing oppositional theories. These theories explain the unbridgeable gap between art and pornography in an oppositional way: art is concerned with suggestion, beauty, contemplation, complexity, originality, imagination, or a combination of these properties, whereas pornography is explicit, ugly, simple, repetitive, and invites us into the realm of lust and fantasy. The problems with these theories are many. Most importantly, they define both art and pornography too narrowly, failing to appreciate the variety in both of these domains. Further, in their distinctions between art and pornography, there seems to be a conflation between art and good art. The qualification of something as art is reduced to the deployment of the author's favorite aesthetic concept, and this aesthetic concept is then used to assess pornography. In this sense, pornography is not tested against art, but against the author's idea of good art. Since the incompatibility position is clearly prompted by a dislike of (certain) pornography (such as that which is ugly, or too explicit, etc.), it will not survive the narrow test for being art (beauty, suggestiveness, etc.). The question of art and pornography is thus not properly addressed; we learn that pornography is bad art, yet this does not tell us why porn and art (film) rarely go well together, irrespective of the particular aesthetic concepts deployed.

In addition, these theories seem to reflect a limited knowledge of or experience with pornography. The beauty of virile bodies, excited genitalia, and entranced faces, the opacity of anonymous desire, abundance, and

generosity, the suggestiveness of leather, latex, bondage tape, and the radical choreographic minimalism of such films is completely ignored. More so, these theories testify to a rather simplistic understanding of the diversity and reception of pornography, in which no room is left for learning processes in visual and visceral desire and pleasure, or for the exploration of the art of pornography. In short, the oppositional properties used in these theories are hierarchical, and seem to relegate pornography to the lower, animalistic domain of human experience. This hierarchical opposition reveals a moralistic desire to protect art from pornography's bad taste. Since we don't share this position, and have not observed in art or porn films any properties that warrant this a priori hierarchical opposition, these extreme incompatibility theories are not convincing to us.

Levinson's incompatibility theory does not make this mistake; his account hinges on a distinction between the pornographic and the erotic. The erotic indeed aims at sexual stimulation (Levinson 2005a), but should not for that reason be tainted by pornography's bad name. The public debates of 'art or porn?' get deflated, and art removed from the dangerous zone of inappropriate attention and censorship, when a clear rule is in place to distinguish erotic art and pornography. Levinson's theory indicates why erotic art can't be classified as pornography: objects that aim at aesthetic reception have foresworn their pornographic potential. Nan Goldin's *Klara and Edda Belly Dancing* aims at aesthetic reception, and is thus not pornography. To make the distinction clear Levinson says that, in some sense of the term, there can be no 'pornographic art'; objects with sexual content and stimulating potential that aim at aesthetic reception are called erotic art. Pornography now consists of those sexual images that by their nature don't or can't aim at aesthetic reception, but aim instead at pornographic reception.

For Levinson's account to be a good account of why porn film doesn't qualify as art film, we have to find out what he means by aesthetic and pornographic reception. Levinson (2005a: 239) gives the following overview of his argument:

1. Erotic art consists of images centrally aimed at a certain sort of reception R1.
2. Pornography consists of images centrally aimed at a certain sort of reception R2.

3. R1 essentially involves attention to form/vehicle/medium/manner, and so entails treating images as in part opaque.
4. R2 essentially excludes attention to form/vehicle/medium/manner, and so entails treating images as wholly transparent.
5. R1 and R2 are incompatible.
6. Hence, nothing can be both erotic art and pornography; or at the least, nothing can be coherently projected as both erotic art and pornography; or at the very least, nothing can succeed as erotic art and pornography at the same time.

The reception pornography aims at is the experience of images as completely transparent. Erotic art, on the contrary, aims at the experience of images as in part opaque, whereby the viewer is thus made to dwell on the image's formal and aesthetic properties. The reason for this difference in reception Levinson locates in the specific nature of pornography, which is 'wholly transparent in both aim and effect' (1998: 409). It is in this respect that erotic art radically departs from pornography. Erotic art is concerned with sexual stimulation, not sexual arousal, and therefore occupies the domain of imagination, not reality. Aesthetic reception is thus absolutely incompatible with pornographic reception, and this is why Levinson concludes for the incompatibility of pornography and art, or in our case, the incompatibility of art film and porn film.

There are a lot of problems to note here (Maes 2011a, 2011b). We only highlight those that are important for our purpose. First of all, it is not certain that R1 is the (central) reception at which (erotic) art aims. Maes points out that, in the case of many artworks, R1 could be considered as the secondary reception, and, surprisingly enough, R2 as the central reception. Art and pornography aim in some instances at the same central reception, and their a priori incompatibility can therefore then no longer be held. Yet if we hold onto R1 as the central reception of (erotic) art, even then we could observe that an artwork that affords R1 may also afford R2 (to the same viewer or to different viewers). This questions Levinson's assumption 5 that R1 and R2 are incompatible and that a work of art cannot aim at both R1 and R2. With regard to pornography this has far reaching implications; it means that a work could at moment x or by viewers X be received as porn, yet this reception does not exclude the possible reception as art at moment y or by viewers Y. This amendment to Levinson's theory is radical, because it

undermines the incompatibility of porn and art when interpreted as a claim about whole artworks, and reduces it to a claim about the incompatibility of certain experiences (Maes 2011a, 2011b).

Japanese Pink Film is instructive in this regard. Consider, for instance Oshima's *In the Realm of the Senses*, Adachi and Arai's *Gushing Prayer*, or Wakamatsu's *Violated Angels*. Originally aimed at sexual arousal, these films got a second critically acclaimed life in the west and are non-oxymoronically qualified as Japanese Sex Cinema (Sharp 2008). If a work could not both aim at reception R1 and R2, this upgrading would be impossible. Its exoticism may be one of the reasons why Pink Film is easily recognized and qualified as art film, yet the reality is that some films in this genre afford both R1 and R2.

Levinson himself mentions Schiele's *Reclining Women* and Courbet's *Sleep*. The character, look, or aspect of these paintings may be aptly characterized as pornographic, yet aesthetic reception is so central to these works, so Levinson argues, that this is clearly erotic art, but which can also be used pornographically (2005a: 238). We can't help wondering if Courbet and Schiele would be pleased with this theoretical erosion of their work, yet Levinson grants this art the compromising qualification of *weakly pornographic art* (235), a definitional concession that cries out for a further amendment to his theory. We want to make sense of Courbet and Schiele as both confident pornographers and shameless artists. A further reservation is in order. It concerns the nature of the central reception at which pornography aims, namely R2, which is not discussed in the above critique.

Like the proponents of oppositional theories, Levinson has a rather limited vision of the reception pornography aims at (R2). In our opinion one can truthfully hold that most pornography is not pornographic art, without assuming that pornography invites the viewer to treat 'images as wholly transparent', and without thus engaging her imagination. It is not only Levinson's distinction between sexual stimulation (erotic art) and sexual arousal (pornography) that is questionable, but also his description of sexual arousal as 'the physiological state that is prelude and prerequisite to sexual release, involving in the male, at least, some degree of erection' (2005a: 229). This focus on release not only genders pornography as male; it also gives us a limited image of male sexuality (erection). Even if this simply echoes the primary reception of pornography, this by no means warrants the a priori characterization of pornography as such. It does no justice to the wide

diversity in pornography and makes abstraction of the growing number of female viewers. The French pornographer Ovidie, who can hardly been seen as a maker of 'erotic' art, explicitly stated that her porn films are not *masturbatories*. Her films are clearly mainstream pornography, yet she subverts the masturbatory scheme fellatio/penetration/sodomy/facial-ejaculation to frustrate or expand sexual arousal and its imaginative trajectories. And from a viewer's perspective, Linda Williams stresses the imaginative power of the principle of maximum visibility (1999: 48) at work in the lab of visual and visceral pleasure (315) that is pornography, and the new imaginative possibilities of the screening of sex, in which 'the very act of screening has become an intimate part of our sexuality' (2008: 326). We think Williams hits the spot here. Incompatibility theories all too quickly limit our pornographic experiences to the most economic means to satisfy a basic need for release. The gross majority of porn producers and consumers may share this perspective on pornography, and it certainly makes the incompatibility between art and pornography very plausible, yet it ignores one of the most crucial aspects of the phenomenology of our pornographic experiences. In screening even most mainstream pornography we go beyond calculating body economics, and we experience an assault on the body that fuels the frenzy of eye and touch. Pornography is a radically embodied medium, and fascinating as such. And it does not simply tap into our urges, it also reveals them to us, and pushes them in new directions. If we take into account this bare truth of pornography, we realize that it reveals much about our sexuality and is not just about basic needs. With this in view, the compatibility of art and pornography is no longer surprising.

In his criticism of Levinson's theory, Maes (2011a, 2011b) argued that R1 and R2 can be compatible *over time*; this effectively disarms Levinson's incompatibility argument and in principle makes way for the compatibility of art and porn. The work of Schiele and Courbet suggests, however, that an aesthetic and pornographic reception can also be compatible *at the same time*. Therefore we want to take things a step further and argue for a more radical compatibility. Maes's remark that R1 is not necessarily the central reception of art is a strong argument for this position, yet we give priority to our own assessment of the pornographic reception, which showed it to be a more layered one than Levinson's R2. If pornography does not necessarily aim at treating images as *wholly* transparent, then this reception can be compatible with the aesthetic reception that treats images as partially

opaque. Concretely this means that in art the troubling experience of brute carnality (pleasure, violence, disgust . . .) can enhance or even constitute the core of the aesthetic reception. Levinson's examples of weak pornography are illustrative in this respect: Schiele's *Reclining Women* and Courbet's *Sleep* aim at an aesthetic reception not despite, but precisely through, their pornographic form and content. The images take our breath away, stimulate our imagination, and our bodies make no distinction here between aesthetic and pornographic bedazzlement. Alina Reyes's *The Butcher* is only an art-work because of the sexual arousal it succeeds at and through which it transgresses the aesthetics of female confessional literature. In a non-porno-graphic vein, Marina Abramovic's performances succeed through the visual and visceral violence they inflict upon the viewer. And Annie Sprinkle's alter-pornographic performances aim at liberating bodies through pleasure and playfulness, showing how art, pornography, and sex-education can meet in the reception they aim at. These examples all suggest that, in the context of a carnal aesthetics, art and pornography are wholly compatible.

A further reason for thinking that art and pornography are compatible can also be extrapolated from our discussion of the paradox of porn. Arousing strong feelings tends to be a praiseworthy feature of art, and this is true across a wide range of feelings: amusement, despair, suspense, curiosity, terror, and even disgust. Genres can sometimes be distinguished by which emotions they provoke, and pornography seems compatible with such a taxonomy. Tragedy provokes sadness, horror provokes fear, comedy provokes joy, and mystery provokes curiosity and surprise. It is natural that there should be a genre that provokes sexual arousal. Levinson objects that this is the job of erotic art, not pornography, on the grounds that the latter aims not for mere arousal, but for release. But this is arbitrary, because release is just one outcome of extreme arousal. A tragedy that triggered violent sobbing and a comedy that sparked uproarious laughter would not cease being art; they would be regarded as resounding successes of the genres. To argue that pornographic reception cannot occur at the same time as art reception might prove too much, since it could not, without inconsistency, be said that strong emotional arousal is (in general?) incompatible with art.

There are also psychological arguments in favor of compatibility. For example, viewing artworks activates the reward system of the brain, which is also active when people view sexual content (Lacey et al. 2011), and the

brain structures that respond to good art are, more generally, like those involved in assessment of facial attractiveness (e.g. Vartanian and Goel 2004). Inhaling oxytocin, a chemical associated with orgasm and sexual fidelity, can also increase the attractiveness of faces (Theodoridou et al. 2009), suggesting a link between the appraisal of visual forms and the experience of sexual arousal. It would be ludicrous to suppose that we cannot view a face as attractive while also being aroused by it, since arousal is often enhanced by attraction. This possibility should apply equally well to art. Indeed, some people argue that art evolved out of courtship. Miller (2001) makes the claim that art production is a product of sexual selection, which implies that people should be aroused when seeing someone create good art. We think this is implausible, given that there is no established link between artistic abilities and fitness, but Miller's data do establish that seeing someone produce good art can increase their sexual attractiveness, suggesting that aesthetic praise and sexual allure can be co-instantiated. It is also plausible that people find some art alluring precisely because of its sexual content. As the Guerilla Girls point out, Western art frequently contains nudes, 85 per cent of which are women, and these nudes are often presented in provocative poses. Some of the most famous paintings in the canon are regarded as good in part because of their sexual allure: Giorgione's *Sleeping Venus*, Botticelli's *Venus and Mars*, and Ingres's *Odalisque*, to name a few. In some cases, we might even fault sexualized works for not being as arousing as they could be; Raphael's *Fornarina* has a dopy expression that detracts from her lascivious pose. The work would be better if its sexual appeal were more complete. One psychological explanation of this fact is that sexual feelings are closely related to awe, wonder, and other positively valenced forms of interest, which constitute feelings of aesthetic appreciation (Prinz 2011). If so, far from being incompatible, sexual excitement may overlap psychologically with aesthetic excitement.

In our assessment of Levinson's incompatibility theory we have shown how difficult it is to hold on to the a priori incompatibility of art and porn. And we have suggested that there may indeed be occasions in which art and porn are highly compatible. In this context it seems inappropriate to argue for the distinction between 'erotic art' and 'pornography.' Not only is there something arbitrary about stating which reception is symptomatic of pornography (stimulation vs. arousal), the distinction also falsely suggests two

clear-cut, non-overlapping categories. We think this dichotomy leaves out what should be properly called 'pornographic art' as a category of art that has a sexual content and form, and sexually stimulates, arouses, or transgresses. 'Pornographic art' is a neutral term that doesn't dictate which sexual reaction, content, form, or norm is worthy of aesthetic reception. The use of 'erotic art,' on the contrary, casts pornography in a pejorative light, which impedes its critical study and evaluation, including of its artistic value. Sometimes it takes little to upgrade from pornography to pornographic art (Pink Film), and the nominal difference between the erotic and the pornographic can obscure that possibility.

There is also a normative case to be made against Levinson's stricture that art lies in the realm of the erotic, but not the pornographic. This denomination could also slow down art's trial-and-error engagement with pornography. In making the distinction, even in the view of safeguarding a large playground for sex and art, one risks subscribing to prudish societal oppositions, and to the idea that as a rule there is something deeply wrong with pornography. This is detrimental to the cultural visibility and legitimacy of pornography, and it has negative consequences not only for the development and quality of pornography as a film genre, but also for the working conditions and the respectability of the actors and actresses.

This does not mean that an erotic/pornographic distinction cannot be drawn. We want to redefine the boundary. In our opinion 'erotic art' should rather be used to refer to pre-pornographic or post-pornographic art; this is art that has a sexual form or content without any real or imagined stimulating or arousing potential. Sometimes, we can still see how in a different context or for a different audience this form and content were productive of sexual arousal, yet it doesn't any more do the trick for us. For example, the explicit reference to oral sex and female orgasm in Louis Malle's *The Lovers* sparked an obscenity trial in the US Supreme Court, but now seems tame.

Our assessment of Levinson's theory stresses the possible compatibility of porn and art, and highlights the possibility of a carnal aesthetics. This makes the scarcity of porn art film even more puzzling. Levinson's incompatibility thesis would have solved the paradox of porn handily, but our critique leaves the puzzle unanswered. So we have more work to do.

3. Redressing the Paradox

We began by arguing that pornographic films have much in common with art films, and this left us with a puzzle: why is so much porn bad, artistically speaking? The most obvious strategy for answering this question was considered in section 2: the thesis that pornography and art are subtly incompatible. This is a popular view in philosophy, but we argued that it is untenable. Here we want to move towards a positive answer. First, however, we will consider a few more answers that may look promising, but don't survive scrutiny.

Assuming that the incompatibility theories fail, a second response to our paradox begins with the observation that most porn is offensive. Perhaps feeling offended is incompatible with regarding something as art. The offensiveness of porn stems from the fact that most of it is still produced for male consumption, and, in a male dominant society, that often involves depicting women in demeaning and objectifying ways. In addition, the production of typical porn often involves the subjugation of women, and consumption of it may cause societal harm by promoting harassment, domination, and violence. From a moral perspective, much pornography is problematic, and this may affect aesthetic qualities. In similar fashion, it may be difficult to take aesthetic pleasure in *Triumph of the Will* or *Birth of a Nation* because they promote values we find abhorrent. This suggestion can't offer a sufficient explanation, however. First, people who do not find standard pornography offensive may also regard it as aesthetically bad. Second, many morally problematic works are still regarded as aesthetically good, including films that glorify violence, paintings that proselytize religion, and literary works that are politically incorrect by contemporary standards. There is hardly a great painting, poem, or film that couldn't be subjected to a scathing moral critique. Third, some of the best examples of porn that achieves high levels of artistic merit are offensive in ways that are similar to the offensiveness of bad porn. Robbe-Grillet's *Eden and After* is an androcentric film in which fully clothed men cage and beat beautiful naked women, but the film is unmistakably an art film, created by one of the century's most influential novelists, with a radical narrative structure, and a dazzling visual style. Many of the best Japanese Pink films include rape scenes. Masumura's *Blind Beast* concerns a blind sculptor who kidnaps a woman to be his model and sexual slave; but the

twisting plot, Freudian subtext, and mind-boggling surreal sets make it an extraordinary artistic achievement.

A third solution, which echoes a theme in incompatibility theorists, is that porn as such aims at sexual gratification, and that that aim can be achieved without worrying about aesthetic quality. If porn consumers mostly want to get off, the cheapest and easiest method might be to sacrifice production values and deliver visual materials that will arouse viewers effectively. This looks like a more promising explanation, but it is also inadequate as stated. First, pornography that is very poorly produced (e.g. bad lighting, poorly acted orgasms, ugly cinematography) will be less effective than porn with aesthetic merit. Second, low production values are compatible with good art (recall the discussion about art films in section 1). Third, the very fact that a film elicits extreme arousal would count in favor of it qualifying as good art, since, as we discussed, evocation of strong emotions is usually considered a virtue in art.

A fourth suggestion takes issue with a core presupposition in the paradox of porn. We have assumed that most pornographic films are bad when viewed as art, but perhaps this is a mistake. Perhaps the declaration that standard porn is bad art is simply an expression of prudishness. Perhaps we convince ourselves we don't like it, because to declare otherwise would make us look insensitive or depraved. Perhaps our dismissal is akin to the elitism manifest in saying pop music can't be good art, or even akin to the classism and sexism that we use to build a wedge between 'high' art and 'lowly' craft. Once we recognize that some art is not highbrow, the resistance may break down. This suggestion is especially inviting because film is traditionally a mass art form, and many great films have been produced within the constraints of popular film genres, such as cinema noir, westerns, and science fiction. Once we admit that there are many great noirs, why not say that there are many great porn films? To be consistent, we could measure success by fulfillment of well-recognized genre conventions. Perhaps a particularly stimulating and inventive blow job would count towards aesthetic recognition. On this view, the Adult Video News Awards (the 'Oscars of porn') should be regarded as recognizing artistic achievement.

We are skeptical. Part of the problem with the view that most porn is good art stems from the more general claim that most film *in any genre* is not especially good. Should the annual winners of the AVN awards be released in special Criterion editions, or screened in the Museum of Modern Art?

Well, no, but such reception is also undeserved for many Oscar-winning mainstream films. Good art is rare in general. And this leads us to a fifth proposal: the frequency of porn that qualifies as bad art is not greater than that in any other genre.

This may seem to help, because it renders the infrequency of art porn less surprising. It makes the dearth of porn art just one case of the general fact that most films don't qualify as art. This may seem to take the sting out of the paradox of porn, but actually it misses the point. In setting up the paradox, we noted that porn has features that *should* render it good from an artistic point of view: evocation of strong emotions, non-narrative structure, gritty realism (or, in some cases, extreme non-realism), moral ambiguity, and so on. These features typify art films and can elevate genre films from their second-tier position to the lofty plane of the artworld. Given its nature, porn should be regarded as good art more frequently than other kinds of films, but this is not what happens. So our puzzle remains.

Progress can be made if we begin to view porn more closely, and uncover how it attains the features that endow other works with good art status. Consider, for example, the way in which pornography elicits strong emotions. It does so by presenting images that are known to cause sexual arousal in target audiences. The word 'cause' here is important. There is something mechanical about most pornography. It arouses by directly playing on our senses. Just seeing sex gets the target viewers aroused. In saying this, we don't mean to imply that there is an innocent eye. What we find visually stimulating may depend on cultural norms. In feudal Japan, an exposed neck became an object of sexual attention. In China, erotic poems were written about the gangrenous stench of bound feet. In contemporary American culture, men evidently like looking at 'cum shots'. In some subcultures, the triggering stimulus might be a person getting spanked, a physical deformity, or an extreme age difference between sexual partners. Once these preferences get entrenched, porn can cause arousal in an automatic way. That may render the arousal cheap, in the sense that it makes the achievement less impressive. Consider, by analogy, a mainstream director who manipulates strong emotions by using overpowering music, or a tight close-up of a crying face. A tearjerker is less impressive when the director uses such simple tricks. Perhaps porn is bad the way Spielberg is usually bad; the films arouse strong feelings by pulling on our heartstrings, or the genital equivalent. This is a sixth solution to our paradox.

We think this solution is partially right. Most porn films are bad because they trigger a simple, single-layered emotional response. This response may be strong, but is not unsettling. Most porn is produced with the objective to make money. To attain this aim it has to be suitable for mass or subculture consumption, and thus to respect the expectations of these target markets. Only reliable products pass this test: not satisfied, money back. This is why the pornographer avoids taking the risk of making a product that could be removed from the target shelves. Thus he—all too often, the pornographer is male—opts for reliable tricks and formats that trigger without exception a strong, simple emotional response of in this case sexual satisfaction from the target group. Like Spielberg, this pornographer is not focused on aesthetic objectives; he is not concerned with the exploration of aesthetic possibilities or with the relation of his work to other artworks. Most porn films are made to give their target group what they want without delay, surprise, or ambiguity. Notice that it is neither the sexual gratification achieved, nor the immediacy or transparency of the work in relation to the viewer, that disqualifies these porn films as art films; the problem is that they bring about gratification in an unimpressive way.

Still, this cannot be a complete solution to our paradox. The artistic failure of pornography often stems in part from the fact that standard porn is emotionally superficial, but there are many excellent artworks that are guilty of the same change. Some Italian neo-realist films, like *Mamma Roma* (Pier Paolo Pasolini, 1962), exploit the fact that we feel empathy for the desperation brought on by poverty. Bernini's *Ecstasy of St. Theresa* is an unsubtle emotional manipulation, in line with the tactics of the Counter-Reformation. Shock-artists, like the Chapman brothers, Andres Seranno, and Lars von Trier also paint with a limited emotional palette. But all this work strikes us as art.

Perhaps—and this is a seventh solution—standard porn doesn't seem like art because it is not made with that intention in mind: it lacks artistic pretensions. As we have underscored, conventional porn has many features that resemble art films: emotional intensity, thin plot, moral transgression, Brechtian acting, and so on. Why, then, doesn't it qualify as art? One simple answer is that these features are not intentional, or at least not intended in the right way. Porn directors do not ask their cast members to deliver their lines in an unnaturally stilted way. Porn directors deliberately minimize plot, but only to accelerate arousal, not as a critique of narrative structure in art. Porn

directors do seek to elicit strong emotions, but, in so doing, they are not trying to achieve catharsis or comment on the human condition. Of course, people who are familiar with the conventions of art films could *view* porn films as artworks, in spite of the fact that they were not intended as such. Otherwise put, porn films might be appropriated as readymades. Many visual artists have drawn on conventional porn, including Andy Warhol, Mel Ramos, Jeff Koons, Ghada Amer, and John Currin. They have discerned artistic significance in porn, either as an element of pop culture (Warhol and Koons), a symbol of women's place in society (Amir), or even as continuous with Renaissance painting (Currin). Likewise, one could recontextualize extant pornographic films and present them as art by exhibiting them in galleries or juxtaposing them with canonical art films. But this would be an ironic gesture, since these films are not meant to be viewed this way.

This explanation of why conventional porn fails to be art presupposes that intentions are important for status as art (cf. Levinson 2005b), while granting that the intentions can be imparted by the viewer or appropriator when absent in the creator. But this reliance on intentions is vulnerable to an objection. Suppose we learned that a director of conventional pornography films *did* have the right art-making intentions. Suppose that the director regarded his products as art films and recognized that plotlessness and amateurish production values were conducive to those ends. We still might resist that claim that he succeeded in making art.

One way to explain this resistance is that, if a standard porn film were made with the intention to be art, those intentions would not be manifest. Standard porn doesn't strike us as art. Resistance would break down if the intentions were more detectable in the work. This connects with a remark that we made in section 1. Art affords an aesthetic stance. Something about the work, perhaps even just its context of presentation, invites us to view it the way we view paradigmatic artworks. Standard porn films do not afford the aesthetic stance. We think this is ultimately the right solution to the paradox of porn, but it needs to be unpacked.

If porn films have so many prototypical features of art, why don't they afford the aesthetic stance? Some of the solutions we have considered help with this question, but they are too monolithic. The fact that porn firms are emotionally superficial detracts from their capacity to invite aesthetic regard, but that singular flaw could be compensated by other features. The problem

with most porn is there is no compensation. Their emotionality is superficial, and so is their beauty, their imagination, and their demonstration of skill. Most porn is mechanical, formulaic, and lacking in innovation. Each instance displays more or less the same skills, the same fantasy scenarios, and the same kind of beauty.

This point about sameness brings out another important failing. Most porn films fail to exhibit a distinctive style of their creators. Distinctive style is something that is aspired for in art films. This aspiration is the central idea behind auteur theory. We expect art film directors to produce works that are as distinctive and recognizable as the works of great painters. When they don't, their status as artists can be called into question. Most porn fails on this score. Russ Meyer managed to achieve auteur status within the sexploitation genre, and, for just this reason, his work is shown in art houses, but he is a notable exception. Most porn lacks the distinctive mark of its creators.

Auteur theory is a bit too demanding, because we can imagine a high level of artistic quality being achieved within a well-established style (consider John Alton's brilliant noir cinematography in Anthony Mann's *Raw Deal*). Auteurs manage to make art because they introduce new styles, and Alton managed to make art because he took an extant style, noir, and brought it to a new level of achievement. The failure of most porn stems from the fact that it does not do either of these things.

The suggestion, then, is that conventional porn shares many features with artworks and art films, but they lack one aspect that we neglected when characterizing art in section 1. They do not manifest any aspiration to excellence in their effort to instantiate characteristic features of art. Notice, we are not suggesting that art must be excellent. Rather, we are suggesting that, in recognizing art, we look for manifest aspirations towards excellence. Even a derivative copy of excellent works would qualify, or a copy of a work regarded as excellent. Porn does not show signs of trying to be good at instantiating a range of characteristics that are prototypical of art. It satisfies itself with the bare minimum of achievement. There is almost never any noticeable pursuit of unique style, painstaking execution, or exceptional beauty. Porn films lack detectable signs of aspiration or achievement along dimensions of aesthetic worth. Because of this, they do not afford an aesthetic stance.

One consequence of this failure is that our engagement with porn tends to be transparent, as Levinson has suggested. With Bresson, when we

encounter Brechtian acting, we focus on it, and take pleasure in this feature of the work. With pornography, we actively filter out bad acting and flawed production values. We do not seek distance, but rather immersion. We try to lose ourselves in the sexual acts by viewing them as real. With paradigm cases of art, we have what Wollheim (1980) called *twofoldedness*: we see both the representational content and the representing form. Art films often remind us that they have formal properties, which are at least as important as their content. With standard pornography, content is more important than form. As with some journalistic photography, the form is just a way of delivering the content.

Incompatibility theorists like Levinson think that this limitation of porn is insurmountable. Above we suggested that transparency need not prevent a porn film from being art; good art often encourages viewers to lose themselves in the content, which, after all, has been constructed by the creators of the work. So we are not suggesting that pornographic art must avoid transparency, only that it can do so, and this is one way it can make its status as art manifest (inventive and challenging content would be another). Levinson would deny the possibility of non-transparency; he says that, if we attend to the formal qualities of a porn film, we lose its pornographic effect. But this worry is mistaken. By necessity, porn films have formal qualities, and one can attend to these without losing sight of the arousing content. This can be achieved by alternating between form and content, as we do when viewing certain realist paintings; a possible example is Géricault's *Raft of Medusa*. Such alternations can lead to intensification; Géricault's dark, angular, centrally focused geometry underscores the horror of being lost at sea. But it may even be possible to experience twofoldness at one time. Consider the exaggerated emotional expressions in silent cinema: we can notice their theatricality while also being moved by them. Likewise, a cluttered *mise-en-scène* can instill a sense of claustrophobia (think of Polanski's *Repulsion*), and sparse long shots can connote psychological desolation (a favorite device of Antonioni). Porn could have twofoldness and still elicit intense sexual pleasure. Porn fails to be art much of the time because it does not pursue this possibility.

This brings us to an important point, perhaps the central point of our discussion. Standard porn fails to be art because it fails to afford the aesthetic stance, but porn could be art. Unlike incompatibility theorists, we think art porn is possible. Art is always flirting with its own failure; most pornog-

raphers don't run this risk, nor would the target audience want to run this risk. But this guaranteed sexual gratification is to the detriment of art. Thus, market forces play a role in the dearth of art porn. From this perspective, it is actually somewhat more surprising that genuine art films rarely venture in pornographic directions. Our puzzle about why porn is so often bad has a counterpoint in the sexual restraint in films with aesthetic pretensions. Why is pornography underexplored in art films? If we are right, pornography could be a paradigmatic genre for art films: it has suitable form, content, medium, emotional intensity, and moral ambiguity. So why is it that art films so rarely have pornographic content? This is a second paradox of porn.

Here again, market forces might matter. Art films occupy a mixed domain with regard to distribution and target groups. Squeezed in between art galleries and mainstream cinema, the art film is very vulnerable to labeling and the disciplinary taste of its audience. The X-label is more often than not commercial suicide not only for commercial but also for art films (Williams 2008: 259), and the art film audience is highly influenced by mainstream cinema's characterization of sexuality as psychology or sentimental rather than carnal. In addition, consumers of art film may be both more liberal and more educated than mainstream consumers, and within liberal circles there is a lively debate about the moral status of pornography. Thus, if art films were more carnal, they might risk losing their already small audiences. Of course, such market forces are contingent and culturally specific. Artistic directors were able to thrive within Japan's Pink Film industry, which became a safe haven for people on the political, social, and aesthetic margins. The 'free love' movement of the late 60s and 70s also created a climate for carnality in art, and thus we see European directors such as Pasolini, Ferreri, Verhoeven, and Makavejev pushing the pornographic envelope.

In summary, we think standard porn is not recognized as art (and, for us, fails to qualify as art) because it does not afford the aesthetic stance. And it fails to afford the aesthetic stance, because it lacks manifest aspiration to instantiate the characteristic features of art. Porn could be aesthetically aspirational and aspirational art films could incorporate pornographic elements, but this rarely happens. Market forces help to explain why the crossover is so rare. Rare but also regrettable. We think that porn would be better if it were more artistic. Standard porn films don't impress us, they don't make us tremble and fear, they don't inspire us with awe or capture us by surprise: we are not impressed or unsettled by the way this sexual

gratification came about. Good pornographic art should be like good sex, artful sex: we are not only sexually satisfied but also dazzled by this sexual satisfaction. In our final section, we will explore the prospects for pornographic art.

4. How Porn Could Be Better

We have suggested that there is double dissociation: an absence of artistic pretension in porn films, but also a neglect of pornography in art films. This is perhaps regrettable. The exploration of the artistic or aesthetic dimensions of a screening of sexual experiences can enrich or make our sexual gratification more complex. The result could be more layered sexual gratification; a sexual gratification to which is added a sense of bedazzlement. Fortunately, we don't think the gulf between pornography and art is essential. We have argued that there is no principled reason for thinking these categories are incompatible. That leaves us with a final question: what would count as an artistic porn film, or a pornographic art film?

Bedazzlement is difficult to characterize, because there is no formula. And that is precisely the point. Standard pornography is excruciatingly formulaic. It has no more invention than the scratching gesture we use to remedy a passing itch. A good porn director, like a good lover, breaks from routine sexuality. That does not mean good pornographers stop worrying about pleasure. The ultimate intention may be to arouse, just as the author of a tragedy aims to induce despair, but artistic achievement requires that the arousal be brought about in new and impressive ways. Doing so can involve the same kinds of skills that typify art films generally: adding emotional complexity, imposing a distinctive style, and violating genre conventions. The sexual nature of pornography affords many opportunities to do this. Directors can push beyond comfort zones, by eroticizing things we might not have seen in that light. Novel situations, unconventional camera angles, montage editing, careful use of both the visible and the invisible can all be used to heighten arousal.

Though rare, we do think there are compelling cases of films that have brought art and pornography together. Within art film, efforts to introduce strong sexual content have met with mixed success. Lars von Trier includes explicit unsimulated vaginal intercourse in *The Idiots*, but the film's overt

efforts to shock make the emotion effect of this scene more jarring than titillating. Stanley Kubrick tries to titillate in *Eyes Wide Shut*, but what he delivers is neither porn nor art, but an adolescent male fantasy, which indulges the narcissism of jealousy while compensating with some Amazonian nudes. Like Kubrick, Teuvo Tulio, one of Finland's best directors, also ended his career with a sexually themed film. *Sensuala* is a kind of feminist soft porn film about a Laplandish woman's descent into prostitution. With surreally saturated colors, political subtext, and bizarre plot, this film could have been a masterpiece, but the androcentric treatment of sexuality and campy delivery makes it feel more like sexploitation than art. Another near miss is Jodorowsky's *Holy Mountain*, which effectively integrates sexual content into a lavish psychedelic nightmare, though it could hardly be called arousing.

These examples are art films with an increased dose of sexuality. What about films that are intended as pornographic but also manage to qualify as art? Some Pink films, like Adachi's *Gushing Prayer*, which tells the story of a 15-year-old prostitute, would qualify. Also Maria Beatty's films, which are inspired by German expressionism, surrealism and film noir, and cover bondage, sadomasochism, and fetishism in lesbian sexuality, are recognized as porn art films. For a recent illustration, consider the experimental and largely public funded *Dirty Diaries*, a 2009 collection of thirteen pornographic short films made by Swedish feminists and produced by Mia Engberg. Some of these short films have pornographic shortcomings, but they support the idea that art and porn are compatible, and they depart from the risk-free recipe of sexual gratification. Four shorts are particularly successful in their attempts to offer sexual gratification along with an artistic appreciation of the means thereof. In *Skin* (Elin Magnusson), in which two persons in full-body nylon stockings are having sex and eventually cut open the nylons with scissors, the viewers' visual frenzy for skin and genitals is frustrated, but at the same time their pleasure is doubled by the presence of the nylon second skin. The scissors-in-action play with the contrasting worlds of everyday object manipulation and the thrilling sado-masochistic anticipation of fear. These dynamics are enhanced by an ambiguous game that the nylon is playing with our imagination: the artificial use of a common material marries the shivers of latex and bondage to the traditional, coded desire for legs covered in nude nylon. This whole episode may be a sexualized homage to Sanja Iveković's *Personal Cuts* (1982), an avant garde

short, screened at the world's top museums, in which a woman cuts her way out of a full body stocking. In *Fruitcake*, Nelli Rosselli creates an anal aesthetic that surpasses in close-up and obsession mainstream hardcore, and precisely by this excess she radically breaks with the conventional hetero- and homosexual language of anal sex. *Authority* stages rough sex between women in Berlin's graffiti-covered squats and abandoned urban spaces; the hostile environment is the natural beat in building up the spell of sexual violence, which is explicitly framed as a sexual politics of emancipation in which the viewer participates by sexual gratification. Pella Kagerman's *Body Contact* plays with the paradox of 'artificial' and 'real' body contact, and grants the viewer sexual gratification in a situation that self-referentially reveals its artificial and amateurish nature. These are only a few, rather embryonic examples of how artistic ambitions can enrich our sexual gratification.

With regard to art films, pornography is a rich and underexplored domain and we can only dream of what it would have been if art film directors had explored this domain more thoroughly. The frenzy of the eye, the thrill and trouble of carnality, the emotional intensity and violence, the maximum visibility, the carnal aesthetics, the radical choreography (minimalism/repetition/automatism), the Bressonian absolute realism are only a few of the directions of how we imagine pornography in art films could be explored and experimented with. Indeed, it is not difficult to conceive pornographic variants of traditional art-house styles: pornographic expressionism, surrealism, neo-realism, and new wave. One might, as homework, story board an Antonioni anal scene, a Murnau masturbation, or Godard group sex. As we have said, pornography possesses all the means to do things with artistic bravura; pornography has a deeply emotional and intensely disrupting potential, and it can stage in radical, explicit, or direct ways close-to-our-skin sexual experiences that are always constructed in a more or less dialectical relation with the norms of sexual morals and politics.

There are many pornographic masterpieces in the history of art, yet few art films successfully explore these possibilities. Maes (2011a) refers to these successful pornographic art films as 'unpornographic', but stresses that what he means by this is not what is commonly meant. Pornographic art films, he explains, are 'unpornographic' insofar as they depart from the typical features of mainstream porn films; they are truly pornographic, however, in their potential for providing sexual gratification. We think this use of

'unpornographic' is confusing, and it seems to be the only occasion where Maes makes a concession to the pejorative use of 'pornography', 'Porn art films' (in contrast with porn films) are atypical, because they part with the representation of sexual experiences in conventional ways and do not aim at cheaply earned sexual gratification, but it does not follow that these films are 'unpornographic.'

Maes (2011a) agrees that *Skin* is a good example of a porn art film. With this short, Magnusson took up Mia Engber's plea for unconventional pornography that takes our sexual experiences and gratification along unexpected paths, but as an artwork it is not different in kind from Magnusson's non-pornographic efforts. In fact, her artistic battle with pornography radicalizes the reach and strength of her former work, and leaves us more deeply and sexually gratified and unsettled. We could characterize *Skin* as alter-pornographic: Magnusson creates a new, different pornographic language and imagery, which leaves mainstream pornographic images behind and triggers unexpected sexual associations and desires. In an alter-pornographic effort, the sexual landscape has changed, and thus the paths of our sexuality have taken a radically other route. Patrice Chéreau's *Intimacy* (2004) installs an alter-pornography by the introduction of ordinary sex aesthetics: the sexual intensity is created by ordinary bodies, meeting up in ordinary places, having ordinary desires and ordinary sexual experiences. In the screening sex tradition, the ordinary is exceptional and surprising, and thus sends shivers down the spine of the viewer. Some alter-pornographic films explicitly have an anti-pornographic dimension; this is the case with Catherine Breillat's *Anatomie de L'Enfer* (2004), in which the narrative is about woman as the (self-convicted?) prisoner of a male pornographic universe, yet the visual language experimentally breaks out of this confinement and plays with a radically different carnal aesthetics, triggering in the viewer new forms of curiosity, desire, arousal, and gratification.

Some pornographic art films have no alter-pornographic dimension whatsoever; they simply parasitize mainstream pornography, but have a clearly anti-pornographic dimension. These films succeed at sexually engaging the viewer in something that at the same time produces disgust and alienation. This self-referential pleasure/disgust dynamics is the most troubling aspect of these films. The directors of *Baise-moi* (2000, Virginie Despentes, Coralie Trinh Thi), for instance, criticize patriarchal pornocracy by a hysterical reversal of the roles. Catherine Breillat's *Romance* (1999) gives

a bitter account of female sexuality; women's sexual world is exclusively inhabited by the imagery of male pornography, up to the point that even the male characters become the puppets of this female heteronomy, as well as the viewer, whose sexual arousal is confined and dictated by it. Other pornographic art films also parasitize mainstream pornography, yet have no anti-pornographic features. Jens Thorsen's *Quiet Days in Clichy* (1970) introduces pornography in new wave cinema, while adhering to its typical misogynism. Christophe Honoré's *Ma Mère* (2004) is an overall unsuccessful, yet nevertheless powerful attempt to adapt Bataille's posthumous novel of the same name. The viewer here embarks upon an erotic Bataillean journey that approves of life up until death, and is startled by the violent depths of his own sexual desires. A more successful film is Michael Rowe's *Ano Bisiesto* (2010), in which an alter-pornography of sadomasochism violently stretches the viewer's body and soul up to the point where pleasure and pain radically meet.

The diversity of these examples shows that art porn need not have a single relationship to mainstream porn. It can be transcendent, critical, or parasitic. In this sense, art porn is a bit like artistic tragedy. As a genre, tragedy is so common that the majority of cases are trite and manipulative. It is standard for daytime television. Artistic tragedies escape these vices in a variety of different ways. Some, like Pasolini's *Mama Roma*, add moral ambiguity and gritty realism, while not breaking from standard genre conventions. Others, like Bresson's *Mouchette*, are alter-tragic insofar as they deprive the audience of the usual crutches, such as overt emotional expression, which provide release when confronted with human adversity. Still others might be deemed anti-tragic, because they challenge extant norms about which life circumstances should warrant despair, by recasting loss in a positive light or recasting bourgeois pleasures as a source of despair. Agnes Varda's *Le Bonheur* exemplifies both forms of transgression. Art porn is thus like art film more generally in that it can achieve expressive success by positioning itself in different ways relative to conventional films. The possibilities for creating art porn have hardly been tapped.

We want to note, in closing, that there is a further reason for producing artistic pornography. Artistic porn is less morally problematic than conventional porn. First of all, it gives voice to sexualities that have been deemed deviant and silenced. Second, it would be less objectifying for performers; when porn is made for artistic expression rather than mere gratification, those involved can see themselves as part of a creative process rather than as a

mere means to gratification. Third, to the extent that viewing conventional pornography promotes mistreatment of women, viewing art porn might help promote more progressive attitudes, by, for example, reversing traditional gender roles or otherwise complicating gender dichotomies that fuel patriarchy.

5. Conclusions

We began with a paradox: pornographic films have many features that are characteristic of art films, yet rarely seem to qualify. The most tempting explanation is that pornography and art are incompatible. We reject this view. Instead, we think that pornography and art have tended to flourish under disjoint market forces, and that conventional pornography lacks certain normative features that are used to classify things as art. But porn need not be artless. We think the intersection of art film and pornography is underexplored, and that art and porn could be mutually reinforcing. The creativity associated with art could make sexual content more exciting and affecting, and the transgressive carnality of pornography could amplify artistic intensity and impact. Art films often operate under an unstated moralistic code, where certain things remain hidden from view. Love and lust are pervasive themes in art films, just as they are in mainstream cinema, but sexual acts usually go on off screen or beneath the covers. Art films often aim to arouse strong emotions, bringing sadness, mirth, and fear to their extremes, but lascivious feelings are heavily constrained. Causing tears is encouraged, while other moistening sentiments are undersolicited. Perhaps it is time for a correction. The real solution to the paradox of porn is not philosophical, but cinematic. The paradox can be redressed by lifting the covers on sexuality in art films, and by using porn as an outlet for creative expression, social critique, and subversive aestheticism.

References

Bartel, Christopher (2010) 'The Fine Art of Pornography? The Conflict between Artistic Value and Pornographic Value'. In Dave Monroe (ed.), *Porn—Philosophy for Everyone: How to Think with Kink*. Oxford: Wiley-Blackwell. 153–65.

Bordwell, David (1979) 'The Art Cinema as a Mode of Film Practice'. *Film Criticism* 4: 56–64.

Burke, Edmund (1757/2009) *A Philosophical Enquiry into the Origin of Our Ideas of the Sublime and Beautiful*. Ed. Adam Phillips. Oxford: Oxford University Press.

Dean, Jeffery (2003) 'The Nature of Concepts and the Definition of Art'. *Journal of Aesthetics and Art Criticism* 61: 29–35.

Gaut, Berys (2000) 'The Cluster Account of Art'. In Noel Carroll (ed.), *Theories of Art Today*. Madison: University of Wisconsin Press. 25–45.

Lacey, Simon, Hagvedt, Henrik, Patrick, Vanessa, Anderson, Amy, Stilla, Randall, Deshpande, Gopikrishna, Xiaoping, Hu, Sato, Joao, Reddy, Srinivas, and Sathian, K. (2011) 'Art for Reward's Sake: Visual Art Recruits Ventral Striatum'. *Neuroimage* 55: 420–33.

Levinson, Jerrold (1998) 'Erotic Art'. In E. Craig (ed.), *The Routledge Encyclopedia of Philosophy*. London: Routledge. 406–9.

——(2005a) 'Erotic Art and Pornographic Pictures'. *Philosophy and Literature* 29: 228–40.

——(2005b) 'Defining Art Historically'. In Peter Lamarque and Stein Olsen (eds.), *Aesthetics and the Philosophy of Art: The Analytic Tradition*. Oxford: Blackwell. 35–46.

Maes, Hans (2011a) 'Art or Porn: Clear Division or False Dilemma?' *Philosophy and Literature* 35: 1.

——(2011b) 'Drawing the Line: Art versus Pornography'. *Philosophy Compass*.

Mag Uidhir, Christy (2009) 'Why Pornography Can't Be Art'. *Philosophy and Literature* 33: 193–203.

Miller, Geoffrey (2001) *The Mating Mind: How Sexual Choice Shaped the Evolution of Human Nature*. New York: Anchor.

Prinz, Jesse (2011) 'Emotion and Aesthetic Value'. In E. Schellekens and P. Goldie (eds.), *The Aesthetic Mind: Philosophy and Psychology*. Oxford: Oxford University Press.

Sharp, Jasper (2008) *Behind the Pink Curtain: The Complete History of Japanese Sex Cinema*. Guildford: FAB Press. 323.

Sibley, Frank (1959) 'Aesthetic Concepts'. *Philosophical Review* 74: 135–59.

Theodoridou, Angeliki, Rowe, Angela, Penton-Voak, Ian, and Rogers, Peter (2009) 'Oxytocin and Social Perception: Oxytocin Increases Perceived Facial Trustworthiness and Attractiveness'. *Hormones and Behavior* 56: 128–32.

Vartanian, Oshin, and Goel, Vinod (2004) 'Emotion Pathways in the Brain Mediate Aesthetic Preference'. *Bulletin of Psychology and Arts* 5: 37–42.

Williams, Linda (1999) *Hard Core: Power, Pleasure, and the Frenzy of the Visible*. Berkeley: University of California Press.

——(2008) *Screening Sex*. Durham, NC: Duke University Press.

Wollheim, Richard (1980) 'Seeing-as, Seeing-in, and Pictorial Representation'. In *Art and its Object*. Cambridge: Cambridge University Press. 205–26.

9

Anti-Pornography
André Kertész's *Distortions*

BENCE NANAY

1. Introduction

One striking feature of most pornographic images is that they emphasize what is depicted and underplay the way it is depicted: the experience of pornography rarely involves awareness of the picture's composition or of visual rhyme. There are various ways of making this distinction between what is depicted in a picture and the way the depicted object is depicted in it. Following Richard Wollheim, I call these two aspects, the 'what' and 'how' of pictorial representation, 'recognitional' and 'configurational', respectively. Some pictures emphasize one of these aspects while underplaying the other. Pornographic pictures typically evince little concern with drawing attention to their 'configurational' aspect (Levinson 2005: 232).

Instead of examining pornography, where the 'configurational' aspect of experience is underplayed, I focus on a historical attempt to create images of the female body where the 'recognitional' element is the one that is underplayed and the 'configurational' elements of the picture form an essential part of our experience. The pictures I have in mind are André Kertész's series of photographs from 1933 called *Distortions*.

I argue that Kertész's *Distortions* are in this respect the counterpoint of pornography: they may be the least pornographic representations of the female nude that exist. Instead of ignoring the configurational aspects of the picture, making the picture transparent and fully at the service of showing the female body and thus the triggering of arousal, Kertész aims to achieve the exact opposite. His photographs strip the female body of all its sexual

connotations and draw our attention to the formal features of the picture—which is quite a feat in light of the subject matter of those pictures, which normally draws our attention away from the formal features of pictures.

The opposition between pornography and Kertész's *Distortions* may help us to characterize the 'configurational' aspect of our experience of pictures. It is relatively clear what the 'recognitional' aspect of our experience of pictures is: it is constituted by what is depicted in the picture. It is much less clear what the 'configurational' aspect of our experience is. Is it constituted by our awareness of the picture's surface properties? If so, could we use reference to the depicted object in order to characterize it? Or is it constituted by our awareness of the way the depicted object is depicted? If so, what is the relation between the 'configurational' aspect of our experience of pictures and our awareness of formal properties? By examining pictures that aim to direct our attention to the 'configurational' aspect of our experience of them in spite of the fact that they are of the female nude, I hope to answer some questions about the experience of pornographic pictures where the 'configurational' aspect is typically underplayed, as well as some general questions about picture perception.

2. *Distortions*

The 206 photographs that constitute the *Distortions* series are not among the best photographs by André Kertész. In fact, they are among the least carefully composed ones (if we do not consider the commercial work Kertész did for various fashion magazines in the 1930s and 1940s and for *Home and Garden* in the 1950s). Nonetheless, they are considered to play an important role in the history of twentieth-century photography as well as in the history of twentieth-century depictions of the female nude. The *Distortions* photographs were admired by (and arguably also influenced) Calder, Picasso, Sergei Eisenstein, Henry Moore, Francis Bacon, Jean Arp, and Giacomo Balla (but frowned upon by Alfred Stieglitz).

The art historical importance of these pictures can be attributed to two factors. First, Kertész's photos bear clear resemblance to some important nude paintings of the same period, notably, Matisse's *Pink Nude* (1935) and Picasso's *Girl Before a Mirror* (1932), as well as to Henry Moore's early reclining figures. Thus, it seems that the same compositional principles

appeared at the same time in different arts (this point was made in Kramer 1976, for example). Further, Kertész's *Distortions* can be seen as an influence on a number of later works, such as De Kooning's *Women*, Dubuffet's *Corps de dames*, and maybe even Giacometti's sculptures (again, see Kramer 1976).

It is much easier, of course, to distort parts of a female nude in a painting or a sculpture than to do so in a photograph. Kertész used two distorting mirrors from an amusement park and employed two models, Najinskaya Verackhatz and Nadia Kasine (although Kasine was sent home after a couple of shots and only Verackhatz is visible in almost all of the 206 photographs).

We have reason to believe that Kertész did the shooting in a relatively short period of time and in a not particularly conscientious manner (see e.g. Guégan 1933, Browning 1939, Brassaï 1963, Jay 1969, Ford 1979, Phillips 1985, Lambert 1998, and Esquenazi 1998 on various aspects and circumstances of the shooting). While he himself remembered taking 'about 140 photos' (Kertész 1983: 82), he in fact took 206 photos. Many of these use the same distortion effect. One recurring effect—where the lower part of the photo is undistorted and the upper part is stretched horizontally—can be seen in nineteen different photographs (*Distortion #59, 160, 167, 52, 172, 68, 63, 159, 165, 164, 61, 163, 157, 174, 53, 142, 176, 169, 77*).

There is a significant variation with regards to the degree and nature of these *Distortions*. Some photos are only very slightly distorted, so they could almost be taken to be veridical depictions (*Distortion #167, 119, 6, 16, 21, 68, 74*). Others are almost impossible to recognize (especially, *Distortion #200, 73, 48, 136, 149*). As Kertész himself says in a gallery flyer (for the exhibition Andre Kertész: *Distortions*. Pace MacGill Gallery, New York City, November 1983), 'I would develop glass plates and make prints for myself. When I showed them to the model, she told me she was quite sure that it was not her in all of the photographs' (quoted in Phillips 1985: 50–1). There is also a wide variation in which parts of the female body are distorted and which ones are not.

Twelve of these photos were published in September 1933 in *Le Sourire* (the magazine that approached Kertész with this idea) and a couple more in *Arts et métiers graphiques* some months later. The rest remained unknown until 1976, when all the surviving *Distortions* were published in a book format (something Kertész had been pursuing since 1933).

The *Distortions* photos were not the first distorted photographs: Louis Ducos du Hauron made distorted portraits as early as 1889. They were not

even the first distorted photographs in Kertész's oeuvre. He made a couple of distorted portraits of a woman's face in 1927 and of Carlo Rim in 1929. His early *Underwater Swimmer* (1917) could also be seen as the first in this genre in Kertész's life—this photo was included as the first photograph in the *Distortions* volume in 1976. Nor was *Distortions* the last attempt at using this method. He experimented with distorted 'nature mortes' in the late 1930s and early 1940s—often in the context of advertisements, and, ironically, these shots are often more in tune with Kertész's general compositional principles than the 1933 series. But those less than twenty *Distortions* that were known before the publication of the 1976 volume had a lasting impact both on Kertész's reputation and on the history of nude photography.

3. Pornography in 1933?

All of these photos depict a female nude and in most of them the model is in positions that are strongly sexually evocative. Do they then count as pornography? They were certainly considered as such when they first appeared in print. The *Distortions* photographs were commissioned by, and published in, the magazine *Le Sourire*, a magazine known for the frivolity of its content, and even described by some as a 'soft porn magazine' (Armstrong 1989: 57). It seemed clear that they were commissioned not so much for their aesthetic value as for their erotic interest.

Later, when Kertész emigrated to the United States, he did not manage to sell these photos or have them published in book form precisely because they were taken to be too pornographic. As Kertész himself says later, 'When I came to New York the publishers said to me, "In the United States this is pornography and we will go together to prison if we publish it"' (Kertész 1983: 90).

In fact, even Beaumont Newhall, photography curator at the Museum of Modern Art, had reservations about whether these pictures could be exhibited. As he allegedly told Kertész, 'With the sex, what you have done is pornography; without the sex, it is art' (Colin 1979: 24). In fact, Newhall asked Kertész to crop the photos above the pelvis, but Kertész was not willing to do that. He remembers: 'I was furious. It is mutilation, it is like cutting off an arm or a leg' (Kertész 1983: 90).

On reflection, there are at least two odd things about this controversy. First, in about half of the *Distortions* photographs either the pelvis is not visible, or else it is distorted to such a degree that it is not recognizable (though may be imaginable). Second, *Distortions* was actually not that provocative compared to some other photographic material that was circulating at the time. There were much more explicit and offensive pornographic photographs in that period. One important example is Man Ray's series of *Automne, Été, Hiver, Printemps* from 1929, four years before *Distortions*, which are straight photographs of himself having intercourse, presumably with Kiki de Montparnasse. This series was intended for a special issue of a Brussels-based magazine, *Variétés* on erotic poetry. The special issue consisted of two poems, one by Aragon, one by Benjamin Péret, and the four photographs by Man Ray. It was in fact published in 215 copies (one of them is up for sale for 23,000 USD on the internet as I write this).

The controversy over the pornographic nature of Kertész's *Distortions* is especially ironic as I will argue that these pictures constitute one of the least pornographic representations of the female nude. Thus, I agree with Charles Hagen, who said that 'these pictures themselves are never sexually charged' (Naef 1994: 129) and with Sylvia Plachy who was of the same opinion: 'I don't think those pictures are very sexual' (Naef 1994: 130).

In the introduction to the *Distortions*, Hilton Kramer wrote that 'Kertész's transformations of the female anatomy are at once erotic and aesthetic' (Kramer 1976: n.p.), but even this is an exaggeration—I aim to show that the erotic aspect of these pictures is almost nonexistent, especially in comparison with the aesthetic one.

A related important question is whether these pictures objectify their subjects. And it is difficult to disagree with Kramer, who says that

They do not victimize but celebrate their subjects [...] there is humor in these pictures but it is the humor of love. They are sometimes funny, but they are never mean or detached or disingenuous [...]—the love songs of a photographer. [...] They preserve a fondness for their subject that is lyrical and loving. (Kramer 1976: n.p.)

Not everyone agrees. Rudolf Kuenzli has reproached Rosalind Krauss for being too tolerant regarding Kertész's *Distortions* (Kuenzli 1991: 23). According to Kuenzli, there is 'obvious misogyny in these works' (Kuenzli 1991: 24). Carol Armstrong, in contrast, argues at length that the claims of

feminist art criticism fail to apply in the case of *Distortions* (Armstrong 1989): there is no 'male gaze', she claims, only the gaze of the female subject directed at herself.

In short, there are open debates about whether these photographs are pornographic, erotic, neither, or both, and if they are, how offensive they are. I do not here want to engage with the complex issue surrounding objectification, but if, as I argue, these photographs are the antithesis of pornography—as different from it as possible, then the charges of misogyny against them are surely unmotivated.

4. The Recognitional and the Configurational

The starting point of my analysis is Jerrold Levinson's account of pornography. Levinson argues that there is an important difference between the way we experience pornographic pictures and the way we experience other pictures. (I put non-pictorial forms of pornography to the side as they are irrelevant from the point of view of the assessment of Kertész's *Distortions*.)

To put it simply, some images are 'erotic images'. For Levinson, this means that they are 'intended to interest viewers sexually' (Levinson 2005: 230). Not all images of sexual organs or acts are erotic images in this sense— for example illustrations in an anatomy textbook are not. Some, but not all, 'erotic images' are pornographic images. These are 'centrally aimed at a sort of reception [that] essentially excludes attention to form/vehicle/medium/ manner, and so entails treating images as wholly transparent' (Levinson 2005: 239). In short, 'transparency of the medium is [. . .] a virtual *sine qua non* of pornography' (Levinson 2005: 237).

I am not endorsing this as a definition of pornography or of pornographic images, which is how Levinson intended it—there may be other ways of defining pornography, not in terms of its intended reception, but in terms of its content, for example. Nor am I endorsing the more specific claims Levinson makes about the incompatibility of pornography and art (see Kieran 2001 for some skepticism). What I do want to take from Levinson's account is his claim about our responses to, or experiences of, pornography. How and whether we can get from this type of response to a characterization of pornography is a question I put aside.

The response that pornography aims at, according to Levinson, excludes 'attention to form/vehicle/medium/manner, and so entails treating images as wholly transparent' (Levinson 2005: 239). However, the term 'transparent' brings with it a number of potential confusions. There is a large body of literature on whether our experience of photographs is necessarily transparent in the sense Levinson claims our experience of pornography is (Walton 1984, 1997; Lopes 2003). Levinson takes this alleged similarity between the transparency of photographs and the transparency of pornography to be an encouraging sign, as reflected in the fact that 'photography is the prime medium for pornography, that which has displaced all other such media in that connection' (Levinson 2005: 232). According to Levinson, the transparency of photographs and of pornography explains why this is the case.

The problem is that not everyone agrees that our experience of photographs is transparent: that we see through them the way we see through binoculars (see e.g. Warburton 1988; Currie 1991; Carroll 1995: 71; Currie 1995: esp. 70; Carroll 1996: 62; Cohen and Meskin 2004; Meskin and Cohen 2008; Nanay 2010b), and if any of these arguments are correct, then Levinson cannot use the experience of photographs as an analogy for the experience of pornography. However, I do think that the gist of Levinson's proposal is right: our experience of pornography is transparent in some sense of the term. But he cannot use the alleged transparency of photographs as a way of elucidating what is meant by the concept of transparency. Levinson is deliberately vague when characterizing the transparency of our experience of pornography: he says that it 'excludes attention to form/vehicle/medium/manner' (Levinson 2005: 239). But of course these four concepts, 'form', 'vehicle', 'medium', and 'manner', are not synonyms, and depending on which one of them we take a transparent experience to exclude attention to, we end up with very different concepts of transparency.

In order to make this formulation of the transparency of the experience of pornography less ambiguous, I will add two more concepts to these four. I borrow Dominic Lopes's concept of 'design-property': a picture's design is constituted by 'those visible surface properties in virtue of which a picture depicts what it does' (Lopes 2005: 25). I take this concept to be equivalent to Richard Wollheim's concept of the 'configurations aspects' of pictorial

representations.[1] Many philosophers make a distinction between what is depicted by a picture and the way the depicted object is depicted in it. Wollheim calls these two aspects, the 'what' and 'how' of pictorial representation, 'recognitional' and 'configurational', respectively (Wollheim 1980, 1987, 1998; see also Nanay 2004, 2005, 2008). Lopes calls the latter 'design'.

Now we can reformulate what I take to be Levinson's main claim about the experience of pornography: we experience pornographic pictures as transparent if our experience does not involve attention to the 'design' or 'configurational' aspect of these pictures, but only to the 'recognitional' aspect. I will analyze what this claim entails and show how it rules out pornographic responses to Kertész's *Distortions* in the next section.

5. Inflection

We have seen that pictures have 'configurational' and 'recognitional' aspects: design-properties and depicted properties. Sometimes we are attending to one, sometimes, the other, sometimes both. It is the 'attending to both' that I want to analyze a bit further, with the help of the concept of 'inflection'. It has been suggested that sometimes, but not always, our experience of pictures is *inflected*. As Dominic Lopes says:

Features of the design may inflect illustrative content, so that the scene is experienced as having properties it could only be seen to have in pictures. (Lopes 2005: 123–4)

Note that this does not happen each time we see something in a picture. Most of the time, our experience of pictures is uninflected. But sometimes it is inflected. Inflected pictorial experiences then are special. The question is what makes them special. The most important feature of the inflected experience of pictures seems to be that when we have experiences of this

[1] Wollheim uses the terms 'configurational' and 'recognitional' somewhat ambiguously: he sometimes talks about the 'configurational' and 'recognitional' aspects of our experiences and sometimes about the 'configurational' and 'recognitional' aspects of the pictorial representations. I'm assuming that the relation between these two ways of using these concepts is the following: an aspect of an experience is 'configurational' if it attends to the 'configurational' aspects of the pictorial representation, that is, to its design properties.

kind, the perceived object is experienced differently from the way it would be experienced face to face. Here is Lopes again:

Design seeing transforms the content of seeing-in so that it no longer matches the content of seeing the scene face to face. Design is 'recruited' into the depicted scene so that the scene no longer looks the way it would when seen face to face. (Lopes 2005: 40)

Michael Podro, who introduced the concept of inflection, also says that in the case of the inflected experience of pictures, the picture's design is 'recruited' into the depicted scene and this is why the scene does not look the way it would when seen face to face (Podro 1998: 13, 26). It is not clear, however, what it is supposed to mean that the picture's design is 'recruited' into the depicted scene. Podro's other formulations of inflected pictorial experiences are equally metaphorical: he says that when our experience of pictures is inflected, then besides seeing the scene in the design, we also see the design in the scene (Podro 1991: 172). He also says that inflected pictorial experience straddles the boundary between the marked surface and the depicted object (Podro 1998: 17, 28). If we want to understand the difference between inflected and uninflected pictorial experiences, we need to make sense of these metaphors.

Robert Hopkins goes through a couple of possible interpretations of inflected pictorial experiences and settles for the following:

Sometimes, what is seen in a surface includes properties a full characterisation of which needs to make reference to that surface's design (conceived as such). (Hopkins 2010: 158)

I have myself defended the following concept of the inflected experience of pictures: when our pictorial experience is inflected, we attend to a relational property that cannot be fully characterized without reference to both the picture's design and the depicted object. I called these properties that we attend to in the case of inflected experience of pictures 'design-scene properties' (Nanay 2010a: 194). Another appropriate term would be 'con-figurational-recognitional' properties. The point is that both aspects of the picture (both the configurational and the recognitional, both the design and the depicted) show up in our experience.

There are many ways of unpacking the notion of 'design-scene property': it could be referred to as the property of how features of the picture's design

give rise to or undergird the experience of the depicted object; or of how the depicted object emerges from the design, etc. What is important is that when our pictorial experience is inflected, we are consciously attending to 'design-scene properties'.

Not all 'design-scene properties' are particularly interesting, and attention to 'design-scene properties' does not guarantee the aesthetic appreciation, let alone the aesthetic experience, of a picture. But this concept is general enough to accommodate the main candidates for, and intuitions about, inflection. When we have an inflected pictorial experience, we experience how the depicted object emerges from the design. We see the depicting design 'undergirding' the depicted scene: 'seeing a picture as a picture amounts to seeing its undergirding—to seeing, as it were, the process of depiction and not merely its product' (Lopes 2005: 39). Design seeing, which is necessary for inflected pictorial experiences, 'amounts to seeing design features as responsible for seeing-in' (Lopes 2005: 28). Or, as Hopkins says (summarizing the view he himself disagrees with): 'inflection [. . .] offers us the opportunity better to appreciate how the one emerges from the other' (Hopkins 2010: 165). It is hard to see how these properties we see in surfaces would be capable of all this if they were not relational: if they did not make reference both to the picture's design and to the depicted object.

If this analysis is correct then the way we experience pornography cannot be a case of inflected pictorial experience. The experience of pornography, as we have seen in the last section, excludes attention to the 'configurational' or 'design' features of the picture, whereas in the case of inflected experiences, we attend to a relational property that cannot be fully characterized without reference to the 'configurational' or 'design' features of the picture. The experience of pornography and inflected pictorial experience are incompatible.[2]

And now we can return to Kertész's *Distortions*. A crucial feature of these photographs is that they force us to have an inflected pictorial experience. More precisely, it is not possible to see the depicted object in these pictures without attending to the 'design-scene properties' of these pictures. In the case of most pictures, we can attend to a variety of different properties of the picture while seeing the depicted object in the picture. When I am looking

[2] Like Levinson, I use the term 'the experience of pornography' as a shorthand for 'the experience pornography intends to trigger or has the function of triggering'.

at Cézanne's *The Bay from L'Estaque*, I can attend to smoke coming out of the chimney on the right without paying any attention to the design properties at all. Or, I can attend to the ways in which just a couple of brushstrokes give rise to the depiction of swirls of smoke. The latter experience is inflected, the former is not. And it is up to us which kind of experience we have while seeing the smoke in the picture.

But in the case of the *Distortions* photographs, if our experience is not inflected, we have no chance of seeing the depicted nude in the picture. In order to know whether we see a woman with slender arms (distorted) or with very thick arms (undistorted), we need to also attend to the way the nude is distorted in the mirror. In many cases, in order to even be able to recognize which body part is in the upper left corner of the picture, one needs to attend to the way the nude is distorted in the mirror—to the 'configurational' or 'design' aspects of the picture. In short, the *Distortions* photographs force us to have an inflected experience: if we want to see what is depicted at all, we need to see it in an inflected manner.

But if, as I argued, inflected experience and the experience of pornographic pictures exclude each other, then this makes it extremely difficult to experience Kertész's photographs as porn.[3] This makes Kertész's *Distortions* photographs examples of anti-pornography: pictures that, rather than being disposed to trigger reactions normally associated with pornography, are carefully constructed in such a way that they make any such reaction extremely unlikely.

Hilton Kramer notes in his introduction to *Distortions* that 'Kertész's images [are] often close to the frontiers of abstraction' (Kramer 1976: n.p.). This is true of Kertész's photographs in general, but also true of the *Distortions* photographs. They are indeed close to the frontiers of abstraction, but they are also careful not to trespass those frontiers. As Kertész emphasized in his piece 'Caricatures and *Distortions*' in the third volume of the *Encyclopedia of Photography*, 'the viewer must not be left in a state of bewilderment which so often results from seeing the unrelated mass of curves, angles, lights and

[3] I said this makes it extremely difficult to experience these pictures as porn. It does not make it strictly speaking impossible to do so—I do not want to deny that, in some sense of possibility, it is possible to experience nude photographs as porn. It may be possible, for example, to experience the configurational features of these photographs as simply an obstacle to having a pornographic experience. This is clearly not the experience Kertész's photographs are intended to trigger.

shadows which compose the poorer distortion pictures. There must be an emphatic governing theme in every picture' (Kertész 1970: 569–70).

The *Distortions* photographs, like most of Kertész's photographs, make sense both as figurative photographs and also as abstract compositions. But, and this is what is unique about this series, we cannot see these photographs as figurative photographs without *also* seeing them as abstract compositions of 'unrelated mass of curves, angles, lights and shadows'. It is only the attention to the 'unrelated mass of curves, angles, lights and shadows' that make it possible to see the female nude in these pictures. And this experience is the exact opposite of the experience associated with pornography.

6. Conclusion: Kertész's *Distortions* versus Man Ray's *Mr and Mrs Woodman*

In conclusion, I want to contrast the radical nature of Kertész's experiment with the anti-pornographic depiction of the female nude with another, equally radical attempt but in the opposite direction. Man Ray's photographs in his *Mr and Mrs Woodman* series depict two small wooden mannequins without faces making love in various (quite suggestive) positions. Man Ray first experimented with these pictures in 1926–7 (Mr Woodman made his appearance, all alone, even earlier, in 1920), but made a series of 27 photographs in 1947, which were later published in 50 copies by Editions Unida (1970). (He used the same wooden mannequins in other, self-standing photos, for example in his *Mr and Mrs Woodman in front of the TV* (1975), which are not particularly erotically charged.)

Although Man Ray's *Mr and Mrs Woodman* photographs are not of human bodies, but rather of pieces of wood stuck together, they manage to achieve the result that the 'recognitional' aspect of our experience effectively ousts the 'configurational' one: we are prompted to experience these photographs as pornography—the design is very unlikely to show up in our experience.

In short, there is a striking contrast between the way we naturally experience Kertész's *Distortions* and the way we naturally experience Man Ray's *Mr and Mrs Woodman* series. What makes the contrast between these works of two great modernist photographers, Kertész and Man Ray, especially striking is that while Kertész uses the naked female body, the erotic subject *par excellence*, he manages to make the 'recognitional' aspect of pictorial

representation irrelevant, whereas Man Ray uses pieces of wood, something that is *par excellence* not erotic, and manages to make the 'configurational' of the pictorial representation irrelevant.

Kertész makes anti-pornography with female nudes, whereas Man Ray makes pornography with pieces of wood.

References

Armstrong, Carol (1989) 'The Reflexive and the Possessive View: Thoughts on Kertész, Brandt, and the Photographic Nude'. *Representations* 25: 57–70.

Brassai (Halasz Gyula) (1963) 'Mon Ami, A. Kertész'. *Camera* 4: 1–6.

Browning, Artur (1939) 'Paradox of a Distortionist'. *Minicam* 7–9.

Carroll, Noël (1995) 'Towards an Ontology of the Moving Image'. In Cynthia A. Freeland and Thomas E. Wartenberg (eds.), *Philosophy and Film*. New York: Routledge.

——(1996) *Theorizing the Moving Image*. Cambridge: Cambridge University Press.

Cohen, Jonathan, and Meskin, Aaron (2004) 'On the Epistemic Value of Photographs'. *Journal of Aesthetics and Art Criticism* 62: 197–210.

Currie, Gregory (1991) 'Photography, Painting and Perception'. *Journal of Aesthetics and Art Criticism* 49: 23–9.

——(1995) *Image and Mind: Film, Philosophy and Cognitive Science*. Cambridge: Cambridge University Press.

Esquenazi, Jean-Pierre (1998) 'La Femme aux *Distortions*: essai sur les fantômes photographiques'. In Jean-Pierre Esquenazi and Frederic Lambert, *Deux études sur les distortions de A. Kertész*. Paris: L'Harmattan. 63–170.

Feagin, Susan L. (1998) 'Presentation and Representation'. *Journal of Aesthetics and Art Criticism* 56: 234–40.

Ford, Colin (1979) 'Introduction'. In *André Kertész: An Exhibition of Photographs from the Centre Georges Pompidou, Paris*. London: Arts Council of Great Britain.

Guégan, Bertrand (1933) 'Kertész et son miroir'. *Arts et métiers graphiques* 37 (September 15, 1933), 24–5.

Hopkins, Robert (1998) *Picture, Image and Experience: A Philosophical Inquiry*. Cambridge: Cambridge University Press.

——(2010) 'Inflected Pictorial Experience: Its Treatment and Significance'. In Catharine Abell and Katarina Bantilaki (eds.), *Philosophical Perspectives on Depiction*. Oxford: Oxford University Press. 151–80.

Jay, Bill (1969) 'Andre Kertész, Nude Distortion, an Incredible Experiment'. *Creative Camera* 1: 12–15.

Kertész, Andre (1970) 'Caricatures and *Distortions*'. In Willard D. Morgan (ed.), *Encyclopedia of Photography, Volume III*. New York: Greystone Press. 569–76.

—— (1976) *Distortions*. New York: Alfred Knopf.

—— (1983) *Kertész on Kertész: A Self Portrait*. New York: Abbeville.

Kieran, Matthew (2001) 'Pornographic Art'. *Philosophy and Literature* 25: 31–45.

Kramer, Hilton (1976) 'Introduction'. In André Kertész, *Distortions*. New York: Alfred Knopf, n.p.

Krauss, Rosalind, and Livingston, Jane (1985) *L'Amour Fou: Photography and Surrealism*. Washington, DC: Corcoran Gallery of Art.

Kuenzli, Rudolf E. (1991) 'Surrealism and Misogyny'. In Mary Ann Caws, Rudolf E. Kuenzli, and Gloria Gwen Raaberg (eds.), *Surrealism and Women*. Cambridge, Mass.: MIT Press. 17–26.

Lambert, Frederic (1998) 'La Différence entre l'image'. In Jean-Pierre Esquenazi and Frederic Lambert, *Deux Études sur les Distortions de A. Kertész*. Paris: L'Harmattan. 9–58.

Levinson, Jerrold (1998a) 'Erotic Art'. In E. Craig (ed.), *The Routledge Encyclopedia of Philosophy*. London: Routledge. 406–9.

—— (1998b) 'Wollheim on Pictorial Representation'. *Journal of Aesthetics and Art Criticism* 56: 227–33.

—— (2005) 'Erotic Art and Pornographic Pictures'. *Philosophy and Literature* 29: 228–40.

Lopes, Dominic McIver (1996) *Understanding Pictures*. Oxford: Oxford University Press.

—— (2003) 'The Aesthetics of Photographic Transparency'. *Mind* 112: 433–48.

—— (2005) *Sight and Sensibility*. Oxford: Oxford University Press.

Meskin, Aaron, and Cohen, Jonathan (2008) 'Photographs as Evidence'. In Scott Walden (ed.), *Photography and Philosophy: Essays on the Pencil of Nature*. New York: Blackwell. 70–90.

Naef, Weston (ed.) (1994) *Andre Kertész: Photographs from the J. Paul Getty Museum*. Malibu, Calif.: The J. Paul Getty Museum.

Nanay, Bence (2004) 'Taking Twofoldness Seriously: Walton on Imagination and Depiction'. *Journal of Aesthetics and Art Criticism* 62: 285–9.

—— (2005) 'Is Twofoldness Necessary for Representational Seeing?' *British Journal of Aesthetics* 45: 263–72.

—— (2008) 'Picture Perception and the Two Visual Subsystems'. In B. C. Love, K. McRae, and V. M. Sloutsky (eds.), *Proceedings of the 30th Annual Conference of the Cognitive Science Society (CogSci 2008)*. Mahwah, NJ: Lawrence Erlbaum. 975–80.

—— (2010a) 'Inflected and Uninflected Perception of Pictures'. In Catharine Abell and Katarina Bantilaki (eds.), *Philosophical Perspectives on Depiction*. Oxford: Oxford University Press. 181–207.

—— (2010b) 'Transparency and Sensorimotor Contingencies: Do We See through Photographs?' *Pacific Philosophical Quarterly* 91: 463–80.

Phillips, Sandra S. (1985) 'Andre Kertész: The Years in Paris'. In Sandra S. Phillips, David Travis, and Weston J. Naef (eds.), *Andre Kertész: Of Paris and New York*. New York: Thames and Hudson. 17–56.

Podro, Michael (1991) 'Depiction and the Golden Calf'. In N. Bryson, M. Ann Holly, and K. Moxey (eds.), *Visual Theory*. New York: Harper Collins. 163–89.

—— (1998) *Depiction*. Cambridge, Mass.: Harvard University Press.

Walton, Kendall (1984) 'Transparent Pictures: On the Nature of Photographic Realism'. *Critical Inquiry* 11: 246–77.

—— (1990) *Mimesis and Make-Believe: On the Foundations of the Representational Arts*. Cambridge, Mass.: Harvard University Press.

—— (1997) 'On Pictures and Photographs: Objections Answered'. In Richard Allen and Murray Smith (eds.), *Film Theory and Philosophy*. Oxford: Oxford University Press. 60–75.

Warburton, Nigel (1988) 'Seeing through "Seeing through Photographs"'. *Ratio* (new series) 1: 64–74.

Wollheim, Richard (1980) 'Seeing-as, Seeing-in, and Pictorial Representation'. In *Art and its Objects*, 2nd edn. Cambridge: Cambridge University Press. 205–26.

—— (1987) *Painting as an Art*. Princeton: Princeton University Press.

—— (1998) 'On Pictorial Representation'. *Journal of Aesthetics and Art Criticism* 56: 217–26.

10

An Aesthetics of Transgressive Pornography

MICHAEL NEWALL

This chapter is concerned with pornography that achieves what I shall consider its primary effect, sexual arousal, in part by representing a certain kind of norm-breaking: the violation of social or moral norms about sexual behaviour. I call this kind of pornography *transgressive pornography*. Such pornography includes scenarios featuring couplings deemed by society inappropriate to various degrees: sex between strangers, sex in public places, sex that transgresses professional ethics, sex between members of different social classes, between members of different age groups, incest, sexual violence, bestiality, and so on. Such scenarios, especially the milder ones, may sometimes function as little more than an 'interesting' way of framing otherwise standard sex scenes, but they can also add to sexual arousal, and are sometimes clearly designed to do so.

How widespread is this kind of transgressive pornography? Notable examples occur around a French literary tradition, and some of these will be the focus of this chapter. Susan Sontag's 1967 essay 'The Pornographic Imagination' draws attention to this tradition, examining, in particular, literary works such as *Story of O*, *The Image*, and especially the pornographic writings of Georges Bataille. For Sontag, transgression, especially in its stronger versions, is the distinctive feature of this pornography. This tradition goes back to the Marquis de Sade, and continues to have a presence in contemporary French literature and film (Best and Crowley 2007: ch. 4).

But transgressive pornography also figures in popular culture. Laura Kipnis draws attention to a range of subgenres of commercial pornography

serving the tastes of various sexual subcultures. She cites subgenres focused on the elderly and obese, and on spanking, 'feathering', and diaper-wearing. Kipnis thinks that transgression has a presence in more mainstream pornography too. For instance, she sees *Hustler* magazine as 'determined to violate all the taboos observed by its more classy men's-rag brethren' (Kipnis 1999: 130). Just how much transgressive pornography permeates pornography in popular culture is a matter for debate, and I will remark on this at the end of the chapter.[1]

I am inspired by an analysis made by Noël Carroll (2001), to show that the breaking of norms in transgressive pornography can also provide a basis for other affective states.[2] Such affects can arise adventitiously in popular pornography, but in literary pornography they are exploited for artistic purposes. Section 1 draws attention to three such 'pornographic' affects, aside from sexual arousal, that are elicited in literary examples of transgressive pornography: disgust, humour, and awe. Section 2 shows how each of these affects has a basis in the norm-breaking of transgressive pornography. Section 3 investigates the artistic value that can accrue to these affects by examining Georges Bataille's *Story of the Eye*, and the roles that disgust, humour and awe play in it. I conclude by suggesting that this constellation of affects goes some way to mapping a distinctive aesthetic of literary examples of transgressive pornography.

Three points to note before beginning. First, in speaking of a pornographic aesthetic, or the aesthetics of pornography, I do not mean to imply that pornography is aesthetic in the sense of providing some experience of beauty, but rather in the sense of offering feeling or affect. That is to say, this is a study of affects that arise from transgressive pornography, their basis and their artistic use. Second, I tend to use 'transgression' and 'norm-breaking' interchangeably. That is, transgressions need not be breaches of significant

[1] It is worth noting here that Kipnis sees all pornography as essentially transgressive: '[P]ornography obeys certain rules, and its primary rule is transgression . . . its greatest pleasure is to locate every one of society's taboos, prohibitions and proprieties and systematically transgress them, one by one' (Kipnis 1999: 164). In the process, Kipnis believes pornography shows up hypocrisies (especially about beauty, sexual attraction, and sexual behaviour) and so reveals things that as a society, we try to repress. She is relentlessly upbeat about the effects of pornography, playing up the positive political effects she claims for it, and minimizing its harmful effects on women. For an alternative view of the harmful effects of pornography, see Eaton (2007).

[2] Carroll shows that norm-breaking ('the transgression of a category, a concept, a norm, or a commonplace expectation' (Carroll 2001: 249)) underlies the perception of horror (an affect that bears some relation to disgust) and humour in the 'horror-comedy' subgenre of film.

social and moral norms; they may also be breaches of minor norms. Third, it will be objected by some that pornography cannot be art (e.g. Levinson 1998, 2005). To my mind such concerns are dealt with well by others (e.g. Kieran 2001; Maes 2011), so I will not treat them here. Still, if my analysis of the artistic character of some pornography convinces, it can only bolster the case for the existence of pornographic art.

1. The Pornographic Affects

1.1 Disgust

The presence of disgust in pornography, especially popular pornography, may be unintentional on the part of the pornographer—for whatever reason the audience fails to be aroused and is instead disgusted. But disgust can also be intentionally courted by the pornographer. Sade's *The One Hundred and Twenty Days of Sodom* (Sade 2005) is perhaps the outstanding example of this. The 600 'passions' it describes have something of the quality of an exhaustive catalogue of transgressive possibilities. Sade begins with the least transgressive of these, 150 'simple passions' involving non-penetrative sexual activity, progressing through 150 'complex passions', 150 'criminal passions', and concluding with 150 'murderous passions'. Part way through the simple passions, Sade gives up the narrative structure to simply list brief descriptions of most of the passions. To convey the sense of these I give an example of each in turn:

146. A man goes to great lengths to have women—married and unmarried—seduced. He provides men for them and lets them use his bedroom. Meanwhile, he goes into the next room and, unknown to them, watches through a peephole. (Sade 2005: ii. 230)

72. A man cuts up a Host with a knife and shoves the crumbs up his ass. (Sade 2005: ii. 241)

145. A man chains one of a girl's hands to a wall and leaves her without food. Two days later he gives her a large knife and places just out of her reach a heaping array of delicacies. If she wishes to eat, she must cut off her forearm; otherwise she will die of starvation. Her torturer watches her through a window. (Sade 2005: ii. 270)

78. A man inserts a funnel into a woman's mouth and pours molten lead down her throat. (Sade 2005: ii. 283)

Sade acknowledges that at some point in his book—presumably for most readers somewhere between the most anodyne of transgressions, and those involving murder—sexual arousal will fail, to be replaced by other feelings, prominent among which we may take to be disgust:

Many of the extravagances which you are about to witness will no doubt displease you, but there are a few among them which will warm you . . . We do not fancy ourselves mindreaders; we cannot guess what suits you best: it is up to you to take what pleases you and to leave the rest alone; another reader will do likewise, and another reader still, and so forth until everyone is satisfied. (Sade 2005: ii. 187)

Sade thus claims to cater to differences in his readers' tastes, but the extreme content of many of the passions, together with other remarks he makes, suggest he may be disingenuous. He says at one point, '[t]he idea of crime is always able to ignite the senses and lead us to lubricity' (84), and at another 'there is no libertine . . . who is not aware of the great sway murder exerts over the senses' (13). He elsewhere praises his libertines extensively, recommending their outlook and lifestyle; and he supports transgressive sexual practices, up to and including murder, with his 'philosophical' arguments (see, for example, dialogue 5 from *Philosophy in the Bedroom*, Sade 2005: vol. i). Sade, then, gives two ways of understanding disgust in his work. Disgust may just be evidence of differences of taste, and so inescapably limn his work for every reader. Or it may be something that his readers are intended to confront and overcome, so they may explore, if only in imagination, the full spectrum of transgressive sexual possibilities including violence and murder. In either case disgust is a part of the Sadean aesthetic.

1.2 Humour

Disgust is not the only response that may occur when sexual arousal fails.

Sex, and especially the ornately implausible sex described in transgressive pornography, can simply strike us as ridiculous. As with disgust, pornographers may make their audience laugh unintentionally, but this may also be a calculated effect on the part of the writer. For instance, Raymond Queneau's comic pornographic novel *We Always Treat Women Too Well* capitalizes on the tendency of transgressive sex to humour.[3] The setting is

[3] Despite its sexual content, it is not agreed that *We Always Treat Women Too Well* is pornography. Some instead deny that it has any pornographic potential, understanding it as simply a critical send-up of

Dublin during the Easter Rising of 1916. A group of Irish republican rebels occupy a small post office by the Liffey, and Gertie Girdle, an English woman working there, finds herself locked in a toilet while the other employees are killed or expelled from the building. Later, Gertie is discovered, and the rebels, surrounded by an overwhelming force of British troops, find themselves drawn from their pledge to conduct themselves 'correctly' in her presence. Queneau sees ample scope for comedy in the pornographic form. For instance, one coupling, with the rebel Caffrey (Queneau names his characters after those in Joyce's *Ulysses*), is interrupted when he is decapitated by a shell:

The body continued its rhythmic movement for a few more seconds...the kind of disembrained mannikin still surmounting her finally lost its momentum, stopped jerking, and collapsed. Great spurts of blood came gushing out of it. Whereupon Gertie, screaming, wrenched herself free, and what remained of Caffrey fell inelegantly on to the floor...she retreated to the window, her thoughts in some disarray, trembling, covered all over with blood, and moist with a posthumous tribute. (Queneau 1981: 122)

This is an example of humour where amusement stems from an incongruity: put bluntly, the idea that a corpse can engage actively in sex is absurd. Another kind of humour, calling for another kind of example, appears to have a basis in the release of repressed tensions. Here humour seems to arise from a release of tensions that accumulate in the course of everyday life, where we must abide by norms that mean many of our desires must go unrealized (Freud 1960 gives a famous analysis of this kind of humour). Consider, for example, the humour that can come from seeing an authority figure one resents subjected to some practical joke or other indignity. The amusement will typically be more intense than that coming from the same joke or indignity levelled at, say, a random passerby. This kind of humour is also found in pornography. For example, in Sade's *Philosophy in the Bedroom*, a young woman, Eugénie, is corrupted by a band of libertines. Her mother, Madame de Mistival, is a figure of strict and conventional morality, and when she appears she is singled out for an especially horrible attack, which Sade clearly intends to be an occasion for humour of this kind—though we

pornography. See for example Valerie Caton's remarks in her foreword to *We Always Treat Women Too Well* (Queneau 1981: 2–5).

may well have trouble finding humour in it ourselves. The episode draws to a finish once Madame de Mistival has been raped by a syphilitic valet. One of the libertines, Madame de Saint-Ange, then declares:

I believe it is now of the highest importance to provide against the escape of the poison circulating in Madame's veins; consequently Eugénie must very carefully sew your cunt and ass so that the virulent humour, more concentrated, less subject to evaporation and not at all to leakage, will more promptly cinder your bones. (Sade 2005: i. 316)

The description of the elaborately botched sewing that follows appears intended, by turns, to arouse the reader with explicit descriptions and provide occasion for laughter at the sexual humiliation of the prudish Madame de Mistival.

1.3 Awe

I regard awe and the sublime as closely related. Phenomenologically I do not see any pressing reason to make a distinction between them here, and accordingly my discussion of awe slips at points into talk of the sublime. I speak of awe rather than sublimity primarily to avoid the positive value judgement generally associated with the term sublimity—the term awe is more readily understood as a neutral description. This is not to say that calling an object 'awesome' does not also often have a positive implication, but it need not. This is implicit in the analysis of awe given by psychologists Dacher Keltner and Jonathan Haidt. 'Awe' they write, 'is felt about diverse events and objects, from waterfalls to childbirth to scenes of devastation' (Keltner and Haidt 2003: 297). In contrast to the first two items on their list, a scene of devastation (say, in the wake of a natural disaster or war) is not likely to be seen as valuable—the world would be a better place without such events—but that does not affect our ability to feel awe in the presence of such a scene.

That we can find the representation of norm-breaking sexual activity disgusting or laughable will hardly come as news. The arousal of awe requires more explanation. Partly this is because the examples of awe I discuss are not an immediate response to pornographic passages, as are disgust and humour. Rather, they occur on reflection, and the examples I consider give space over to such reflection, and encourage it in the reader. Partly it is because transgressive pornography tends to hold in contempt

objects that might ordinarily be subject to respectful awe: authority figures, moral law, religion—all are undermined by the power of sexuality. But this is just where awe comes in. For under such circumstances one thing can still be seen as a subject of awe—sexuality itself. Consider the assessment made of transgressive sexuality by the protagonist of Bataille's *Story of the Eye*:

I did not care for what is known as 'pleasures of the flesh' because they really are insipid; I cared only for what is classified as 'dirty'. On the other hand, I was not even satisfied with the usual debauchery, because the only thing it dirties is debauchery itself, while, in some way or other, anything sublime and perfectly pure is left intact by it. My kind of debauchery soils not only my body and my thoughts, but also anything I may conceive in its course, that is to say, the vast starry universe, which merely serves as a backdrop. (Bataille 1982: 42)

'Two things', so Kant said, 'fill the mind with ever new and increasing admiration and awe, the more often and steadily we reflect on them: the starry heavens above me and the moral law within me' (Kant 1956: 161–2). For Bataille's protagonist these Kantian occasions for sublime experience are trumped by transgressive sexuality.[4]

Sade's attitude is different, but not a world away from those described by Bataille and Queneau. For Sade, transgressive sexuality is a feature of nature. Like other forces of nature it deserves respect and admiration. But it is also an integral part of us, and if we are to truly realize our potential, it is something we should not only respect, we should give ourselves over to it. In the dedication to *Philosophy in the Bedroom*, he writes: '[y]our passions, which the cold and dreary moralists tell you to fear, are nothing more than the means by which nature exhorts you to do Her work.... [S]purn the precepts of your idiotic parents; yield instead to the laws of Nature' (Sade 2005: i. 208).

[4] It is not clear whether Bataille is taking a passing shot at Kant here. Queneau, though, certainly does. As their soon to be exploded sense of 'moral law within' starts to be challenged, '[t]he rough rebels began to realize that correctness was constituted of a certain reserve (meaning that there are certain-things-you-Kant-do), or, at the very least, of a certain mastery of one's primitive reflexes' (Queneau 1981: 59–60). Bataille's and Queneau's observations are hardly a refutation of the Kantian sublime. But they do suggest that it is possible to find sublimity in transgressive sexuality. This is not in itself a problem for a Kantian approach, which can argue that such an unorthodox object can appear sublime to us on account of 'a certain subreption', whereby 'the respect for the object is substituted for respect for the idea of humanity within our[selves as] subject[s]' (Kant 1987: 114). Still, it would leave the Kantian in an awkward position so far as it allows that transgressive sexuality, which can break violently with morality, can be apprehended as sublime.

2. Norm-Breaking and the Pornographic Affects

I now show how each of these affects can be understood as a response to the norm-breaking of transgressive pornography. The idea that norm-breaking plays a role in these particular affects is not novel—it finds support in diverse sources in psychology and philosophy. In the introduction I touched on the role of norm-breaking in sexual arousal, so I will now give accounts of its role in disgust, humour, and awe. Note that my claim is not that norm-breaking alone is a sufficient condition for these affects. In each case further conditions will be required—I will say a little about these, but a detailed examination of them is beyond the scope of this chapter. Let me also add here an observation on the relation of these affects in our experience. In general, I consider that these affects follow one another in the experience of reading the texts I have mentioned: e.g. sexual arousal may be replaced by disgust, then humour, or awe before returning to sexual arousal, and so on. But I do not rule out the possibility that some of these affects might be experienced simultaneously. Sexual arousal tinged with disgust might be such a combination, though other combinations seem (at least on the face of it) improbable: say, sexual arousal and humour.

2.1 Disgust

Psychologist Paul Rozin and his colleagues understand disgust as falling into four categories. They hold that the capacity to feel the first of these, 'core' disgust, evolved in order to protect us from disease and infection. It includes the revulsion we feel at spoiled food, excrement, and bodily fluids. Out of core disgust, they propose, the other forms of disgust developed. 'Animal-nature' disgust is elicited by death, hygiene violations, violations of the 'body-envelope'—and sex. 'Interpersonal' disgust includes disgust at contact with strangers and 'undesirables', and 'moral' disgust is revulsion at moral offences (Rozin et al. 2000: 639–45).[5] Each of these involves the perception of a threat to the subject—whether that be a physical threat, or a social or

[5] The idea that other forms of disgust have their origins in Rozin's 'core' disgust has been supported by a recent study showing that the distinctive facial expressions associated with disgust are also elicited by moral offences (Chapman et al. 2009). This result also lends support to Rozin's claim that our description of such offences as eliciting moral disgust is not just figurative: moral disgust and 'core' disgust really are forms of the same emotion.

moral threat—that arises from the breaking of some physical, social, or moral norm. Core disgust maintains a physical boundary—a physical norm—between our bodies and substances that could physically contaminate them. Animal-nature disgust emerges from an existential desire to disown our 'animal' or 'natural' state. This involves the maintenance, again, of physical boundaries that the elicitors of animal-nature disgust—poor hygiene, 'violations of the body envelope', and the presence of death—threaten. Interpersonal disgust is a response to people who do not satisfy our norms of appearance or social behaviour. Moral disgust is a response to transgression of certain (usually serious) moral norms.[6]

Rozin et al. classify sex as eliciting animal-nature disgust, which seems appropriate so far as sex can remind us of our 'lower' animal nature. But it will also be clear that transgressive sex, depending on precisely what it involves, can fit any or all of the four categories: that is to say its transgressive character can involve it in the breaking of a range of the physical, social, and moral norms that can lead to disgust. Of course particular examples of transgressive sex will not be apt to cause disgust in every individual. But Rozin's approach suggests a measure by which we might determine whether an individual will feel disgust. Norm-breaking is likely to cause disgust *in us* when that norm is important to us in some way—perhaps, explicitly or implicitly, we have some personal investment in the maintenance of those norms. But if we do not hold those norms in high regard, we will not feel disgust at seeing them broken. So for those of us without moral concerns regarding a pornographic description of a non-transgressive sex act, the description may prompt 'animal-nature' disgust, but for an individual with moral reservations about what is described, it may also prompt moral disgust.

2.2 Humour

One kind of theory of humour is explicitly based on the idea that humour arises from norm-breaking: incongruity theories. Schopenhauer gives a well-known version:

[6] The anthropologist Mary Douglas (1966) makes a comparable analysis, arguing that disgust in general is a response to upsetting categories of various kinds.

In every case, laughter results from nothing but the suddenly perceived incongruity between a concept and the real objects thought through it in some relation; and laughter itself is just the expression of this incongruity. (Schopenhauer 1966: i. 59)

For Schopenhauer, the incongruity at work in humour is a breaking of a rule of language or logic—the incorrect application of a concept to a particular case. Modern versions extend Schopenhauer's idea to include almost any form of category-breaking. Take Carroll's formulation:

for a percipient to be in a mental state of comic amusement, that mental state must be directed at a particular object—a joke, a clown, a caricature—that meets certain formal criterion, namely, that it be apparently incongruous (i.e., that it appear to the percipient to involve the transgression of some concept or some category or some norm or some commonplace expectation). (Carroll 2001: 249)

What makes an incongruity a source of humour rather than disgust? Drawing on Carroll's ideas, to be perceived as humorous, an incongruity must be seen as harmless (Carroll 2001: 251). Disgust, however, as I have said, always involves a norm-breaking—and thus a kind of incongruity—that brings with it a sense of threat to the percipient. An incongruity theory would seem to explain the humour in Queneau's description of Caffrey's completion of the sexual act in spite of his decapitation, since the fantastic quality of this episode makes it unlikely to threaten a broad-minded reader's sense of social or moral propriety. But it is less obviously successful in explaining the kind of humour that Sade hopes to draw from his description of the attack on Madame de Mistival. Another kind of theory, 'release' or 'relief' theory, such as Freud's, is more clearly able to explain this. Release theories endorse the idea, already mentioned, that humour, or certain kinds of humour, arise from a release of repressed tensions that build up in observing the various prohibitions of everyday life. However, I want to point out here that this kind of humour also involves norm-breaking, for it involves the breaking of norms with which society requires us to accord. In order to tell a joke against an individual or institution that has authority over us, we break the rules it imposes, if only in a minor or symbolic way—through representing, for example, a situation in which the authority is stripped of its power in some respect. This is what occurs in the case of Madame de Mistival (and Freud's theory seems especially suited here, for he thinks that humour in particular dissipates violent and sexual tensions). The humour Sade hopes to draw from

the libertines' attack on her comes at the expense of the pain, humiliation, and powerlessness of this representative of the prevailing morality of Sade's time.

2.3 Awe

Keltner and Haidt propose that awe is a response to the failure of our perceptual or conceptual categories to accommodate an object:

[A]we involves a challenge to or negation of mental structures when they fail to make sense of an experience... Such experiences can be disorienting and even frightening... since they make the self feel small, powerless and confused. They also involve feelings of enlightenment an even rebirth, when mental structures expand to accommodate truths never before known. The success of one's attempts at accommodation may partially explain why awe can be both terrifying (when one fails to understand) and enlightening (when one succeeds). (Keltner and Haidt 2003: 304)

The object of awe must therefore, at least at first, be one that exceeds perceptual or conceptual categories, especially in terms of size or power.[7] Keltner and Haidt go on to suggest that awe has a 'primordial' counterpart, like core disgust, and that this is an evolved tendency to find the leader of one's group an object of awe. Some of the behaviour that we associate with awe—fearfulness, submissiveness—would thus have evolved to strengthen social groups in prehistoric times (Keltner and Haidt 2003: 307–8). Awe then developed different aspects as it came to be applied to different objects: such as the supernatural, highly skilled or moral individuals, and aspects of the natural world.

Stripped of Keltner and Haidt's evolutionary analysis, philosophers will recognize their proposal as a restatement of an old idea about the sublime: Kant held that the experience of the mathematical sublime stems from the imagination being frustrated in its inability to adequately present an object to the mind: 'the feeling of the sublime is a feeling of displeasure that arises from the imagination's inadequacy' (Kant 1987: 114). Keltner and Haidt's account of accommodation also echoes Kant's claim that the feeling of the

[7] Carroll also makes a similar link: '[c]ertain types of religious awe are also located in the vicinity of incongruity' (Carroll 2001: 423, n. 31).

sublime 'is at the same time also a pleasure, aroused by the fact that this very judgment . . . is in harmony with rational ideas' (Kant 1987: 115).[8]

If transgressive sexuality can be seen as having the power to challenge and negate social and moral norms, as I outlined in the previous section, then it will satisfy the criterion Keltner and Haidt set for awe. Often, it is a challenge to conceptual rather than perceptual categories or norms. Unlike, say, the power of a violent storm or a volcanic eruption, the force embodied in sexuality is not usually directly perceptible. Rather it is something we infer, principally from observing its effects and extrapolating accordingly. Also it may be that in order to seem an object of awe, sexuality must be conceptualized as a threat to social and moral norms generally. That is, we must infer from its unsettling of particular norms that it is a more general, and so awesome, threat. These considerations would help us understand why sexuality can often seem awesome only on reflection, as it does in the examples in Sade and Bataille. In these cases, it is only once we have conceptualized the force of sexuality, and conceptualized it as able to overwhelm social and moral rules in general, that it can seem to us an object of awe. That said, I would not want to rule out that sexuality's force can sometimes be perceived directly. The perception of one's own sexuality is one example. The palpable sexuality expressed by certain individuals is another. Think of the 'maneater' of Hall & Oates's eponymous song, or the carnality expressed by screen figures such as Johnny Depp, Robert Mitchum, Kim Basinger, or Marlene Dietrich.[9]

3. Pornographic Art: *Story of the Eye*

We have seen that transgressive pornography, in addition to producing sexual arousal, can be capable of occasioning disgust, humour, and awe, and that all these affects develop out of the norm-breaking of the genre. I have touched on the uses disgust, humour, and awe can have in the context of literary pornography: Sade's use of disgust, Bataille's and Sade's presentation of sexuality as an object of awe, Queneau's and Sade's efforts to make the reader laugh. This section aims to give an account of how this

[8] Keltner and Haidt do not mention Kant (although they discuss Burke).
[9] I thank Hans Maes and Jerrold Levinson for pressing me on this point, and Levinson for suggesting the examples I have listed.

constellation of effects can be brought together to a broader artistic purpose; that is, to show how these affects can play a central role in establishing and conveying artistic meaning. To this end this section sketches an account of the role disgust, humour, and sexual arousal play in Bataille's *Story of the Eye* (I have already spoken of awe with reference to *Story of the Eye*, but will say a little more about it at the end of the section). I choose *Story of the Eye* on account of its pre-eminent place in the genre of transgressive pornography, and because Bataille's extensive theoretical writings make his artistic intentions in *Story of the Eye* relatively clear.

From Bataille's theoretical writings it is apparent that he saw transgressive sexuality, disgust, and laughter as different manifestations of what he sometimes calls simply 'being'. Being is for him primal and animal, but becomes focused and intensified in the act of breaking with social, religious, or moral norms: '"Being" increases in the tumultuous agitation of a life that knows no limits' (Bataille 1985: 172). Disgust, laughter, and the sexual arousal associated with transgressive sex all involve a physically felt awareness, a 'revelation' of being in this sense (e.g. Bataille 1985: 132, 176). The term revelation is important. For Bataille, being is what is most valuable in our identity, and what we should strive to discover and realize most fully in our lives.

Transgressive sexuality yields this awareness for Bataille in a most obvious way, through the mental and physical intensity of the sexual experience it affords. It should be added that Bataille shares much with Sade in his appreciation of the pleasures the pain and death of others can afford. But he departs from (or perhaps extends) Sade in the existential importance he accords transgressive sexuality. Paul Hegarty gives an account of this aspect of Bataille's thought (Bataille's use of the term 'eroticism' correlates fairly well with what I call 'transgressive sexuality'):

Bataille opens up the erotic as both deadly and where life is actually at its height. Eroticism is 'assenting to life up to the point of death' and 'in essence the domain of eroticism is the domain of violence, of violation' (Bataille (1986): 23, 16). In order, then, to 'live life to the full', death (in the form of loss of the self) must be encountered (but not overcome or mastered). The individual must be threatened with their own dissolution, and this is what is meant by eroticism being about violation. (Hegarty 2000: 106)

Sontag, who shares a similar view to Bataille, points out that in order to be understood, such ideas require a reassessment of a received view of sexuality:

'the prevailing view—an amalgam of Rousseauist, Freudian, and liberal social thought—regards the phenomenon of sex as a . . . source of emotional and physical pleasure' (Sontag 1994: 56). On this view, sex becomes polluted by religion, and other sources of repression, which distort sexuality, creating what we think of as perversions. Bataille has a different conception of sexuality in which transgressive sexuality (which Sontag calls 'the obscene') becomes

a primal notion . . . something much more profound than the backwash of a sick society's aversion to the human body [S]exuality remains one of the demonic forces in human consciousness—pushing us at intervals close to taboo and dangerous desires. (Sontag 1994: 57)

These desires range from,

the impulse to commit sudden arbitrary violence upon another person to the voluptuous yearning for the extinction of one's consciousness, for death itself Everyone has felt (at least in fantasy) the erotic glamour of physical cruelty and an erotic lure in things that are vile and repulsive. These phenomena form part of the genuine spectrum of sexuality. (Sontag 1994: 57)

For Bataille transgressive sexuality, in even its most extreme and dangerous forms, is a part of normal human sexuality.[10] This is manifested most clearly for Sontag in Bataille's embrace of death as aphrodisiac: 'Bataille understood more clearly than any other writer I know of that what pornography is really about, ultimately, isn't sex but death' (Sontag 1994: 60) Her thought is not that all pornography is about death, or transgressive, but that the most full and intense pornographic exploration of sexuality will ultimately center on this theme. Compared to Sade, there is little death in Bataille's pornography, but, Sontag suggests, Bataille's deaths count for more. In contrast to Sade's interchangeable victims, Bataille 'invest[s] each action with a weight, a disturbing gravity, that feels authentically

[10] The question of whether transgressive sex is a natural element of human sexuality, or whether it is a perversion of this sexuality, lies beyond the scope of this chapter, and is in any case not relevant to the results I intend to establish. However, I am inclined to agree with Graham Priest's dismissal of sexual perversion as a moral category. 'Sex', he writes 'has no particular aim or goal; at least, not in any sense that automatically grounds a moral evaluation. It is implicated in lots of causal processes; and the moral evaluation of these is another matter entirely' (Priest 1997: 371).

"mortal"', and which conveys, as Bataille has it, a revelation of being (Sontag 1994: 61).[11]

In the case of disgust, the perceived threat to the individual occasions a visceral self-awareness. To be disgusted is to feel one's body and mind repulsed by the object of disgust. For Bataille, disgust (and also laughter and sexual arousal) has a link with death: death 'guarantees the totality of disgust'—that is, it is in the presence of death that we can feel disgust (and these other affects) most intensely (Bataille 1985: 132). And it is this strongest form of disgust that yields an intense awareness of being: 'the pure avidity to be *me*' (Bataille 1985: 132).

For Bataille, laughter brings with it a pleasurable awareness of the self in revolt from those norms that restrict it (a view that suggests the release theory). But like disgust this mental aspect is accompanied by a bodily aspect: the physical act of laughing. For Bataille this is significant because it involuntarily disables and reduces to a kind of animal state what he takes to be, at least at a symbolic level, the primary vehicle of the expression of reason: the mouth (Bataille 1985: 59–60). As with disgust, humour is most intense—'[a] kind of incandescent joy—the explosive and sudden revelation of the presence of being'—when it takes as its subject death in some form— when it 'casts a glance . . . into the void of being' (Bataille 1985: 176).

As I have said, Bataille recognizes that these affects in their strongest forms are allied with transgression or norm-breaking. In *Story of the Eye*, the norms under attack are predominately social and moral norms (including religious rules), and Bataille, in order to ensure the most comprehensive realization of being, assaults these in a systematic manner, leaving no norm unsullied (although without achieving the phantasmagoria of transgression of Sade). Bataille tells of an incident that seems to hold the features of this programme in embryo. In the essay 'Coincidences', written to accompany *Story of the Eye*, he describes how his blind, syphilitic father was struck suddenly with dementia. After examining Bataille's father,

[t]he doctor had withdrawn to the next room with my mother and I had remained with the blind lunatic, when he shrieked in a stentorian voice: 'Doctor, let me

[11] Sontag allows that 'few people regularly, or perhaps ever, experience their sexual capacities at this unsettling pitch' (Sontag 1994: 57), and at the end of her essay she also makes it clear that she does not believe that it is desirable that everyone experience the full 'spectrum' of sexuality.

know when you're done fucking my wife!' For me, that utterance, which in a split second annihilated the demoralizing effects of a strict upbringing, left me with something like a steady obligation, unconscious and unwilled: the necessity of finding an equivalent to that sentence in any situation I happen to be in; and this largely explains *Story of the Eye*. (Bataille 1982: 73)

Let me now turn to the final episode from *Story of the Eye*, containing the most extreme transgressions in Bataille's narrative. My intent is to show how it is through sexual arousal, disgust, and humour, arising from a programmatic series of transgressions of ascending severity, that Bataille hopes to evince from his readers the revelatory awareness of an increase in being that he believes is available in these affects.

In the final three chapters of *Story of the Eye*, the nameless (male) protagonist, Simone, and Sir Edmund enter a Catholic church in Seville, where Simone seduces a young, handsome priest, and the group then subject him to elaborate sexual torture and humiliation, ending in his murder. The series of transgressions develops as follows. First, the priest's code of moral sense is overcome as he willingly gives himself over to his and the protaganists' sexuality. After allowing Simone to perform oral sex on him in the confessional, the group carry him to the vestry: '"Señores", the wretch snivelled, "you must think I'm a hypocrite"' (Bataille 1982: 61). The priest is presented as both disgusting and laughable; he is induced to urinate into the church's chalice and drink the contents before ejaculating into the ciborium:

The paralyzed wretch drank with well-nigh filthy ecstasy at one long gluttonous draft . . . with a demented gesture . . . he bashed the sacred chamber-pot against a wall. Four robust arms lifted him up and, with open thighs, his body erect, and yelling like a pig being slaughtered, he spurted his come on the host in the ciborium . . . (Bataille 1982: 62)

Sir Edmund then announces to the priest, '"You know that men who are hanged or garrotted have such stiff cocks the instant their respiration is cut off, that they ejaculate. You are going to have the pleasure of being martyred while fucking this girl"' (Bataille 1982: 64). The cues for laughter dry up here (though they need not necessarily, cp. Queneau). Disgusted horror, and, perhaps, Bataille hopes, sexual arousal come to the fore after this as the party begin the more earnest, almost sacrificial business of asphyxiating their hapless victim during sex.

Bataille's notion of being and the value he attaches to it, the value he gives to transgression, and the place he gives death in his thinking (not to speak of his apparent endorsement of murder) will all be contentious.[12] So even if one finds oneself subject to the pornographic affects Bataille means to elicit, one will be unlikely to understand them as having the revelatory quality Bataille desired. It might be wondered whether these issues preclude our appreciation of *Story of the Eye*.

In particular, an ethicist will hold that appreciation of this work must suffer on this basis. So, Kendall Walton once claimed of *Triumph of the Will* that its aesthetic value was either destroyed or rendered completely 'morally inaccessible' by its moral flaws (Walton and Tanner 1994: 30). Some will hold the same opinion of Bataille's work. Other ethicists will hold a more tempered view. Berys Gaut writes that 'a comedy presents certain events as funny (prescribes a humorous response to them), but, if this involves being amused at heartless cruelty, then the work is not funny or at least its humour is flawed, and that is an aesthetic defect in it' (Gaut 2007: 233). He would presumably say much the same of the other affects that Bataille aims to elicit: *Story of the Eye*'s ethical flaws would then also be aesthetic flaws.

I do not want to explore in any depth here the question of the moral difficulties in valuing *Story of the Eye*, but let me make two points. First, there are accounts that do not see these difficulties as insurmountable obstacles to appreciation (Kieran 1996; Jacobson 1997). Second, although it might not always be easy to surmount these obstacles, it is clearly possible. Daniel Jacobson responds to Walton's claim about Reifenstahl's film by pointing out that 'some . . . who are neither formalists nor fascists, will find this report to be at odds with their experience of that film' (Jacobson 1997: 188). I would add that many literary classics, from Homer onwards, are developed around worldviews and value systems we do not share, and would find objectionable if we were to encounter them in contemporary life outside fiction. In that sense *Story of the Eye* is no different from many works we rank as having high artistic quality. Like other such works, we can find it worthwhile engaging with its fictions both at the level of narrative and affect, and at the level of the worldview and value system that organize the

[12] Bataille's thinking in life followed his thinking in art so closely that in the 1930s he came to found a secret society that, it would appear, seriously contemplated human sacrifice: 'A consenting victim was sought; apparently one was found. A sacrificer was sought, but apparently in vain' (Surya 2002: 250).

narrative. Bear in mind too that another potential obstacle to appreciation, disgust, is a crucial part of a 'correct' response to Bataille's novella. Disgust, despite involving a sometimes deeply unpleasant feeling, should not preclude appreciation of other elements. Rather, it should be the occasion for the kinds of reflections on self that I have described, if not the full-blown revelation Bataille hoped to provoke.

I finish this analysis of *Story of the Eye* by returning to awe. It will be apparent that what I have said in section 1.3 about Bataille's presentation of transgressive sexuality as an object of awe complements my account here, in that transgressive sexuality is an aspect of Bataille's sense of being, and so it is appropriately held in awe on Bataille's worldview. But it can also be observed that awe is not so obviously a Bataillean affect as are disgust and humour. First, Bataille does not discuss awe in his theoretical writings. Second, awe is more often associated with conventional religious values, respect for authority, and so on; all of which Bataille rejects. I do not think these objections are deeply concerning: Bataille's lack of discussion of awe does not on its own rule out my proposal, and the awe I have described is hardly of a conventional kind. Still I am happy to allow that awe exists on the periphery of Bataille's aesthetic—it is not as crucial to him as disgust and humour.

4. Conclusion: The Aesthetics of Pornography

The constellation of affects I have examined—arousal associated with sexual transgression, disgust, humour, and awe—articulates a distinctive pornographic aesthetic: a cluster of feelings that are ever-present possibilities for a writer describing transgressive sexual acts. One might think that transgressive pornography is a small subgenre of pornography generally. But while the severe transgressions seen in the examples I have discussed may suggest this, we can now identify evidence that points to transgression being much more widespread in pornography. Most, perhaps all, pornography, literary and visual, when it fails to arouse can seem disgusting or laughable. This suggests that norm-breaking, if only of a relatively minor sort, is widespread in pornography, and perhaps a generic feature of it. The simple fact that pornography involves the presentation of something usually expected to

be private—sexual activity—in the public sphere is perhaps enough to render every example of pornography in Western culture an act of transgression, albeit usually minor.[13]

That said, the use of the pornographic aesthetic to artistic ends is a rarity. Of course, making space for other kinds of feeling and content apart from sexual arousal counters to some degree the primary purpose of pornography, so it is unsurprising it does not compete with what we may call commercial pornography. From an artistic viewpoint it is bound by certain constraints too. First, the pornographic aesthetic seems best to suit the temporal media of literature and film. Photography, painting, and sculpture provide ample scope for the representation of sexual transgression, but they do not so readily support or control the experience of alternating between the pornographic affects. A second limitation lies in pornography's curtailed emotional repertoire compared to literature or film taken generally. My discussion of Story of the Eye shows that, in the right hands, the pornographic aesthetic can still be artistically rich, but this does not change the fact that the writer is using a limited range of affects. The examples I have used, Sade, Queneau, and Bataille, point to a final constraint, this time thematic: all their works have, to put it in the most general terms, sexual transgression and its significance as central themes. This will not be surprising. The pornographic affects are all responses to such transgressions, and involve an awareness of these transgressions—so it is to be expected that they form a basis for meditations on sexual transgression.

To point out the constraints of a genre is not to point out its failures. All genres have characteristics and limitations of their own. One of the purposes of genre is that it allows the artistic development of approaches and themes that would otherwise not be fully treated in literature and art—and its constraints are properly understood as part of this focus. This seems to me especially the case here. The transgressive affects and themes of this genre would irretrievably mar most literary fiction, but are worthy of exploration in themselves in a genre specifically devoted to them.[14]

[13] Whether such transgression satisfies my requirement that transgression contribute to sexual arousal will be unclear.

[14] I am grateful to Hans Maes and Jerrold Levinson for very helpful comments on drafts of this chapter.

References

Bataille, Georges (1982) *Story of the Eye*, trans. Joachim Neugroschal. Harmondsworth: Penguin.

——(1985) *Visions of Excess: Selected Writings 1927–1939*, ed. and trans. Allan Stoekl. Minneapolis: University of Minnesota Press.

——(1986) *Erotism: Death and Sensuality*. San Francisco: City Lights Books.

Best, Victoria, and Crowley, Martin (2007) *The New Pornographies: Explicit Sex in Recent French Fiction and Film*. Manchester and New York: Manchester University Press.

Carroll, Noël (2001) 'Horror and Humor'. In Noël Carroll, *Beyond Aesthetics*. Cambridge: Cambridge University Press.

Chapman, H. A., Kim, D. A., Susskind, J. M., and Anderson, A. K. (2009) 'In Bad Taste: Evidence for the Oral Origins of Disgust'. *Science* 323(5918): 1222–6.

Douglas, Mary (1966) *Purity and Danger*. London: Routledge & Kegan Paul.

Eaton, Anne W. (2007) 'A Sensible Antiporn Feminism'. *Ethics* 117: 674–715.

Freud, Sigmund (1960) *Jokes and their Relation to the Unconscious*, trans. James Strachey. London: Routledge & Kegan Paul.

Gaut, Berys (2007) *Art, Emotion and Ethics*. Oxford: Oxford University Press.

Hegarty, Paul (2000) *Bataille: Core Cultural Theorist*. London: Sage.

Jacobson, Daniel (1997) 'In Praise of Immoral Art'. *Philosophical Topics* 25(1): 155–99.

Kant, Immanuel (1956) *Critique of Practical Reason*, trans. Lewis White Beck. New York: Liberal Arts Press.

——(1987) *The Critique of Judgment*, trans. Werner S. Pluhar. Indianapolis: Hackett.

Keltner, Dacher, and Haidt, Jonathan (2003) 'Approaching Awe, a Moral, Spiritual and Aesthetic Emotion'. *Cognition and Emotion* 17(2): 297–314.

Kieran, Matthew (1996) 'Art, Imagination and the Cultivation of Morals'. *The Journal of Aesthetics and Art Criticism* 54(4): 337–51.

——(2001) 'Pornographic Art'. *Philosophy and Literature* 25(1): 31–45.

Kipnis, Laura (1999) *Bound and Gagged: Pornography and the Politics of Fantasy in America*. Durham, NC: Duke University Press.

Levinson, Jerrold (1998) 'What is Erotic Art?' In E. Craig (ed.), *The Routledge Encyclopedia of Philosophy*. London: Routledge.

——(2005) 'Erotic Art and Pornographic Pictures'. *Philosophy and Literature* 29(1): 228–40.

Maes, Hans (2011) 'Art or Porn: Clear Division or False Dilemma?' *Philosophy and Literature* 35(1): 51–64.

Priest, Graham (1997) 'Sexual Perversion'. *Australasian Journal of Philosophy* 75(3): 360–72.

Queneau, Raymond (1981) *We Always Treat Women Too Well*, trans. Barbara Wright. New York: New Directions.

Rozin, P., Haidt, J., and MacCauley, C. R. (2000) 'Disgust'. In M. Lewis, J. M. Haviland-Jones, and L. F. Barrett (eds.), *Handbook of Emotions*, 2nd edn. New York: Guilford Press.

Sade, Marquis de (2005) *The Complete Marquis de Sade*, 2 vols., trans. Paul J. Gillette. Los Angeles: Holloway House.

Schopenhauer, Arthur (1966) *The World as Will and Representation*, 2 vols., trans. E. F. J. Payne. Mineola, NY: Dover Publications.

Sontag, Susan (1994) 'The Pornographic Imagination'. In Susan Sontag, *Styles of Radical Will*. London: Vintage. First published 1967.

Surya, Michel (2002) *Georges Bataille: An Intellectual Biography*, trans. K. Fijalkowski and M. Richardson. London: Verso.

Walton, Kendall L., and Tanner, Michael (1994) 'Morals in Fiction and Fictional Morality'. *Proceedings of the Aristotelian Society, Supplementary Volumes* 68: 27–66.

IV

Pornography, Ethics,
and Feminism

11

On the Ethical Distinction between Art and Pornography

BRANDON COOKE

Ordinary usage seems to suggest that the term 'pornographic' is pejorative, while the term 'erotic' is neutral or approving. Justifying this distinction, and determining which items belong in the extension of each term, is at the center of many debates about art and pornography. Simply appealing to differences in content is unlikely to be helpful, since much art and all (or nearly all?) pornography has sexual content, and the explicitness of that content in artworks is sometimes comparable to that found in the most explicit pornography.

If we deny that pornography earns ethical disapproval merely on grounds of its sexual content, we might consider that pornography earns its ethical condemnation either because it, unlike erotic art, has blameworthy effects, or because it is in some way intrinsically immoral.

There are, I claim, no persuasive grounds on which the ethical distinction between art and pornography as generic kinds can be maintained. From the fact that something is a pornographic work, it does not follow directly that the work is ethically flawed. Neither does it follow directly from the fact that something is a work of art that the work is immune to ethical criticism. Any moral condemnation or exculpation of a work of pornography or erotic art will have to appeal to the particular features of that work in its proper context of appreciation.

I shall offer two modes of argument in support of this No Ethical Difference claim. First, and negatively, I will undermine some of the more prominent arguments that claim that pornography (but not, usually, erotic

art) is as a category morally flawed. Secondly, I will offer positive arguments in support of the idea that features of erotic (and non-erotic) art which are morally exculpatory are also features of much pornography. This offers some explanation for the fact that anti-pornography arguments often decline to put erotic art in their sights. I aim to show that a fatal flaw in many of those arguments is that they overlook certain features of much pornography that are relevant to its proper interpretation, and so to its ethical status.

1. Identifying Pornography

The project of providing a definition of 'art' in terms of necessary and sufficient conditions has yet to be completed to everyone's satisfaction, and the attempt to draw a well-defined descriptive boundary between art and pornography would seem to be hostage to the fortunes of that project. It will be enough for my arguments here just to have some uncontroversial instances of pornography and non-pornographic art, even if there are instances of pornographic art; the claim that there is an ethical difference between pornography and art would be unsustainable if there is in fact no way to identify uncontroversial instances of each. I will assume that a sufficient condition for an item's being pornography is that it is a token of some communicative material created with the sincere and successfully realized intention that it be usable for sexual arousal, but not the intention to foster intimacy between author and audience.[1] The latter qualification is needed to distinguish pornography from sexually explicit letters and pictures exchanged between intimates but not intended for wider public use; if this qualification seems arguable, the rest of the condition seems to pick out uncontroversial instances of pornography, which is enough for my arguments here.

Note that this allows for the possibility of art, even 'serious' art, which is also pornography. Arguments against the possibility of pornographic art have not been successful, and at any rate, those claims look difficult to maintain in the face of 'serious' artists who have expressed sincere intentions to create

[1] This sufficient condition is adapted from the definition of pornography defended by Rea (2001). Rea's definition is admirable in its attempt to be genuinely descriptive, but Maes (this volume, Ch. 1) correctly identifies a subtle evaluative aspect of the definition. My appeal to a sufficient condition alone is meant to allow for the identification of some instances of pornography.

pornographic art. Robert Mapplethorpe wanted some of his photographs to be 'smut that is also art' (Danto 1992: 326). Oshima Nagisa's film *Ai no korida* (*In the Realm of the Senses*, 1976) was, in the words of Linda Williams, 'a radical extension of the possibilities of pornography and thus . . . a testing ground for challenging the very notion of obscenity' (2008: 183). And Georges Bataille's novel *L'Histoire d'oeil* (1928) fully exemplifies Kipnis's characterization: 'pornography obeys certain rules, and its primary rule is transgression. Like your boorish cousin, its greatest pleasure is to locate each and every one of society's taboos, prohibitions, and properties and system-atically transgress them, one by one' (1996: 164).

The very idea of pornographic art will strike some as questionable, even incoherent. For the purposes of my argument, this possibility is irrelevant, since nothing that follows depends on any pornography also being art. Rather, what will be important is that much pornography shares certain features with certain artistic kinds (as well as, in some cases, with non-art items such as games of make-believe). In the absence of an argument for or against the possibility of pornographic art, the more neutral assumption is that it is a possibility, so long as the existence of such instances is neither a premise in any of my central arguments, nor obviously incoherent.

Contemporary art criticism has often cast art with sexual content as being in the business of 'critique', or 'interrogation', or 'questioning'. Certainly a lot of contemporary art has done just that. But as sexuality is such a large part of the human experience, it would be surprising, and disappointing, if artists' concerns were deliberately narrowed in this way, to the exclusion of other artistic and expressive aims. Again, there are well-documented examples of artists setting out to make works that celebrated a wide range of sexual activities and interests. Only the advocate of what Levinson calls 'ludic' interpretation (1996: 176–7), which wholly divorces interpretation from any consideration of authorial intention and tolerates a great degree of disregard for ordinary linguistic conventions (especially when punning is involved), can fully ignore such intentions. Both anti-intentionalists and hypothetical intentionalists typically admit the relevance of an artist's so-called 'categorial' intentions, and the intention to create something that is both porn and literature seems to count as a categorial intention *par excellence*.[2]

[2] Livingston (2005) presents what I consider decisive objections against both the idea that categorial and semantic intentions can be distinguished in any neat way, and the idea that admitting an author's

At any rate, nothing in what follows relies on the possibility of pornographic art for the ethical redemption of pornography as a media genre. That redemption lies instead in proper consideration of some features that much pornography shares with much art. If those features are common to many instances of both kinds, and those features neutralize the ethical condemnation of artworks, then they similarly weaken anti-pornography arguments. Defenders of the ethical distinction will either have to find some other ethically relevant difference, or accept that ethical criticism of pornography must proceed on a case-by-case basis, just as it must with works of art.

2. Pornographic Fiction

Anti-pornography arguments typically fail to square with the fact that much pornography is fiction, but its status as fiction bears on its proper ethical evaluation. Some examples of pornographic fiction are narrative porn films, photographic features that, with or without the aid of text, tell a story, and erotic stories that exclusively use language. Not all pornography is fiction, of course. Graphic sexual images intended primarily to arouse, and with no narrative content, may be pornographic but not fictional. And not all fiction is literature, or even art descriptively understood—think of many philosophical thought experiments.

A standard characterization of fiction holds that it is, or involves, the use of language, images, or some other representational medium to invite the audience to imagine that certain things are the case. It is enmeshed in a practice that, paradigmatically (though not always), includes the conventional assumption that what is being uttered is not an assertion. Livingston (2005) provides a useful 'sketch' of an analysis: 'S's utterance of U is a fictional utterance just in case (1) what U expresses is primarily a sequence of imaginings, and (2) S makes U with the primary intention of inviting the members of some audience, A, to engage in the sequence of imaginings' (184).[3] So when a storyteller utters, 'Once upon a time, there lived a very naughty boy who never listened to his mum,' it is part of the practice of

categorial but not semantic intentions is genuinely warranted. See especially pp. 158–64. That said, if categorial intentions are admissible and not demonstrably incoherent, then my arguments here go through on any sane theory of artistic interpretation.

[3] Currie (1985) proposes an analysis of fictional utterance along these lines. See especially p. 387.

fiction that the storyteller is understood not to be making assertions about some actually existing naughty boy. Call this utterance about what is true in the fiction the *fictive report*. Understanding the story will require the audience to make further inferences about what is true in the fiction—that the boy appears a certain way, that he is human, and so on. While the fictive report is not being asserted by the storyteller, it is often the case that the storyteller has other illocutionary intentions, some of which may indeed involve expressing or implying her actual beliefs about the (actual) world. For instance, our storyteller might be expressing the belief that disobeying your mother is a bad thing.

Consider, now, some typical examples of erotic or pornographic fiction.

Example A (a pictorial pornographic narrative without text). A series of photographs without text shows a pizza delivery man knocking at the door of a sorority house. A young woman answers the door, invites the delivery man in, and offers him a beer. The woman and her friends reveal that they have no money to pay, so three of them have sex with the delivery man.

Example B (a pictorial pornographic narrative with text) A series of photographs with text show, at first, a waitress being pinched by a man, in view of his pool buddies. The captions read

Though she pretends to ignore them, these men know when they see an easy lay. She is thrown on the felt table, and one manly hand after another probes her private areas. Completely vulnerable, she feels one after another enter her fiercely. As the three violators explode in a shower of climaxes, she comes to a shuddering orgasm. ('Dirty Pool', from *Hustler Magazine*, from Langton and West 2009: 184)

Example C (a work of erotic art). Ellen von Unwerth's book *Revenge* (2003) uses text and photographs to tell the story about a number of beautiful young women who go to live in the country manor of the Baroness, a relation by marriage. The early days of the women's sexual play come to an end when they are imprisoned and sexually degraded and humiliated by the Baroness and her servants. Eventually, the women escape the manor, only to return and take revenge on their tormentors.

What is directly presented in these examples is the fictive report. The audience is invited to imagine that certain things are the case. Do these examples also make higher order genuine assertions, or otherwise express or imply beliefs about the actual world? It is unclear. Langton and West claim

that in example B, at least, a shared non-fictional presupposition is required for making sense of the story. Following MacKinnon, they argue that what fictional stories like 'Dirty Pool' implicitly assert is that 'gang rape is enjoyable for men', 'gang rape is enjoyable for women', and 'sexual violence is legitimate'. Establishing that this, or anything, is genuinely asserted by fictions such as 'Dirty Pool' requires both philosophical argument and careful critical interpretation of the work. From the fact that something is reported or implied by the fiction, either at the level of the story or at a higher thematic level, it does not follow that the fiction's authors are genuinely asserting any of those things. As Lamarque reminds us, 'The cautious first step . . . is to assume a distance between author and [work] statement, for example by attributing the content to an implied speaker, or noticing an ironic tone, or identifying the sentence as *thematic*, pointing to motifs in the work to come' (2009: 182).

More carefully, higher order fictional statements or presumptions of erotic fiction can be understood as holding that it is fictionally true that something is the case. For example, Kipnis argues that much heterosexual pornographic fiction involves 'a fantasy of a one-gender world, a world in which male and female sexuality are completely commensurable, as opposed to whatever sexual incompatibilities actually exist.' 'Pornography's premise is this: What would a world in which men and women were sexually alike look like?' (1996: 200). Similarly, Kammer holds that 'An archetype of male [heterosexual] erotica is the woman who participates enthusiastically in sex, who loves male sexuality, who needs not be cajoled, seduced, or promised ulterior awards' (Strossen 1995: 162). Example A involves just such fictional truths, and its use of them is a large part of A's being a porn cliché. But again, argument and critical interpretation is needed before it can be established that any relationship obtains between fictional truths and genuine assertions.

The distinction between depiction and document, between fictional utterance and genuine assertion, and even between (pretend) acting and (actually) doing is sometimes completely ignored in the anti-pornography literature. In her *Only Words*, MacKinnon asserts that 'in terms of what the men are doing sexually, an audience watching a gang rape in a movie is no different from an audience watching a gang rape that is reenacting a gang rape from a movie, or an audience watching any gang rape' (1993: 28). As Bernard Williams puts it, 'that weasel qualification, "in terms of what the

men are doing sexually", has to do a lot of work to stop that from being, to put it plainly, a lie' (1994: 10).

Langton and West (2009) take more care to respect the difference between fictional utterance and genuine assertion. They construe the issue as one concerning how one can learn from fiction, more or less setting aside the crucial point that fictional utterances are not offered as beliefs to be taken up, but rather as material for non-alethic imagining. It is true that one can learn from fiction, but how this happens, and how this feature of the use of fiction bears on its ethical status, requires more careful attention than Langton and West give it. Langton and West's 'Fictional Saying Argument' (FSA) examines three distinct cases. Premises (1) and (2) are common to all three cases. Premises (3) through (6) complete the argument for fiction that 'purports to be fact'. Premises (7) through (12) complete the argument for fiction using background assumptions purported to be true both in the fiction and in the real world. Premises (13) through (16) completes the argument for instances of fiction where certain authorial intentions are obscure.

The Fictional Saying Argument:

1. One can acquire knowledge, both moral and factual, from fiction.
2. If it is possible to acquire true beliefs from fiction, then acquiring false beliefs is also possible.
3. The simplest case to consider is one in which the fiction purports to be fact: all of the implicit and explicit propositions purport to be true, and are taken to be true of the actual world (e.g. Orson Welles's broadcast of *The War of the Worlds*).
4. Autobiographical descriptions of sexual fantasies purport not to be fiction.
5. In such cases, the authors can be called liars.
6. In such cases, it is easy to see how people could acquire beliefs about the real world from porn fiction. These beliefs are false, since the purported fact is merely fantasy.
7. However, much pornography both is and purports to be fiction.
8. Most fictional stories play out against a background of purported fact.
9. These background propositions are purported to be true both in the fiction, and in the real world.

10. If the authors are background liars (ill-informed, indifferent, or outright deceivers), then some background propositions may be false.

11. If readers expect authorial reliability from such authors, they may acquire false beliefs.

12. So, if authors of pornography are background liars and are treated as reliable by their audience, that audience may acquire false beliefs (e.g. 'women enjoy rape').

13. Instead of being background liars, authors of pornography may be 'background blurrers': background propositions are presented as fiction, but the authorial moves which enable readers to distinguish fact from fiction are blurred.

14. The distinguishing authorial moves depend in part on what readers already know or believe.

15. A reader ignorant of women may be unable to distinguish fact from fiction among background propositions.

16. As a result, such a reader may acquire false beliefs about women (e.g. that they enjoy rape).

The first target of the FSA is fiction that purports to be fact. 'Purport' courts ambiguity, but let us assume that what is meant is 'appear to be or do, especially falsely'. Then the first sub-argument (ending with 6) needs to distinguish between two cases: descriptions of fantasies, and the particular sort of 'fiction' described by Langton and West. Descriptions of fantasies, when offered as such (e.g. 'I fantasize about . . .'), are not fiction at all, but factual reports of certain of a person's mental states. If one presents one's fantasies in writing, they are not lies, and neither are they fiction.

The second case to be distinguished is the Orson Welles type. Care is needed here. If we take seriously the idea of a 'fiction' that purports to be entirely factual, and is so taken, then depending on the particular features of the case, it is likely that we don't have an instance of a fictional work at all. This is because the illocutionary condition (that the utterance is made with the primary intention of inviting the audience to imagine what is expressed) is not met. Here it is worth mentioning that the Orson Welles case would be a borderline one, except for the fact that the *War of the Worlds* broadcast was occasionally interrupted with a reminder that what was being broadcast was a dramatization. That reminder is evidence that the illocutionary condition was satisfied, even if many of the broadcast's audience did not get the

message. At any rate, since these cases will not meet the necessary conditions of fictionality, the first sub-argument may be set aside.

The second sub-argument is also flawed. The target here is fiction authored by 'background liars', but that title depends on the use of a false theory of fictional truth.[4] Following Lewis (1978), Langton and West claim that implicit fictional truths are purported to be true both in the fiction and in the real world. That is sometimes true, but it is also true that many implicit fictional truths are false, and believed to be so by authors and readers. Fantasy and science fiction routinely imply that ghosts, dragons, and wizards with magical powers exist, and that faster than light travel is possible. Premise (9), then, is sometimes true, though it is unacceptable as a categorical feature of fictional truth. It is an implicit fictional truth that the individuals in Examples A, B, and C are all human beings, with the same physiological features as people in the actual world. But the 'background liar' mantle can easily be shrugged off by an author who does not intend that the audience believe that, say, 'women enjoy rape' is an actual world truth.

Finally, the third sub-argument focuses on 'background blurrers'. Authors may inadequately demarcate the boundary between purely fictional truths and truths common to the fiction and the actual world. Ignorant audience members might lack the knowledge needed to determine whether a fictional truth is restricted to the fiction, or also actually true. Langton and West say little about what would count as authorial background blurring, nor do they provide any examples. They say that 'one can expect it to be more likely in circumstances where authors are indifferent to a clear boundary between fiction and background, and where readers are likewise indifferent. . . . [They also] rely in part on what readers already know or believe' (2009: 192). This argument is far too weak to do the desired work. It is certainly true that readers may acquire false beliefs from fiction. Reading George MacDonald Fraser's *Flashman* novels, I may acquire false beliefs about the Crimean War. But this hardly makes Fraser, or his books, morally culpable. Minimally, this would require either a deliberate intention on the part of Fraser to mislead his readers, or a blameworthy negligence to signal that his work is fiction.

[4] For decisive criticisms of Lewis, and for the correct theory of fictional truth, see Livingston (1996) and (2005).

This latter condition *might* be met by Orson Welles's performance of *War of the Worlds*. Pornographic or erotic examples of comparable borderline cases include, perhaps, John Cleland's eighteenth-century novel *Memoirs of a Woman of Pleasure* (commonly known as *Fanny Hill*),[5] or the 1970s German sexploitation 'Schoolgirl Report' films; if these examples don't quite fit the bill, we can at least imagine similar works where the intentions to present something as fiction are significantly obscured. The difficulty identifying or constructing such examples partly lies in the fact that some of the ways audience members distinguish factual from fictional material are bound up with the very actions by which those audience members come into contact with the material in the first place: going to the fiction section of a library or bookstore, going to a cinema, or to an art gallery instead of a medical school lecture theater. In other words, while the content itself may seem indeterminately fact or fiction, and be presented in a way that it is difficult to tell which it is, the way one finds and accesses that content often provides important cues that help settle the question.

But in the usual case, the author's intention to present a fiction is well articulated by the way the work is presented: in a book labeled as fiction and lacking scholarly footnotes, in a film prefaced by a disclaimer that what follows is a work of fiction, and followed by credits matching performers to roles. *Fanny Hill* seems all too literary in its description of sexual acts and organs. And viewing 'Schoolgirl Report' as a serious documentary uncovering 'What parents find unthinkable' is undone by the amusingly awful acting as well as doubts about how any such documentary footage might have been obtained.

Langton and West are right that ignorant audience members might acquire false beliefs through fiction. But unless there is some blameworthy authorial negligence or intent to mislead, acquiring false beliefs can hardly be held against the work or its author. When I am receiving a fictional work, any epistemic responsibility to sort fact from fiction is mine, and it would be absurd for me to pass the buck to *Flashman* or Fraser if I failed an exam on nineteenth-century military history due to my reliance on a fictional work. Similarly, if one comes to believe that women enjoy rape from pornographic

[5] I thank Hans Maes for reminding me of this example. It is not clear, however, to what extent this work was sincerely received as a non-fictional memoir. On this point, see Wagner's introduction to the novel, Cleland (2001).

fiction, the epistemic (and perhaps moral) failure accrues to the reader. This is not to deny that a particular work's author might have the intention to foster certain beliefs about the world, and this is sometimes the proper locus of ethical condemnation. But Lamarque's suggestion that a fiction's audience exercise caution when determining whether a fictional proposition is also offered as one about the world can be cast plausibly as a norm of proper fictional reception: Assume that truths in the fiction are offered *only* as such, unless there is adequate evidence to the contrary. In light of this norm, the idea that fictional porn audiences expect real-world authorial reliability is just silly. Here it is worth noting an important difference between fiction and propaganda. Both can lead audiences to adopt false beliefs, and indeed, both can lead to the adoption of false and morally pernicious beliefs. But propaganda differs from fiction in that certain of its explicit or implied propositions are intended to be taken up as fact; that is not the usual case with fiction. If the norm of proper fictional reception is plausible, then so is this corollary of the norm: don't accept as a belief some proposition expressed or implied by a fictional work, unless the real world provides sufficient evidence for that belief. Think of this as a norm of reader responsibility. This norm receives its mandate from the authorial intention that imagining, and not believing, is the central propositional attitude that is to be taken toward a work of fiction.

The modal weakness of most of the FSA's claims cannot be stressed enough. The ubiquitous 'may' yields an argument that is far too weak to support key claims they make: that 'pornographers...are liars, or background liars, or background blurrers. Presuppositions are introduced by pornography, authors innocently or otherwise fail adequately to indicate the line between fiction and background, readers innocently or otherwise take fiction for background, and accordingly come to believe certain rape myths' (194). Langton and West fail to take seriously what it is to create and to receive pornographic fiction as fiction.

What about 'Dirty Pool'? It seems plausible, though not certain, that an implied fictional truth of the story is that gang rape is enjoyable for men and women, or at least these particular people. (Of crucial importance here is whether the events of 'Dirty Pool' truly constitute rape.) With the failure of the FSA, what Langton and West really need to show is that it is wrong to invite someone to imagine that gang rape is pleasurable, or that it is wrong to imagine this. If such an argument could be delivered, it would do much

more than show the moral failures of pornographers and their audiences. It would most likely also show that the authors and audiences of much non-pornographic fiction were similarly culpable. After all, a lot of fiction invites its audience to take pleasure in the representation of unethical[6] acts, and to imagine that certain unethical acts or corrupt lifestyles are pleasant, amusing, or otherwise recommended. Many people enjoy daydreaming about, say, wreaking havoc in the offices of their professional rivals and causing them grievous harm—all without having the least intention to act in such ways, and without any thought that it would be alright to do more than imagine such things.

Langton and West, and other anti-pornography writers, deliberately blur an important distinction that operates for pornography's audiences, and indeed, operates for many people generally. It is common for both men and women to fantasize about, to take pleasure in imagining, doing things that they would never want to do. It is well documented that rape fantasies, fantasies about group sex, fantasies about sex with proscribed individuals, and so on, are extremely common in men and women. But it certainly does not follow that the people who take pleasure in imagining such things want to do them, or think that it would be acceptable to do so. Just as with much fiction, what is depicted in a pornographic image is not necessarily asserted, endorsed, or recommended as an action to be performed in real life. This reflects the fact that many people fantasize about performing or being involved in acts which they do not want to perform or be involved in in real life. Indeed, when it comes to the pornographic representation of such things, understanding that the representation is a fiction is a necessary part of the enjoyment of that representation—as is the case with fictional (as contrasted with documentary) representations of tragedy, of crime, and so on.

That distinction is more easily recognized or reflected in much erotic art, since when we take something to be a work of art, we accept that there are certain conventions of appreciation that govern, among other things, what the content of the work is, what is being asserted (if anything), and what the scope of that assertion is. But even if pornography makes less obvious use of artistic framing conventions, it does not follow that a pornographic image

[6] 'Unethical' here, and throughout, comprehends but is not exhausted by the immoral, following Bernard Williams's distinction between the ethical and the moral. See especially his (1985). I do not use 'unethical' to mean something like 'mildly wrong'.

straightforwardly recommends some particular real-world behavior. It is still frequently the case that a pornographic work presents something for enjoyment as fantasy, even if the scene is acted out by real people performing real sex acts in front of a camera. Think about the distinction between watching an abduction in a play, and seeing one in real life.

Pornographic fiction, like all fiction, is a spur to imaginative activity, and not primarily a vehicle for the conveyance of beliefs about the world. And again, although Langton and West are correct that false beliefs can be acquired via pornographic fiction, as from all fiction, more is needed to establish the moral culpability of pornography or its authors. The FSA fails to show that pornography categorically, or even typically, satisfies that requirement.

3. Exploitation

The ethical distinction between art and pornography might instead be drawn on the grounds that pornography is wrongfully *exploitative*, while art, perhaps including erotic art, is not. Certainly, the distinction is sometimes made in just this way. This proposal is complicated by the fact that artworks are sometimes judged to be exploitative or even pornographic, and both of those labels have been applied to works without sexual content. What is needed is first a better understanding of what it is for a representation to be exploitative, and second, an investigation into whether the distinctions between art and pornography helps license the ethical evaluative distinction between the two categories.

Much work has been done on whether or not pornography (sometimes in contrast to art, sometimes not), subordinates, oppresses, or wrongfully objectifies certain individuals or groups. I will not consider those arguments here. However, it bears mentioning that while subordination, oppression, and wrongful objectification are all plausibly thought of as intrinsically wrong, they are also all common precursors to wrongful exploitation. Consider, for instance, that slavery was typically enabled by denying the humanity, or equal moral standing, or capacity for genuinely autonomous living, of those enslaved. Once those moves are made, exploitation is easy, and easily rationalized. So while evaluating claims of subordination, oppression, and objectification is an important task for philosophers, the

(surprisingly) less examined but closely related issue of exploitation merits careful investigation.

Critics of pornography claim that at least most heterosexual pornography is exploitative. The charge is also leveled against some artworks. Allen Jones's artwork *Chair* (1969) is a nearly life-size sculpture of a woman lying on her back, with her legs pressed to her chest and her feet in the air. She wears only leather gloves, shorts, and boots. A leather seat cushion is strapped to the back of her thighs. *Chair* and its companion pieces *Table* and *Hat Stand* are sculptures taking furniture as their subject. Their sexually provocative appearance was intended, like much Pop Art, to confront the artistic canon. The pieces caused immediate and lasting outrage. *Chair* was attacked with acid. All three of the works have been called exploitative. Examples of non-erotic works of art that have been called exploitative include Diane Arbus's photographs of adults with Down syndrome, and Sally Mann's photographs of her (often naked) children in *Immediate Family*.

It isn't hard to find other such examples. Representations of bodies, sexuality, poverty, misfortune, suffering, and violence are often called exploitative. But what does it mean to call an artwork exploitative? A person might be exploited in the production of an artwork. But it is not clear that this would make the work itself exploitative. Also, some allegedly exploitative artworks involve no one but the artist in their production. *Chair*, for one, was not produced with the aid of a human model. That fact would surely not pacify its critics.

To start, a distinction is needed between the neutral and pejorative sense of 'exploitation'. The neutral sense is simply 'to make use of', and in this sense every artwork involves exploitation, as the artist makes use of a scene before her, of pigment and canvas, or of the tone qualities of a quintet of instruments. Our interest is in the pejorative sense, but the laziest way to make the charge is to equivocate between the two. Herein I will use 'exploitation' to mean 'wrongful exploitation'.

Although alternative definitions of wrongful exploitation have been offered, Feinberg (1990) and Wertheimer (1996) give the most useful and intuitively appealing non-Marxist definition,[7] which captures the ideas that

[7] Marxist definitions are best avoided here, because appealing to them commits one to a large set of controversial claims, and because they tend to imply that exploitation is nearly everywhere, which would make pornographic exploitation just another bit of a monotonous landscape.

exploitation involves unfairness, and often a taking advantage of another's vulnerability for some benefit. I follow them in characterizing exploitation in this way: to exploit a group or individual is to benefit unfairly by taking advantage of certain of that group's or individual's characteristics or circumstances.

Exploitation needs to be distinguished from other blameworthy ways in which persons can be treated. Exploitation is sometimes confused with coercion, but there can be coercion without exploitation, as when I refuse to talk to my friend until he tries to quit smoking. There can also be exploitation without coercion. If *Chair* is exploitative, its making and exhibition involved no coercion, and most critics consider it to be a poor defense of pornography that the models and performers voluntarily do their job. It seems conceivable that exploitation can occur without the intention to exploit, for instance, through negligence. Finally, exploitation can occur even when the exploitative transaction is mutually consented to and of mutual benefit to both parties. Consider Adam, who finds Bill and Bonnie stuck in a ditch off the side of an icy country road. Bonnie is in labor and needs to get to the hospital 20 miles away. Adam offers to help them for $200. If Bill and Bonnie accept, however reluctantly, here is an example of just such an exploitative transaction.

Here, candidates for the exploiter A include the author, the work, and a work's publisher or exhibitor. Candidates for the exploited B include the model, the artistic subject, a group of which the model or subject is a member, and the work's audience. All genuinely exploitative art must involve A's turning some characteristic or circumstance of B to some advantage for A or for another. B may or may not have consented, and B may or may not lose from the exploitation.

Critical usage comprises at least three kinds of exploitation claim, distinguished by the objects of exploitation. The first kind applies to cases where some actual person or group of persons is exploited in the making of the artwork. Mann's *Immediate Family* is claimed to be exploitative in this sense, and MacKinnon claims that at least all heterosexual pornography is as well. The work becomes the vehicle for transforming the subject's vulnerability into unfair profit for the artist and for the work's exhibitors, distributors, and owners.

The second kind applies to works that exploit their audiences. This might take the form of pandering, satisfying the audience's morally defective

preferences or sensibilities. This is another sense in which pornography is said to be exploitative.

Finally, a work might be called exploitative because it recommends, endorses, enables, or causes the exploitation of some third party by the work's audience. According to MacKinnon, Langton, and others, pornography is exploitative in this sense too, as it allegedly asserts, implies, or presupposes that a state of sexual servitude is both desirable for and desired by women.

These kinds are not mutually exclusive, of course. Some have argued in effect that Reagan Louie's (non-erotic) photographic series *Sex Work in Asia* is exploitative in all three of these senses. MacKinnon and others claim that heterosexual pornography is also multiply exploitative.

Although the surface of our language indicates that we take works themselves to exploit, this cannot literally be so. Works of art are not agents, and so cannot unfairly take advantage of anything. It is not literally the work that exploits, but (usually) the artist, or the exhibitor, or the owner. The work is an instrument, or mode, or manifestation, or endorsement of exploitation performed by some agent. We can admit a derivative sense in which works are properly called exploitative, just so long as we do not lose sight of the fact that what confers this sense is the activity of an agent.

The second and third kinds of exploitation, and not the first, are the ones relevant to the question of an ethical distinction between art and pornography. With the first kind, art making is part of the context of exploitation, though the exploitation is not necessarily evident in the work. We often simply don't know enough about the production of individual artworks to judge whether they involve exploitation in their making. Exploitation in this sense does not entail exploitation in the second or third senses (and the converse is also true). And many works, such as Jones's *Chair*, involve no exploited parties in their making. Most importantly, in the first case there is no special problem making sense of exploitative art (or pornography) as such—the general account of exploitation can be employed directly, while the making of art (or pornography) just happens to be the context in which the exploitation occurs. However, with the second and third kinds, there seems to be a stronger sense in which we may judge the *work* to be exploitative. How is it, then, that an artwork can be exploitative independent of its history of making?

Many so-called exploitative works appear to be instances of mediated exploitation, where A exploits B on behalf of C. Frequently this takes the form of pandering—noncoercively exploiting the moral deficiencies of another by providing him the services he voluntarily seeks, even if it should be contrary to his interests or conscience. Pornography has been said to do this on the grounds that the filmmakers, producers, distributors, and so on gain by satisfying a contemptible or blameworthy interest of the film's audience. Recent anti-pornography arguments have focused less attention on the exploitation of largely male audiences, and more on other exploited parties, though Nussbaum (1995) seems to suggest that this is part of the problem with pornography.

The usual worry here is that women as a group are exploited by heterosexual pornography. The straightforward application of our analysis of exploitation to this claim would mean that producers or exhibitors of pornography gain some unfair benefit by making use of the circumstances or characteristics of women. This in turn could be understood in a number of different ways: that the circumstances or traits of women themselves are turned to unfair advantage, that porn gains by endorsing or recommending exploitation, or that porn causes exploitation. In fact all of these more specific exploitation claims have been made. The first one, at least, can be safely put aside, as it is unclear just what it would mean to do this. As for the remaining interpretations, it will be instructive to return to Allen Jones's erotic artwork *Chair*.

Since no model was involved in its making, *Chair* must be exploitative in virtue of Jones's making some unfair gain from women generally. The work does make use of female bodily traits, but does it do so in a way that is unfair? Does *Chair* endorse the exploitation of women? Does it express the attitude that women should literally or figuratively be treated as mere objects?

To answer yes requires ignoring the art historical and theoretical context in which the work is situated. The work aims to thumb its nose at the notion of fine art by presenting a sculpture that in many ways—as a piece of pointedly useless furniture, as a sexually provocative representation of the human figure—pushes back against comfortable notions of what counts as art. Nearly everything about *Chair* is designed to provoke the response that it is not art, a problematic response given that one encounters the object in a gallery, which we enter with certain expectations and assumptions. Jones's work is thus an exemplary instance of Pop Art. Of course, that theoretical

context could be, and has been, utterly ignored, and then the judgment that it is exploitative might more easily be made. I believe that this explains the outrage against the work. But we do not accept that one is free to disregard the art theoretical context and repurpose the work to suit one's individual judgment. Just as actions and utterances depend on their native contexts for their significance and meaning, so do artworks. Viewed in its proper context, *Chair* is correctly seen as not exploitative.

Still, the fact remains that whatever its theoretical and historical context, *Chair* represents a woman in a position of sexual submission. Is this not sufficient to justify the exploitation claim? We must remember that many characteristics of art and art-related practices stand in the way of facile charges of exploitation, and so if there is not exactly a special license for artworks, these characteristics are relevant to ethical evaluation and may block certain ethical judgments. One is the simple fact that it is at least often permissible for artists via their work to engender imaginings of things that would be impermissible to endorse or act upon in the real world.[8] Penn's *Bonnie and Clyde* encourages us to sympathize with the main characters and withholds any serious moral condemnation of their actions (which in the real world would be almost as wrong as expressing an endorsement). Icelandic sagas express pro-attitudes toward objectively wrongful acts. This is not a privilege exclusive to artworks, obviously. Games of make-believe routinely involve pretending to perform immoral acts, yet such games are not thereby immoral. Further premises are needed to support the conclusion that encouraging such imaginings is wrong. The usual move is to claim that doing so is causally connected with actually performing immoral acts. I examine the causal claim in the next section.

Another complication is the equivocal content of many works of art. Harry Benson's photograph of a cloaked breastfeeding woman at a Ku Klux Klan rally can inspire revulsion or sympathy toward the Klan, depending on the viewer's antecedent beliefs. Reagan Louie's photographic series *Sex Work in Asia* more readily invites the charge that it is exploitative because it depicts exploited sex workers. Still other works invite varying interpretations because the relevant genre conventions are unclear or misunderstood.

[8] This is not just a privilege of artists, as a canvassing of games of make-believe commonly played by children shows.

Chair does not obviously assert, endorse, or recommend anything. It is deeply equivocal, and that is part of its enduring interest as a work of art.

Much pornography is fiction, and so is not necessarily asserting anything. But some pornography cannot be classified as fiction, for example, individual 'centerfold' photographs. Given the equivocal nature of such images, though, we need to know more about the context of their presentation before the exploitation charge can be made to stick. Images presented in the right intentional context can endorse exploitation, among other things. But given the usual context of presentation of pornographic images, it is at least as plausible to range them under the intention to present certain persons and situations as sexual possibilities to entertain in the imagination. If this is right, then pornographic works are no more exploitative in virtue of their being pornography than is Fragonard's *The Swing* (1766) or Bouguereau's *Nymphs and a Satyr* (1873). This is not to deny that some items of pornography might be exploitative, just as some artworks are, and it is surely true that some pornographic images, as well as some non-erotic paintings, films, short stories, some athletic scholarships, and some jobs, to name a few items, are exploitative in the first sense named above. But our focus has been on the second and third senses in which we might call a work exploitative, because these senses really involve features or effects of the works themselves, independently of how the works actually came into being. And in these cases, it is clear that careful attention to the particular details of individual cases is required if 'exploitative' is to be more than an easily tossed brickbat, to borrow Hacking's phrase (1996).

Up to now I have deferred discussion of the possibility that pornography, or indeed an artwork, might be exploitative in virtue of its effects. Allen Buchanan argues that pornographic 'centerfolds contribute to an environment in which more direct and familiar types of exploitation of women by men is encouraged, and it does this by spreading the image of women as sexual playthings. The pictures then have a direct causal influence on the way the woman's role is conceptualized in society and that in turn makes certain kinds of exploitation possible' (Feinberg 1990: 191) This is, at best, indirect exploitation—an enabling or endorsing of exploitation, but not itself exploitation. Still, a successful causal claim along these lines might not be vulnerable to the arguments presented so far, and so it is now time to turn our attention here.

4. Causal Arguments

The exploitation charge against *Chair* involves a disregard of its art theoretical context. It is also supported by an argument much like one commonly made against low-budget horror films:

1. Producers of slasher films profit from the moral deficiencies of their audience.
2. The specific moral deficiency is taking enjoyment in fictional depictions of extreme cruelty and violence.
3. No one is harmed and no one's autonomy is violated.
4. Nonetheless, it is wrong to gain by feeding morally deficient tastes.
5. So, slasher films or their producers pander to their audience.

This argument can be generalized. For instance, one might claim that certain sexual depictions pander by appealing to the corrupted tastes or imprudent choices of their audiences. The problem with this argument lies in premises 1 and 2. They appear to assume that there is no instrumental or intrinsic value in employing the imagination in fantasies that would be morally wrong to enact, or that there is no moral distinction between engaging the imagination and acting. This assumption might be justified if imagining such things made it likelier that one would do such things or try to bring them about. Alternatively, it might be justified if enjoying such things deformed one's ethical character. However, these are empirical claims which, though apparently widely accepted across cultures, and from antiquity (see, of course, Plato) have little support in reliable empirical study. They are variations of the 'Life Imitates Art' claim in its straightforwardly causal sense.

Wayne Booth, in *The Company We Keep*, argues that the Life Imitates Art claim is widely accepted by readers and writers, and that this shared belief is an important axiom in the proper interpretation of many literary works. None of this secures the actual truth of the claim, however. It may, for all that, have a standing similar to the claims of Freudian psychoanalysis—empirically false, but sometimes important as a shared set of interpretive premises.

Supporters of the Life Imitates Art claim believe that art's special power to mold character means that it is a potentially pernicious thing, and so

something to be controlled and harnessed for 'nobler' purposes. But we need to distinguish three claims:

1. A diet of ethically bad art dulls one's aesthetic sensibility.
2. A diet of ethically bad art deforms one's ethical character.
3. A diet of ethically bad art provides one with a poor range of choices or models relevant to shaping one's character.

The Life Imitates Art claim needs claim 2, and there is no obvious connection between the truth of 1 or 3 and the truth of 2. Claim 2 attributes to art a causal power that overrides both the role of choice in the formation of one's character (apart from one's choices in art) and the role of the many non-art influences on one's character. Even granting the truth of 3, life itself typically presents one directly with many models of admirable and contemptible character.

Supporters of Life Imitates Art often talk as if the only influences on one's character are artworks, when, for all but a certain species of Wildean aesthete, they are far less significant than a whole host of other influences: friends, family, colleagues, teachers, enemies, upbringing, socio-economic circumstance, etc.

Character identification is one commonly proposed mechanism of ethical deformation. But the claim that an artwork's audience identifies with morally bankrupt characters is at best a vague thesis, and clearly false understood in certain ways. Viewers of Terrence Malick's *Badlands* or Arthur Penn's *Bonnie and Clyde* do not take up murderous lives on the run, despite the striking distance that both of these films keep from expressing any sort of negative judgment of this sort of life. The friend of the thesis needs to explain why only certain forms of identification take place—why, for instance, while an audience member is not motivated to act in some ways, she is motivated to take up certain attitudes or endorse certain values she did not previously hold. I suspect that this explanatory burden cannot be met, in part because extracting the moral content of a work, as well as identifying with its characters, calls on the antecedent moral values and attitudes of audience members.

In her 'A Sensible Antiporn Feminism', Anne Eaton gives the clearest and most careful framing of the causal claim. She acknowledges that 'a depiction of subordination or degradation is not by itself an endorsement of that subordination or degradation' (2007: 682). However, she claims that

'pornography endorses by representing women enjoying, benefiting from, and deserving acts that are objectifying, degrading, or even physically injurious and rendering these things libidinally appealing on a visceral level' (682). On one reading, this claim is undone by the same considerations that undermine Langton and West's FSA.

Eaton rightly contends that a meaningful causal claim can be made when the link between the use of pornography and its alleged harms raises the probability of those harms, all other things being equal. So even if philosophical arguments fail to shed light on the mechanism by which such harms are produced, a carefully designed empirical study could nonetheless show that there is some correlation. Eaton concedes that so far the reliable empirical work on this question does not provide any evidence for a correlation. Indeed, as Pally's extensive survey of the research in *Sex and Sensibility* (1994) shows, not only is there no reliable evidence of correlation, many studies have suggested that there may be significant benefits to pornography. More recent meta-studies such as Malamuth, Addison, and Koss (2000) are similarly inconclusive, finding at most (in this case) only a correlation between having the 'highest "predisposing" risk level for sexual aggression' and frequent pornography use, and sexual aggression (85).

Examining empirical studies of purported causal links between non-sexual fictions and harms is illuminating. The string of suicides following the publication of Goethe's *The Sorrows of Young Werther* is often cited as evidence of just such a link. But if there were such a causal connection, surely we should have many more documented examples. In fact, recent empirical work suggests that fictional depictions of suicide (in television programs) are not causal stimuli for attempted suicides,[9] even if there is an imitation effect for the depicted suicide method (Berman 1988). Comparison with a more interactive type of fiction might be even more useful in this context; it is frequently claimed that playing violent video games increases teenagers' violent behavior. But the most reliable recent study on this question, conducted in 2004 by Lawrence Kutner and Cheryl Olson of Harvard Medical School (Kutner and Olson 2008), found that there was no evidence for this claim. In the absence of reliable scientific evidence, the

[9] Meaning that such depictions were not correlated with any statistically significant increase in the incidence of suicide.

continued insistence on causal links between these various fictions and unethical or harmful behavior looks like so much confirmation bias.

Langton is not impressed by this. She writes, 'suppose a cigarette company marketed a kind of cigarette that caused cancer, but also caused many people to stop noticing the symptoms of cancer, in others and (more rarely) in themselves, and prevented people from caring about the symptoms if they did notice them. What a coup! Diseases don't in fact work like this, but perhaps pornography does' (2008: 2). The analogy is very nearly question-begging, and deploying this model in the face of a dearth of evidence for the causal claim renders that claim unfalsifiable. This move, then, is illegitimate.

5. Conclusion

Much pornography is fiction, and so typically neither asserts nor recommends its fictional truths and attitudes. Non-fiction pornography is no less material for the imagination, and it is this connection with imagining that makes it on a par, ethically, with art. Sometimes an artwork is an appropriate object of ethical criticism, and sometimes so is an item of pornography. What many critics of pornography have missed, though, is that imaginings are not morally equivalent to actions, or to genuine attitudes, and much of what these critics find defective about porn is, as it were, all in the head. This is precisely why establishing that an artwork is ethically flawed requires much more than showing that it has a certain content. If my arguments are sound, the same is true of much pornography. The causal mechanism by which art, or pornography, is supposed to cause harm or induce unethical behavior or attitudes has not been discovered, and there is so far inadequate evidence for any such causal link. There is no categorical ethical distinction between art and pornography. At the very least, the arguments I have examined here provide no grounds for it.[10]

[10] Portions of this chapter have been presented to audiences at Minnesota State University Mankato, Lingnan University, and the 2007 Annual Meeting of the American Society for Aesthetics. I would like to thank those audiences for their thought-provoking observations and objections. Special thanks go to Ted Cohen, Berys Gaut, Alessandro Giovannelli, Raf LeClerq, Dick Liebendorfer, Paisley Livingston, Alex Neill, Anna Christina Ribeiro, Tom Rogers, Elisabeth Schellekens, Neven Sesardic, Brian Soucek, as well as the editors of this volume, Hans Maes and Jerry Levinson, for prompting me to think more carefully about these matters.

References

Berman, A. (1988) 'Fictional Depiction of Suicide in Television Films and Imitation Effects'. *American Journal of Psychiatry* 145(8): 982–6.

Booth, W. (1989) *The Company We Keep: An Ethics of Fiction*. Berkeley: University of California Press.

Cleland, J. (2001) *Fanny Hill, or, Memoirs of a Woman of Pleasure*. London: Penguin Books.

Currie. G. (1985) What is Fiction? *Journal of Aesthetics and Art Criticism* 43(4): 385–92.

Danto, A. C. (1992) 'Playing with the Edge: The Photographic Achievement of Robert Mapplethorpe'. In M. Holborn and D. Levas (eds.), *Mapplethorpe*. New York: Random House. 311–39.

Eaton, A. W. (2008) 'Reply to Critics'. *Symposia on Gender, Race, and Philosophy* [online]. 4(2): 1–11. Available from: <http://web.mit.edu/sgrp/2008/no2/Eaton0508.pdf>. [Accessed 30 January 2011.]

——(2007) 'A Sensible Antiporn Feminism'. *Ethics* 117 (July): 674–715.

Feinberg, J. (1990) *Harmless Wrongdoing: The Moral Limits of the Criminal Law*. Oxford: Oxford University Press.

Hacking, I. (1996) Blurb for A. Wertheimer, *Exploitation*. Princeton: Princeton University Press.

Kipnis, L. (1996) *Bound and Gagged: Pornography and the Politics of Fantasy in America*. New York: Grove Press.

Kutner, L., and Olson, C. (2008) *Grand Theft Childhood: The Surprising Truth about Violent Video Games*. New York: Simon and Schuster.

Lamarque, P. (2009) *The Philosophy of Literature*. Oxford: Blackwell Publishing.

Langton, R. (2008) Comments on A. W. Eaton's 'A Sensible Antiporn Feminism'. *Symposia on Gender, Race, and Philosophy* [online]. 4(2): 1–5. Available from: <http://web.mit.edu/sgrp/2008/no2/Langton0508.pdf>. [Accessed 30 January 2011.]

——and West, C. (2009) 'Scorekeeping in a Pornographic Language Game'. In R. Langton, *Sexual Solipsism*. Oxford: Oxford University Press. 173–95.

Levinson, J. (1996) 'Intention and Interpretation in Literature'. In J. Levinson, *The Pleasures of Aesthetics: Philosophical Essays*. Ithaca, NY: Cornell University Press. 175–213.

Lewis, D. (1978) 'Truth in Fiction'. *American Philosophical Quarterly* 15(1): 37–46.

Livingston, P. (2005) *Art and Intention*. Oxford: Oxford University Press.

——(1996) 'Characterization and Fictional Truth in the Cinema'. In D. Bordwell and N. Carroll (eds.), *Post-Theory: Reconstructing Film Studies*. Madison, Wis.: University of Wisconsin Press. 149–74.

MacKinnon, C. (1993) *Only Words*. Cambridge, Mass.: Harvard University Press.

Maes, H. (2011) 'Drawing the Line: Art versus Pornography'. *Philosophy Compass* [online]. Available from <http://onlinelibrary.wiley.com> doi/10.1111/j.1747-9991.2011.00403.x.

Malamuth, N., Addison, T., and Koss, M. (2000) 'Pornography and Sexual Aggression: Are there reliable effects and can we understand them?' *Annual Review of Sex Research* 11: 26–91.

Nussbaum, M. (1995) 'Objectification'. *Philosophy and Public Affairs* 24(4): 249–91.

Pally, M. (1994) *Sex and Sensibility: Reflections on Forbidden Mirrors and the Will to Censor*. Hopewell, NJ: Ecco Press.

Rea, M. (2001) 'What is Pornography?' *Noûs* 35(1): 118–45.

Strossen, N. (1995) *Defending Pornography: Free Speech, Sex, and the Fight for Women's Rights*. New York: Scribner.

Von Unwerth, E. (2003) *Revenge*. Santa Fe, Calif.: Twin Palms Publishers

Wertheimer, A. (1996) *Exploitation*. Princeton: Princeton University Press.

Williams, B. (1985) *Ethics and the Limits of Philosophy*. Cambridge, Mass.: Harvard University Press.

——(1994) 'Drawing Lines. Review of *Only Words* by MacKinnon, C.' *London Review of Books*, 12 May, 9–10.

Williams, L. (2008) *Screening Sex*. Durham, NC: Duke University Press.

12

Concepts of Pornography
Aesthetics, Feminism, and Methodology

ANDREW KANIA

There are two broadly philosophical literatures on pornography. By far the largest is concerned with moral issues raised by pornography. This literature falls into two phases.[1] The first phase comprises the debate between moral conservatives, who objected to pornography on the grounds of its explicit sexual nature, and liberals, who defended pornography on grounds of something like freedom of speech or expression. Though this debate is not stone cold, the liberals seem to have won it. However, it has been largely replaced by a different one between feminists who object to pornography on the basis that it contributes to the oppression of women and those who reject these feminist arguments.[2] There is also a much smaller literature concerned with aesthetic or artistic issues concerning pornography. For the most part, this literature has been concerned with examining the distinction commonly made between pornography and art (particularly 'erotic art').

One task facing parties to these debates is that of making explicit what exactly pornography is—offering something like a definition or analysis of the term or concept 'pornography'. In keeping with the goals of this volume, I aim to do two things in this chapter. First, I will discuss a recent notable attempt to sharply distinguish pornography from erotic art, and argue that the attempt fails. Then I will turn to methodological questions about how we ought to go about defining 'pornography', questions which

[1] For an excellent summary of these phases, on which I draw in what follows, see West 2004.

[2] Those who reject such arguments are a heterogeneous group, including many who identify themselves as feminists.

lead quickly to others about why we want such a definition. I believe that philosophers of art can make important contributions to this definitional project, but only if their contributions are informed by recent work in feminism, philosophical analysis, and art history.

1. Levinson's Distinction between Pornography and Erotic Art

In a fairly recent paper, Jerrold Levinson (2005) argues for a clear distinction between the concepts of pornography and erotic art. The distinction is *clear* in the sense that the concepts are clearly different, not in the sense that the border is sharp. It is a *distinction* in the sense that the two categories are disjoint, according to Levinson—pornography is not a species of erotic art, nor do the two kinds overlap. The reason for this, in short, is that pornography cannot be art, according to Levinson. Levinson's arguments are partly an extension of those he offered in a paper seven years earlier (1998), but he also replies to the arguments of Matthew Kieran (2001), who had in the meantime published a paper arguing that erotic art and pornography are not distinct, but overlap. While Kieran does not say whether all erotica or pornography must be art, he does say that pornography may be, and some actually is, erotic art.

Levinson first rejects defining pornography in terms of the sexual explicitness or the moral status of the representation.[3] It is clear, he thinks, and almost everyone agrees, that there can be sexually explicit, yet non-pornographic representations, such as those in a biology textbook. And even if, as some allege, all pornography were immoral, it would not follow that the immorality is part of the *concept* of pornography; it seems more plausible that the immorality would follow from some other feature essential to the pornographic.[4] Instead, Levinson argues that '[w]hat makes the difference [between erotic art and pornography] is what they are for, what response they are designed to evoke, what they are meant to do to us, or we with them' (261).[5]

[3] Levinson officially restricts himself to still images, but he discusses literary works, and it seems his account could easily be extended to all pornographic representations.

[4] I will return to moral definitions of 'pornography' in section 5.

[5] All page references are to Levinson 2005 unless otherwise indicated.

What erotic art and pornography have *in common* is an intention on the part of their creators to sexually *stimulate* us, that is, to induce 'sexual thoughts, feelings, imaginings, or desires that would generally be regarded as pleasant in themselves' (260). That they are similar in this way is what makes distinguishing them a worthwhile project. Each goes beyond this commonality in different ways, however. Creators of pornography aim not only to stimulate us sexually, but to sexually *arouse* us, that is, to induce 'the physiological state that is prelude and prerequisite to sexual release' (260). Though he does not say so explicitly, Levinson seems to mean that pornography is intended by its creators to be used as a sexual or masturbational aid.[6] On the other hand, erotic art is perhaps not intended to induce physiological arousal,[7] but either way it is certainly not intended to be used as a masturbational aid. Erotic art *is*, however, intended 'to reward artistic interest' (*passim*), by which Levinson means 'roughly...[interest in] the way the medium has been employed to convey the content' of the representation (262). It is these two different purposes of pornography and erotic art that make them mutually exclusive, according to Levinson. For sexual arousal, what one wants is maximum transparency—all content and no form. As Levinson memorably puts it, pornographic representations 'should present the object for sexual fantasy vividly, and then, as it were, get out of the way' (264). This precludes taking artistic interest in the representation in question.

2. Criticisms of Levinson's Theory[8]

There are a number of problems with Levinson's argument. One is that there is some slippage between the intentions of the creator of the representation and what is done by a receiver of the representation.[9] In a helpful

[6] Levinson suggests that pornography is 'intended to arouse sexually in the interests of sexual release' (260–1), but it is not obvious that the goal of the use of pornography is always orgasm (i.e. 'sexual release'), nor, hence, that pornography must be intended for this. I take the intention that a representation be used as a sexual *or* masturbational aid to be a charitable amendment of Levinson's account.

[7] Levinson is not entirely consistent on this point. See, for example, his discussion of Nicholson Baker's novella *Vox*, which Levinson classifies as erotic art, but which he says 'is...sexually stimulating, even arousing...[although] its paramount aim is not that of producing sexual arousal and release' (264). I return to this example below.

[8] Many of the criticisms I make in this section are similar to those made by Kieran (2001), Hans Maes (2009), and David Davies (this volume).

[9] I use the term 'receiver' in attempt to stay neutral between 'appreciators' or 'audiences' of erotic art and 'users' or 'consumers' of pornography.

summary of his argument at the end of his essay, Levinson begins with the idea that erotic art and pornography are each 'centrally aimed at a certain sort of reception' (270), as outlined above. The remaining premises claim that one cannot adopt both these modes of reception at once. The conclusion is that nothing can be both erotic art and pornography. But the claim that two modes of reception cannot be adopted simultaneously in response to a single representation has no implications for whether both can be *intended* by the representation's creator. Thus, even if Levinson's premises are all true, his conclusion does not directly follow from it.

This might be considered an uncharitable interpretation of Levinson's argument, for while the idea that nothing can be both erotic art and pornography is the first, and strongest, conclusion Levinson draws, he immediately goes on to offer two weaker alternatives: '[i] nothing can be both erotic art and pornography; or at least, [ii] nothing can be coherently projected as both erotic art and pornography; or at the very least, [iii] nothing can succeed as erotic art and pornography at the same time' (271). I consider the weaker conclusions in the course of my discussion below. In terms of charity, however, it is worth noticing that if Levinson is forced to retreat to a weaker conclusion to save his argument, it will be at the expense of the conclusion he seems most interested in defending throughout his essay.

One way of resolving the problematic shift within Levinson's argument from what creators of erotic art and pornography *intend* to what receivers of such things *do* would be to move from an account of the distinction between erotic art and pornography in terms of creators' intentions to one in terms of receivers' modes of reception. But I suspect Levinson would, rightly, reject this kind of move. For this would relativize the categories to which representations belong to particular occasions of use. No representation would count simply as pornography or erotic art; a representation would rather count as pornography for this person on this occasion, because of the way the person approaches it, but not for others on other occasions, or even for the same person on a different occasion, due to how it is approached on each occasion.[10] It seems more plausible to describe these kinds of shifts as people

[10] Jennifer Saul (2006a) comes uncomfortably close to implying that pornography is subjective in this sense.

treating certain things *as pornography* or *as erotic art*, just as you may hear the sound of the train you ride in *as music*, when it is in fact no such thing.

A second possible resolution would be to retreat to the second disjunct in the conclusion of Levinson's summary argument quoted above: Since these modes of reception are incompatible, no rational creator could intend any representation for both. A first response to this reply would be to question the likely rationality of creators of representations. There's nothing like reading artistic manifestos to get a philosopher worried about the rationality of creators.[11] But I will leave this strategy aside; even if the claims it relies on are true (and the discussion below suggests that they are not), it will not achieve what Levinson aims to, namely to show that nothing can be both pornography and erotic art. For to show that would require an additional, implausible assumption that artists (or pornographers, or both) must have coherent intentions with regard to their creations.

The most promising strategy available to Levinson, then, is to retreat to something like the third disjunct in the conclusion quoted above: A successful pornographic artwork would have to elicit two incompatible responses (an artistic response and sexual arousal), and this is impossible. What I aim to show in the remainder of this section and in the next is that such responses are not incompatible in any sense that would establish the impossibility of successful pornographic art.

First, let us grant that on any given occasion the two modes of reception—(i) aiming at one's sexual arousal and (ii) considering the way in which the representation's content is conveyed in its medium—are incompatible; they cannot both be adopted simultaneously. The relevance of this claim is called into question when we consider that creators need not create representations for only a single occasion of reception. Whether we focus on uncontentious artworks, uncontentious pornography, or cases in the disputed middle ground, it seems likely that almost all such representations are intended for multiple occasions of reception by multiple people. What is to stop the creator, then, from creating a representation with the intention that it be taken in any number of incompatible ways, on different occasions, by different people—or the same people, for that matter? Nothing, it would

[11] To be fair, most artists, perhaps not without reason, express similar fears for the sanity of philosophers on reading works of aesthetics.

seem. In fact, if we consider just artworks for a moment, it seems plausible that *rewarding multiple different modes of reception for which it was intended* is one important mark of artistic value. For a simple illustration, consider musical counterpoint. For most people it is impossible to hear a four-voice fugue simultaneously horizontally (paying attention to the separate voices) and vertically (paying attention to the chords momentarily made up of the notes constituting each voice's melody). But we praise, rather than condemn, composers capable of producing such works. This is bad news for Levinson's account, since it seems a prima facie reason to allow for a category of pornographic art—art that rewards, among other modes of reception, a pornographic approach, as it were.[12] One question this response raises is what Levinson means when he says that nothing can succeed as art and pornography *at the same time*. If anything succeeds as harmony and counterpoint at the same time, it is Bach's fugues. If it turned out that no one can in fact appreciate both these aspects simultaneously, even if it turned out this were a *necessary truth*, we would surely hold this irrelevant to whether Bach's fugues succeed harmonically, say. What this shows is that the relevant sense in which artworks can succeed at two things 'at the same time' is not the sense according to which a single receiver could experience both things simultaneously.

But, second, we need not grant that the modes of reception essential to pornography and erotic art are incompatible—even on a single occasion of reception. Consider, by analogy, religious art.[13] At least some of it seems aimed centrally at turning the mind away from things of this world, towards contemplation of God alone. How does such art, when successful, work? Not by offering as transparent a picture of God as possible, and then getting out of the way (whatever that would mean). Religious artists use all the same artistic techniques to achieve their intended effects as other artists do. Now, when one is treating such a devotional work as intended, one is surely not explicitly, consciously having thoughts such as 'What a great use of chiaroscuro!' or 'Lambs are so meek and mild; what an appropriate image for

[12] Levinson might reply that there is an important difference between *aesthetic* responses, such as attention to harmony or melody, and *non-aesthetic* responses such as sexual arousal. But such a distinction causes problems for any theory of art, as we shall shortly see, and particular problems for Levinson's own definition of art, as we shall see in section 4.

[13] See David Davies's chapter in this volume for another comparison of religious and pornographic art.

Christ'.[14] But, equally surely, such thoughts are playing an essential role somewhere in one's experience of the work. (I assume here that much of one's experience of artworks, including appropriate and rewarding experience, is not consciously accessed, and much of it probably *inaccessible* to consciousness.) Spelling out the ways in which our awareness of the artistic techniques and aesthetic effects of an artwork affect our experience of it is a major task, one I cannot begin to engage in here. But we don't need to know the details in order to see the point for Levinson's theory. The point is that the criterion he sets for a representation's being art is either so demanding as to implausibly exclude many uncontentious artworks from the realm of art or too weak to exclude most of what he wants to exclude as unartistic pornography.

Let's take each horn of the dilemma in turn. One is that didactic novels, religious paintings, urns adorned with narrative friezes, and so on, will not count as art, since Levinson's argument against the possibility of artistic pornography will work just as effectively against all of these. In order to be art, something must be aimed at a kind of aesthetic reception, but such reception will exclude the item's being treated primarily as a teaching tool, an object for meditation, or something to stick flowers in. My guess is that Levinson will find this horn of the dilemma less appealing than the alternative. To remove himself from it, he must allow that artworks may admit of multiple different modes of reception, whether simultaneously or not. But this lands him firmly on the other horn: he now cannot exclude the pornography he wanted to exclude in the first place from the realm of art on the grounds that it is intended for a non-aesthetic mode of reception.

3. Some Examples

There is a recent genre of voyeuristic pornographic moving image—or so my students tell me—that employs the style of a security camera. This is professional, staged pornography, not actual security tape footage, but it is produced so as to give the appearance of being actual security tape footage, just as big-budget movies such as *The Blair Witch Project* (Daniel Myrick and

[14] If it is the case that one could have such conscious thoughts and *still* have the kind of religious experience intended by the work's creator, then this might be enough to make the point I wish to here. (Thanks to Hans Maes for pointing this out.)

Eduardo Sánchez, 1999) or *Cloverfield* (Matt Reeves, 2008) give the appearance of being shot by amateurs. These moving images are pornography if anything is. They have no artistic pretentions, and would be unlikely to earn the evaluative epithet of 'erotic' from many people's lips. Yet, clearly, if successful, these moving images achieve their pornographic effect by drawing attention to the way in which their representational content is conveyed. If a viewer did not realize this particular visual style was that of a security camera, with the imaginative implication that what they are seeing happened between two people, say, who thought they were unobserved, the viewer would miss a large part of the point and effect of the images.

It might be argued that there is a difference between the global way in which the 'verité' style of this kind of pornography contributes to its effect and the specific ways in which particular formal features of works of art contribute to their effects.[15] This is doubtless true, but it ignores uncontentious artworks the verité style of which contributes to their effects in a similarly global way. Consider *Cloverfield* and *The Blair Witch Project* once more. These may not be great artworks, but it would be difficult to argue that they are not artworks at all, and more difficult still to argue that no artwork sharing their style could be art. Examples of *good* artworks in a similarly transparent style include *United 93* (Paul Greengrass, 2006) and, arguably, many cinematic works of Italian neorealism.

My point here is not to argue that security-camera-style pornography is art.[16] Rather, the point is to reject the idea that the way in which the medium is used to convey the content of pornography must be concealed by its creators or ignored or repressed by its receivers. And once we see this for security-camera-style pornography, we can, by comparison, see that it applies to all pornography. Levinson's claim that pornographic media simply present the action, and then get out of the way, brings to my mind the claims of generations of marketers of sound equipment. As Lee Brown has pointed out, each new technological development brought along with it the claim that it was the ultimate in sound reproduction technology, finally getting rid of the sonic middle-man, and delivering the sound of the performance directly to your living room (2005: 212–13). Just as experienced listeners

[15] Thanks to the editors for suggesting this response.

[16] It is difficult, though, to see how Levinson could exclude them from that realm, given his work explicitly devoted to the definition of 'art', a point I shall return to below.

can tell a 1960s LP from a first-generation CD, experienced viewers can tell the grainy footage of a duskily lit boudoir in a 1970s pornographic film from the sharp digital images of brightly lit Southern California poolsides in 1990s pornography. (Or so various generations of my colleagues tell me their students tell them.) And these differences are relevant to the content being conveyed.

The most plausible response I can imagine Levinson giving to these examples is that although all pornography *has* a style that we might take an interest in, we are not intended to *notice* or *pay attention to* this style. But even if we ignore security-camera-style pornography, which is not amenable to this response, this just returns us to the dilemma; the response is too strong. If we followed this argument to its logical conclusion, we would end up allowing only broadly modernist works into the fold of art. There are simply too many artworks, even *kinds* of artworks, that are not intended for Brechtian attention to their medium. I have given particular cinematic examples above. But think also of romance, crime, and science-fiction novels, the decorative arts, pop songs, and so on. Finally, note that it is hardly contentious that one central goal of the visual arts in the West for several centuries was to provide a seemingly veridical, transparent visual experience, as if the viewer were in direct perceptual contact with the world of the work. Such works seem to be attempts, at least in part, to present whatever they represent 'vividly, and then, as it were, get out of the way' (264). But, then, if Levinson's argument succeeds, they should be excluded from the realm of art.

This raises a deep question for the philosophy of art: the question of what constrains legitimate modes of reception for, approaches to, or interpretations of, artworks. The points just considered suggest that the context of creation does not constrain such things as tightly as much recent contextualist work has suggested, whether that context is construed narrowly, in terms of the artist's actual intentions, or broadly, in terms of how it would be reasonable to expect an idealized contemporary audience for the work to approach it. Consider, again, a work which was intended by its creator to provide a certain religious experience. Suppose the artist intended her use of the medium to be ignored, following the tradition in which she was working. When we pay attention to her use of the medium, are we treating her work inappropriately? Are we treating a non-artwork as if it were art? Unfortunately there is not space enough here to investigate these issues

further. The assumption I work with in what follows is that such modes of reception *are* appropriate. I work with this assumption in part because I believe it is correct, in part because it is a conclusion Levinson would surely embrace (and thus does not beg any questions against him).

I now turn to uncontentious examples of erotic art. Matthew Kieran gives the examples of Nicholson Baker's novella *Vox*, some of Anaïs Nin's short stories, and the erotic drawings of Rodin and Klimt. He agrees with Levinson that these are erotic artworks, but argues that they are also pornographic according to Levinson's own criteria. In short, they are clearly aimed at sexual uses. Levinson gives a number of responses to this general argument. About *Vox*, he says that 'it *mimics* pornography . . . it is . . . sexually stimulating, even arousing . . . But the point is that that is not *all* it is, nor all it is *intended* to be, nor what it is *ultimately* aimed at' (264). He says that Klimt's drawings 'are not pornography, but rather art, albeit art that might be *mistaken* for pornography by inattentive viewers, or that might be *used* as pornography by viewers happy to lose sight of its artful fashioning and just enjoy the erotic upshot thereof' (265).

Levinson's basic response here seems to be that these examples are not pornography, because not intended for sexual uses. As a claim about these particular works, this strikes me as implausible, and a consideration of other examples from global art history only strengthens the case against Levinson. But even if he is correct about these particular cases, surely we can imagine some Danto-esque indiscernible counterparts of these works that *were* intended for sexual uses. The only place for Levinson to turn in the face of this argument is where the above quotations show him turning: he allows the pornographic intent of erotic art, but attempts to show that it is a subsidiary concern of the artist. There are now two ways forward. Levinson could claim that to count as pornography a representation must be solely or exclusively intended for sexual use. He suggests this criterion at times, yet it is clearly not going to do the work he wants it to. It's a bad joke that pornographers of the 1970s wanted to make their productions more artistic, but the cliché holds some truth. An account of pornography according to which pornographic intent must be the creator's *sole* aim in creating a representation will be far too narrow. The other option is to say, as Levinson does at various points, that the pornographic intent of the representation's creator must be ultimate, or central. But this option makes it difficult to exclude the possibility of pornographic art. For a central concern with

arousing your audience does not preclude a substantial subsidiary concern with artful and attention-worthy use of your chosen medium, as we have already seen.

There are two last responses Levinson might give that I have not yet dealt with head-on. One is that although we have seen that a central concern with providing a religious experience, or teaching a lesson, or creating a functional object does not preclude a substantial subsidiary concern with artful and attention-worthy use of a medium, it does not immediately follow that a central concern with *sexually arousing* one's audience is compatible with such use. Perhaps there is something special about the goal of arousal that precludes artistic use of one's chosen medium. The second (weaker) response is that even if pornographic art is possible, *good* pornographic art is not possible, or (weaker still) at least very difficult, for this reason.

It seems to me that the last, weakest response would be a concession of defeat. It's difficult to make aesthetically valuable didactic novels, religious paintings, and functional vases. But if that shows anything, it's that these are worthwhile artistic pursuits. The other responses must rely on the claim that there is something peculiar to sexual arousal in particular as an artistic goal that precludes the artful use of the medium (or successful such use). It seems implausible that having your audience's arousal as a *goal* could preclude the aesthetic use of your chosen medium unless you subscribed to some sort of naïve expression-theory of art. That is, the idea would have to be that one would get so hot and bothered during production of the work, because undergoing the arousal one was intending to elicit from one's audience, that one would be incapable of concentrating on the other task at hand. Though this might certainly happen in individual cases, it doesn't seem plausible as a universal claim. The intermediate, weaker claim is more plausible. If one succeeds in getting one's audience hot and bothered, won't they be unable to concentrate on your artful use of the medium? Perhaps, but this just returns us to the issues discussed above. Sobbing your heart out during a tragedy prevents you from paying maximal attention to the scansion of the poetry; that doesn't prevent Shakespeare from intending you to respond in both ways, or his plays from being successful at both arousing emotions and being prosodically beautiful.

4. Some Other Possible Views

It should be surprising to anyone acquainted with the literature on the definition of 'art' that Levinson, in particular, should find himself in this position. For it is a position closely akin to that in which defenders of simple functional definitions of art find themselves. What is the most obvious problem with aesthetic, or expression, or mimetic definitions of 'art'? Simply that each theory is too narrow, capturing an important, but far from complete, class of artworks. When it comes to the definition of art, Levinson is well known for his intentional-historical definition: (roughly) in order to be art something must be intended for regard in some way past artworks are or were correctly regarded (Levinson 1979, 1989, 1993, 2002). Part of the point of this definition is to take into account the lesson of the failure of simple functional definitions, to allow for a multiplicity of legitimate ways in which art can be intended to be taken. But in his work on pornography and erotic art, Levinson seems precisely to be promoting an aesthetic conception of art: in order to be art, something must be centrally intended to be regarded in one particular way, to wit, with respect to the way in which its medium conveys its content. So not only is Levinson's theory of the distinction between erotic art and pornography inadequate on its own terms, it seems to be in tension with his work explicitly devoted to the definition of 'art' (Maes 2009).[17]

I have been arguing against Levinson's view that no art can be pornographic. In positive terms, I have been trying to show that there can be (and that there is in fact) some pornographic art. This is the same conclusion Matthew Kieran defends. But Levinson might reasonably ask for more than this. If we reject his theory, is the result that all pornography is art? If not, how can we distinguish the two without appealing to Levinson's criteria? I will outline three possibilities here.[18]

One option would be to argue that while art can be pornographic, there is still a distinct kind of representation, which we might call simply *pornography*, which has no artistic intention. This is the option that seems closest to

[17] There is a similar tension between Levinson's definitions of 'art' and 'music' (the latter given in Levinson 1990a). See Kania 2011.

[18] This is not the place to decide this issue, since it would require a theory of art, which I don't have to hand.

Levinson's views; where he is inconsistent (e.g. with respect to whether art can be aimed at sexual arousal), this is a reasonable interpretation of the view that conflicts with his main view.[19]

Another option would be to argue that all pornography is art, since all pornography is intended to be regarded in ways in which existing art is or was correctly regarded.[20] This seems to be the result of combining what we've learned from the problems with Levinson's view of erotic art and pornography with his definition of 'art'. If some art is correctly regarded with a view to one's sexual arousal, then pornography created with just that intention seems to count as art. To really turn the screw, we might say that given the overlap between the regards intended for erotic art and pornography, Levinson is automatically committed to pornography's being art. This is prima facie plausible because the two intended modes of reception plainly overlap in Levinson's view: erotic art is intended to be regarded with an eye to sexual stimulation, while pornography is intended to be regarded with an eye to sexual stimulation as a prerequisite to sexual arousal and release. The intention to approach both kinds of thing with an eye to sexual stimulation provides us with the necessary overlap.

Levinson might respond that the preservation of this single intention across the two cases does not provide substantial enough overlap for pornography to count as art. But this raises the question—one that has been raised generally against Levinson's definition—of whether the amount of overlap can be characterized in such a way that the extension of 'art' comes out neither too narrow nor too broad. (See the discussion of this point, and related references, in Levinson 1989 and 1993.)

A third option would be to argue that the definition of 'art' is a misguided enterprise. Instead, it might be argued, things are more or less artistic, and pornographic representations fall all along the spectrum, as do all sorts of other things (images, pots, buildings, texts, and so on). The security-camera pornography that I discussed above is as unartistic as just about any fictional moving image could be. Nonetheless, you might think that because of the way we are intended to pay attention to its use of its medium, it is a little

[19] Whether such a view could be squared with Levinson's definition of art is another question, as becomes evident in the following paragraph.

[20] Peter Lehman (2006: 6-10) argues for this conclusion, though not by way of Levinson's definition of art. Thanks to Hans Maes for bringing this text to my attention.

artistic. If this is right, then one thing it shows is that such an aesthetic intention is far from the central mark of 'artiness'.

5. Kinds of Conceptual Projects

How did Levinson arrive at this uncomfortable position? The answer is pretty clearly stated at the opening of his essay. There he lists five intuitions he aims at preserving while clarifying and sharpening the distinction between erotic art and pornography. The intuitions are (i) that items in both categories are 'concerned with sexual stimulation or arousal', (ii) that 'erotic' is a 'neutral or even approving [term, while] "pornographic" is pejorative or disapproving', (iii) that, unlike the term 'erotic art', the term 'pornographic art' 'seems an almost oxymoronic one', (iv) that 'pornography has a paramount aim, namely, the sexual satisfaction of the viewer, [whereas] erotic art . . . includes other aims of significance', and (v) that 'our interactions with erotic art and pornography are fundamentally different in character, as reflected in the verbs' commonly used to describe those interactions: we 'appreciate (or relish) erotic art, [but] consume (or use) pornography' (259–60).

Some of these intuitions (i, iv, the first half of v) are clearly substantive issues that feature explicitly in the account Levinson goes on to give. They are presumably theoretically revisable in light of further consideration, though Levinson, of course, thinks they do not in fact need to be revised. But others (ii, iii, the second half of v) are fairly explicit attempts to preserve something like 'common usage': the evaluative difference between the terms 'erotic art' and 'pornography', the oxymoronic sound of the phrase 'pornographic art', and the use of verbs such as 'consume' and 'appreciate' in relation to pornography and erotic art, respectively.

Sally Haslanger (2000, 2006) has provided a rough taxonomy of the various kinds of projects philosophers engage in when attempting something like a conceptual analysis or definition. What she calls a *conceptual* project is aimed at elucidating some particular *concept*, a shared psychological unit, primarily by attempting reflective equilibrium through largely a priori reflection on one's intuitions about general claims and particular cases. A *descriptive* project, on the other hand, seeks to bring our concepts into line with the world, using more empirical methods to discover the objective

phenomena our concept seems to be attempting to track. For example, when engaging in a *conceptual* project we may conclude that our concept of FISH is that of a relatively small aquatic animal with scales and fins. However, if we are engaged in a *descriptive* project, we will defer to the ways in which biologists carve up the world; as a result, we may discover that some fish do not have scales, for instance.[21] We might add to these a *common-usage project*, an empirical examination of what people pre-reflectively use a term to refer to. This would differ from a conceptual or descriptive project in that it would attempt to achieve no (or as little as possible) reflective equilibrium between this concept and other factors (e.g. the coherence of our overall conceptual scheme). Such a project might reveal that FISH is a prototype concept and that people generally classify dolphins as fish.

There is a further kind of project, however, which Haslanger calls *analytical*. This is really a meta-level project, which takes a critical attitude towards the three kinds of projects limned above. An analytical project has two parts. In the first, one steps back from the concept in question and asks why we have it, what work we want it to do for us. In the second part, one generates the best concept for the job identified in the first part. When applied to the concept FISH, we may find that the biological concept is the central one, but that no harm comes from using our intuitive concept in some contexts (for instance, when in a pet shop).[22]

Engaging in an analytical project with respect to the concept FISH may not sound very interesting. Rather, the details of descriptivist projects are likely to strike us as more interesting: What are fish, really? But there has been much interesting philosophical work on the sort of concept that FISH is—so-called natural-kind concepts—and how the reference of such concepts is determined. Such work can be fruitfully viewed as part of an analytical project, in Haslanger's terms. (If the point of the concept FISH is to contribute to our carving nature at the joints, then we ought to take biologists' pronouncements about what fish are more seriously than fishmongers'.) When we turn to more ethically or politically freighted concepts such as

[21] One might think of these first two kinds of project as aimed at discovering nominal and real definitions, respectively, but I leave their motivations, methods, and even individuation largely unexamined.

[22] In her 2006, Haslanger suggests alternative terms for the three kinds of projects she considers: internal (for conceptual), external (for descriptive), and ameliorative (for analytical). I stick with the original terminology for simplicity.

those of race or gender, analytical projects become even more interesting and urgent, because of arguments that such concepts (or the things they pick out) are 'socially constructed'. What this means is, roughly, that in order to explain why something or someone falls under a given concept, one must make reference to social factors, such as the way it is generally accepted that such things or persons should be treated (Haslanger 2003). This much is a descriptive project motivated by the idea that the concept in question picks out an objective, albeit perhaps social, kind of thing or person: We look at the world, including the social world, and see what criteria must be met by something in order to fall under a given concept. In many cases, the fact that a concept is socially constructed in this sense will be uninteresting. (For instance, no one will be surprised to hear that *being a friend* is in large part a matter of how one treats, and is treated by, others.) The interesting cases are those in which the social construction of the concept is not obvious, in particular, concepts that at first glance seem purely objective or natural-kind concepts, but turn out in fact to be socially constructed. Uncovering the socially constructed nature of such a concept is what Haslanger calls a 'debunking project' (2003). Debunking projects may be urgent because the concept in question may be contributing to the oppression of a group of people; its apparently objective or natural status may give the illusion that that oppression is natural; and its debunking may help to end that oppression. This part is the analytical project: We ask why we have a certain conceptual scheme when others are available, how this affects us, and what we ought to do about it.

For instance, we usually think of WOMAN and MAN as biological, natural-kind concepts. But Haslanger argues that, in fact, these concepts operate for the most part as 'thick', socially constructed concepts. She argues (roughly) that a *woman* is someone who is perceived to be biologically female, is marked as socially subordinate as a result, and is thereby in fact subordinated (Haslanger 2000). Making this conceptual content explicit has some odd results. For instance, it may be that the Queen of England, or a biologically female person who successfully 'passes' as a man, is not in fact a woman. But Haslanger believes that making this content explicit will help end the oppression of women by making us uncomfortable with many of the ways in which we treat people on the basis of their perceived biology.

Looking at it in light of Haslanger's work, I think we can see Levinson's account of the distinction between erotic art and pornography as a *descriptive*

project.[23] He seeks not just to limn these two concepts a priori, but to take into account the social reality of the way in which things are divided into these two categories. People do, in fact, distinguish pornography from erotic art, and the items so distinguished are treated differently. The former term is, in fact, pejorative, the latter not.[24] These concepts are socially constructed in the sense outlined above. My critical discussion of this project has so far been largely 'internal' in the sense that I have not questioned the point of engaging in the descriptive project. Rather, I have criticized Levinson's theory of the distinction between pornography and erotic art on descriptive grounds. But these results naturally prompt us to engage in an *analytical* project, asking the 'external' questions of why we have the distinct concepts of erotic art and pornography, and whether those reasons are ones we should, on reflection, endorse.

6. The Analytical Project: (What) is Pornography? (What) do we Want it to be?[25]

As I noted at the outset, though there is a small literature on its aesthetics, most philosophical discussion of pornography has been concerned with its moral and legal standing, and has recently revolved around feminist arguments. The central questions have been: (1) What is pornography? (2) How much pornography, if any, is morally bad, and why? (3) How bad is it? and, consequently, (4) How ought it to be regulated, if at all? I will ignore the final, policy question, focusing on the moral issues instead. But it is worth saying something about feminist answers to the first question, since they have traditionally been very different from those offered by metaphysicians and aestheticians. Many feminists have defined pornography in terms of what might be called its moral content: Pornography is representations that are, or contribute to, or reinforce, the subordination or oppression of women. (See, for example, the essays in part one of Dwyer 1995.) Most of

[23] Michael Rea (2001), by contrast, might be seen as having arrived at his definition of 'pornography' via a conceptual project.

[24] Of course, not *everyone* distinguishes pornography from erotic art, or uses the former term disapprovingly. But I think these are reasonable generalizations about, say, turn-of-the-millennium US attitudes. In any case, I grant this to Levinson for the sake of argument. Some of the dissenting voices are discussed in the next section.

[25] I have adapted this heading from the title of Haslanger 2000.

these theorists have been well aware that there can be sexually arousing representations that do not contribute to the oppression of women—Levinson's reason for rejecting such definitions—but they define 'pornography' stipulatively, reserving a term such as 'erotica' for non-oppressive materials (e.g. Steinem 1978; MacKinnon 1987; Brison 2007). Many critics argue this is an unhelpful starting point, since these feminists essentially acknowledge (albeit largely implicitly) that there can be pornography, in the ordinary (i.e. common-usage) sense of the term that is morally acceptable. But if we reconceive what these feminists are doing in analytical terms, it is easier to understand why they offer this stipulative definition. They might argue that the point of a concept of pornography (for theorists, at least) is, or should be, to combat the oppression of women (and perhaps other groups, such as people with sexualities different from the heterosexuality dominant in our culture).

Nonetheless, there has recently been a move to use the terms 'inegalitarian pornography' and 'egalitarian pornography' to name these two classes of material. This is, in part, 'just' a verbal issue, but the motivation seems to be the pragmatic political one of ridding feminism, particular anti-pornography feminism, of its public image (at least in the US) as censorious and anti-sex (Eaton 2007: 674–7). It can thus also be seen as part of a different answer to the questions raised by an analytical project about 'pornography'.[26] I support this recent trend, but I emphasize that it is more a break with earlier feminist rhetoric about, rather than attitudes towards, pornography.

How is inegalitarian pornography supposed to contribute to the subordination of women? In short, by eroticizing it. How exactly eroticization contributes to subordination is a complex matter, which I will not address.[27] But there is a prior question which has interesting consequences for the issues I have been discussing, namely: How does inegalitarian pornography eroticize women's subordination? There is, again, much to be said here, but one relevant point is that it is not just a matter of a certain kind of content. Even acts that seem the best candidates for anti-feminist content, such as rape, can be represented in uncontentiously feminist art. How so? A work as

[26] Jennifer Saul 2006b gives an analogous argument against Haslanger's proposed analyses of gender and race concepts.

[27] See Eaton 2007 for an excellent introduction to this topic, and also the references therein.

a whole can convey an *attitude towards* its representational content, in virtue of the way in which that content is represented, and the context in which the work is presented.[28] What is morally reprehensible about inegalitarian pornography, then, is not its sexually explicit content, but the attitude expressed towards that content (see, for example, Steinem 1978; Gracyk 1987; Eaton 2007: 676). This is what allows for the possibility of *egalitarian* pornography—representations aimed at the sexual arousal of their recipients that do *not* eroticize the subordination of women. In fact, Eaton has suggested that in light of the problems, both ethical and pragmatic, with state regulation of pornography, promoting egalitarian pornography may be one promising route for 'sensible antiporn feminists' to pursue (Eaton 2008: 9–10).

Looking at Levinson's account of the distinction between pornography and erotic art in light of these ideas presents a new kind of problem for his account. If what distinguishes egalitarian from inegalitarian pornography is in part the attitude it takes towards its representational content, and that attitude is or can be expressed in part by the way in which the content is conveyed, then producers of egalitarian pornography must intend recipients to take notice of that way, and recipients must do so. Looked at in one way, this is just another internal objection to Levinson's account, further evidence that people do approach pornography in a way he labels 'artistic', and in fact *must* do so if they are to experience it appropriately. But looked at another way, from the point of view of an analytical project, it constitutes a different objection. If we want to use the concept of pornography for feminist purposes, and if Eaton et al. are correct, then Levinson's account of the distinction between pornography and erotic art cannot stand, since it does not allow for the possibility of egalitarian pornography. Levinson might respond that this argument mistakes a largely verbal dispute for a substantive philosophical one. After all, most feminist theorists have used the term 'pornography' in a similar sense, a sense in which 'egalitarian pornography' would be an oxymoron. But it is important to note that this consequence arises for the two theories for very different reasons. This becomes clear when we turn our attention from 'pornography' to 'erotic art'.

[28] How it does this is another complex topic I must pass over, but see Gracyk 1987 and David Davies, this volume.

As Levinson points out, the former term is commonly used pejoratively, while the latter is neutral, perhaps even commendatory. But some of what we commonly label 'erotic art', what Kieran and I, among others, would call 'pornographic art', can eroticize the subordination of women just as easily as what is commonly called pornography. This is a commonplace in art history (e.g. Berger 1972; Duncan 1977; Nead 1992).[29] In discussions of the morality of pornography, however, erotic or pornographic art is commonly overlooked, the focus being on what is *commonly called* pornography—primarily mass-market photographic images, both still and moving. This is a mistake since, if it continues, a significant source of subordinating material may go unnoticed. To the extent that Levinson's account encourages or maintains the overlooking of this kind of representation, it can be criticized from an analytical point of view, as conflating common-usage and descriptive projects.[30] It seems plausible that the reason Levinson's account fails, in descriptive terms, is that hidden ideologies are shaping the way we commonly divide representations into pornography and erotic art.

It is noteworthy that many feminist discussions of pornography can be criticized on the same score. In part, feminists have focused on what is commonly called pornography because it forms a massive socio-economic system, compared to which the contributions of erotic or pornographic art to the oppression of women can seem insignificant. But one should not forget that the honorific nature of the term 'art' is closely connected to a history of gender- and class-based injustice. It is difficult to explain the line between 'art' and 'craft', for instance, without making reference to the fact that crafts are what women and working-class people have traditionally produced (Berger 1972; Mattick 1993; Korsmeyer 2008: part 1).[31] One upshot of this nexus of ideologies is that the cultural status of a particular image—a high-art nude, for instance—may contribute to the oppression of women in a far more powerful way than a representationally similar mass-produced item—a single photograph in a pornographic magazine, say

[29] For an excellent summary of the history of this discourse, and a reformulation and defense of the central claim, see Anne Eaton, this volume.

[30] Of course, this is not to say that *Levinson* encourages such overlooking. Compare what I say about feminist theorists below.

[31] I do not mean to suggest that this is anything like a complete theory of the distinction between art and craft; on the other hand, I doubt any such theory would be complete without some reference to these factors.

(Eaton, this volume). The hidden nature of such ideology means that the contribution pornographic high art makes to the oppression of women might yet be significant, compared to that of mass-market pornography, and even more difficult to see.[32]

References

Berger, John (1972) *Ways of Seeing*. London: British Broadcasting Corporation.

Brison, Susan (2007) '"The Price We Pay"? Pornography and Harm'. In Hugh LaFollette (ed.), *Ethics in Practice: An Anthology*. Malden, Mass.: Blackwell. 377–86.

Brown, Lee. B. (2005) 'Phonography'. In Lee B. Brown and David Goldblatt (eds.), *Aesthetics: A Reader in Philosophy of the Arts*, 2nd edn. Upper Saddle River, NJ: Pearson Prentice Hall. 212–18.

Duncan, Carol (1977) 'The Aesthetics of Power in Modern Erotic Art'. Reprinted in Arlene Raven, Cassandra L. Langer, and Joanna Frueh (eds.), *Feminist Art Criticism: An Anthology*. Ann Arbor: UMI Research Press. 59–69.

Dwyer, Susan (ed.) (1995) *The Problem of Pornography*. Belmont, Calif.: Wadsworth.

Eaton, A. W. (2007) 'A Sensible Antiporn Feminism'. *Ethics* 117: 674–715.

——(2008) *Symposia on Gender, Race and Philosophy* 4(2). Accessed online at <http://web.mit.edu/sgrp/2008/no2/Eaton0508.pdf> 24 July 2009.

Gracyk, Theodore (1987) 'Pornography as Representation: Aesthetic Considerations'. *Journal of Aesthetic Education* 21: 103–21.

Haslanger, Sally(2003) 'Social Construction: The "Debunking" Project' in Frederick F. Schmitt (ed.), *Socializing Metaphysics: The Nature of Social Reality*. Lanham, Md.: Rowman & Littlefield. 301–25.

——(2000) 'Gender and Race: (What) Are They? (What) Do We Want Them to Be?' Reprinted in Ann E. Cudd and Robin O. Andreasen (eds.), *Feminist Theory: A Philosophical Anthology*. Malden, Mass.: Blackwell, 2005. 154–70.

——(2006) 'Philosophical Analysis and Social Kinds: What Good are our Intuitions?' *Proceedings of the Aristotelian Society*, supp. vol. 80: 89–118.

Kania, Andrew (2011) 'Definition'. In Theodore Gracyk and Andrew Kania (eds.), *The Routledge Companion to Philosophy and Music*. New York: Routledge. 1–13.

[32] For helpful discussion of the issues in this chapter, I thank Anne Eaton, Jerrold Levinson, Hans Maes, Christy Mag Uidhir, Alex Neill, and Aaron Smuts. For the opportunity to have some of those discussions, I thank the organizers of the conference Aesthetics Anarchy III, held at Indiana University, Bloomington, in spring 2011: Jonathan Weinberg, Sandra Shapshay, and Michael Rings.

Kieran, Matthew (2001) 'Pornographic Art'. *Philosophy and Literature* 25: 31–45.

Korsmeyer, Carolyn (2008) 'Feminist Aesthetics'. In Edward N. Zalta (ed.), *The Stanford Encyclopedia of Philosophy*, Fall 2008 edition. Accessed online at <http://plato.stanford.edu/archives/fall2008/entries/feminism-aesthetics/> 24 July 2009.

Lehman, Peter (2006) *Pornography: Film and Culture*. New Brunswick, NJ: Rutgers University Press.

Levinson, Jerrold (1979) 'Defining Art Historically'. Reprinted in Levinson 1990a: 3–25.

——(1989) 'Refining Art Historically'. Reprinted in Levinson 1990a: 37–59.

——(1990a) *Music, Art, and Metaphysics: Essays in Philosophical Aesthetics*. Ithaca, NY: Cornell University Press.

——(1990b) 'The Concept of Music'. In Levinson 1990a: 267–78.

——(1993) 'Extending art Historically'. In *The Pleasures of Aesthetics: Philosophical Essays*. Ithaca, NY: Cornell University Press. 150–71.

——(1998) 'What is Erotic Art?' Reprinted in Levinson 2006: 252–8.

——(2002) 'The Irreducible Historicality of the Concept of Art'. Reprinted in Levinson 2006: 13–26.

——(2005) 'Erotic Art and Pornographic Pictures'. Reprinted in Levinson 2006: 259–71.

——(2006) *Contemplating Art: Essays in Aesthetics*. Oxford: Oxford University Press.

MacKinnon, Catharine A. (1987) 'Frances Biddle's Sister: Pornography, Civil Rights, and Speech'. Reprinted in Susan Dwyer (ed.), *The Problem of Pornography*. Belmont, Calif.: Wadsworth, 1995. 52–66.

Maes, Hans (2009) 'Art and Pornography: Essay Review of Jerrold Levinson's *Contemplating Art*'. *Journal of Aesthetic Education* 43: 107–16.

Mattick, Paul Jr. (1993) 'Art and Money'. In Paul Mattick Jr. (ed.), *Eighteenth-Century Aesthetics and the Reconstruction of Art*. Cambridge: Cambridge University Press. 152–77.

Nead, Lynda (1992) *The Female Nude: Art, Obscenity and Sexuality*. New York: Routledge.

Rea, Michael (2001) 'What is Pornography?' *Noûs* 35: 118–45.

Saul, Jennifer (2006a) 'Pornography, Speech Acts and Context'. *Proceedings of the Aristotelian Society* 106: 229–48.

——(2006b) 'Philosophical Analysis and Social Kinds: Gender and Race'. *Proceedings of the Aristotelian Society*, supp. vol. 80: 119–43.

Steinem, Gloria (1978) 'Erotica and Pornography: A Clear and Present Difference'. Reprinted in Susan Dwyer (ed.), *The Problem of Pornography*. Belmont, Calif.: Wadsworth, 1995. 29–33.

West, Caroline (2004) 'Pornography and Censorship'. In Edward N. Zalta (ed.), *The Stanford Encyclopedia of Philosophy*, Fall 2008 edition. Accessed online at <http://plato.stanford.edu/archives/fall2008/entries/pornography-censorship/> 15 October 2010.

13

What's Wrong with the (Female) Nude?

A Feminist Perspective on Art and Pornography

A. W. EATON[1]

In her study on the female nude, Lynda Nead recounts the following story:

On 10 March 1914, shortly after 10:00 a.m., a small woman, neatly dressed in a grey suit, made her way through the imposing entrance of the National Gallery, London. It was a Tuesday and so one of the Gallery's 'free' days. . . . The woman made her way through the Gallery's succession of rooms, pausing now and then to examine a painting more closely or to make a drawing in her sketch book. Eventually she made her way to a far corner of Room 17, where she stood, apparently in rapt contemplation, before a picture on an easel. By now it was approaching lunch-time and the room was beginning to empty of the crowds who filled the gallery on its 'free' days. Suddenly, the tranquility of the museum was broken by the sound of smashing glass. . . . The woman in grey was Mary Richardson, a well-known and highly active militant suffragist; the painting she attacked was Velazquez's 'Rokeby Venus'.[2]

Richardson was brought to court and tried. At her defense, she explained that the attack was meant as retribution for the Government's imprisonment

[1] A distant ancestor of this chapter was presented at the American Society of Aesthetics annual meeting in 2002 where it received helpful comments from Ivan Gaskell, Paul Guyer, and Alexander Nehamas. I presented a substantially revised version at the University of Illinois-Chicago where members of the philosophy department offered challenging comments. Faith Hart and Mary Stroud read the paper carefully and gave lots of good advice. Finally, I am grateful to Hans Maes and Jerry Levinson for their thoughtful and detailed comments. Thank you all for helping me to make this a better chapter.
[2] Lynda Nead, *The Female Nude: Art, Obscenity and Sexuality* (Routledge, 1992), 34.

of Emmeline Pankhurst, also a militant suffragist and founder of the Women's Social and Political Union. But for the purposes of retribution and drawing attention to her cause, *any* treasured artwork would have been a suitable candidate for attack. Why wind her way deep into the museum to go after *this* particular painting? What Richardson did not explain until much later, in an interview in 1952, was that she 'didn't like the way men visitors to the gallery gaped at [the *Rokeby Venus*] all day.'[3]

Even before Richardson made the connection explicit, you'd probably guessed that there was some relationship between her fight against sexism and her disapproval, to put it mildly, of Velasquez's painting. But how, exactly, should we formulate this connection? What, after all, is wrong with gaping at a picture of a beautiful naked woman? How else are you supposed to look to this painting, which, after all, almost *asks* to be looked upon with open-mouthed desire?

Richardson's actions, less than her remarks, indicate that the problem was not so much with the gaping museum patrons as it was with the picture itself. In addition to her motives of retribution and gaining notoriety for her cause, she appears to have found fault with the picture for so candidly catering to the carnal appetites of heterosexual men. But just what is the problem here? Although there are arguments against licentious images in general, puritanical iconoclasm was not the motive in this case. Behind Richardson's attack on Velazquez's painting was, I suggest, a specifically feminist critique of the female nude.

My task in this chapter will be to offer a clear and persuasive formulation of that critique. My aim is neither to uncover Richardson's specific psychological motives, nor to justify her actions. (Just to be clear, I do not advocate the physical destruction of great artworks!) Rather, I aim to explain why the female nude—by which I mean the *genre* of artistic representations that take the unclothed female body as their primary subject matter—has been a target of feminist criticism for nearly a century.

One might ask, How is what has come to be known as 'the problem of the female nude' in need of explanation? After all, in feminist circles it is now taken as an established fact that there is something wrong, ethically speaking, with representing the unclothed female body in the manner that has dominated Western art as far back as one cares to look. But what is self-evident to

[3] From an interview printed in the London *Star*, February 22, 1952. Cited in Nead, *Female Nude*, 37.

feminists is not always clear to those who are not familiar with or not convinced by feminist arguments.

This is especially true in the case of the female nude. After all, some of the finest treasures of Western art fall into this genre, from the Venus de Milo to Titian's *Venus of Urbino* to Ingres's *Grande Odalisque* to Matisse's *Blue Nude*. If these are deeply problematic works, as many feminists contend, their flaw is far from self-evident. Human beings take erotic pleasure in looking at representations of bodies that they find attractive. If there's nothing wrong with this interest—a compelling argument against it has yet to present itself—then what's wrong with pictures that cater to it? Of course, different people will find different kinds of bodies attractive and so, to be fair to all, the artistic tradition should gratify these many different tastes and orientations. But, one might argue, this is the situation in the history of European art: there are hard-bodied Apollo's and David's as well as voluptuous Venuses of all shapes and sizes. On this view it is easier to see why one might think that there's something wrong with representing nudity per se than it is to understand singling out the *female* nude as problematic. If heterosexual women should not feel bad about the pleasures they take in representations of unclothed men, why should heterosexual men feel bad about the pleasures they take in representations of unclothed women? They are, after all, *just representations*.

These are just some of the objections that one unconvinced by feminist arguments might raise against a feminist critique of the female nude. Since it is these unconvinced whom we most need to address, it is important for feminists to speak to such worries. Unfortunately, feminist work on the female nude tends to 'preach to the choir'; that is, it tends to address feminists who are already predisposed to accept the view. Not only will this do little to change the minds of the unconvinced, but it is also bad for feminism because it leaves too much unsupported. We need to continually respond to the kind of critical pressure that is often best formulated by the unconvinced in order to support our views with the best arguments.

My aim in this chapter is to offer a precise, compelling, and jargon-free articulation of the problem, from a feminist perspective, with the female nude. At times this will mean providing new arguments to fill in gaps that have not been addressed; at other times I will simply be making explicit what others have left implicit. I aim throughout to earnestly consider other sides of the issue and, in particular, to take seriously the possibility that there *might not*

be anything at all wrong with the female nude. (I ultimately do not think that this is so, but I intend to give the view its due.) Finally, I also mean to avoid what I take to be a common failing in the philosophy of art, namely allowing one's theory to hover at such a level of abstraction that it's difficult to see how it speaks to actual works of art. Instead, my account of the problems with the female nude will be grounded in the material and historical specificity of the artworks in question. (On this last point I should note that I discuss lots of particular works that cannot be reproduced here. To follow my arguments it will be important to *see* how they are supported by the art. To this end I strongly recommend consulting a visual arts database.)[4]

My account proceeds as follows. Section 1 outlines the general shape of the feminist critique. Section 2, drawing on the work of Martha Nussbaum and Rae Langton, explains how pictures can sexually objectify. Section 3 lends some much-needed precision to the concept of a paradigmatic form of sexual objectification, namely the *male gaze*. Section 4 explains how works of visual art could be said to sexually objectify a *type*, such as 'women,' rather than merely sexually objectify specific women. Section 5 explains what exactly is wrong, from a feminist point of view, with the sexual objectification of women. Section 6 concludes by discussing the implications of this critique for thinking about the relationship between art and pornography.

1. Basic Formulation of the Feminist Critique

Here, in a nutshell, is the most fundamental formulation of the feminist critique of the female nude. Women's subordination has several sources and components, one of the most significant being the sexualization of traditional gender hierarchy; that is, the way in which dominance and related active traits are eroticized for males whereas the contraries are eroticized for females. Insofar as it makes male dominance and female subordination sexy, the female nude is one important source of this eroticization and in this way is a significant part of the complex mechanism that sustains sex inequality.

[4] An excellent and stable database of high quality images of European art from the eleventh to the mid-nineteenth centuries is the Web Gallery of art: <http://www.wga.hu>. (Note that to search this database, you must use artist's names in their original languages, so, for instance, 'Titian' = 'Tiziano'.) In addition, most major museums now offer online databases of their collections.

Stripping things down in this way makes it clear what the female nude has in common with pornography, at least from one kind of feminist perspective, namely one that has its roots in J. S. Mill and is more fully developed by Catharine MacKinnon. The basic idea here is that the eroticization of gender hierarchy lies at the heart of women's subordinate position in society.[5] In particular, people's—both men's *and women's*—experience of sexual desire and standards of sexual attractiveness have been systematically shaped in a way that renders women's subordination and men's dominance sexy. Erotic representations, according to this line of thought, have a powerful influence over our erotic tastes and are an important source of this eroticization of sex hierarchy. The female nude and pornography—in particular what I have called *inegalitarian pornography*[6]—are two important kinds of erotic representation that feminists single out for criticism on these grounds.

Despite this important similarity between the female nude and pornography, there are significant differences between the female nude and inegalitarian pornography in terms of their roles in promoting and sustaining the sexual objectification of women, as I shall suggest in the final sections of this chapter. Before we can explore these similarities and differences, however, we need to clarify the terms of the feminist critique of the female nude and anticipate some objections.

First, as briefly mentioned above, by 'female nude' I mean the genre of artistic representations that take the unclothed female body as their primary

[5] Mill observed that 'a means of holding women in subjection [is] representing to them meekness, submissiveness and resignation of all individual will into the hands of a man, as an essential part of sexual attractiveness' (*The Subjection of Women* [1869], ed. Susan Okin (Hackett, 1988), 16). Mill mentions this only in passing, but the idea that the eroticization of gender hierarchy plays a significant role in sustaining that hierarchy has been developed most fully and notably by Catharine MacKinnon in *Toward a Feminist Theory of the State* (Harvard University Press, 1989), chs. 6 and 7 and in *Feminism Unmodified* (Harvard University Press, 1987), chs. 2 and 3, although she does not, to my knowledge, see Mill as a source. MacKinnon argues convincingly that gender difference itself is the effect of power imbalance: 'Male and female are created through the eroticization of dominance and submission' (*Toward a Feminist Theory of the State*, 113, my emphasis). Pornography, she famously argues, plays an integral role in this eroticization. Where I agree with this as a characterization of what I call *inegalitarian pornography*—which, I should note, characterizes mainstream heterosexual pornography for men, as well as some other—I think it a grave mistake for MacKinnon to cast this is a feature of pornography per se. Her refusal to acknowledge that some forms of pornography can sidestep—much less *thwart*—the eroticization of male dominance and female subordination is what leads many to suspect—wrongly, I think—that sex-negativity motivates her feminism. I develop this point in 'A Sex-Positive Antiporn Feminism' (forthcoming).

[6] Prompted by an interesting essay by Larry May, I make the distinction between *egalitarian* and *inegalitarian* pornography in 'A Sensible Antiporn Feminism,' *Ethics* 117(4) (July 2007), 674–715.

subject matter.[7] As with antiporn feminism, the feminist critique of the female nude depends on a generalization about the *dominant mode* of this genre, namely that it sexually objectifies women. There are, of course, exceptions to this generalization, some of which I discuss below. This is to say that *not* all artistic representations of the female nude sexually objectify, just as not all pornography sexually objectifies women. But the predominant form of heterosexual pornography,[8] like the predominant form of the female nude in the European artistic tradition, are both deeply sexually objectifying of women. Indeed, the fact of the predominance of this way of representing the unclothed female body is itself part of the problem from a feminist perspective, as I argue in the final section of this chapter.

Second, in saying that the female nude promotes and sustains sex inequality I in no way mean to suggest that it, or even sexual objectification generally, is single-handedly responsible for gender inequality. Rather, gender inequality should be understood as *systemic* in nature, which is to say that there is no single element sufficient for the injustices women suffer. In the form it takes today, gender inequality is a complex whole sustained by a functionally related group of interacting, interrelated, interdependent, and diverse elements: exploitation in the workplace, everyday practices and rituals, representations of various sorts, rules and regulations, mores and customs, violence and the threat thereof, and so forth.[9] Singling out any one element for critical analysis risks giving the false impression that one is holding it solely responsible for women's oppression. This is what I mean to dispel here. The female nude as I describe it below is but one element in a system of oppression; it is, however, a significant element.

Third, I do not mean to suggest that the female nude is or was ever responsible for women's lack of rights. But feminists have long realized that there is much more than lack of rights underpinning women's subordin-

[7] I stand by this generalization for nearly all artistic traditions in human history. In this chapter, however, I shall be concerned with the European artistic tradition.

[8] Elsewhere I make the case that only a subset of all pornography is problematic from a feminist perspective. However, this subset, which I dub *inegalitarian porn*, is by far the dominant form of pornography. See my 'A Sensible Antiporn Feminism'.

[9] This point is persuasively argued in the following now classic essays. Marilyn Frye, 'Oppression', in *The Politics of Reality* (The Crossing Press, 1983), 1–16. Iris Marion Young, 'Five Faces of Oppression', *Philosophical Forum* 19(4) (1998), 270–90. Sandra Bartky, 'On Psychological Oppression', in *Femininity and Domination: Studies in the Phenomenology of Oppression* (Routledge, 1990), 22–32.

ation.[10] In addition to its economic and legal dimensions, sex oppression also has significant social and psychological dimensions. One such significant dimension, which many feminists have gone to great lengths to articulate with subtlety and detail, is men's and women's internalization of an erotic taste that manifests, promotes, and sustains male dominance.[11] In particular, women and men both learn to eroticize men's ascendancy over women. (Consider, for instance, the very common preference—on the part of both heterosexual men and women—that a man be taller than his female mate. This is just one example of the eroticization of a subtle form of male dominance and female subordination that permeates our everyday experience.) Because erotic desire plays such an important role in most peoples' lives, the eroticization of sex inequality is a significant way that this inequality is sustained and reproduced.

But what, one might wonder, does any of this have to do with pictures and other representations of unclothed women? The short answer is that representations of various sorts shape our erotic taste by making gender inequality sexy. Advertising, television, movies, popular music and videos, pornography, and high art encourage and entice us to connect sexual desire with women's inferiority to men. Although the nude is just one among many such representations, it plays a special role in the eroticization of sex inequality, as explained in the final section below.

At this point one might object that the source of the eroticization of male dominance and female submissiveness evident in the female nude and pornography is natural rather than cultural.[12] The general idea at work here is familiar: our female ancestors who chose dominant males (and vice versa) enjoyed greater reproductive success. The taste for male dominance and female passivity were advantageous for early hominids as they faced a host of challenges in their environment. In this way, the inegalitarian shape of the dominant mode of erotic taste, which so many feminists decry, is an evolutionary adaptation that has become hardwired into our

[10] See Ann E. Cudd, *Analyzing Oppression* (Oxford University Press, 2006) for an excellent summary and also compelling original arguments.

[11] Bartky, Frye, MacKinnon, and Mill op. cit. Simone de Beauvoir is another important source for this thought: *The Second Sex*, trans. Borde and Malovany-Chevallier (Vintage, 2011; original 1949), especially vol. ii, chs. 3, 5, 7, 10, and 12.

[12] This kind of objection to a feminist critique is common but this particular formulation in relation to the female nude comes from Jerrold Levinson.

basic physiological and psychological makeup. As evolutionary psychologist David Barash puts the point, 'There is good reason to believe that we are (genetically) primed to be much less sexually egalitarian than we appear to be.'[13]

A full response to this kind of sociobiological objection deserves a study of its own and I can only gesture at a response here. First, an enormous amount of work must be done to make the point scientifically viable: a specific trait must be isolated, it must be shown to be genetically heritable, and it must be demonstrated to be an adaptation rather than the result of drift, mutation, or recombination. This is a tall order that few, if any, sociobiological accounts have filled.[14] But let us assume that our erotic tastes and sexual behaviors are 'natural' in the sense that they evolved through a process of natural selection, as the objection maintains. First, we must distinguish between what selection favors and what is morally right and just. Whether natural or not, eroticizing women's subordination to men is morally wrong—at least wherever women as a group are subordinate to men, which is the context in which we find ourselves today—and should be thwarted as much as is reasonable given other constraints. But, our objector might protest, if these preferences and tendencies are hardwired in the sense just described then they are inevitable and so it is senseless to speak of a moral obligation to override it. This brings me to my second point, namely that genes do not determine human behavior.[15] For one thing, phenotypes often differ under varying conditions,[16] and for another, cultural transmission of ideas, values, skills, and tastes is a significant source of human behavior.[17]

[13] David Barash, *The Whisperings Within* (Harper and Row, 1979), 47.

[14] See Philip Kitcher, *Vaulting Ambition: Sociobiology and the Quest for Human Nature* (MIT Press, 1985) for a strong doubts that sociobiology could ever fill this order.

[15] Sociobiologists whose work might be cited as support for the above objection themselves acknowledge this very point. For instance, in their controversial *A Natural History of Rape: Biological Bases of Sexual Coercion* (MIT Press, 2000) Randy Thornhill and Craig Palmer argue that rape is either the by-product of an adaptation or an adaptation itself. However, they insist that rape can be prevented when its evolutionary causes are taken into account. For criticisms of this book, see Cheryl Brown Travis (ed.), *Evolution, Gender and Rape* (MIT Press, 2003).

[16] Anne Fausto-Sterling puts the point this way: 'in animals and humans alike, male-female interactions around sex and the rearing of offspring are variable matters. Depending on their environments, both sexes can exhibit a wide range of behaviors. Changing the environment can change a set of behaviors.' 'Beyond Difference: Feminism and Evolutionary Psychology,' in Hilary Rose and Steven Rose (eds.), *Alas, Poor Darwin: Arguments Against Evolutionary Psychology* (Jonathan Cape, 2000), 184.

[17] Peter Richerson and Robert Boyd are long-standing proponents of this view. See, for instance, *Culture and the Evolutionary Process* (University of Chicago Press, 1985) and *Not By Genes Alone: How Culture Transformed Human Evolution* (University of Chicago Press, 2005).

The latter is the focus of the critique presented here where the idea is not, to repeat myself, that a particular cultural form is single-handedly responsible for sexist attitudes and conduct. Rather, the feminist critique presented here maintains that in its sexual objectification of the unclothed female body, the female nude is one significant source of the values that sustain and perpetuate male dominance.

In making this case we encounter three difficulties. First, it is not so easy to spell out exactly what it means for a visual representation to *sexually objectify* anyone. *People* objectify people, but can a picture do this? If so, how are we to distinguish sexually objectifying pictures from, for instance, anatomical renderings of the unclothed female body, on the one hand, and avowedly feminist representations of the same, on the other? Second, it is far from obvious that there is anything wrong with sexual objectification in the first place. After all, many consider objectification to be a normal and even healthy part of human sexuality. If it is acceptable for women to objectify men, for men to objectify men, and for women to objectify women, what is the problem with men sexually objectifying women? If there is a problem with sexual objectification in general, what is it? Third and finally, even if one can explain how pictures sexually objectify and explain what is wrong with this in the case of the female nude, there remains the problem of explaining how a picture can be said to sexually objectify *woman in general*. With few exceptions, visual representations appear to trade in *tokens*, not types. Pictures, so it would seem, do not have access to the concept 'woman' in general; rather, pictures appear to depict only *particular* naked women. Even if you thought that the sexual objectification of the woman in, for instance, Ingres's *Ruggiero Rescuing Angelica* (1819, Musée du Louvre) were obvious, it might still seem a stretch to say that the picture comments on women in general, and so an even further stretch to claim that it harms women as a group.

These are the sorts of questions that a compelling feminist critique of the female nude must address. I mean to put these worries to rest by answering each of these questions below.

2. Sexually Objectifying Pictures

We shall make our way through some of the questions just raised by starting with the claim that representations of the female nude sexually objectify women.

Even if you do not agree that the genre of the female nude is marked by a predominant tendency to sexually objectify women, the meaning of the claim may at first blush seem clear and unproblematic: a group of pictures and other representational works represent something that is not an object— namely a woman—as if she were an *object*, and in particular a *sexual* object. But this seemingly straightforward formulation of the purported problem raises questions. What exactly is involved in depicting a person *as if she were an object*? This question is particularly tricky in the case of purely visual representations (by which I mean: paintings, photographs, drawings, engravings, and sculpture) because they are non-verbal and do not have recourse to, for instance, *similes* as one does in language. One can use language, as Balzac did, to express the thought that a 'woman is like a lyre which gives up its secret only to him who knows how to play it.'[18] But how could you paint, sculpt, or draw a figure in such a way that she seemed both 'like a lyre' and like a woman?

Before I begin my explanation of the mechanisms of objectification available to the *visual* arts, we need to get clear about two things. First, objectifying pictures need not represent objectifying acts or states of objectification. Second, not all pictures representing objectifying acts or states of objectification are themselves objectifying pictures. On this last point, imagine, for instance, a picture that simply *documented* an act of rape.

With these clarifications in mind, let us begin our examination of objectifying pictures with the concept *objectification*. To objectify is to treat as a mere thing something that is in fact not a thing. Martha Nussbaum has persuasively shown that there are a variety of conceptually distinct ways to treat a person as a thing. (Note that in practice several of these may overlap in a single instance of objectification). Since her analysis is well known, I shall only briefly summarize the different things that may be involved in treating a person *as an object*:[19]

1. Instrumentality: to treat a person as a tool for her purposes
2. Denial of autonomy: to treat a person as lacking autonomy and self-determination

[18] Quoted in Simone de Beauvoir, *Second Sex*, 397. The Balzac quote comes from *Physiologie du marriage*.

[19] Martha Nussbaum, 'Objectification,' *Sex and Social Justice* (Oxford University Press, 1999), 213–39. Her outline of these seven dimensions of objectification begins on p. 218.

3. Inertness: to treat a person as lacking agency and perhaps also activity

4. Fungibility: to treat a person as interchangeable with (a) other objects of the same type and/or (b) objects of other types

5. Violability: to treat a person as lacking boundary integrity, as something that it is permissible to smash up or break into

6. Ownership: to treat someone as a thing that is owned and that can perhaps be bought, sold, traded, given away, or acquired

7. Denial of subjectivity: to treat someone as something whose experience and feelings need not be taken into account.

To this list Rae Langton has recently added a few more:[20]

8. Reduction to body: to treat a person as identified with her body or body parts

9. Reduction to appearance: to treat a person primarily in terms of how she appears to the senses.

10. Silencing: to treat a person as silent, lacking the capacity to speak.

Taking these ten 'faces' of objectification as a starting point, I suggest that there are nine ways in which artworks belonging to the genre of the female nude objectify the person or people represented. Each of these incorporates several of the different modes of objectification outlined by Nussbaum and Langton. As with Nussbaum's and Langton's lists, my list aims to make explicit the conceptually distinct visual means of objectification, means that are not mutually exclusive and are even sometimes mutually entailing. In practice, as we shall see, a single artwork can objectify the unclothed female body in several of the ways described here.

2.1. Visual metaphor

The work suggests an analogy between a person and an inert thing through visual similarity and proximity. Often the inert thing to which the woman is compared is an object to be consumed or used as a means to some end. Examples:

[20] Rae Langton, 'Autonomy-Denial in Objectification,' from *Sexual Solipsism: Philosophical Essays on Pornography and Objectification* (Oxford University Press, 2009), 223–40.

A. Woman as musical instrument: Titian's various 'Venus and Musician' paintings[21] or Man Ray, *Le Violon d'Ingres* (1924, Getty Collection).[22]
B. Woman as vessel: Ingres, *La Source* (1820, Musée d'Orsay, Paris).
C. Woman's body or body-part as fruit: Paul Gaugin, *Two Tahitian Women* (1899, Metropolitan Museum of Art, New York).

2.2. Eroticization of violation

The work makes the physical violation of a woman sexy. Examples:

A. Eroticization of rape: Titian, *Rape of Europa* (1559–62, Isabella Stewart Gardner Museum, Boston); Rubens, *Rape of the Daughters of Leucippus* (1670, Alte Pinakothek, Munich)[23]
B. Eroticization of physical destruction: Delacroix, *The Death of Sardanapalus* (1827, Musée du Louvre, Paris).

2.3. Foregrounding of erogenous zones

Figure is posed so as to make breasts, pubis, and/or buttocks the focus, often while minimizing or even erasing any traces of subjectivity. Examples:

A. Giorgione's *Sleeping Venus* (*c.*1510, Gemäldegalerie, Dresden) is the prototype for a whole tradition of recumbent nudes. The figure's bodily position is marked by a noticeable vulnerability and availability that cannot be explained by sleep; rather, the function of the pose is to emphasize vulnerability and to provide maximal visual access to erogenous zones. (The so-called *pudica* gesture, by the way, calls attention to that which it supposedly hides, and the shape of the hand itself

[21] Titian and his workshop produced several paintings representing a nude Venus reclining on a lusciously draped couch in the company of a male musician fully dressed in contemporaneous patrician clothing playing a lute or an organ. In several cases, the musician stares directly at Venus' crotch or breasts, as in the most famous of these examples, *Venus with Organist and Cupid* (1548, Museo del Prado, Madrid).

[22] 'Violon d'Ingres' is French idiom that means 'hobby,' especially an artistic hobby. Not only does this photograph objectify by turning the armless female torso into a musical instrument, but the title suggests that this female model, Kiki, was a 'hobby' of Man Ray's.

[23] The eroticizing representations of rape from the fifteenth through nineteenth centuries are too numerous to even begin to enumerate here. During the mid- to late Renaissance, such fantasies were protected from moral scrutiny by a mythological veneer: the eroticized and violated unclothed bodies were lent moral and cultural respectability by being represented as Danaë, Leda, Io, Europa, or a generic nymph. For a good analysis, see Diane Wolfthal, *Images of Rape: The 'Heroic' Tradition and Its Alternatives* (Cambridge University Press, 1999), ch. 1, especially '"Heroic" Rape Imagery.' See also A. W. Eaton, 'Where Ethics and Aesthetics Meet,' in *Hypatia: A Journal of Feminist Philosophy* (Winter 2003), 159–88.

is a visual metaphor for the genitals 'concealed' below it.)[24] Her subjectivity is important only insofar as her loss of consciousness emphasizes her utter passivity and vulnerability.

2.4. Divided into sexual parts

A more extreme version of 2.3 above, the work does not even represent the entire person but only erogenous parts.

A. Courbet, *L'Origine du monde* (1866, Musée d'Orsay, Paris)
B. *L'Action enchaînée* (Enchained Action) (1906), a larger-than-life head-less and limbless unclothed torso by Maillol that for many years was the centerpiece of the grand staircase of the Art Institute of Chicago.

2.5. Generic body

Typically the female nude is a generic figure that lacks any suggestion of a unique personality, particular identity, or distinctive qualities. Rather, the nude is simply one of the many sexually available bodies that constitute the type. While this feature is best seen with the entire genre or even an oeuvre taken into consideration—e.g. all of Titian's unclothed women are virtually identical—there are a few famous single works offering a super-abundance of generic docile soft bodies that make this point:

Examples:

A. Ingres, *Le Bain turc* (Turkish Bath) (1862, Musée du Louvre, Paris) or Bouguereau, *Les Oréades* (1902).
B. 'Bathers,' a favorite modernist theme, offered an opportunity to cram into a single canvas many female nudes in various poses of sexual availability. Gauguin, Matisse, Picasso, Renoir, and Seurat, for in-stance, made several versions.

[24] For a shrewd and informative discussion of the origins of the *pudica* gesture, see Nanette Solomon, 'Making a World of Difference: Gender, Asymmetry, and the Greek Nude,' in Ann Olga Koloski-Ostrow and Claire L. Lyons (eds.), *Naked Truths: Women, Sexuality, and Gender in Classical Art and Archaeology* (Routledge, 1997), 197–219.

2.6. Eroticization of passivity, powerlessness, and lack of autonomy

Some already mentioned do this (e.g. Giorgione, Titian, Rubens, Delacroix), but also consider the popular theme of 'nymph and satyr'; e.g. Correggio's famous version (1524–5, Musée du Louvre, Paris) and the many versions produced by Picasso.

2.7. Diegetic surveillance or self-surveillance

The work makes the unclothed female the object of someone's gaze within the diegetic world of the work, thereby thematizing her function as a means to the end of the viewer's erotic visual gratification. We have already seen some works that do this like Gaugin's *Tahitian Women*. But the unclothed female is often also the object of her own gaze, demonstrating her internalization of 'the male gaze' (more on this in the next section).

A. Velazquez's *Rokeby Venus* or Titian's many representations of Venus with a mirror.[25]
B. Hans Memling, *Vanity* (1485, Musée des Beaux-Arts, Strasbourg).

As John Berger notes, such works not only sexually objectify women but also morally condemn them for it.[26]

2.8. Gratuitous nudity

By this I mean two things:

A. First, nudity can be gratuitous in the sense that it is not called for by the narrative circumstances in the picture. Consider, for instance, Titian's famous *Bacchanal of the Andrians* (1523–4, Museo del Prado, Madrid), where the nude strikes a familiar vulnerable and revealing pose while playing no role in diegetic events and remaining utterly unintegrated into the composition. As in so many works in this genre, the nude is there to serve as sexual eye candy and nothing more.
B. Nudity can also be gratuitous in the sense that even when there is a narrative motivation for the figure's state of undress, this only thinly disguises the *real* point of such pictures which, once again, is to offer a

[25] Titian and his workshop did several versions of this, the most famous of which is from 1555 and now hangs in the National Gallery, Washington DC.

[26] John Berger, *Ways of Seeing* (Penguin Books, 1972), 51.

titillating view of an unclothed female body. In fifteenth- and sixteenth-century Europe, for instance, an artist couldn't get away with the bold and unapologetic display of the female body for the sake of the viewer's erotic pleasure alone, so she was Venus, or some other figure revived from ancient mythology. This pretext was *evident as such* to artists and patrons from the beginning.[27] This need for a mythological pretext persisted through the mid-nineteenth century—consider the *Birth of Venus* by Cabanel (1865) and Bouguereau (1879), both in the Musée d'Orsay—although it is plainly obvious that the mythological veneer hardly explains the writhing poses of utter surrender and availability. Although Venus was just born, you might say that she comes into the world ready for immediate use.

2.9. Passive poses of availability and surrender

The classic pose for the female nude is (a) recumbent, (b) frontal (so that pubis and breasts are in full view), and (c) often with one arm raised above

[27] Consider the following famous example. The Duke of Urbino, the eponymous first owner of Titian's famous paining, in a letter from March 9, 1538, referred to it *not* as 'Venus' (*la Venere*) but, rather, as 'the naked lady' or 'the nude lady'; the words are the same in Italian—*la donna nuda* (Georg Gronau, *Documenti artistici urbinati*, Raccolta di fonti per la storia dell'arte, vol. i (Florence, 1936), 93, no. XXXI). The same phrase was used in 1598 by a man writing to the Duke to ask for a copy, to which the Duke responded that he preferred not to be identified as the painting's owner, explaining that he only kept this 'lascivious work' in his collection because it was by Titian (see Charles Hope, '"*Poesie*" and Painted Allegories', in J. Martineau and C. Hope (eds.), *The Genius of Venice, 1500–1600* (Abrams, 1984), 36). Titian himself acknowledged the *real* point of some of his most important mythological paintings in a letter to his patron, Philip II of Spain, who commissioned a set of mythological paintings featuring unclothed women. After having sent the first painting in the series, the *Danae*, Titian wrote to Philip to announce the shipment of the second painting which was to be a pendant of the *Danae*, namely the *Venus and Adonis*. Titian writes: 'And as the Danae which I have already sent to Your Majesty is seen entirely from the front, I want to vary it in this other [painting], showing the figure from the opposite side; thus the room in which they are to hang will be more appealing' (*Raccolta di lettere sulla pittura, scultura ed architettura* (Rome, 1757), ii. 22). This letter makes it clear that the woman's posture in these pictures is explained *not* by some narrative event in the painting but, rather, by the desire to provide maximal visual access to the unclothed female body, and in particular to erogenous zones which are foregrounded and highlighted through a variety of compositional devices. I mean to suggest that what is driving these pictures is not the mythological narrative but rather the viewer's erotic titillation; this is their function, their *raison d'être*. For a compelling account of Titian's mythological paintings along these lines, see Charles Hope, 'Problems of Interpretation in Titian's Erotic Paintings', in Massimo Gemin and Giannantonio Paladini (eds.), *Tiziano e Venezia, Convegno Internazionale di Studi, Venezia, 1976* (Vicenza, 1980), 11–24. For a sophisticated treatment of these issues with respect to the *Venus of Urbino* in particular, see the essays in Rona Goffen (ed.), *Titian's Venus of Urbino* (Cambridge University Press, 1997).

head. The pose is passive, unprotected, vulnerable, and suggests sexual availability.[28]

Examples:

A. Giorgione's *Sleeping Venus*, mentioned above, is the prototype for this pose whose influence one can still see in twentieth-century master-pieces such as Matisse, *Blue Nude (Nu bleu, Souvenir de Biskra,* 1907, Baltimore Museum of Art) and Picasso, *Les Demoiselles d'Avignon* (1907, Museum of Modern Art, New York).

3. The Male Gaze

My brief analysis of the various means by which a work of visual art can sexually objectify makes it clear that the primary function of the female nude is to provide visual erotic pleasure. But, many feminists hasten to remind us, this erotic pleasure is of a gendered sort. This brings us to the familiar concept of 'the male gaze':[29] the female nude, it is often said, is first and foremost characterized by works that cater to male interests and desires. Despite the term's common currency, particularly in art history and gender studies, 'the male gaze' remains murky and in need of clarification.

There is a temptation to understand the concept empirically, as if it described actual audiences and their viewing practices. Conceived this way, 'the male gaze' is taken to designate, for instance, the desirous, open-mouthed stare of the museum patrons who provoked the *Rokeby Venus'* attacker. But if this is what is meant by the concept, then it privileges heterosexual male viewers while ignoring the many others who were exposed to these pictures from their inception. This leads one to ask, as some frustrated critics have, What of the heterosexual *women* who have been looking at these pictures over the ages? What of the *homosexual* men? What of the *lesbians*? Why should we say that the female nude is any more an

[28] Sociologist Erving Goffman makes a similar observation with respect to the ubiquity of this pose for women in advertising: 'a recumbent position is one from which physical defense of oneself can least well be initiated and therefore which renders one very dependent on the benignness of the surround. (Of course, lying on the floor or on a sofa or bed seems also to be a conventionalized expression of sexual availability.)' Erving Goffman, *Gender Advertisements* (Harper Torchbooks, 1979), 41.

[29] The term 'male gaze' was first coined in Laura Mulvey's now classic and widely reproduced essay, 'Visual Pleasure and Narrative Cinema', *Screen* 16(3) (Autumn 1975), 6–18.

object of the *male* gaze than it is of, say, the *female* gaze, or better, the *lesbian* gaze?[30]

However well-meaning, such questions are misguided.[31] This is because 'the male gaze' is best construed *not* as an empirical concept meant to describe actual viewing practices on the part of audiences, even in cases where a description of this sort is accurate. Rather, 'the male gaze' should be understood as *normative*, referring to the sexually objectifying 'way of seeing,' to use John Berger's term, that the work in question solicits.[32] To say that a work embodies *the male gaze* is to say that it calls upon its audience to 'see' (whether literally or figuratively[33]) the woman represented—in this case the unclothed female body—as primarily a sex object. To describe this 'way of seeing' as 'male' is not to claim anything about how all, or even most, men respond to such pictures; rather, it is to note that this is the 'way of seeing' proper to someone in the masculine social role, a role which, it should be noted, is avowedly heterosexual. (For this reason it would be more fitting to call this ideal viewing position the *masculine* gaze.)

A related common but misguided conception of 'the male gaze' is the assumption that works embodying this way of seeing address men exclusively. This is understandable since works like those we have been considering have the obvious function of arousing the erotic desires of heterosexual men. As art historian Charles Hope puts the point about *Venus of Urbino* and similar paintings by Titian, 'The implication is that these pictures were for the most part mere pinups, and that the girls were seen as little more than sex objects.'[34] However, I suggest that both pinups and high art nudes address women as well, although the *function* of these representations is importantly different in each case. The nude is one of those cultural forms that teaches

[30] See, for instance: bel hooks, 'The Oppositional Gaze', in hooks, *Black Looks: Race and Representation* (South End Press, 1999); Mary Devereaux, 'Oppressive Texts, Resisting Readers, and the Gendered Spectator', in Peg and Carolyn Korsmeyer (eds.), *Feminism and Tradition in Aesthetics* (University Park, Pennsylvania State UP, 1995).

[31] I mean that these questions misunderstand the normative nature of the concept *male gaze*. I decidedly do not mean that inquiries into female spectatorship are misguided. In film theory, Mary Ann Doane was one of the first to raise the question of female spectatorship with her essay 'Film and the Masquerade: Theorizing the Female Spectator', *Screen* 23(3–4) (September–October 1982), 74–87.

[32] I first made this case in 'Feminist Philosophy of Art', *Philosophy Compass* 3(5) (September 2008), 873–93. One could correctly apply the concept 'male gaze' to a work that had never been viewed by a single man. What one would mean, in such a case, is that the work prescribes to its viewers a particular 'way of seeing', namely seeing the woman represented as primarily a sex object.

[33] I mean to leave open the possibility that a verbal description could embody the male gaze.

[34] Charles Hope, 'Problems of Interpretation in Titian's Erotic Paintings', 119.

women to see themselves in terms of masculine interests. As Mill might have put the point, the female nude is an important part of how women learn that 'meekness, submissiveness and resignation of all individual will into the hands of a man, [are] an essential part of [their] sexual attractiveness.'[35] By representing inertness, passivity, violability, and lack of autonomy *as* sexually attractive characteristics in females, the nude eroticizes objectification and subordinance. And insofar as the nude is one of those cultural forms that emphasizes our appearance and sexual appeal above all other characteristics, it offers an ideal of feminine self-understanding in which our sexual appeal to men becomes, as Mill puts it, 'the polar star' of our identity.[36]

The narcissism that results from this learned obsession with our appearance and sexual attractiveness itself becomes a theme of the genre, as noted in number 7 in my list above. The nude is not just a sight for the masculine gaze; she is a thing to be looked at *even by herself*, although always evaluated through masculine eyes. As art historian John Berger astutely puts the point,

A woman must continually watch herself. She is almost continually accompanied by her own image of herself. Whilst she is walking across a room or whilst she is weeping at the death of her father, she can scarcely avoid envisaging herself walking or weeping. From earliest childhood she has been taught and persuaded to survey herself continually.[37]

The male gaze is to be internalized by men and women alike. It is for this reason that I say that the female nude's target audience, then, is both sexes.

This is not to say, however, that the nude's male and female audiences are somehow *forced* to take up the male gaze. A viewer could be either *unable* or *unwilling*, perhaps for ethical reasons, to look upon the nude in the way that

[35] John Stuart Mill, *The Subjection of Women*, ed. Susan M. Okin (Indianna: Hackett, 1988 [1869]), 16.

[36] Ibid. Sandra Bartky makes a similar point: 'Subject to the evaluating eye of the male connoisseur, women learn to evaluate themselves first and best' (Bartky, 'On Psychological Oppression', 28).

[37] Berger, *Ways of Seeing*, 46. It is worth noting that Berger's point is part of a larger observation about the role of 'double consciousness' in oppression. The term 'double consciousness' comes to us from DuBois in describing the situation of African-Americans as: 'a world which yields him no true self-consciousness, but only lets him see himself through the revelation of the other world. It is a peculiar sensation, this double-consciousness, this sense of always looking at one's self through the eyes of others, of measuring one's soul by the tape of a world that looks on in amused contempt and pity' ('Of Our Spiritual Strivings' in *The Souls of Black Folk* (CreatSpace, 2011; original 1903). Bartky assimilates the concept to sex oppression ('On Psychological Oppression') and although Berger does not explicitly use the term, I take him to be making a similar point about the female nude and the male gaze.

the pictures prescribe. Nothing prevents imaginative resistance[38] to the male gaze, but such resistance is bound to interfere with one's appreciation of the work in question. A viewer who refused to inhabit the male gaze would be unable to properly appreciate, for instance, Velazquez's painting, and there are deep questions, that I cannot explore here, about whom or what is to blame for this failure: the painting or the viewer.[39]

For the moment, let us consider the question of whether all representations of the female nude are necessarily marred by the male gaze. Is it possible to represent the unclothed female figure in a manner that does *not* sexually objectify?

I'll address this question by way of an example: Artemisia Gentileschi's *Susanna and the Elders* (1610, Pommersfelden). In the Apocryphal story from the Book of Daniel, Susanna is in her garden bathing when attacked by two elders of her community who plan to rape her. They threaten her but she does not give in and, after a series of complicated events, they are tried and convicted for their crime. From the fifteenth to the eighteenth centuries, the story provided a pretense for displaying the unclothed female body, much like Lucretia or Venus or Danaë, but unlike these others, the Susanna story was (1) sanctioned by its Christianity and, more important for our purposes, (2) offered heightened erotic appeal by its inclusion of two lecherous men.[40]

Artists before and after Artemisia's time typically represented the moment *before* Susanna notices the elders, when she is is calmly going about her bath,

[38] For a recent summary of the philosophical literature on imaginative resistance, see Tamar Gendler, 'Imagination', in Edward N. Zalta (ed.), *The Stanford Encyclopedia of Philosophy* (Fall 2011 edn.), <http://plato.stanford.edu/archives/fall2011/entries/imagination/>, especially section 5.2.

[39] To get started on this very interesting question, see the debate between Berys Gaut and Daniel Jacobson. Gaut, I think, would say about such a case that the picture in question is at fault and, further, that this kind of moral failing is of an aesthetic sort. See Berys Gaut, 'The Ethical Criticism of Art', in Jerrold Levinson (ed.), *Aesthetics and Ethics: Essays at the Intersection* (Cambridge: Cambridge University Press, 1998), 182–203; 'Art and Ethics' in B. Gaut and D. Lopes (eds.), *The Routledge Companion to Aesthetics*, 2nd edn., pp. 431–43; and Berys Gaut, *Art, Emotion and Ethics* (Oxford: Oxford University Press, 2009), especially ch. 6. Daniel Jacobson, by contrast, would argue that in such a case the audience would be at fault for lack of imaginative delicacy. See Jacobson, 'In Praise of Immoral Art', *Philosophical Topics* 25 (1997), 172ff.

[40] I owe this observation to Mary Garrard, *Artemisia Gentileschi* (Princeton University Press, 1989), 191. As evidence, Garrard cites the following description of Rubens's several representations of Susanna by the Belgian writer, literature critic, and curator of the Plantin-Moretus Museum in Antwerp, Max Rooses: 'Il est permis de croire que, pour lui, le charme du sujet n'était pas tant la chasteté de l'héroïne biblique que l'occasion de montrer une belle femme nue, *deux audacieux qui tentent une enterprise gallante*, et les emotions fort diverses qui en résultent pour chacun de personages' (my emphasis). Max Rooses, *L'Oeuvre de P. P. Rubens: Histoire et description de ses tableaux et dessins*, 5 volumes (Antwerp: J. Maes, 1886–92), i. 171. Cited in Garrard, p. 530 n. 21.

with little to distract us from the visual center of the picture, namely her voluptuous and opalescent body. Consider, for instance, Tintoretto's version *Susanna and the Elders*, (c.1555–6, Kunsthistorisches Museum, Vienna). By contrast, the core of Artemisia's painting is, as Mary Garrard aptly puts it, 'the heroine's plight, *not* the villain's anticipated pleasure.'[41] In Artemisia's picture Susanna's body is not idealized by contemporaneous standards: notice the groin wrinkle, the lines in her neck, her hanging breast, and her awkwardly proportioned legs and reddish feet. Further, unlike many of the nudes we've seen thus far, Susanna's subjectivity is foregrounded in the psychological anguish expressed on her face, in her unusually well-defined gesture of resistance and hiding, and in her contorted posture. In contrast to the weak, passive, positively limp nudes we've seen thus far, Artemesia's Susanna is a *figura serpentinata*, an artistic term for this type of energetic spiral pose characteristic of Mannerist art. The pose conveys the potential energy of a wound coil about to spring, and for this reason was in this period typically reserved for male figures. In these ways, Artemisia's Susanna is shown as heroic in her struggle against forces of evil. Although the picture represents her unclothed and represents her sexual objectification, it does so without sexually objectifying her.

Here we have an example of the point made at the start of section 2 that there is an important conceptual distinction between a representation *of* sexual objectification and a sexually *objectifying* representation. Whereas the latter prescribes the male gaze, the former could *register* the male gaze without *endorsing* it; this, I argue, is how Artemisia's *Susanna* works. (This is not to say that a representation cannot both sexually objectify *and* represent sexual objectification: Tintoretto's *Susanna* and Titian's *Rape of Europa*, mentioned above, do both.)

4. Types, not Tokens

Thus far I have made the case for a peculiarly *pictorial* means of sexual objectification. I wager that this constitutes the dominant mode of representing the unclothed female body in the Western artistic tradition. It is in this way that the genre of the nude perpetuates and promotes a damaging

[41] Garrard, ibid. 189.

gender stereotype, namely that women are first and foremost sex objects; that is, that a woman's sexuality, and in particular her sexual appeal to men, is a primary feature of her identity.

At this point a serious objection arises. While it is clear that all of the artworks mentioned thus far objectify an individual woman or women, what licenses the conclusion that a picture can objectify *women in general*? A stereotype, after all, is a demeaning and restrictive generalization about a *group*, but none of the artworks we've seen so far depict women *as a group*. Even when a picture offers a swarm of docile and voluptuous unclothed bodies, as we saw in Ingres's *Turkish Bath*, it would seem that at most one is entitled to say that the picture sexually objectifies *these* women, not the entire *class* of women.

Indeed, with few exceptions, visual representations appear unavoidably bound up with details.[42] Putting something in visible form makes it concrete and specifies particular traits: representing a woman requires making decisions about all of her visible physical features, from the shape of her nose to the size of her feet. The more abstract the representation, of course, the less information conveyed about particularities, and so the claim about object-ification of women in general might hold for abstract nudes. But the case made here has relied heavily upon pre-modern and early modern works— for reasons to be made clear—and with few exceptions these would seem to represent individual women in all their particularity; that is, they seem to offer us tokens, not types. So how can a visual representation stereotype women as a whole?

This is an important question that, to my knowledge, finds no answer in the literature. My answer has two parts: the female nude in the European tradition is almost always both *generic* and *idealized*.

As mentioned in section 2.5 from my list above, by 'generic' I mean that the individual unclothed females comprising the genre tend to lack distinct-ive qualities that suggest individuality and set each apart from the rest. Instead, there is a strong tendency for nudes to exhibit qualities common to a group, where this is defined by a particular oeuvre, a period style, and the genre itself. (This is an important point to which I return in the final section of this chapter: in order to see that a particular figure is generic, you must appeal to the group of which it is a part.) One such commonality is

[42] Visual symbols for abstract notions—such as light as a symbol of knowledge—is one exception.

posture. As noted in section 2.9 from my list above, female nudes tend to strike very similar poses of surrender and availability that highlight breasts, pubis, and/or buttocks. Whether recumbent (à la Giorgione's *Sleeping Venus*) or standing (à la Bouguereau's *Birth of Venus*), these poses are peculiar to female nudes and are rarely used for unclothed males. But it is not simply pose that makes female nudes generic: female nudes tend to share physiognomic qualities as well. Regardless of time period, nudes are regularly pale and without any trace of body hair, with full round breasts and erect nipples. Facial features are also quite similar, particularly within the context of an oeuvre: for instance, all of Titian's nudes, whether Venus or Danaë or some other goddess, have the same facial features, the same skin tone, the same long blondish wavy hair, and even almost always wear the same pearl earrings. This is not simply a point about artistic style, for despite the fact that Titian's men are recognizably in the artist's style, they nevertheless exhibit individuating features. Female nudes are rarely represented as unique personalities distinguishable from others; rather, all peculiarities are left out in favor of a sameness that renders the figures interchangeable or, as Nussbaum would put it, fungible.

There are good reasons why the unclothed females represented throughout the tradition do not lend themselves to being identified as particular individuals. First, this would undercut their 'pinup function' (see remark by Charles Hope in section 3 above). Generic figures are better suited to serve the fantasies of a wide audience of male viewers. But individuality would also undercut the *normative* function of the nude where the women depicted serve as ideals of female beauty and erotic excellence. (To repeat a point made earlier, this is an ideal for both male and female audiences.)

This idea that the nude is both generic and ideal—both a model of and a model for women—was theorized in humanistic treatises on painting at the time that painters like Botticelli, Giorgione, and Titian were developing their prototypes. Most notably, Leon Battista Alberti spells out his method of what one might call 'ideal imitation' in his treatise on painting, *Della Pittura*.[43] Like so many of his contemporaries, Alberti firmly believed both that paintings should copy nature *and* be beautiful. This presents the artist

[43] First written in Latin (*De Pictura*) and then translated into Italian by Alberti himself in 1435–6, *Della Pittura* is arguably the first modern theoretical treatment of painting. It had considerable influence on both artists and other treatises on art.

depicting the human form with a serious challenge since, Alberti notes, 'complete beauties are never found in a single body, but are rare and dispersed in many bodies.'[44] Alberti's advice is to follow the example of the ancient painter Zeuxis, 'the most excellent and most skilled painter of all.' According to legend,[45] Zeuxis 'chose the five most beautiful young girls from the youth of that land in order to draw from them whatever beauty is praised in a woman.'[46] Following this venerable example, the painter of the female nude should consult nature directly by selecting from many different women for representation the fairest parts of each to produce a composite figure that would be *both* true to nature and more perfect than any existing woman. The resultant nude would be both everywoman (generic) and what every woman should be (ideal). This ideal, I argue, is a sexual object.

5. What's Wrong with Sexual Objectification?

We've now seen how the female nude sexually objectifies, and how through genericization and idealization the object of that sexual objectification is 'woman' as a type rather than a particular token woman or women. But none of this explains why feminists have a problem with the female nude. An important question still remains, namely: What is wrong with sexual objectification? After all, many would agree that some form and degree of objectification constitutes a normal, and even salutary, dimension of human sexual activity.

Against such a view, some, most notably Kant, have disparaged all sexual objectification as the practice of making oneself into a thing to be used by another, a mere means to an end that degrades one's humanity and reduces one to the level of (other) animals.[47] If this is the kind of concern that feminists mean to adduce against sexual objectification, then the concern ought to apply to the sexual objectification of *men* as well. From such a view

[44] *Della Pittura*, Book III. Translation taken from *On Painting*, trans. John Spencer (Yale University Press, 1966), 92.

[45] The story is recounted by Pliny (*The Natural History* XXXV, xxxvi, 64) and Cicero (*De inventione* II. i. 1–3) and by many after Alberti.

[46] *On Painting*, 93.

[47] See the section titled 'Crimina Carnis' from Kant's *Lectures on Ethics*, trans. Louis Infield (Hackett, 1963), 169–71. For an interesting recent interpretation of Kant's views in relation to contemporary feminism, see Evangelia Papadaki, 'Sexual Objectification: From Kant to Contemporary Feminism', *Contemporary Political Theory* 6 (2007), 330–48.

one should expect sexually objectifying representations of *male* nudes to come under fire. Consider the following list of famous examples of beef-cake—that is, sexually objectified unclothed males—from the European tradition:

- Michelangelo, so-called *Dying Slave* (*c*.1513, Louvre, Paris)
- Rodin, *Age of Bronze*, also known as *The Vanquished* (modeled 1867, cast *c*.1906)
- Mantegna, *St. Sebastian*, (*c*.1458, Kunsthistorisches Museum, Vienna)[48]
- El Greco, *Martyrdom of St. Sebastian* (*c*.1577–8, Museo Catedralico, Palencia)[49]
- Titian, *Three Ages of Man* (1511–12, National Gallery of Scotland, Edinburgh) (Note, by the way, that in this picture the partially clothed youth's sex organ is compared to an instrument to be played by the (mostly) clothed young woman.)

Each of these figures is accurately characterized by at least some combination of the concepts from Nussbaum's and Langton's list: they are inert, fungible, violable, silenced, anonymous, passive, subjectivity-less, enslaved, sexually violated, and/or reduced to their bodies and appearance. Why do feminists not criticize *these*? Is there a double standard at work here? I don't think so. The feminist critique of the female nude does not object to sexual objectifi-cation per se; it is not Kantian in this regard.

In order to see why the *female* nude is singled out as specially problematic, we need to understand a key methodological aspect of the feminist critique of the female nude that is too often left inexplicit, namely that the critique cannot be framed adequately from the perspective of methodological indi-vidualism. Here I am importing the term 'methodological individualism' to aesthetics and art criticism to refer to the view that all artistically relevant features of an artwork can be explained by appeal to individual works alone.[50] Methodologically individualist accounts hold, either explicitly or

[48] The 1480 version in the Louvre and the 1506 version in the Galleria Franchetti in Venice are also good examples.

[49] The later version, from *c*.1610–14, now in the Museo del Prado, Madrid, is also a good example.

[50] The term 'methodological individualism' comes to us from political philosophy that is often of a feminist bent. The following two essays provide a good introduction to and critique of the concept. Marilyn Friedman and Larry May, 'Harming Women as a Group', *Social Theory and Practice* 11(2) (1985), 207–34. Iris Marion Young, 'Five Faces of Oppression', *Philosophical Forum* 19(4) (1998), 270–90.

implicitly, that all of a work's artistic properties can be defined, explained, and appreciated for that work independently of all other individual artworks. Supra-individual and aggregate artistic categories play no explanatory or evaluative role in such accounts. This, I wager, is the dominant view in art history, art criticism, and the philosophy of art, a preeminence likely due to stress laid on the uniqueness and particularity of artworks.

While I strongly agree that it *is* crucial to attend to the uniqueness of artworks in all of their richness and subtlety of detail in both formal and historical terms, I contend that resting at the atomistic level of individuals will leave obscured some of the deep problems that most concern feminists. This is because these problems are not intrinsic to individual works themselves but, rather, can only be captured through appeal to *relational* features of female nudes and to *patterns* seen in aggregate artistic categories. The problem, to put it succinctly, is the systematic and preeminent sexual objectification of the female body, and only the female body, that persists throughout the European artistic tradition. To adequately capture this, we need to take what Marilyn Frye calls a *macroscopic view* of things.[51] Here are at least four things that a macroscopic view brings into focus:

1. There are a large number of works where a sexually objectified female nude appears with clothed and active men who are not sexually objectified. Consider, for instance, the many famous works where a sexually objectified female nude is featured with fully dressed men who are engaging in some artistic or intellectual activity.

- Titian's six paintings of Venus with Musician.[52]
- Giorgione, *Fête champêtre* (1508–9, Musée du Louvre, Paris)
- Manet, *Déjeuner sur l'herbe* (1863, Musée d'Orsay, Paris)

[51] Frye argues that in order to understand how particular practices can be oppressive, one must take a macroscopic view of the larger systems in which the particular practices are embedded. She writes: 'One cannot see the meanings of these rituals [such as the man's opening the door for the woman] if one's focus is riveted upon the individual even in all its particularity. . . . The oppressiveness of the situations in which women live our various and diverse lives is a macroscopic phenomenon . . . [which you can see] when you look macroscopically.' *Politics of Reality* (The Crossing Press, 1983), 6–7.

[52] For instance: several pictures of *Venus with Cupid and Organist* (1548–9, Staatliche Museen, Berlin; 1548 Museo del Prado, Madrid); *Venus with Organist and Little Dog* (c.1550, Galleria degli Uffizi); *Venus and Lute Player* (1560, Fitzwilliam Museum, Cambridge; 1565–70, Metropolitan Museum of Art, New York).

A sub-genre of these are countless pictures that explicitly thematize the role of the female nude in the practice of making art. In many of these works the model's gaze is averted or downcast, de-emphasizing her subjectivity—and her supple posture is one of vulnerability—her arms often pulled back in an exposed, unguarded, and revealing gesture. He, on the other hand, is not just clothed but deeply absorbed in the artistic act. She is the object of his gaze, the passive material for his creative intelligence, and sometimes also his inspiration and muse. His job: make great art. Her job: sit and look pretty. Here are just a few examples from different periods:

- Albrecht Dürer, *Draughtsman Drawing a Nude* (1525, woodcut).
- Gustave Courbet, *The Painter's Studio* (1855, Musée d'Orsay, Paris). [Here the nude woman plays the role of the artist's inspiration and muse rather than subject matter.]
- Matisse, *Artist and Model* (c.1919, National Gallery of Canada, Ottawa)

These works illustrate the way that the female nude has come to stand as the archetypal artwork. When artists represent themselves at work, the default subject matter is often an unclothed female body. It's not surprising then, that a nude is often the first thing one sees upon entering some of the great museums in the European world.[53]

This is rarely the case with male nudes. I know of very few works in which unclothed, docile men consort with clothed, actively engaged women. This disparity in the visual treatment of females and males, with an egregiously disproportionate emphasis placed on the docile sexuality of the former, is an important element of the feminist critique. It becomes even more apparent when one moves to consider the aggregate category of the genre itself.

2. The second thing one must consider to fully understand the feminist critique is the sheer prevalence of the female nude in the Western tradition

[53] Here are two examples. Until very recently, Maillol's *L'Action enchaînée*—a larger-than-life headless and limbless buxom torso with arched back to enhance buttocks and breasts—stood smack in the middle of the grand staircase of the Art Institute of Chicago and was the very first work a visitor saw upon entering the museum. One of the very first works one sees upon entering the Musée d'Orsay in Paris—and of the first works, the one that is most prominently displayed—is Schoenewerk's *Jeune Tarantine* (1871), a sculpture of a nude woman in a back-breaking reclining pose with pelvis thrust above the chest so as to highlight her perky nipples and pubic region. *Jeune Tarantine* is displayed on a pedestal about 1.5 feet above the floor so that the viewer cannot but help looking down onto her splayed body.

when compared with male nudes. The female nude is omnipresent in most major periods of European art (medieval art being a notable exception), and while representations of unclothed males exist, their numbers do not approach the female nude through all styles and periods. It is due to this widespread and uneven preoccupation with sexually objectified unclothed female bodies that the term 'nude,' in art circles, has come to designate *female* nudes exclusively and it is only when the unclothed body in question is male that one must specify gender. Comparing the two genres (female nudes vs. male nudes) allows us to see the glaringly uneven importance placed on women's appearance and sexual appeal.

This is yet another way in which the nude can be said to stereotype women. Stereotyping is achieved not simply through the generic but ideal types offered up by individual works; the stereotype of woman-as-sex-object is also achieved by the genre itself in its insistent, repeated, pervasive sexual objectification of women's unclothed bodies throughout much of the Western artistic tradition.

3. Third is the *manner* in which unclothed female bodies are typically represented *compared with that of unclothed male bodies.* The problem is not simply that the unclothed female body is almost always sexually objectified in the ways described throughout this chapter; an important part of the problem is that male nudes *typically* are *not.* Although sexually objectified male nudes exist in the European tradition—consider, for instance, Thomas Eakins's *Arcadia* (*c.*1883, Metropolitan Museum of Art)[54]—they are *exceptional* in this regard. Typically, male nudes are represented as active, strong, heroic, and unassailable figures engaged in combat, thinking, or other 'manly' activities. Consider the following famous works:

- Antonio del Pollaiuolo, *Battle of Ten Nudes* (Engraving, 1470s, Galleria degli Uffizi, Florence)
- Ingres, *Oedipus Answering the Sphinx's Riddle* (1808–20, Musée du Louvre)
- Michelangelo, *David* (1504, Galleria dell'Accademia, Florence)
- Rodin, *The Thinker* (Bronze, first casting 1902)

[54] Thanks to Hans Maes for this example.

The feminist critique does not focus simply on the fact that female nudes are represented as passive, vulnerable, weak, fungible, and lacking subjectivity. Indeed, I would argue that there's nothing *intrinsically* wrong with an individual picture of an unclothed woman that sexually objectifies her in these ways. The problem, from a feminist perspective, is that the overwhelming majority of female nudes have traditionally been represented this way while the majority of male nudes (and here we should keep in mind the first point, that this total number is considerably smaller) are not. There are very few active, strong, psychologically engaging, heroic female nudes and I know of no female counterparts to *The Thinker*, the Pollaiuolo engraving, or *David*. To make this point vivid, try the thought experiment of imagining a work like Ingres's *Turkish Bath* with men rather than women,[55] or Pollaiuolo's *Battle* with women rather than men. The results, I think you'll find, will seem so foreign as to border on the absurd.

4. Fourth, let us conjoin this imbalance—this one-sided abundance of objectified female flesh—with women's cultural, and especially artistic, disenfranchisement, by which I mean women's exclusion from the artistic canon. This exclusion takes two forms. First, although women make up roughly one-half of the human population, they are almost entirely absent from the pantheon of great artists, including modern and contemporary artists.[56] Second, the kinds of artefacts traditionally produced by women— e.g. clothing, quilts, pottery, needlework, and weaving—have not been taken seriously *as art* but, instead, have been relegated to the diminished categories of 'decorative arts' or 'crafts'.[57] The problem, then, is *not* that this or that particular representation of the female nude was produced by a man,

[55] To make this point, in 1972 Linda Nochlin made a photograph entitled *Buy My Bananas* of an unclothed man holding a tray of bananas just below his penis. A visual metaphor that is unremarkable when the subject is an unclothed woman becomes absurd when it is an unclothed man who offers the fruit. Feminists artists like Sylvia Sleigh, Joan Semmel, and Judy Chicago have also engaged in 'turn the tables' projects where male nudes are eroticized. Sleigh, as Hans Maes has reminded me, even produced her own all-male *Turkish Bath* (1973), although the picture does not come close to offering as many unclothed supple bodies as Ingres's.

[56] The seminal analysis of this fact is Linda Nochlin's 1971 essay, 'Why Have There Been No Great Women Artists?' reprinted in Linda Nochlin, *Women, Art, and Power and Other Essays* (Harper & Row Publishers, 1988), 145–78.

[57] For a summary of the feminist critique of canon formation, see my 'Feminist Aesthetics and Criticism', *Encyclopedia of Philosophy*, 2nd edn. (Macmillan, 2005) and 'Feminist Philosophy of Art', *Philosophy Compass* 3(4) (2008). Also see Carolyn Korsmeyer's entry on 'Feminist Aesthetics' (revised 2008) for the *Stanford Encyclopedia of Philosophy* online.

but that men are overwhelmingly responsible for the entire genre. *Pace* Foucault and intentional fallacy theorists,[58] it *does* matter who's speaking: the message one gets strolling through the great museums of the world, or even just flipping through an art history textbook, is that women are connected to great art not as its creators, but simply as bodies, as the raw material out of which men forge masterpieces. (Here I remind you of the theme of artist-and-model discussed earlier.)

This point is humorously captured in a 1989 poster by the Guerilla Girls, an artist activist group. The poster features a gorilla mask atop the body of Ingres's *Grande Odalisque* and reads: 'Do women have to be naked to get into the Met. Museum? Less [sic] than 5% of the artists in the Modern Art sections are women, but 85% of the nudes are female.'[59] On September 1, 2004, the Guerilla Girls returned to the Met with another survey to find that the situation had only worsened: a mere 3 per cent of the artists in the modern and contemporary section are women, and 83% per cent of the nudes are female.

To sum up, I have argued that the female nude sexually objectifies women, and that this is achieved through the use of ideal types in individual representations and also through the sheer omnipresence of such images in the Western tradition. But this raised the question, What's wrong with sexual objectification, anyway? After having briefly compared the genre of the female nude with that of the male nude and considered its place within the broader artistic tradition, we are now in a position to see the answer.

Isolated instances of sexual objectification are not necessarily any more problematic for women than for men. Indeed, in some cases sexual object-ification is most welcome; it makes sense at certain appropriate times for a women to want to be a sexual object for her lover rather than, say, a challenging intellectual sparring partner. The problem is that women do not have this choice because we live under the umbrella of sexual objectifi-cation.[60] The most extreme and violent form of this sexual objectification

[58] Such as Barthes, and Beardsley and Wimsatt in analytic tradition.

[59] This poster can be seen on the Guerilla Girls website at <http://www.guerrillagirls.com/>.

[60] Sandra Bartky puts this point well: 'But surely there are times, in the sexual embrace perhaps, when a woman might want to be regarded as nothing but a sexually intoxicating body and when attention paid to some other aspect of her person—say, to her mathematical ability—would be absurdly out of place. If sexual relations involve some sexual objectification, then it becomes necessary to distinguish situations in which sexual objectification is oppressive from the sorts of situations in which it is not. The identification

can be seen in the fact that women live with the constant threat of rape and are not safe on the streets or at home. But a less extreme example is the persistent preoccupation with women's bodies, appearance, and erotic appeal. The constant emphasis on women's appearance and sex appeal at the expense of any other important aspect of our identity extends to almost every aspect of our lives. This is not merely something that is done to us. Women have come to internalize 'the male gaze', to see ourselves through objectifying eyes and in terms of male interests.

If we lived in a world where everyone, men and women alike, lived under this umbrella of sexual objectification, that might be weird but to my mind not unjust or otherwise morally problematic (unless, of course, sexual objectification were unwelcome). The injustice that concerns feminists arises from the fact that men do not live under this umbrella. Men get to choose when to play the role of sex object whereas women have no such choice. It is this asymmetry—where women are continually reduced to objects of men's pleasure but not the converse—that underpins gender injustice. The nude, I have shown, is one of the means of perpetuating this injustice.

6. Concluding Thoughts about Art and Pornography

> Pornography becomes difficult to distinguish from art and ads once it is clear that what is degrading to women is the same as what is compelling to the consumer.
>
> Catharine MacKinnon, *Toward a Feminist Theory of the State*[61]

What's wrong with the female nude, to put the point succinctly, is that it promotes sex inequality by eroticizing it. To those familiar with the literature, this will sound an awful lot like one dimension of a certain kind of feminist critique of pornography.[62] According to that critique, standard heterosexual pornography—what I have elsewhere called *inegalitarian*

of a person with her sexuality becomes oppressive, one might venture, when such an identification becomes habitually extended into every area of her experience.' 'On Psychological Oppression', 26.

[61] P. 113.

[62] I say 'one dimension' because antiporn feminists are also concerned with the harms incurred to women in the *production* of pornography. Although this may have an analogue in the realm of high art, I do not discuss it here.

pornography—eroticizes women's subordination to men and this, antiporn feminists charge, can have a host of harmful effects on real women's lives.[63] Similar worries have also been leveled against mainstream advertising, music and music videos, and various other aspects of popular culture, as seen in the quote from MacKinnon above. The similarity that feminist critique brings to light between the nude and other cultural forms could make it seem as if, from a feminist perspective, the nude is just another of the many elements of our culture that make sexism sexy. This is sometimes thought to render the distinctions between 'art' and 'pornography' or 'advertising' irrelevant from the viewpoint of feminist critique.

This, however, overlooks the important way in which these distinctions do matter from a feminist perspective, and a reason why the female nude should have a special place in our account of the role of representations in bending our erotic taste toward sex inequality. The female nude not only eroticizes but also aestheticizes the sexual objectification of women, and it does so from on high. These two features, which I shall explain in turn, serve well the nude's function of promoting sex inequality and so should make it a cultural form of primary concern to feminists.

The female nude aestheticizes sexual objectification of women insofar as all of the works discussed in this chapter display considerable attention to the formal and material dimensions of the representations. *Pace* Charles Hope, this is an important difference between the nude and the average porno-graphic photo: the nude demands to be looked at as art, to be appreciated for its composition, textures, portrayal of light and shadow, and other formal and material features.[64] Many of the works discussed in this chapter are quite beautiful and compelling and display dazzling skill and creativity. This not only makes the message of female inferiority and male superiority more compelling, but insofar as one considers art to be immune to moral scru-tiny—a common enough view in the history of Western thought[65]—the

[63] How exactly to understand these effects is a matter of some dispute. I offer what I consider to be the most sensible way of understanding pornography's effects in 'A Sensible Antiporn Feminism' and 'Feminist Philosophy of Art'.

[64] As Jerrold Levinson notes, artistic representations invite us to 'dwell on features of the image itself, and not merely on what the image represents', whereas pornographic representations 'present the object for sexual fantasy vividly and then, as it were, get out of the way'. 'Erotic Art and Pornographic Pictures', *Philosophy and Literature* 29 (2005), 232–3.

[65] Proponents of the idea that art qua art—that is, the aesthetic dimension of a work which is what makes it art—is immune to ethical criticism range from Kant to Oscar Wilde. For a contemporary

nude's aestheticization protects it from feminist criticism. As feminists we may be uncomfortable with the eroticization of sex inequality, but as appreciators of art qua art (on this view) we should be ignoring artworks' moral failings and attending instead to the aesthetic dimension of the work.

Unlike most contemporary philosophical discussions of art and pornography, I have deliberately focused on older works, many of which are uncontested masterpieces. Many of these works are prominently featured in almost any survey of Western art history: they are canonical. The artistic canon is generally thought of as the repository of our highest and most enduring values. *Art* with a capital 'A' is a hallowed category of works that demands our undivided attention, respect, special care and maintenance. I have shown that some of the gems of the Western canon offer not (or not just) beautiful and profound truths about the human condition, but actively promote women's subordination to men. Art's venerated status invests this message of male superiority and female inferiority with special authority, making it an especially effective way of promoting sex inequality. As art historian Carol Duncan eloquently puts it, 'as sanctified a category as any our society offers, art silently but ritually validates and invests with mystifying authority the ideals that sustain existing social relations.'[66]

In short, unlike pornographic works, the 'artistic gems' I've been discussing (a) make sex inequality not just sexy but also beautiful, (2) lend sex inequality special authority, and (c) and present themselves as immune to, or at the very least resistant to, moral and political scrutiny. This gives feminists good reason to worry about the nude at least as much as we worry about pornography, and perhaps even more, since the nude's appeal is more insidious.[67]

overview of the position as well as responses to it, see Noël Carroll, 'Art and Ethical Criticism: An Overview of Recent Directions in Research', *Ethics* (2000), 350–87, particularly section II. For an astute analysis of Carroll's take on autonomism, see Daniel Jacobson, 'Ethical Criticism and the Vice of Moderation', in Matthew Kieran (ed.), *Contemporary Debates in Aesthetics and the Philosophy of Art* (Blackwell, 2006), 343–6.

[66] Carol Duncan, 'The Esthetics of Power in Modern Erotic Art', in *The Aesthetics of Power: Essays in Critical Art History* (Cambridge University Press, 1993), 118.

[67] Thanks to Jerry Levinson for pushing me to complete this thought.

14

Taking a Moral Perspective
On Voyeurism in Art

ELISABETH SCHELLEKENS

What is most striking about [certain exceptional] works . . . is the trans-
formation of the picture surface into a plane that is both permeable and
productive of reflection. This is not quite the transparent window of
the conventional Renaissance perspective, before which the spectator is
installed like the stationary audience at a pictured drama. Rather, it is
as though a mechanism is set in play by our regard into the space of
the painting, such that its representational content impinges upon
the 'backspace' of our imaginary world: the world, that is to say,
from which a further imagined spectator, positioned *behind* us, might
see both the painting in question and ourselves framed as attentive
audience.[1]

In the act of perceiving a representational artwork, a viewer is generally first
and foremost invited to engage with the scene, event, or person represented
in that work. Members of an artistic audience are encouraged to observe and
consider the content made visible to them in a particular artistic context, and
they often do so in ways that involve forming both imaginative and affective
relations with the work in question. Interestingly, some artworks extend a
twofold invitation to their viewers, inciting us not only to connect to an
individual scene or theme but also to do so from a specific point of view or
perspective. This is not a call to form a certain opinion or verdict about the
content of the work or to interpret what is represented in a certain way.

[1] Harrison 2005: 23–24.

Rather, we are invited to take up a position from which we can relate to the depicted scene or theme in a remarkably direct manner—so direct in fact that merely occupying that platform somehow implicates us in what we are observing.

One example of this kind of artwork is Tintoretto's *Susannah Bathing*. To perceive this work is not only to see the various elements depicted and to grasp the underlying narrative. It is also to inhabit a surreptitious perspective through which we witness something we are not meant to be witnessing. The artist has chosen for his subject matter a private act, an intimate moment, not intended to be observed by anyone. By revealing this moment in the artwork, the artist may put the viewer in a privileged position, but it is in other respects a compromised point of view which turns him or her into a 'peeping tom'—or voyeur—alongside the elders that spy on the naked Susannah.

The representational content of some works, then, 'impinges upon the 'backspace' of our imaginary world', to use the phrase employed by Charles Harrison in *Painting the Difference*, insofar as there is room to take a step back from the point of view an artwork invites us to inhabit and conceive of that very perspective as part of the experience afforded by the artwork itself. From this angle we 'might see both the painting in question and ourselves framed as attentive audience' and this can be the starting point of the appreciation of that artwork in its own terms. The voyeuristic ingredient that some artworks contain thus effectively catapults the viewer into this invasive form of looking.

Central to voyeurism in general, of course, is the idea that we not only enjoy watching something, but that we take a kind of delight in the fact that we should not be watching that something.[2] The transgression at play here is at least partly based in the disregard for another person's desire for privacy or solitude where that disregard is itself a source of pleasure. In this sense, voyeuristic art is rooted in the practice of forcing one's way into the intimate corners of another person's life for purely 'private delectation'.[3]

[2] As we shall see, the normative component of the experience—the fact that we *ought* not to be witnessing that which we are witnessing—may be grounded in a variety of reasons, ranging from the fact that a particular scene was not originally intended to be witnessed by others to the explicit and continuous lack of consent on behalf of the observed subject.

[3] Phillips 2010b: 55.

In virtue of soliciting an involvement with a particular scene or theme from a specific point of view, voyeuristic art gives rise to a multitude of pressing philosophical questions. In a first instance, one may ask whether this unique platform from which we are to perceive a work is itself a part of that work, and if so, how. To what extent, in other words, is the perspective which seems to incriminate us in the act of prying actually constitutive of the very work it offers us a perspective of? How, if at all, are we to separate the point of view of the 'attentive audience' from the representation which that audience is in the process of observing?

Another set of questions touches on that which sets voyeurism in art apart from voyeurism in general. One may ask what artistic media succeed in adding to the voyeuristic experience, such that perspectives considered dubious in non-artistic contexts might seem legitimate in artistic contexts. For instance, what makes one photograph a work of art and another simply an illegal record of someone else's private behaviour? After all, whereas the former is increasingly hailed as a genuine form of artistic expression,[4] the latter has gradually been subjected to severe punitive legal restrictions.

The issues I would like to focus on in this chapter have to do with the changing nature of the notion of voyeurism in art and the manner in which voyeurism has enabled art to lead a philosophical discussion with itself, so to speak. This slow transformation, I shall argue, is to be understood primarily in moral terms. I shall begin by examining what we mean by voyeurism and distinguish between different kinds of voyeurism in art.[5] Some of these kinds, I shall argue, stretch the traditional concept of voyeurism to include works that may not be typically voyeuristic in the usual sense. I shall then reflect on the specific delight we take in engaging with voyeuristic works and discuss the way in which that enjoyment may render voyeuristic art morally problematic. I will show that this moral tension lies at the heart of what voyeuristic art is and why we seek to engage with it. Finally, I shall suggest that what may be perceived to be the gradual erosion of moral taboos and inhibitions leads to a genuine difficulty for voyeuristic art, namely whether there are any innovative forms of expression left for it to explore.

[4] See, for example, the exhibition 'Exposed: Voyeurism, Surveillance and the Camera' at the Tate Modern in London, summer 2010.

[5] A further issue is whether the making of art can count as an act of voyeurism.

1. Cases of Voyeurism in Art: Some Examples

Certainly to a twenty-first-century spectator, Tintoretto's *Susannah Bathing* (1555–6) is without a doubt more beautiful than shocking or shameful. Not only is Susannah's body tastefully angled so as not to expose her nudity too blatantly, but her virginal qualities and the general peacefulness of her demeanour encourages an aesthetic contemplation of the depicted scene which nearly makes us forget altogether about the two old men lurking behind a hedge and the impending tragedy. The biblical context of this incident may historically have served as a good excuse for representing an event with such explicit sexual character, but the fact remains that what we are looking at is an innocent woman about to be assaulted and then falsely accused of promiscuity (an accusation that eventually leads to the elders' trial and death). As viewers, we too are 'peeping toms', catching Susannah unaware and unselfconscious, observing her not merely as an artist would observe a graceful motif, but as nosy onlookers more interested in satisfying our own ill-placed curiosity than respecting Susannah's right to privacy as she bathes alone in her own garden. Although virtue triumphs in the end, the work's audience has taken a titillating moral detour: we have temporarily inhabited the position of flawed human beings whom we despise but with whom we nevertheless share not only a visual perspective but also certain instincts and desires.

In this last respect, Tintoretto's painting is to be contrasted with a work such as Titian's *Venus of Urbino* (1538). Here, the voyeuristic element of the representation addresses itself immediately to the viewer—the remarkably matter-of-fact stare of the goddess is targeted directly at us. There is no escape, no sense in which our implication is by association only, and we cannot speedily return to a moral comfort zone from which we can distance ourselves from the voyeur's perspective. Instead, we are the object of Venus' gaze, the subject of the sexual dynamic she is projecting. Titian's goddess seems made for the eyes of the model's lover and by engaging with it we become that lover for a moment.[6] There is no shame to be detected in

[6] To use Roger Scruton's words, 'in the *Venus of Urbino* . . . the lady draws our eyes to her face, which tells us that this body is on offer only in the way that the woman herself is on offer, to the lover who can honestly meet her gaze. To all others the body is out of bounds, being the intimate property of the gaze that looks out from it: not a body but an embodiment . . . The face individualizes the body, possesses it in

Venus' expression as she invites us to indulge in what she is about to offer, perhaps even smiling at our hesitation or timidity to approach her. In comparison to Venus, Susannah seems prudish, naïve, and inexperienced.[7]

Voyeurism is also manifestly at play in Alfred Hitchcock's *Rear Window* (1954). The film centres around Jeff (James Stewart), an adventurous photographer recuperating at home from an accident in which he broke his leg. A man of action rather than reflection, Jeff adjusts badly to his room-bound condition and devotes himself entirely to observing his neighbours and imagining their stories from the piecemeal snippets of their lives which come to him through his New York City apartment window. Jeff sees them go about their daily routines all the while suffering from the heat wave that forces them to keep their windows wide open. One neighbour in particular, Mr Thorwald, catches Jeff's attention as he notices that Mr Thorwald's convalescing wife has suddenly disappeared. After many twists and turns, Jeff becomes convinced that Mr Thorwald has murdered his wife and persuades his fiancé Lisa (Grace Kelly) to help him reveal the murderer. Both Jeff and Lisa are nearly killed by Mr Thorwald themselves, but in the end, the originally sceptical inspector Doyle (Wendell Corey) returns to the scene and saves the day.

The view from Jeff's rear window is reminiscent of the cross-section of a doll's house, and a cross-section of everyday life is exactly what Jeff witnesses. Interestingly, what sets his imagination in motion is not so much the two newlyweds who spend most of their time in their bedroom, or the beautiful dancer who lingers at her window, but a morbid fascination with Mr Thorwald and his wife. In spying on the oblivious Mr Thorwald, Jeff and Lisa experience the *frisson* of having stumbled across something as shocking as murdering one's own spouse. The excitement it generates between them is palpable, and the thrill with which they set about trying to solve the mystery suggests a nearly childish delight at the intrusion of such a dark event in their lives. Spying on their neighbours brings the couple closer together,

the name of freedom, and condemns every covetous glance as a violation. The Titian nude . . . retains a detached serenity . . . of a person, whose thoughts and desires are not ours but hers.'

[7] Rather like Titian's *Venus of Urbino,* Manet's *Olympia* (1863) fixes her spectator directly with an indifference which seems to speak of her immunity from the commerce of sexual desire and thus her power over it. In Manet's work, however, the goddess seems more impudent and provocative—although Titian's *Venus* may be frank and unashamed Manet's *Olympia* seems confrontational and proud.

establishing a newfound closeness between them as a direct result of their invading the privacy of others.[8]

The voyeurism in question here is broader in scope than the one we find in Tintoretto or Titian, for the perspective Hitchcock offers extends further than one particular event or scene. Rather, the spying involved in *Rear Window*—presented entirely from Jeff's visual perspective, except when we are spying on Jeff, as it were—captures something about how we relate to our fellow human beings in general and society at large. The connection between Jeff and the opposite block of flats may well, as Francois Truffaut has suggested,[9] be symbolic of the relation between the spectator and the screen, but it also tells us something about how modern man views his surroundings: we observe others and the unfolding of their lives from a distance and we only get involved when doing so satisfies a curiosity of our own. We watch Jeff's neighbours through his binoculars, we watch them being watched by Jeff, we watch Jeff watching them, and we watch a screen which makes these events come to life. We then go home to our own apartments only to be observed by our own neighbours there. When does this process of looking and being looked at end?

A work such as Vito Acconci's *Following Piece* (1969) takes this issue one step further by looking specifically at the separation between the public and private spheres and questioning whether it is even possible to draw such a distinction. The piece is an art performance, or a work of performance art, in which Acconci selected a person at random in the street and followed them until he or she could no longer be followed (when they entered their house, for example). The performance was carried out every day for one month, and could take up to several hours. The artist presented each event to his audience in the form of typewritten records and documenting photographs.

Not only does this work take the concept of voyeurism to an extreme by actively ignoring covenants of appropriate personal distance and relentlessly observing everything that person does—both artist and artwork physically invading the subject's space in order to pry more efficiently and uninterruptedly. It also turns the practice of voyeurism into an act of surveillance where that act is redefined as one of an artist's principal roles, using members of the public for the purposes of art without having obtained their consent.

[8] For more on *Rear Window*, see for example Lemire 1999.
[9] See Truffaut 1955.

The curiosity that drives the voyeuristic act here is simultaneously an interest in the other person and his or her habits *and* an interest in the artistic power of voyeurism itself.

2. What Makes these Works Voyeuristic?

If voyeurism can take different expressions in artistic contexts, as the works discussed above seem to suggest, how are we to conceive of the concept of voyeurism in art? What, in other words, is it about these works that make them instances of voyeuristic art?[10] In order to shed some light on this question, let us begin by drawing a distinction between (i) the nature of a work's representational content and (ii) the conditions surrounding the viewing of that content (or work).

First, for an artwork to be voyeuristic it must depict some intimate act, moment or behaviour. That act, moment or behaviour can be explicitly sexual (as in *Susannah Bathing* and *Venus of Urbino*) or not (as in *Rear Window* and *Following Piece*), and can implicate the viewer directly (as in *Venus of Urbino* and *Rear Window*) or not (as in *Susannah Bathing* and *Following Piece*). Second, for a work to be voyeuristic, the person represented must typically be unaware of the fact that he or she is being observed. In other words, the subject has generally not given his or her consent to being observed in this way. As we have already mentioned, this lack of consent can come in degrees: it can be absolute and exclude any possible viewer (as in *Susannah Bathing*); it can be partial (as in *Venus of Urbino*); or it can be somewhat flexible according to socially determined norms (as in *Rear Window*, where one may well expect a neighbour from the opposite block of flats to have some view into one's apartment although not for that neighbour actively to be spying on one, and *Following Piece,* where one may expect another person to see one in passing but not for that other person to become one's indefatigable stalker). Third, voyeurism rests on an asymmetrical relation between viewer and viewed insofar as it assumes a lack of perceptual

[10] Whilst my main aim in this section is to provide a set of conditions in terms of which voyeuristic artworks can be defined, I do not presume that all works fall neatly within—or without—this artistic category. We can ascribe voyeuristic elements to some works without therefore having to categorize them as voyeuristic *tout court*. For more on this point in relation to Rembrandt's *Bathsheba at her Bath* (1654), see n. 13.

reciprocity. As Joel Rudinow puts it, '[t]he voyeur seeks a spectacle, the revelation of the object of his interest, that someone or something should be open to inspection and contemplation; *but no reciprocal revelation or openness is conceded.*'[11]

Each of these conditions broadens the traditional conception of voyeurism in art somewhat to include cases where the observed behaviour is intimate yet non-sexual, cases where the person observed is aware of being observed to some extent, and cases where the person observed actually allows the prying in a limited sense.[12] Although the subjects may expect some viewing and may allow some form of observation, that is not to say that they realize or give their consent to the kind and degree of observation which actually takes place. In *Rear Window*, for example, Mr Thorwald can reasonably expect some intermittent and irregular viewing by his neighbours, but not Jeff's uninterrupted spying with binoculars. Similarly, the very premise of the *Venus of Urbino* seems to be that the model is making a significant exception by allowing herself to be seen by her lover—an exception she appears unlikely to extend.

Now, it follows from the distinction between (i) and (ii) that the delight to be gained from engaging with voyeuristic art can be directed either at the work's representational content *and* the viewing itself, or merely at the viewing—or, to be more precise, the conditions under which a work is viewed. Our fourth condition for voyeurism thus takes the following form: for a work to be voyeuristic, the delight we take in engaging with it must at least partly be grounded in the fact that we are witnessing something we in some sense shouldn't be witnessing. Although it is at best difficult and at worst impossible to generalize in this way, one may speculate that a viewer might take delight in both the representational content and the viewing conditions in the case of *Venus of Urbino*, for example, whilst

[11] Rudinow 1977: 176.

[12] It is important to note that extending the concept of voyeurism in art in this way does not necessarily conflate the distinction between works of art that are voyeuristic and works of art that are *about* voyeurism (where a work could be about voyeurism without necessarily also being voyeuristic). In a voyeuristic work the viewer not only shares a visual perspective with the voyeur—i.e. the represented scene, event, or person is quite literally seen from the perspective of the voyeur (as in *Susannah Bathing*, *Rear Window*, and *Following Piece*). As we shall soon see in greater detail, the gratification sought in engaging with the work must also rest, at least partly, on witnessing something one shouldn't really be witnessing.

primarily gaining enjoyment from the viewing conditions in *Following Piece*, say.[13]

We know that our viewing is inappropriate insofar as our subjects' activities are not intended to be seen by us and that by viewing them we are violating their privacy (even in the cases where a degree of invasion is tolerated). The added factor that there is a sense in which we enjoy invading that other person's privacy suggests that we take pleasure, precisely, in behaving improperly.[14]

3. Is Voyeurism in Art Morally Problematic?

In principle, then, there are three aspects of voyeuristic art that could make it morally problematic, namely (i) the nature of the work's representational content, (ii) the way in which we partake of that content, and (iii) the fact that we enjoy the way in which we partake of that content. Any of these three factors could put a work across the line of what is generally considered morally acceptable by, respectively, (i´) representing a morally questionable scene, (ii´) inviting morally dubious ways of viewing, or (iii´) encouraging viewers to take pleasure in the morally questionable scene, or dubious way of viewing, or both.

The weight ascribed to each of these factors may well change over time, with one causing greater concern at one period and another seeming more problematic at another moment in time. Certainly, to its sixteenth-century viewers, the depicted scenes in *Susannah Bathing*, for example, were not only considered more arousing, but also more audacious—scandalous even—than they appear to us today, so that the voyeuristic pleasure taken in those scenes by the original audience might well have overshadowed any delight rooted in peeping and prying.[15]

[13] This fourth condition is important since not all works that meet these three criteria are necessarily voyeuristic. Rembrandt's *Bathsheba at her Bath*, for example, falls under that category. Here, however, the delight we take in engaging with Rembrandt's painting is not grounded in the fact that we are observing something which we shouldn't be seeing. For more on this point, see Gaut 2007, chapter 1.

[14] That is to say, either the person observed realizes that he or she is being observed but makes an exception in this particular case or, again, that person exceptionally allows the observer to witness the intimate moment in question. In both cases, the sense in which something that *ought* not to be witnessed is nonetheless seen still pervades—and intensifies—the experience of the piece.

[15] In that respect, perhaps, voyeuristic art of that period might have been closer to erotic art than it is today. For more on erotic art, see Levinson 2005 and 2006.

Nowadays, it seems fair to say that the most morally problematic aspect of voyeuristic works has to do with the fact that we tend to establish—or impose—a relation with another person without having that person's permission to do so. In other words, what we seem to find principally objectionable with voyeurism today is that we create a connection, for the sake of our own pleasure, with another person in which that other has, to some degree, no wish to participate.

Certainly in non-artistic, non-fictional environments, observing intimate scenes without the subject's consent can be illegal. In 2005, a section declaring voyeurism to be a sexual offence was added to the Canadian Criminal Code such that '[e]very one commits an offence who, surreptitiously, observes—including by mechanical or electronic means—or makes a visual recording of a person who is in circumstances that give rise to a reasonable expectation of privacy'.[16] Similarly, in the United Kingdom, voyeurism became a criminal offence in 2004 when it was added to the Sexual Offences Act.[17] Again, in the United States, video voyeurism is a sexual offence in several states, and the *Washington Penal Code* defines voyeurism as follows:

[a] person commits the crime of *voyeurism* if, for the purpose of arousing or gratifying the sexual desire of any person, he or she knowingly views, photographs, or films another person without that person's knowledge and consent while the person being viewed, photographed or filmed is in a place where he or she would have a reasonable expectation of privacy.[18]

Central to the grievance which motivates the criminalization of voyeurism is thus the harm done to the unknowing subject, where that harm is cast in terms of the violation of their privacy. A person is held to violate another person's privacy when he or she 'intentionally intrudes, physically or otherwise, upon the solitude or seclusion of another or his private affairs or concerns' and is thus 'subject to liability to the other for invasion of his privacy, if the intrusion would be highly offensive to a reasonable person'.[19]

[16] *Criminal Code of Canada*, paragraph 162.
[17] *Sexual Offences Act*, section 67.1–3.
[18] *Washington Penal Code*, section 9A.44.115, 2a.
[19] Restatement of the Law, Second, Torts, section 652. Quoted in T. Allen et al. 1998: 1087.

Of course, one might ask whether an unknowing subject really can be harmed and, if so, in what sense.[20] After all, how could a person be hurt by something that he or she is not even aware of? In a first instance, and as we have just seen, some violations of privacy actively breach the subject's moral and legal rights. As Daniel Nathan writes in relation to a case where male mineworkers had been spying on their female colleagues whilst they were taking showers in their locker rooms:

the women claimed that they were harmed in obvious and significant ways by the voyeurs. The eight women filing suit reported their feelings of humiliation and personal degradation, the long term effects on their ability to sleep, work and concentrate, and the damaging consequences on their personal relationships, including the dissolution of at least one of their marriages.[21]

Understood in these terms, abusing another person's right to privacy involves desecrating that other person's integrity and honour which, in turn, can have highly practical consequences (such as lack of sleep or the breakdown of personal relationships).[22]

But how are we to understand cases where the person observed is in fact aware that he might be seen to a certain extent (such as Mr Thorwald) or when that person actually allows the viewing by a limited audience (such as Titian's Venus)? What, if anything, might be morally problematic about that? Obviously, on the one hand, grounding the moral complexity of voyeuristic works in a lack of awareness or permission may seem to remove any sense in which works that are less typically voyeuristic can be problematic in their own right. On the other hand, and as our fourth condition shows, the delight taken in voyeuristic works of this kind is still fundamentally contingent on a transgression—even when the subject is aware or allowing *to a degree*. Mr Thorwald cannot reasonably expect Jeff and Lisa's viewing to be quite as invasive as it actually is, nor can Titian's model reasonably expect to be seen quite as indiscriminately as she currently is. As long as the delight taken in the work is still one which relies on breaking a

[20] For an interesting discussion of the concept of harm in this context and how harm can be caused even if the subject is unaware of the offence, see Wertheimer 2008.

[21] Nathan 1990: 365.

[22] Of course, even if the subject never finds out that their privacy has been violated (and so that at least some practical consequences such as the ones listed here never occur), one can argue that his or her integrity has been disrespected and undermined.

moral taboo or crossing the line of what is traditionally conceived as morally acceptable, there is still an element of the experience which is sufficiently immoral to dub the work morally problematic.[23] What less typically voyeuristic cases of this kind suggest, then, is that the morally problematic nature of voyeuristic works may well be a matter of degree.

Clearly, in non-artistic contexts the interest and pleasure at the heart of voyeurism is defined in explicitly sexual terms, and it is not the aim of this chapter to assess the extent to which flying under the banner of art may or may not create a parallel set of moral standards for voyeurism. Certainly, the extensive use of photography and film in both artistic and non-artistic contexts shows that the factor which sets voyeurism in art apart from voyeurism in general doesn't have to do with the media employed.[24] Instead, that factor has to capture something about the way in which we engage with the voyeuristic piece and what it is we are looking for in our engagement with it. For despite the fact that voyeuristic art obviously has to fulfil the basic criteria of voyeurism, it is nonetheless first and foremost to be viewed *as* art.[25]

A helpful reference in this connection is Jerrold Levinson's discussion of the possibility of pornography being considered as art and the distinction between pornographic pictures (which he considers not to be a viable artistic category) and erotic art (which he considers to be a viable artistic category). The key to Levinson's argument is that, '[w]ith artistic images we are invited to dwell on features of the image itself, and not merely on what the image represents'.[26] For Levinson, because sexual arousal and release is the aim of pornography, it 'essentially excludes attention to form/vehicle/medium/manner, and so entails treating images as wholly transparent'.[27] Artistically erotic works, by contrast, encourage us to look beyond the 'mere' image, so

[23] The works discussed here rely on the fact that not *everything* is supposed or allowed to be seen. If that element is lost we may well gradually move into the domain of exhibitionism rather than voyeurism.

[24] See, for example Andy Warhol's 'camera view' and Sophie Calle's *Les Dormeurs* (1979). Cf. Phillips 2010a: 57 and 2010b: 144.

[25] The fact that some of the depicted scenes are fictional (such as in *Rear Window*) or mythical (such as in *Susannah Bathing*) can be relevant too. After all, we are not literally observing a 'real-time' situation. Thanks to Jerrold Levinson for drawing my attention to this.

[26] Levinson 2006: 263. According to Levinson 2006: 253, '[t]he erotic work of art does more than merely refer to or acknowledge human sexuality; rather, it expresses an involved attitude toward it, whether of fascination, obsession, or delectation, and in addition, invites the viewer's imaginative engagement, along similar lines, with what is shown.'

[27] Levinson 2006: 271.

to speak, and immerse ourselves in the work's artistic character, whilst pornographic pictures use depiction as a means to a simple—and non-artistic—end.

Without wanting to suggest that non-artistic voyeuristic pictures are necessarily pornographic—nor that all pornographic pictures are necessarily voyeuristic[28]—this is clearly a distinction that transfers to our own context. Just as with pornographic pictures and films, voyeuristic records don't tend to invite the viewer to reflect on their broader context, or on their underlying meaning. In cases of non-artistic voyeurism, all there is to 'get out of' engaging with the picture or film is the satisfaction of a specific desire, and the instances of such voyeurism are only successful to the extent that they manage to satisfy just this desire. In the artistic case, however, as the examples we have examined show, any desire that might be satisfied couldn't be conceived in such straightforward terms. What we are looking for, in voyeuristic art, is something altogether less instrumental and one-dimensional.

At the same time, however, voyeuristic and erotic art have in common that our enjoyment of them isn't purely 'aesthetic', at least on a strict reading of that term. Our experience here—our appreciation of their artistic and aesthetic qualities—cannot be separated from the delight specific to the kind of art that it is. In an erotic context, of course, the arousal of sexual appetite is germane to the aims of the pleasurable experience that arises from engaging with such works. In the context of voyeuristic art, the appetite that is aroused is rather different even when it is sexually charged. For our appreciation of voyeuristic works is tinged by the moral dimension of the conditions under which we view them.

4. Voyeurism in Art as a Moral Concept

One distinctive feature of voyeurism in art is the manner in which it invites us to simultaneously occupy the point of view of the 'attentive audience' *and* that of the person standing in the 'backspace' of the immediate audience. And perhaps this is one of the ways in which voyeurism in art is different

[28] According to Scruton 1994: 138–9, '[t]he genuinely erotic work is one which invites the reader to re-create in imagination the first-person point of view of someone party to an erotic encounter. The pornographic work retains as a rule the third-person perspective of the voyeuristic observer.'

from voyeurism in non-artistic contexts—it offers us a visual perspective which itself can be examined from an ulterior perspective. From there, we can see how the artist manipulates us by placing us in the position of a 'peeping tom'—playing with our moral conscience by forcing us to occupy the perspective of a conventional voyeur.

The thrill involved in breaking taboos and indulging in something we know to be inappropriate is central to the moral tension voyeuristic art relies on. We experience that *frisson* in virtue of being a spectator of a titillating scene, but also because we can simultaneously observe ourselves qua spectator from an external point of view, so to speak, and reflect on those very taboos and our indulgences in them.[29] Voyeuristic art, it seems, would not be truly voyeuristic if it didn't involve an element of illicit behaviour or evoke some form of moral unease since that is precisely what heightens our experience of voyeuristic works.

Voyeurism in art is a moral concept, then, insofar as it relies on the idea that we imagine doing or are actually doing something that would invite the censure of others were they aware of our voyeuristic actions. Obviously, because it is still art, this aspect of the piece tends to remain at the level of an idea—we are excited by the *thought* that we are doing something improper or naughty and, as a result, the censure in question is unlikely to lead to a legal conviction. But if there were no component of this kind in the voyeuristic experience, it would most probably turn into another form of artistic expression altogether. Voyeuristic art manipulates the boundaries of our moral codes, of what we are willing to do and how far we are ready to stretch the tenets which uphold that code even when the artwork plays on the lack of permission and seems willing to make limited or occasional exceptions. The fact that it does so at the same time as it appeals to our artistic sensibilities encourages us to think about how art—and our responses to it—are deeply linked to our moral belief systems.[30]

[29] I don't mean to suggest that all voyeuristic art is fundamentally reflective in any specifically theoretical sense. As Hans Maes has pointed out to me, one might consider some of Degas's nudes as examples of works that are straightforwardly voyeuristic without inviting us to 'reflect' on that voyeuristic gaze itself. I merely mean to suggest that the appropriate form of appreciation of voyeuristic works involves insight into the fact that the work is voyeuristic.

[30] Voyeuristic art is morally questionable in a different way from what has been referred to in the literature as 'immoral art', or works which put forward an immoral point of view. On the view known as immoralism, some works of art are good precisely *because* they represent and endorse with vividness a morally reprehensible perspective (such as William Burroughs's *Confessions of an Unredeemed Drug Addict*

The examples discussed earlier show this precisely in several interesting ways. In a first instance, they reinforce the point that what we consider morally acceptable (or not) can change over time. In terms of representational content, Manet's *Olympia* might well have stunned its nineteenth-century audience about as much as Tintoretto's *Susannah Bathing* had done three hundred years before, but most twenty-first-century viewers will be entirely immune to the shock of the brazen nakedness of the models and their expressions. In terms of viewing conditions, such paintings strongly suggest that what we consider public or private isn't set in stone either. A work such as *Rear Window* shows that what counts as acceptable or not insofar as invading another person's privacy is concerned is nowadays far from obvious. In *Following Piece,* Acconci himself physically invades the space of his subject, the artist turning into both voyeur and stalker, completely without consideration for how unpleasant this might be for the person being followed. The voyeuristic act becomes bolder and less concerned to remain hidden, the voyeur less embarrassed about his inappropriate behaviour.

A work like Tracey Emin's *My Bed* (1998) takes this point further still. Here, the artist propels one of her most private belongings straight into the public arena by revealing the remainders of her recent sexual activities even before her audience has had a chance to develop a curiosity in it. The bed, covered by stained sheets and surrounded by used condoms, dirty underwear, and cigarette butts, invites the viewer to become the voyeur of an artist who willingly exposes herself to the audience, as if the artist took a special delight in doing so. In *My Bed*, the spectator invades the private space of the artist at the invitation of that artist and in that sense both artist and spectator are 'peeping toms'—the spectator observing the artist and the artist observing the spectator. Work, artist, *and* subject seem to thrive on the fact that someone is seeing something which they shouldn't really be seeing, and in that sense *My Bed* builds a voyeuristic element into a work that is fundamentally exhibitionist. With a piece like this, widely recognized as

or Leni Riefenstahl's *Triumph of the Will*). But with voyeuristic art, as we have already seen, it is not so much the representational content which is morally problematic, but rather the conditions under which we observe that content. To this extent, voyeuristic art transfers the morally questionable aspect of the work from its content to the way in which it is viewed. For more on immoralism in art, see for example Jacobson 1997 and Kieran 2001.

one of the most iconic artworks of recent times, there would seem to be few taboos left for art to break.

5. The End of Voyeurism in Art?

It seems, then, that voyeuristic art in particular, and most probably art in general, has had to revise its parameters of appropriateness in parallel with changes in our moral codes. Specific artworks, on occasion, have actively contributed to this change by jolting our assumptions and forcing us to question the foundations of our moral beliefs. Of course, the further away we have moved the goalposts of what is considered morally dubious—perhaps especially in terms of sex—the less 'material', so to speak, has been left for voyeuristic artworks to explore.[31]

As a result, voyeurism seems to have become more and more diluted, and more and more art has come to be conceived as voyeuristic, or at least superficially so. In fact, in much contemporary art, the artistic perspective itself seems to have turned into a 'voyeuristic' gaze eager to divulge anything that might be described as intimate or shocking. In this sense at least, the voyeuristic perspective comes dangerously close to being confused with the more established role of the artist as insightful commentator. And whilst a voyeuristic standpoint can provide an insightful commentary, simply constructing a voyeuristic perspective isn't always enough for the purposes of art.

If nothing really feels taboo anymore, and voyeurism seems to have been watered down in this way, can there still be innovative voyeuristic art? One area where voyeurism in a general, non-artistic context, has strengthened its presence is contemporary social institutions centred around the cult of celebrities and 'catching' them on camera or film. Celebrity gossip magazines and the like are clearly predicated on the widespread desire to erode the notion of privacy—to put everything out there, literally speaking. At the same time, social networking applications such as Facebook and Twitter turn their users, in some sense, into minor 'celebrities', drawing pleasure from having intimate snippets of their lives revealed to their 'followers'. Such a context, where notions of privacy and propriety seem universally to

[31] For a particularly interesting discussion of Manet's *Olympia*, see Nehamas 2007.

be on the retreat, suggests a growing need for voyeuristic artworks whose importance consists in their affording opportunities to reflect on the shrinking of the private sphere. Emin's *My Bed*, for example, is important precisely because its reflexive structure allows us to question our own obsession with the sex lives of others, perhaps especially of the rich and famous—it catches us in the act, so to speak.

Acting against this, however, is the way in which inflation in the currency of voyeurism in art causes such artworks to forfeit their own power. The less voyeuristic works engage our sense of propriety, the less meaningful the application of the concept of voyeurism becomes. As I have argued in this chapter, by ignoring the fact that voyeurism cannot be understood independently of its moral extension, such artworks lose the capacity to offer valuable commentary and critical reflection on precisely the psycho-social phenomenon of which they are in many respects symptomatic.

One of the main aims of this chapter has been to draw attention to the different ways in which moral concerns arise in the context of art that takes an intimate act or moment for its subject matter. Not only do many recent philosophical accounts of sexually charged works set these moral questions to one side.[32] In general, where moral aspects are considered, our theories have tended to concentrate on the effects that viewing such art may have on our society and its members at large. For example, discussions about the notion of pornography have targeted the consequences that engaging with pornography may have on our conception of women, say, or our conception of women's relationship with men.[33]

Clearly, engaging with pornography can have repercussions that are detrimental to our society, perhaps especially for women. What this chapter has set out to show, however, is that several moral issues arise even before we turn our attention to the effects of this kind of experience. Rather, our goal has been to examine the *way* in which viewing representations of intimate acts can, at least at times, be described as morally problematic—not the fact *that* we view them but *how* we view them.

[32] Perhaps especially with regards to pornography and the question of whether pornographic works can count as art. See, for example, Kieran 2001, Mag Uidhir 2009, Maes 2010, Vasilakis 2010.

[33] See, for example, Soble 1985 and Parent 1990.

References

Allen, T. et al. (1998) 'Privacy, Photography and the Press'. *Harvard Law Review* III (4): 1087.

Bourriaud, Nicolas (1992) 'Vito Acconci, Performance after the Fact'. *Documents sur l'art contemporain*. Paris.

Gaut, Berys (2007) *Art, Emotions and Ethics*. Oxford: Oxford University Press.

Gili, Marta (2010) 'From Observation to Surveillance'. *Exposed*. London: Tate Publications. 241–5.

Harrison, Charles (2005) *Painting the Difference: Sex and Spectator in Modern Art*. Chicago: University of Chicago Press.

Jacobson, Daniel (1997) 'In Praise of Immoral Art'. *Philosophical Topics* 25(1): 155–99.

Kieran, Matthew (2001) 'Pornographic Art'. *Philosophy and Literature* 25(1): 31–45.

Lemire, Elise (1999) 'Voyeurism and the Postwar Crisis of Masculinity in *Rear Window*'. In John Elton (ed.), *Alfred Hitchcock's* Rear Window (Cambridge Film Handbooks). Cambridge: Cambridge University Press.

Levinson, Jerrold (2005) 'Erotic Art and Pornographic Pictures'. *Philosophy and Literature* 29(1): 228–40.

—— (2006) 'What is Erotic Art?' *Contemplating Art: Essays in Aesthetics*. Oxford: Oxford University Press. 252–8.

Linker, Kate (1994) *Vito Acconci*. New York: Rizzoli Publications.

Maes, Hans (2011) 'Art or Porn: Clear Division or False Dilemma?' *Philosophy and Literature* 35(1): 51–64.

Mag Uidhir, Christy (2009) 'Why Pornography Can't Be Art'. *Philosophy and Literature* 33(1): 193–203.

Metzl, Jonathan (2004) 'Voyeur Nation: Changing Definitions of Voyeurism 1950–2004'. *Harvard Review of Psychiatry* 12: 127–31.

Nathan, Daniel (1990) 'Just Looking: Voyeurism and the Grounds of Privacy'. *Public Affairs Quarterly* (October): 381–402.

Nehamas, Alexander (2007) *Only the Promise of Happiness*. Princeton: Princeton University Press.

Parent, W. (1990) 'A Second Look at Pornography and the Subordination of Women'. *Journal of Philosophy* 87(4): 205–11.

Phillips, Sandra S. (2010a) 'Looking Out, Looking In: Voyeurism and its Affinities from the Beginning of Photography'. *Exposed*. London: Tate Publications. 11–15.

—— (2010b) 'Voyeurism and Desire'. *Exposed*. London: Tate Publications. 55–9.

Rudinow, Joel (1977) 'Representation, Voyeurism and the Vacant Point of View'. *Philosophy and Literature* 3(2): 173–86.

Scruton, Roger (1994) *Sexual Desire*. London: Phoenix.

—— (2009) *Beauty*. Oxford: Oxford University Press.

Soble, A. (1985) 'Pornography: Defamation and the Endorsement of Degradation'. *Social Theory and Practice* 11(1): 61–87.

Truffaut, François (1954) 'Autres filmes'. *Arts* 483(3), 20.

Vasilakis, Mimi (2010) 'Why Some Pornography May Be Art'. *Philosophy and Literature* 34(1): 228–33.

Wertheimer, Alan (2008) 'Consent and Sexual Relations'. In Alan Soble and Nicholas Power (eds.), *The Philosophy of Sex: Contemporary Readings*, 5th edn. Lanham, Md.: Rowman & Littlefield.

Index